Writings About Art

Carole Gold Calo

Assistant Professor of Art History
Stonehill College

PRENTICE HALL
Englewood Cliffs, New Jersey 07632

Library of Congress Cataloging-in-Publication Data

Writings about art / [edited by] Carole Gold Calo. *N*
 p. cm. *7425*
 Includes bibliographical references. *.W85*
 ISBN 0-13-761701-1 *1994*
 1. Art—Bibliography. I. Calo, Carole Gold.
 Z5931.W85 1993
 [N7425]
 700—dc20 92-47106
 CIP

Editorial/production supervision
 and interior design: Mariann Murphy
Acquisitions editor: Bud Therien
Prepress buyer: Herb Klein
Manufacturing buyer: Bob Anderson
Cover design: Karen Salzbach

© 1994 by Prentice-Hall, Inc.
A Division of Simon & Schuster
Englewood Cliffs, New Jersey 07632

Printed in the United States of America

10 9 8 7 6 5 4 3 2 1

ISBN 0-13-761701-1

00009 6463
12.15.93

Prentice-Hall International (UK) Limited, *London*
Prentice-Hall of Australia Pty. Limited, *Sydney*
Prentice-Hall Canada Inc., *Toronto*
Prentice-Hall Hispanoamericana, S.A., *Mexico*
Prentice-Hall of India Private Limited, *New Delhi*
Prentice-Hall of Japan, Inc., *Tokyo*
Simon & Schuster Asia Pte. Ltd., *Singapore*
Editora Prentice-Hall do Brasil, Ltda, *Rio de Janeiro*

*To my father, Bennie Gold, and my mother, the late Helen Gold,
for their enthusiastic support of my professional endeavors*

Acknowledgments

The inspiration for this anthology of readings came from my students and colleagues in the Art Department at the University of Massachusetts, Boston, who led me to new ways of thinking about art.

I would also like to thank the following people for their insights and suggestions: Donna Cassidy, Herbert Cole, Nicholas Capasso, Nancy Steiber, Christie Nuell, Ida K. Rigby, and Gary Zaruba.

I am grateful to those at Prentice Hall who have helped make this book a reality: Bud Therien, Executive Editor College Art and Music, for believing in the concept; Mariann Murphy, Production Editor, for preparing the manuscript; and Keith Faivre, Production Editor, for guiding it into production.

Most importantly, I appreciate the support of my family. Special thanks go to my husband Andrew for his encouragement and patience; to my son Nicholas for sharing my attention; and to my younger son Brett for timing his arrival into the world towards the end of this project.

Contents

Writings About Art

Introduction

Writings about Art is an anthology of readings on various topics of interest to the contemporary student of art and art history. The selections have been chosen to offer the broadest possible spectrum culturally, historically, and ideologically. It is my hope that these readings will encourage critical thinking among students and will elicit strong responses that may be shared in class discussion.

A collection such as this is long overdue. Most anthologies present a historical approach, offering essays on particular works or artists throughout the history of Western art; others provide an in-depth study of a period or style. Although these books may be appropriate supplements for an upper-level course, they have little application in a nonhistorical art introduction, and are often far too scholarly or specialized for the beginning student in a historical survey.

The inspiration for *Writings about Art* came from my own teaching experience and from my conversations with colleagues at numerous colleges and universities. Many of us have felt frustrated with conventional methods of teaching introductory courses and are seeking new, more thought-provoking ways to introduce students to the fascinatingly complex, ever-changing world of art. The nonhistorical art survey (variously titled Language of Art, Visual Fundamentals, Art Appreciation) is most often approached formalistically, focusing on the vocabulary of art, formal analysis, and media and technique. In fact, most of the appropriate textbooks are organized in this manner. The historical art survey, although understandably taught chronologically, is usually presented from a totally Western viewpoint and is characteristically nonissue oriented. Students' interest may be dampened by such narrow approaches, which involve little independent or critical thinking. Presently, many art history

1

departments are engaged in intense pedagogical revisionism. More creative approaches are sought for both the nonhistorical and historical art surveys, but professors are limited by available resources.

Today's students represent a variety of socioeconomic and ethnic backgrounds and span a broad age range. Those coming into an art course for the first time often feel intimated by and disenfranchised from "high culture." Although some have had previous exposure to art, many have never visited a museum or really thought about what is involved in understanding and appreciating art and architecture. Art history professors have a responsibility to make art more accessible to these students, to help them understand that art is relevant to their lives, as it has been for people throughout the centuries, for people of various cultures, religions, and races. A traditional formalist approach is not necessarily the most effective. One possible solution for the nonhistorical survey might be to present a brief introduction to the formal elements of art and the vocabulary necessary to analyze art and architecture, but then to concentrate on topics or issues that might stimulate students' thinking. Because most major historical periods are covered, specific essays may be assigned to supplement the text for a survey course.

The topics I have chosen for this collection are art and religion, art patronage, art and politics, women and art, issues concerning race and ethnicity, public art, and controversies over government funding and censorship. To offer the widest possible overview, I have included essays representing Asian, African, Hispanic, African-American, and Native American cultures; European and American art from various historical periods; and contemporary concerns. This multicultural, topic-oriented approach is intended to broaden the students' understanding of how art interacts with and is affected by culture, religion, politics, economics, and public opinion.

Part I Art and Religion

From the earliest civilizations to the present day, art has served religion and has reflected religious and spiritual concepts. Albert Elsen in "Images of Gods" from *Purposes of Art* compares representations of Apollo, the ancient Greek sun god, with depictions of Christ and Buddha. The author provides the reader with important historical information concerning each of these religious figures and the religions that they inspired. He also discusses how the respective religious concepts that make the Greek pagan rites, Christianity, and Buddhism so distinctive led to different stylistic approaches. Vincent Scully's study, "The Sacred Mountain in Mesopotamia, Egypt, and the Aegean" from *Architecture: the Natural and*

the Manmade, investigates the civic and religious significance of the Near Eastern ziggurat. The author then discusses the symbolism of the Egyptian pyramid, comparing its conceptualism with the nature imagery in later Egyptian temples. Finally, the relationship between sacred mountains in Crete and the design of Minoan palaces is shown to reflect the importance of the earth goddess for a culture deeply connected to nature. "The Interpretation of the Second Commandment" from *Contemporary Synagogue Art* by Avram Kampf explores the relationship between Judaism and art based on interpretation, misinterpretation, and reinterpretation of the Second Commandment as handed down to Moses on Mount Sinai. As the author points out, many reversals of attitudes have been demonstrated throughout the centuries according to internal and external pressures, alternating between more liberal or more fundamentalist reactions to the arts. But ultimately, the attitude toward art in Judaism has to do more with its de-emphasis of material things and its focus on more ethical concerns than it does with any written words. According to Robert Rosenblum in excerpts from *Modern Painting and the Northern Romantic Tradition: Friedrich to Rothko*, both of these artists painted works that have spiritual meaning but are not traditionally sacred. Translating religious feelings into the domain of the everyday, Friedrich's trascendental landscapes offer an alternative to conventional religious art. Likewise, more than a century later, Mark Rothko's mysterious abstractions intimate a "tragic-religious drama" that goes beyond a specific formalized religion.

Part II Art Patronage

Patronage refers to those who support, commission, and purchase art, and it is not surprising that patrons have been extremely important in the history of art. Francis Haskell in "The Mechanics of Seventeenth Century Patronage" from *Patrons and Painters: A Study in the Relations between Italian Art and Society in the Age of the Baroque* considers the influence popes, cardinals, and noblemen exerted in establishing some of the most significant sites in baroque Rome. He goes on to identify specific types of relationships between artist and painter. Agreements were drawn up between painter and patron designating a work's measurements, subject matter, sometimes the number and identity of figures to be included, and time limit; expenses were determined by the skill of the artist and the materials used. So a commissioned work of art from this period was a close collaboration between artist and patron. According to Harold Kahn in his catalog essay, "A Matter of Taste: The Monumental and Exotic in the Qianlong Reign," which accompanied an exhibition titled *The Elegant*

Brush at the Phoenix Art Museum, the Qianlong Emperor, a most influential patron of the arts, left a legacy of taste for Imperial pomp and monumental projects in China that extended far beyond his own eighteenth century. A self-proclaimed poet and artist, he was an avid collector who amassed a splendid Imperial Palace Art Collection and encouraged the restoration of important architecture throughout his land. During his reign a unified Chinese cultural world view was firmly set in place. An essay based on a talk given at the conference *Breakthroughs: Women in the Visual Arts*, "Katherine Dreier: Art Patron with a Social Vision," introduces a different notion of patronage, that of the art lover who wishes to promote avant-garde art and the artists who produce it. Katherine Dreier not only acquired her own collection of modern art, but cofounded the Société Anonyme with Dadaist Marcel Duchamp. Ms. Dreier organized exhibitions, proselytized about the importance of modern art at public lectures, and even planned a museum that would offer a less urbanized general public a view of modern painting and sculpture integrated into a normal home setting. Truly believing that art could effect positive change in society, for more than twenty-five years she zealously devoted herself to promoting its cause. The last selection, "The Structure of the Soho Art Market" by Charles Simpson from *Soho: The Artist in the City*, explores the world of commercial art galleries in Soho and the buyers they attract. The new collectors are often upscale professionals who may just as easily buy directly from the artist during a studio visit as make a major purchase from a gallery. These "new buyers" seem to prefer contemporary art and view collecting as a vehicle for self-expression as well as a statement concerning their new sense of social position.

Part III Art and Politics

Throughout the centuries art has been inextricably intertwined with politics. Often works of art make strong statements about particular events or reflect attitudes of support or criticism for political ideologies. In "Art and Freedom in Quattrocento Florence," Frederick Hartt links the changes that occurred in Florentine painting and sculpture during the first thirty years of the fifteenth century to specific political, economic, and social situations that ultimately affected both style and content. Hartt points out that the Florentine Early Renaissance is an essentially republican style providing symbols of civic pride, *virtu*, and sense of duty for the beleauguered Florentines. Fred Licht provides insight into Goya's "Disasters of War" series in *Goya: The Origins of the Modern Temper in Art*. These gruesome etchings were inspired by atrocities committed during Napoleon's annexation of Spain in the early nineteenth century. The

author compares these prints with journalistic photography and points out a modernity in attitude toward reality discernible not only in the brutal subject matter but in composition as well. In looking at these prints, the viewer is directly confronted with the purposelessness of such violent acts and is forced to take a stand, if only to try to salvage some trace of human dignity. Another aspect of the interaction between art and political events is discussed by Boris Groys in his essay, "The Birth of Socialist Realism from the Spirit of the Russian Avant-Garde," which was previously anthologized in *The Culture of the Stalin Period*. Groys demonstrates that socialist realism, made the "official style" under Stalin, was not a reaction against, but in fact evolved from, the ideas of avant-garde artists of the revolutionary period. Obvious fundamental differences in style and philosophy existed between the two: whereas the avant-garde directed its energies toward forming actual material reality, socialist realism strove to form a psychology of the new Soviet person. Yet, while socialist realism eventually crushed the avant-garde, it did continue and finally implement its program by helping to build a new social, political, and material reality. More recently, Michael Brenson grapples with the question, "Can Political Passion Inspire Great Art?" in an article published in the *New York Times*. Many contemporary artists are addressing political concerns, whether it be statements concerning war in general, U.S. intervention in Central America, or the threat of nuclear annihilation. Brenson reviews earlier examples of art with a political message from Goya to Picasso's *Guernica* to Agitprop, the art of revolutionary propoganda in Russia, to German expressionist reactions to World War I. In comparison, Brenson finds much recent political art to be sophomoric, without any suggestion of broader artistic or human knowledge. The conclusion is drawn that the best political art has always been first and foremost art and secondarily politics.

Part IV Women and Art

In the past twenty-five years women's issues have come to the fore—both depictions of women in art and the position of women artists. Therefore I have divided this chapter into two parts. In the first two essays, imagery representing different roles and interpretations assigned to women reveal quite distinctive cultural attitudes and formal approaches. Herbert M. Cole traces the greater meaning of maternity as depicted in the sculpture of various African tribes in his catalog essay accompanying the exhibition *The Mother and Child in African Sculpture* at the Los Angeles County Museum of Art. The diverse poses, forms, and stylistic treatments of maternal imagery are described. The author digs deeper to study the

social and ritualistic contexts for sculpture representing mother and child to reveal rich spiritual connotations. Susan Casteras surveys various depictions of Victorian women in "The End of the Century and Conflicting Fantasies of Femininity" her concluding chapter in *Images of Victorian Womanhood in English Art*. She notes a new competitor to traditional middle- to late-nineteenth-century images of women (i.e., submissive wives, women performing charitable acts, martyred female workers) in the *femme fatale*. This heartless, self-absorbed, always alluring woman came to be heroicized in British art toward the end of the century as the embodiment of male fantasies, poised between the realities of middle-class Victorian ladies and the aberrant and potentially threatening New Woman. The last two essays in this section deal with problems confronting women artists. Linda Nochlin asks a startling question in "Why Have There Been No Great Women Artists?" from *Art and Sexual Politics*. She cites the dominant white Western male viewpoint in the field of art history and calls for a feminist critique of the discipline (which has since been offered by several feminist art historians including Nochlin herself). She challenges the notion that women's art exhibits an "essential femininity" and addresses the fact that both social and art institutions have historically discouraged women's efforts by making unavailable to them the support and training necessary to achieve proficiency as artists. The issue of parity between male and female artists is updated to consider the struggle of contemporary women artists for equal representation in an *Artnews* article "How Wide Is the Gender Gap?" by Eleanor Heartney. During the 1970s obvious advances were made by certain women artists. Yet in the 1980s, economic realities, a generally conservative shift in societal thinking, and shrinking public funding resources contributed to women artists' decreasing visibility on the art scene. Tokenism replaced true efforts among institutions at fair representation. The anonymous poster-wielding Guerilla Girls and The Women's Caucus for Art are two groups committed to effecting positive change by raising public and institutional consciousness.

Part V Issues Concerning Race and Ethnicity

People of color have long been subject to stereotypical representation in art. In his catalog essay "Race and Representation" for the Corcoran Gallery of Art's exhibition *Facing History: The Black Image in American Art 1710–1940*, Guy McElroy traces changes in the representation of African-Americans in American Art from the cartoonish caricatures of

colonial times through the more dignified Civil War and Restoration images to late nineteenth and early twentieth century efforts to offer a more realistic vision of African-American identity. The Native American has also suffered from invented representations by white artists. In "Inventing 'the Indian,' " an essay included in the National Museum of American Art exhibition catalog *The West as America*, Julie Schimmel concludes that white Americans have perceived Native Americans through assumptions of their own culture rather than attempting to understand Native American culture. Presentations range from the Indian as "noble savage" to the savage who massacres innocent white settlers with the ultimate doom of the Indian and his way of life always implied. According to the author, real Indians have never peopled the paintings of white artists; rather white attitudes toward nature, the right to conquer, and the superiority of white religion and society have been expressed. Recent Hispanic art is the subject of a study by John Beardsley entitled "And/Or Hispanic Art, American Culture," written for the exhibition *Hispanic Artists in the United States: Thirty Contemporary Painters and Sculptors* at the Museum of Fine Arts, Houston. Beardsley addresses the ongoing debate over ethnic self-identification versus assimilation of Hispanics into American culture. He provides examples of several artists who have made different choices concerning this issue: the Chicano movement for Civil Rights; artists who refer to native tradition; those who are inspired by a complex variety of influences; and artists who have assimilated quite thoroughly into mainstream American art movements. The author sees this diversity as a positive contribution to the ever-expanding definition of our collective society. Finally, Lucy Lippard extends the discussion of issues of identity to embrace African-American, Native American, and Asian-American, as well as Hispanic, artists. For Lippard "Naming" is a way in which minority artists work through questions of self-identification, societal stigmas, and cultural pride. In this essay from *Mixed Blessings*, the author stresses the need for a truly viable theory of multiplicity in America before aesthetic concerns can seriously be considered. After pointing out the difficulty in terms such as "primitive art" and "ethnic arts," she focuses on representative artists whose work demonstrates an intense internal searching.

Part VI Public Art

Recently public art has received a great deal of attention because of certain highly publicized controversial installations. Yet public art and architecture have traditionally played an important role in American as

well as European society in representing common ideals. In "The Public Realm" from *America by Design*, Spiro Kostof recognizes public places as fulfilling a collective need to celebrate a sense of belonging and community spirit. He directs our attention to open public spaces and the distinctive vision of Frederick Law Olmsted for urban parks. According to the author, nineteenth-century designs for state capitol buildings attest to an increased public appetite for splendor; simultaneously, public monuments reflect America's desire to universalize yet retain a sense of its own historical identity. However, by the end of the nineteenth-century, the new worldliness and sense of luxury that had come to permeate buildings like libraries, department stores, railroad stations, and office buildings established so grandiose a domain as to distance the general public. However splendid and edifying public art has traditionally been, Douglas Stalker and Clark Glymour vehemently oppose its more recent counterparts. In "The Malignant Object: Thoughts on Public Sculpture," which initially appeared in *The Public Interest*, the authors see public art as a waste of money because, they suggest, most of the public does not even enjoy the artworks they see. Unlike monuments from the past, they contend, contemporary public sculpture presents no intellectual, pedagogical, or economic virtues and may actually be harmful to the public. One of the most talked about public art controversies in recent years has concerned Richard Serra's *Tilted Arc*. Judith H. Balfe and Margaret J. Wyszomirski in an essay entitled "The Commissioning of a Work of Public Sculpture," from *Public Art/Public Controversy: The Tilted Arc on Trial*, explain briefly who is involved in choosing works to be displayed in public places. They go on to describe the events surrounding the commissioning, erection, and removal of Serra's sculpture after heated hearings concerning suitability of that work for its particular site. Together we ponder the possible lessons to be learned from this controversy. Understanding and anticipating public reception of works commissioned for public spaces is imperative. The highly complex, politically charged events surrounding the commissioning and execution of Maya Lin's *Vietnam Memorial* are outlined by Nicholas Capasso in an essay written for *The Critical Edge: Controversy in Recent American Architecture*. The design, chosen by a jury and sanctioned by the Senate and the House of Representatives, met resistance from politically conservative factions and from some Vietnam veterans who felt that the monument was critical, rather than supportive, of the war. To appease the protestors another, more representational monument was erected next to the original. According to Capasso, this type of heated debate over appropriateness of commemorative works of art, while often bitter and protracted, indicates a healthily pluralistic society.

Part VII Controversies Over Government Funding and Censorship

An issue that has come to the public's attention in the past several years concerns government funding and artwork that might potentially be considered offensive by various segments of the population. While the cancellation of the Robert Mapplethorpe exhibition at the Corcoran Gallery of Art in Washington, D.C., and the subsequent obscenity trial in Cincinnati spotlighted this particular photographer, many artists fear that censorious withholding of funding is a present and future threat to artistic freedom. In "The Senses and Censorship" from *The Power of Images*, David Freedberg reviews the relationship between the senses and censorship throughout the history of art, noting that artworks dealing with erotic suggestion have at various times been objected to by some. Exploring the connection between realism and arousal, between the truthfulness of the image and the fetishist gaze, Freedberg attempts to explain the different preconceptions which render the realistic "vulgar," and the "artful" beautiful. The showing of photographs by the late Robert Mapplethorpe, a small number of which displayed explicit homoerotic images and child nudity, elicited an unprecedented legal response. In an article written for *Artnews*, "The Obscenity Trial: How They Voted to Acquit," Robin Cembalest traces the events of the trial in Cincinnati in which Dennis Barrie, director of Cincinnati's Contemporary Arts Center, was charged with obscenity for exhibiting the Mapplethorpe photos. The strategy of the defense is explained, and, more important, the reasoning among the jurors for the acquittal, shedding light on the sometimes hazy distinctions between pornography and works of art. Hilton Kramer, however, was deeply disturbed by the support of the artistic and critical community for Mapplethorpe and poses the question "Is everything and anything to be permitted as Art?" In his *New York Times* article "Is Art above the Laws of Decency?" Kramer relates the Mapplethorpe photographs to nineteenth-century pornographic prints and the "social pathology" their appeal represents, and claims that most of society finds the acts depicted by Mapplethorpe loathesome and therefore unacceptable as art. He claims government money should be given to fund only the highest achievements of our culture. The government's funding of artists and art institutions is the subject of Elaine King's essay, "The NEA: A Misunderstood Patron," adapted from a talk given at an annual College Art Association meeting. The social-historical background for the National Endowment for the Arts (NEA) is outlined. A description of the role the NEA has played in the past twenty or so years in promoting artistic endeavors and in democraticizing art is offered. The diminishing of the NEA in recent years and

the challenging of its open support of diversity of expression are seen as a threat to the growth and development of art in the United States. The author calls for strong leadership from within and without, and financial backing from law makers. Also needed is an educated public, unafraid of controversy, who will make a commitment to promoting the arts.

The selected essays in this anthology are multifaceted, intended to provoke thought and encourage discussion. *Writings about Art* is versatile and can be used in a variety of ways, according to the requisites of a course's curriculum and the interests of the students. On the practical level, it will alleviate for professors the highly time-consuming effort of locating and xeroxing readings for class use. Hopefully this book will inspire more creative teaching methods for introductory-level courses. Most importantly, it will provide students with materials through which they can explore the many dimensions of art as it interacts with their lives and the lives of past and future generations.

1

Images of Gods

Albert Elsen

The history of religion tells us that gods made men in their own likeness, but the history of art tells us that men have remade the gods into their own image. Art has served no more important purpose than giving a visible presence to gods. For millennia, art provided visual reminders of celestial authority and made more intelligible the nature of deities. The sculptured or painted image of the god was the focus of worship and ritual, and it also gave to the faithful a feeling of reassurance and protection. Ancient Greek cities, for example, placed a statue of their tutelary god on the battlements to ensure their defense. The focusing of the imagination upon great and mysterious objects of worship is one means people have used to liberate themselves from the bondage of mundane facts. Investing the god with material form also satisfied mortal curiosity and the desire for familiarity with and recourse to the god. The act of making a sculpture or painting of a god was both an honorific gesture and a means of coming to terms with the supernatural. The finished work of religious art also provided a visible ethic to guide people in the conduct of their lives. Today we need not believe in the religions that inspired the images of Apollo, Buddha, and Christ to be impressed and moved by them. Their greatness as works of art transcends time and the boundaries of religious belief. Still, unless we can share to some extent the original concepts and emotions that produced this sacred imagery, we cannot fully

appreciate the awe, wonder, and gratification with which it was received at the time of its creation. Nor can we appreciate the achievement of the artists who first brought this imagery into being. To content oneself with considering only the visual or aesthetic value of religious art is to miss the equally rewarding experience of learning about significant human attempts to discover and give form to the truth of existence. Sacred imagery shows how elastic is the potential of the human body, which has been represented in so many ways to accommodate such divergent concepts, and how flexible is the human mind that has accepted religious art as real, or at least as convincing and sincere.

Apollo

On the temple of his sacred precinct at Delphi were inscribed the precepts of Apollo:

> Curb thy spirit.
> Observe the limit.
> Hate hybris.
> Keep a reverent tongue.
> Fear authority.
> Bow before the divine.
> Glory not in strength.
> Keep woman under rule.

In his study *The Greeks and Their Gods*, W. K. D. Guthrie has summarized Apollo's value to the Greeks by observing that Apollo is the embodiment of the Hellenic spirit. Everything that distinguishes the outlook of the Greeks from that of other peoples, and in particular from that of the barbarians who surrounded them—beauty of every sort, whether in art, music, or poetry or in the qualities of youth, sanity, and moderation—is summed up in Apollo. Above all, he was the guardian against evil, the god of purification and of prophecy. Any good Greek could see in Apollo the preacher of "Nothing too much" and "Know thyself." Under his most important and influential aspect may be included everything that connects him with principles of law and order. Primarily, he represents the Greek preference for the intelligible, the determinate, and the measurable, as opposed to the fantastic, the vague, and the formless. Apollo was also looked to as a god of nature and was known as "keeper of the flocks." He was the first Olympic victor. He presided over the transition from boyhood to manhood, and he was variously shown as a warlike god who carried a silver bow and as a patron of the arts who played upon a lyre. Concomitantly, he was thought of as the god of both physical and spiritual

healing, capable of purifying the guilty. Finally, he was the patron of civilized situations. . . .

. . . From his first appearance in art, Apollo was interpreted *anthropomorphically*, that is, as having human characteristics, and was depicted in perfect physical form.

The pediment of the Temple of Zeus at Olympia . . . shows Apollo at a legendary nuptial ceremony intervening in a disruption caused by drunken centaurs who were trying to abduct the bride. He epitomizes the Greek ideal of "the cool." The idea being developed in this Apollo [Fig. 1-1] parallels other changes in Greek art. The rigid, frontal symmetry of the earlier statues . . . has been broken by the profile position of the head and by the gesture of the right arm, raised to restore order. Made in mid-5th century B.C., this Apollo departs from the Archaic figures in his softer, more sensuously modeled body, which results in a more subtle joining of the body parts and the

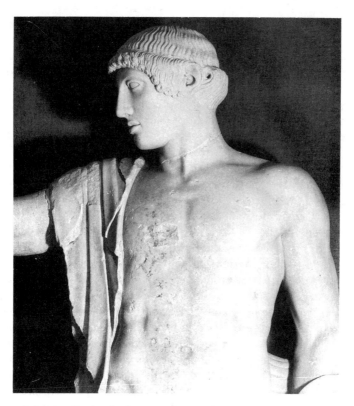

Figure 1-1. *Apollo,* detail of west pediment of the Temple of Zeus. c. 460 B.C. Marble, height 10'4". Archeological Museum, Olympia. Photo by Alison Frantz, Athens.

limbs to the torso. The treatment of the muscular fold of the pelvis, a Greek sculptural convention, affirms the perfect fit of the thighs in the socket of the torso, like the modulated juncture of a column capital with the lintel above. The . . . full-round conception of the body admits successive and varied silhouettes. . . . [Such statues] prompted the 5th-century Athenian public to voice the opinion that their best sculptors could portray beautiful *men*, but not beautiful gods. Even the great sculptor Polyclitus was not immune to this criticism. . . . Scaled larger than the other figures in the composition and placed in the center—both of which are older devices for establishing hierarchy—the god has been assured his authority. The ideal proportions, physical development, and facial features immediately set the god apart from the mortals and centaurs who surround him. It was, however, the . . . qualities of grace and physical self-confidence that endowed this Apollo with dignity and divine identity and with great self-control. . . . Thus, despite the emphasis on corporeality, the portrayal epitomizes conduct and restraint, as well as law and order, through presence and gesture.

Although close in date to the Olympia *Apollo*, the Classical *Apollo* [Fig. 1-2] of the sculptor Phidias carries even further the sensual possibilities of the body. The rigid axis through the center of the body has been eliminated, and the weight is placed on the right leg in a hip-shot pose that creates a more active balance of the body—one of the great achievements of Classical Greek sculpture. In this system of *contrapposto* (or "counterpoise"), the movement of each portion of the body is an ideal compositional counterpart to the Apolline tradition of harmony between spirit and body. The strength of the still-idealized visage and the impressive physique, coupled with the resilient pose, assist in conveying a feeling of authority that has now become more humane. . . . The perfect proportioning of the torso is a striking lesson in moderation, in avoidance of physical or sensual excess.

At the end of the 4th century, the military conquests of Alexander the Great extended the rule of Greece throughout the Near East and into Egypt. This political domination spread Greek art and civilization to many different peoples and thus produced a heterogeneous culture termed *Hellenistic*. In general, the effect of this new internationalism on sculpture was an increasing development toward the more realistic depiction of nature and toward more complex and vigorous compositional mobility.

The Hellenistic *Apollo Belvedere* [Fig. 1-3] depicts the god in decided movement, with his draped left arm extended. It is believed that originally his left hand held the silver bow, his military attribute. The controlled movement permits illustration of Apollo's supreme physical grace and, by implication, his intellectual discipline. While retaining obvious idealized traits in face and body, the *Apollo Belvedere* is the most lifelike, and hence the most nonsacred, of the Apolline sculpture we have discussed, and this

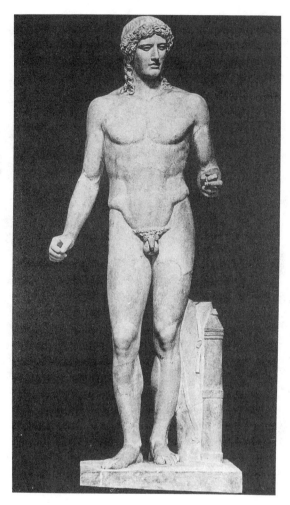

Figure 1-2. *Apollo,* Roman copy after Phidias' original of c. 460 B.C. Marble, height 6'5½". Kassel, Staatliche Kunstsammlungen. Photo by Bildarchin. Foto Marburg/Art Resource.

change corresponds to political and sculptural developments in Greece as a whole. This last figure also suggests why the Greek religion declined in power. The gods are almost totally conceived and presented in human terms, an attitude that permits a fatal familiarity and identification between god and worshiper. This congruence of identity is apparent in spite of the fact that many of Apollo's attributes are beautifully incorporated within the sculpture. The handsome figure, with its athletic and dancerlike grace, retains a suggestion of the purity of mind and body and of the faculty of

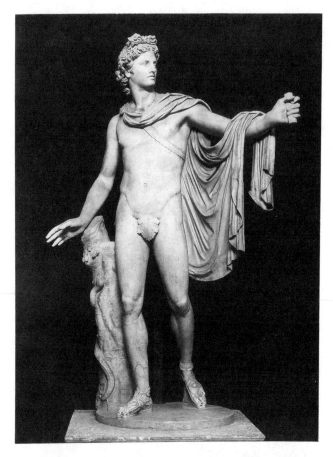

Figure 1-3. *Apollo Belvedere.* Roman copy after Greek original of late 4th century B.C. Marble, height 7′4″. Vatican Museums, Rome. Photo by Alinari/ Art Resource.

wisdom so cherished by the Greeks. In all these images of Apollo, the Greeks sought to present the beauty of the god's mind and of morality through the medium of a beautiful human body. The mastery of sculptural mobility achieved by the artists, while powerfully evoking the personality or temper of the god, may ultimately have caused the weakening of his divine efficacy.

Buddha

The Buddha is traditionally presumed to have lived between 563 and 483 B.C. in the region of Nepal on the border of India. Born a prince, he became a reformer of the Brahmanist religion and a great ethical teacher whose

sermons in many ways paralleled those of Christ. Like Christ, Buddha emphasized meditation and good works and viewed this life as filled with pitfalls. Also like Christ, he did not work toward the establishment of a complex religious order in his own lifetime; the formal religion that evolved from his teaching came long after his death. Buddhism is composed of two main sects. The Mahayana (Great Vehicle) or "pious" sect looks upon the Buddha as a god possessing the power of miracles and protecting the faithful from harm. He is lord of the universe. This sect developed strongly in China and Japan from its origins in India. The Hinayana (Lesser Vehicle) or "rationalist" sect looks upon the Buddha as a great, but human, sage who provided a code of ethics that could deliver humanity from the sources of misery. His image in art was a reminder and not an actual presence, similar to images of Christ in Western art. The Hinayana sect was strongest in Southeast Asia, in Burma, Cambodia, Ceylon, and Thailand.

The history of the images of the Buddha goes back to the first centuries before our era, when he was not shown in human form but was represented by symbols—his footprints, the Wheel of Learning, the tree under which he achieved Enlightenment, an altar, or an honorific parasol recalling his princely origin. The faithful could achieve communion with Buddha by meditating on the symbols that induced his presence. One of the early sculptures that does not show the actual form of the Buddha ... portrays an evil spirit menacing the divine throne. Although the Buddha is physically absent, his attributes, such as the throne and his footprints, as well as the reverent attitude of the court, are indicative of his sacred presence. This initial unwillingness to give tangible form to the Buddha has a parallel in Early Christian art, and there are no images of the Buddha or Christ dating from their own lifetimes. To have given tangible form to either of the gods may have seemed at first a contradiction of their divine being. The incentives for Buddhist artists to change were the growing competition with Hinduism and exposure to Roman and Late Greek art.

Perhaps the earliest freestanding sculpture of Buddha was made in Mathura, India, during the 2nd century A.D. and is termed a Bodhisattva, or potential Buddha. This powerful figure, the Bodhisattva of Friar Bala ... stands about 8 feet (2.4 meters) tall and was originally situated before a tall column. Atop the column was a stone parasol, 10 feet (3 meters) wide, which was carved with symbols of the heavenly mansions and represented the Buddha's royalty. The lion at his feet was also a regal attribute, symbolizing the Buddha as the lion among men. The rigid, frontal, and squarish formation of the body sets it apart from the Mediterranean art of the time and argues that the standing Buddha image was of Indian origin. The symbolism and body type, however, are markedly different

from Hindu sculpture of the 1st century, such as the sandstone god Siva.
. . . In this representation, the god is designated both by a human form
and by his attribute—a giant phallus that was known as a *lingam*. Though
it was accessible only to Hindus, who could enter the sanctuary of the
temple where it was housed and daily annointed with oil, this Hindu icon
helps us to understand why the Buddhists overcame objections to imaging
the local figure of their worship.

When the Buddha was finally given human form by the Gandhara
artists, in the 1st or 2nd centuries of our era—roughly seven centuries
after his death—his body was a materialization of concepts similar to
those the symbols had conveyed. The tasks facing the early sculptors of
the Buddha included the incorporation of 32 mystic signs of his super-
human perfection: among these were the cranial protuberance, symbolic
of wisdom; elongated earlobes, indicative of royal birth; a tuft of hair on
his forehead, which like the sundial halo signified his emission of light;
spoked wheels on the soles of his feet to symbolize the progress of his
doctrine and the power of the sun; and a series of ritual hand gestures,
or *mudras*. The Buddha's right hand pointed downward meant his calling
of the earth to witness his triumph over evil and his Enlightenment or
dispensation of favors; his right hand raised was to dispel fear and give
blessings. By joining his thumb and forefinger, the Buddha set the wheel
of his doctrine in motion.

Of greater challenge to the artist was the endowment of the Buddha's
body with metaphorical significance; according to tradition, the face of
the Buddha is likened to an egg, the eyes to lotus buds or petals, the lips
to ripe mangoes, the brow to the god Krishna's bow, the shoulders to an
elephant's head, the body taper to that of a lion, and the legs to the
graceful limbs of a gazelle. The sculpture had to embody the sacred flame
or fiery energy of the Buddha and his preterhuman anatomy. Finally,
the sculptor had to impart to the statue that ultimate state of serenity,
perfect release from pain, and deliverance from desire that the Buddha
achieved in *nirvana*. According to his teachings, inward tranquillity was
to be gained by first appeasing the senses, for only then could the mind
become well balanced and capable of concentrated meditation. The sen-
suousness of Indian art is partly explained by this attitude that the senses
should not be denied but rather should be used as the first stage in a
spiritual ascent whereby the faithful would ultimately be purged of at-
tachment to the self and the world's ephemeral delights and achieve a
more perfect spiritual union with their gods and ideals. This confidence
in the need for and mastery of the sensual explains why Greek art such
as the Apolline sculptures would have appealed to the early Buddhists,
who used it.

Without question, the seated Buddha statue is indigenous to India

and is a native solution to the problem of how to give artistic incarnation to the Great Teacher and god. The seated position was favored, for in the life of the Buddha it is recorded that after six years of penance he at last came to the Tree of Wisdom, where the ground was carpeted with green grass, and there vowed that he would attain his Enlightenment. Taking up the seated, cross-legged position with his limbs brought together, he said, "I will not rise from this position until I have achieved the completion of my task." It seems likely that the model or prototype for the seated Buddha was the earlier Hindu mystical system of *yoga*, which was constantly before the eyes of the early Indian artists and which was recorded as having been the means of the Buddha's achievement of nirvana. The objective of yoga is enlightenment and emancipation, to be attained by concentration of thought upon a single point, carried so far that the duality of subject and object is resolved into a perfect unity. The Hindu philosophical poem the *Bhagavad-Gita*, described the practice of yoga:

> Abiding alone in a secret place, without craving and without possessions, he shall take his seat upon a firm seat, neither over-high nor over-low, and with the working of the mind and of the senses held in check, with body, head, and neck maintained in perfect equilibrium, looking not round about him, so let him meditate, and thereby reach the peace of the Abyss; and the likeness of one such, who knows the boundless joy that lies beyond the senses and is grasped by intuition, and who swerves not from the truth, is that of a lamp in a windless place that does not flicker.

Through yoga one may obtain the highest state of self-oblivion. It involves highly developed discipline in muscular and breath control and the ability to clear one's mind of all superficial sensory preoccupation in order to concentrate upon a single object or idea. The discipline of yoga seeks not only control of the physical body but also a cleansing and rebuilding of the whole living being. The human body transformed by yoga is shown free not only from defects but also from its actual physical nature. The sensation of lightness, or release from the bondage of the body, induced by yoga produces the "subtle body." . . .

In the Deer Park Buddha [Fig. 1-4], there is no reference to skeletal or even muscular substructure; the body appears to be inflated by breath alone. There is no trace of bodily strain caused by the posture. The seated attitude is firm and easy, indicating the Buddha's mastery of yoga. Unlike the proportions of the Classical Apollo, which were based on the living body, those of the Buddha had become almost canonical by this time and were based on a unit called the *thalam*, equivalent to the distance between the top of the forehead and the chin. The symmetrical arrangement of the body makes of it a triangle, with the head at the apex and the crossed legs as the base. The face, wearing the "subtle smile," is marked by the

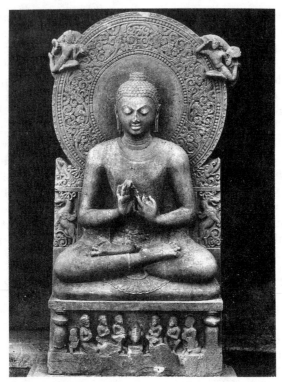

Figure 1-4. *Buddha Preaching in the Deer Park.* A.D. 320–600. Sandstone, height 5'3". Indian Museum, Calcutta.

symbolic lotus-form eyes and ripe lips. The downcast eyes shut off his thoughts from the visible world. Such compositional devices were employed, for the most part, because the sculpture was meant to be contemplated and viewed metaphorically. . . .

While repetition is frequent in the images of Apollo and Christ, Buddhist art exhibited far greater adherence to a prototype for almost fifteen hundred years. The successive replication in Buddhist imagery stems partly from a belief in the magical efficacy of certain prized statues; copies of these were thought to partake of the original's power. Furthermore, the Buddhist artist was not encouraged to work from a living model or to rely on natural perception. With the help of fixed canons, it was his obligation to study the great older images, meditate on them, and then work from his inspired memory. Because the Buddha's beauty defied apprehension by the senses, the artist worked from a conception nourished by existing images and metaphors.

Christt

Good Shepherd and Teacher The first known paintings of Christ seem to date no earlier than A.D. 200 and are found in the Christian catacombs on the outskirts of ancient Rome. Once believed to be secret refuges from persecution or underground churches where large congregations would assemble, these catacombs were actually burial chambers connected by long passages; they were known to and inspected by the Roman government. Their lack of ventilation and restricted size precluded their use for worship services. . . .

Among the first images of Christ, found in the catacombs and in funerary sculpture, are those showing him as the "Good Shepherd," which was a familiar image in Greek art. . . . There is ample evidence to confirm that the Christians recognized and valued the similarity between Christ as the shepherd and Orpheus, the son of Apollo who descended into Hades and sought through the charm of his singing and playing to save his wife Eurydice from the Underworld. The Greek mythological figure had much in common with both Apollo and Christ, since he was associated with salvation, sacrifice, love, and protection. The shepherd image was an ideal expression of the Early Christian community, which was characterized by a close relationship between priest and congregation: the priest was seen as the shepherd, the congregation as the flock. The artistic presentation of the shepherd amid nature was also fitting, for the Early Christian view of paradise was comparable to that of the Roman poet Vergil—a beautiful sylvan paradise where the soul could repose, ruled over by a gentle shepherd. Christ as the shepherd, whose coming Christian theologians saw prophesied in Vergil's writings, thus ruled over a bucolic world as if in a Golden Age. . . . Second-century Christian saints also used the image of a magnificent garden to describe the paradise in which the soul would find rest.

In a 4th-century sarcophagus [Fig. 1-5], the shepherd is surrounded by winged angels harvesting grapes. Such small, childlike figures were customarily substituted for representations of adults in Roman art of this type. Both the angels and the vineyard derive directly from pagan sources in which the grape harvest and wine alluded to premature death and regeneration. This explains the choice of theme for the sarcophagus of a deceased Christian who was well-to-do. Christian art that dates from before the 5th century mostly interprets the Jesus of the Gospels, or *the historical Jesus*—Jesus as the Messiah and not as a divinity. In the Lateran Sarcophagus, Jesus as the shepherd stands upon an altar, which suggests his death and sacrifice for mankind. His resurrection provided hope and a spirit of optimism for the Early Christian community and it

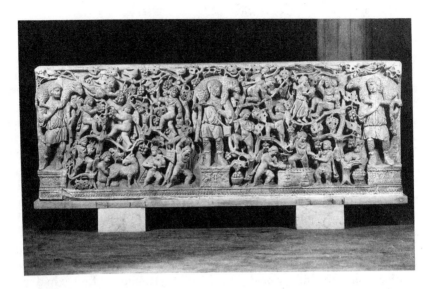

Figure 1-5. *Christ as the Good Shepherd.* A.D. c. 350–400. Marble. Vatican Museums, Rome. Photo by Scala/Art Resource.

converts. There is no stress on Christ's militant or royal nature before the 4th century. The artistic prototype of the historical Jesus seems to have been late Greek and Roman paintings and statues of seated or standing philosophers . . . a type associated with the contemplative or passive life. Artists in the late Roman period often worked on pagan figures at the same time they were fulfilling Christian commissions. Sometimes carved sarcophagi were completed except for symbols or faces; thus they could be purchased by either pagan or Christian clients and finished to suit their purpose.

. . . In the 4th century, Christianity received Imperial support and was no longer the private religion it had been in its earlier phases. The Church was reorganized along the lines of the Roman Empire, the priesthood became an autocracy, and theology and art were subjected to radical transformation and formalization. The external forms and the cult aspect of religion that had been criticized by the historical Jesus became prominent. One of the earliest manifestations of this momentous change is the famous sarcophagus of Junius Bassus, Prefect of Rome, who like Constantine was baptized on his death bed [Fig. 1-6]. The carving, which is in the pagan style of the time, was finished in 359 by a sculptor who imposed a new and strict order to his reliefs in terms of their architectural framing and symbolic sequence and juxtaposition. Christ occupies the center of both registers, and the flanking images are symmetrical and of a symbolic formality. Innovational were the two central scenes of Christ's

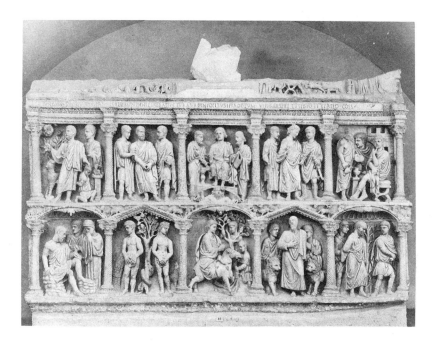

Figure 1-6. *Sarcophagus of Junius Bassus.* A.D. c. 359. Marble, 3'10½" × 8'. Vatican Grottoes, Rome.

royalty: his entry into Jerusalem, equivalent to a monarch's state entry or advent into a city, and his enthronment with the pagan symbol of the cosmos under his feet, indicative of his world sovereignty. The Imperial imagery is thus transferred to Christ, just as Christian and pagan terms for a ruler's greatness were similar. Christ is enthroned between Peter and Paul, to whom he assigns, respectively, the founding of his Church and the spreading of the Gospel. (Roman emperors were similarly shown between consuls.) The youthful beardless Christ may suggest, just as his contemporary catacomb counterpart does, his imperviousness to time. (In later images, Christ is shown with a beard; for theologians, an old head could also signify eternity.)

In the 6th century, the Byzantine Emperor Justinian ordered an ambitious mosaic series for the apse of the Church of San Vitale in the city of Ravenna, which he had just conquered from the Goths. The mosaic of the enthroned Christ flanked by angels and Sts. Vitalis and Ecclesius [Fig. 1-7] . . . in the half-dome of the apse reflects the transition from the historical Jesus to the *theological Jesus*. The incarnate Messiah has been replaced by the Son of God, the humanity and humility of the shepherd

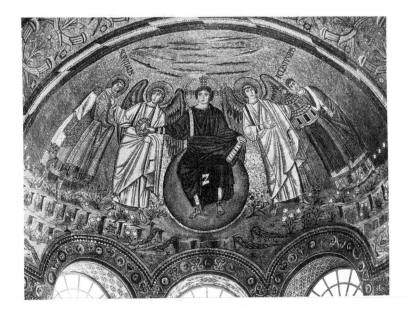

Figure 1-7. *Christ Enthroned, with Sts. Vitalis and Ecclesius.* c. 530. Mosaic. San Vitale, Ravenna. Photo by Alinari/Art Resource.

by the impersonality of a celestial ruler over the hierarchy of religious government. The doctrines that lay behind this mosaic were not those that had been taught by Jesus himself; in San Vitale, the theology of the Incarnation and the Second Coming is the essential subject of the mosaic.

Like a Roman or Byzantine emperor . . . , Christ holds an audience in which he grants and receives honors. Bishop Ecclesius donates the Church of San Vitale to Christ, and Christ gives the crown of mercy and martyrdom to St. Vitalis. This is preeminently sacred art; the more mundane attitudes of earlier Christian imagery have been replaced. The event transpires outside a specific time and place, an intention affirmed by the fact that these saints lived in different centuries. Also, St. Ecclesius presents a replica of the exterior of the church, and at the same time, the mosaic showing the donation is inside this very edifice. Christ sits upon the heavens, yet mystically he is also within the heavens, and beneath his feet flow the four rivers of Paradise. This mosaic demonstrates how theologians had reconciled the divinity and authority of Christ with that of the earthly emperors who acknowledged obedience to him. Christ rules the heavens, while the emperor Justinian, shown in an adjacent but lower mosaic, rules the earth. The relative informality of earlier Christian imagery has been replaced by a complex series of artistic devices conveying the concept of Christ as the Second Person of the Holy Trinity.

This mosaic is a dramatic example of how meaning in art is conveyed. . . . Besides its privileged location and the symbolic shape of the field, the materials are precious and semiprecious stones and glass. Against the gold background of the heavens, symbolizing the ineffable light of God, the youthful, beardless Christ sits attired in the Imperial purple and gold. Certain postures and colors were Imperial prerogatives. Contrasting with the attendant figures who must stand in his presence, Christ is frontal and larger; he appears oblivious of those around him. His ritual gestures of investiture and acceptance make a cross shape of his body, accentuating his centrality in the image and in Christian dogma. Thus scale and gesture may be symbolic, as well as the type of composition. Although the mosaicists may have been inspired by St. John's descriptions of the radiance of Heaven, like the Evangelist, they based the attributes and qualities of divinity on their experience of the highest form of earthly authority known to them, on the magnificent court ceremonies of the temporal monarchs.

The San Vitale mosaic embodies changed aesthetic forms as well as dogma. Each figure, for example, is sharply outlined, with every detail clearly shown as if the viewer were standing close to each subject. The figures do not overlap, and they are all seen as being near the surface of the mosaic, which accounts for their great size. The scene has only limited depth, and no attempt has been made to re-create atmospheric effects or the light and shadow of earthly perception. Positive identification of the role and status of each figure had to be achieved. The colors are rich and varied, but their use over large areas is governed by symbolism. The composition is closed, or strongly self-contained, so that there is no suggestion that the frame cuts off any significant area or action. The figures display, at most, a limited mobility, for their static quality is meant to reflect a transcendent nature and to induce a meditative state in the reverent viewer. Thus artist and theologian combined to give a physical presence to dogma by creating imagery of an invisible, divine world.

More than a century before the San Vitale mosaics were executed, there was painted on a wall of one of the Ajanta caves of northern India a scene of the Buddha in Majesty . . . that bears a striking similarity to these mosaics in its use of formal devices—such as centrality, frontality, and pose and gesture—to show authority. It is possible that both the Ravenna mosaic and the Ajanta fresco were influenced by Eastern sources such as Persian art, which, along with Roman art, provided models for the representation of rank in the late-antique world. The Buddha is enthroned between the sinuous figures of Bodhisattvas (exceptional beings who are capable of reaching nirvana but who renounce the possibility in order to teach others how to attain it) and two of his disciples. Courtiers are shown in the background. Buddha's gesture of teaching and his robe

and posture are as ritualistic as those of Christ in the mosaic. Lions guard his throne, and he and the disciples have halos shown under ceremonial parasols, further symbols of royalty. The flower-strewn background and wall suggest the garden of a palace, a special place that only the faithful are privileged to see and comprehend.

The great Byzantine images of Christ and those in the Early Christian basilicas of Italy are found within the churches. By the beginning of the 12th century, however, French Romanesque sculptors had transferred sacred images to the exterior of the edifices, as seen, for instance, in the great relief carved over the doorway of the Church of St-Pierre in Moissac. . . . This change did not as yet result in a conception of Christ as being of the world of the living. While adopting the ceremonial and sacred traits of the San Vitale image, the Moissac sculptor forcefully added new ideas to the conception of the lordly Christ. Wearing a crown, Christ is a feudal king of kings, surrounded by elders who are his vassals. His remoteness is reinforced by the great difference in scale between his figure and the representatives of humanity. All glances are directed toward Christ as to a magnetic pole. From his immobile frontal figure, the composition moves outward in waves. Angels and evangelical symbols, intermediate in scale between Christ and the elders but more closely proportioned to Christ, serve to impress upon the onlooker the hierarchical nature of the universe and to bridge the figures in motion with the motionless Christ. Here Christ is like the awesome Old Testament God, commanding and completely aloof. He is thus shown as the Redeemer and God of Judgment at the Second Coming. His beauty does not derive from the comely proportions with which Apollo was endowed; rather it is of an entirely impersonal and unsensual nature, appealing to thought and faith.

Christ as Judge There is no analogy in either the Apolline or the Buddhist religion to Christ's Second Coming and the Last Judgment, which are the themes of many of the most dramatic and interesting Christian works of art. . . .

The ordered and legal aspect of the final judgment is stressed by the artist at Conques in both his composition and his disposition of the figures. Each zone and compartment of the scene is strongly separated by a thick stone border on which are written the virtuous phrases, the teachings of the Church, and so on, appropriate to the location. This composition reflects a view of the universe as strongly ordered, so that everyone in it was consigned to a definite area, just as the living at the time had little difficulty in defining their own status in the feudal system. Thus the image of the universe on the last day becomes a projection of the real world as it was involved in the social, economic, and political

structures of the time. The authority and absolute dominance of Christ over the scene is achieved by his centrality and great scale. He sits immobile and frontal as a symbol of power; he gestures upward with his right hand toward Heaven on his right side, with his left hand he points downward to Hell.

The upper zone of the scene contains angels carrying the Cross, the symbol of the Passion and the Second Coming on the day of justice. The central position given to the Cross and the downward movement of the angels draw the eye centripetally to the Supreme Judge. On Christ's right, in the largest zone, is a procession of the saved, who proceed in homage toward the ruler of Heaven. They are led by Sts. Peter, Anthony, and Benedict, who symbolize the origins and rule of the Church. The saints lead a royal figure, believed to be Charlemagne, who had been a benefactor of the Abbey of Ste-Foy. The moral implied by this arrangement is that Charlemagne got into Heaven not by force of the crown he carries but through the prayers and efforts of the holy men—an unsubtle admonition to the secular rulers of the time to support the Church. On Christ's left (our right), in another zone, are those consigned to Hell, nude and cramped in awkward poses, experiencing all sorts of painful indignities and punishments inflicted with enthusiasm by demons.

The lowest zone is divided into two large porticoes known as *basilican castrum*. Between these, literally on the roofs at the point where the buildings come together, the weighing of souls take place; this is also the principal axis of the Cross and Christ. Next to the weighing-in on the left, armed angels are rousing the dead from their coffins, and on the right demons are pummeling the resurrected. In the center of the left portico (that on Christ's right) sits Abraham, who receives the souls of the deceased into his bosom. Entrance to Heaven is through a heavy open door, which reveals a fine medieval lock and set of strong metal hinges. The entrance to Hell is through the jaws of the Leviathan, whose head protrudes through the door to Hell. . . . The Book of Daniel (7:7) describes the terrifying Leviathan that God has created. Hell is ruled over by the seated Devil, surrounded by his squirming subjects. In the treatment of Hell and the Devil, medieval artists had their greatest freedom and could give vent to their fantasies, repressions, and humor. Here as elsewhere, by far the more interesting of the two sides is that dealing with the damned. . . .

The Beau Dieu The judicial and authoritarian aspects of the Byzantine Christ are continued but somewhat relaxed in the 13th-century French sculpture of the Beau Dieu [Fig. 1-8] from the Cathedral of Amiens. The figure of Christ stands between the main doors of the cathedral and below the scene of the Last Judgment. Beneath Christ's feet are the lion and

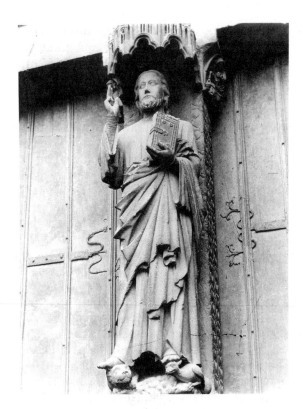

Figure 1-8. *Beau Dieu*, detail of the west portal, Amiens Cathedral. 13th century. Caisse Nationale des Monuments Historiques, Paris.

serpent, symbolic of the evil he conquers. Both in his location and in his appearance, Christ is more accessible to the congregation. He stands before the doors to his house not as a guard but as a host, like a gallant feudal lord. This humanizing of Christ into an aristocratic ideal is reflected in his new familiar name, "the Handsome God," a title in many ways unthinkable at Moissac and Daphné. This investing of Christ with a more physically attractive, a more tender aspect accompanies his reentrance into the world of the living and the reduction of the sacrosanct nature of the art itself. The transition has been from the Byzantine Pantocrator, Lord of All the Universe, to the more human dignity of the Gothic lord of men.

The *Beau Dieu* has an idealized countenance that bears instructive comparison with the head of the *Apollo* from Olympia. . . . The Gothic head is noticeable for its sharp features and subdued sensuality, indicating an essentially Christian attitude toward the body. This is particularly marked in the treatment of the mouth. The more pronounced ovoid

outline of the Christ image, enhanced by the long tightly massed hair, and the axial alignment of the symmetrical beard, the nose, and the part of the hair give the deity an ascetic and spiritualized mien. Despite the generalized treatment of the forehead, cheeks, and hair, the Amiens Christ possesses a more individualistic character than does the Olympian god, who is totally unblemished by the vicissitudes of mortal existence. The eyes of the Gothic Christ are worked in greater detail in the area of the eyelid, and the upper arch is more pointed than the simplified perfect arc of the *Apollo*'s upper lids. In both sculptures, details of the eyeballs were originally added in paint. The Gothic Christ lacks the calm of the Classical Apollo.

Comparison of a Buddha sculpture with a 13th-century head of Christ from the French Gothic cathedral of Reims provides us with a summation of two radically divergent tendencies in the respective art forms of Buddhism and Christianity [Fig. 1-9]. The Buddhist head reveals the development toward anonymity in the celestial countenance, a refusal to glorify a specific individual. It seeks a pure incarnation of that spirit of Buddhism that conceives of the Buddha as representing the incorporeal essence of a religious attitude. The smile on the Buddha's lips recalls his wisdom and sublimity, which he attains in the *abyss*, or sphere beyond nirvana. The Reims Christ wears the marks of his passionate earthly sojourn in the worn and wrinkled surface of his face, and we sense that this deity has a unique and dramatic biography. There is no intimation of past experience, of trial and pathos, in the images of either Buddha or Apollo. Christ's face, however, speaks to us of a tragic personal drama; it displays or implies a far subtler range of feeling than the faces of the other two deities. The Gothic sculptor wished the viewer to read tenderness, compassion, pain, and wisdom in the lines of the divine face. The Reims sculptor may even have taken a French king—perhaps Louis IX (St. Louis)—for his model, so that Christ was now literally presented in terms of man, or *a* man.

The Deaths of Christ and Buddha Western Christian art, like its theology, is dominated by the execution of its God. Buddha's death came tranquilly: for three days, he lay on his right side, with his head resting on his hand, until he passed into the final nirvana . . . in which he was freed from reincarnation. Buddhist art as a consequence does not know the pathos of Christian images. Christ's physical and spiritual anguish on the cross has no counterpart in Buddhist or Greek art. . . .

One of the most impressive and personal interpretations of the theme of the Crucifixion is that by Matthias Grünewald (d. 1528), which occupies one of the main panels of the *Isenheim Altarpiece* [Fig. 1-10]. Painted probably between 1512 and 1515, the altarpiece was intended for the

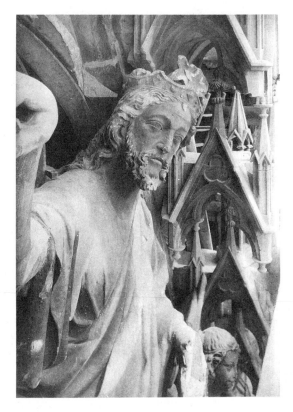

Figure 1-9. Head of Christ, detail from *Coronation of the Virgin*, middle portal, west facade, Reims Cathedral. 13th century. Bildarchiv Foto Marburg/ Art Resource.

monastery church of the hospital order of St. Anthony in Isenheim, Alsace. The monastery's hospital treated patients with skin diseases such as leprosy and syphilitic lesions. It was thought that skin disease was the outward manifestation of sin and a corrupted soul. New patients were taken before the painting of the Crucifixion while prayers were said at the altar for their healing. They were confronted with this larger-than-life painting of the dead Christ, whose soulless body was host to such horrible afflictions of the flesh. Only the Son of God had the power to heal the sinner, for Christ had borne all the sorrows of the flesh that garbed the Word. The previous regal, authoritarian, and beautiful incarnations of Christ were replaced by the image of the compassionate martyr. The vivid depiction of the eruptions, lacerations, and gangrene of the body were intended to encourage patients' identification with Christ,

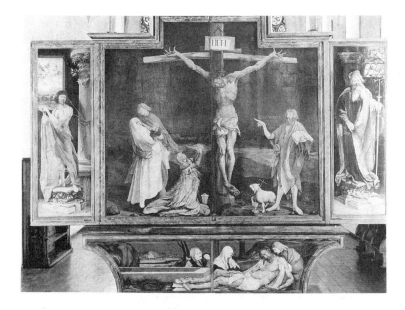

Figure 1-10. Matthias Grünewald, *Crucifixion*, center panel of exterior of Isenheim Altarpiece. Completed 1515. Oil on wood, 8'9⅞" × 10'⅞". Musee d'Unterlinden, Colmar. Photo by Giraudon/Art Resource.

thereby giving them solace and hope. . . . Grünewald probably drew upon the vision of the 14th-century Swedish saint Birgitta, who wrote:

> The crown of thorns was impressed on His head; it covered one half of the forehead. The blood ran in many rills . . . then the color of death spread. . . .

> After He had expired the mouth gaped, so that the spectators could see the tongue, the teeth, and the blood in the mouth. The eyes were cast down. The knees were bent to one side, the feet were twisted around the nails as if they were on hinges . . . the cramped arms and fingers were stretched.

Grünewald's image of Christ goes beyond this description in exteriorizing the body's final inner states of feeling. The extreme distension of the limbs, the contorted extremities, and the convulsive contraction of the torso are grim and eloquent testimony to Grünewald's obsession with the union of suffering and violence in Christ. He focused so convincingly on the final rigidifying death throes that the feet, a single hand, or the overwhelming face alone suffices to convey the expiration of the entire body. The brutal stripping of the living wood of the Cross is symbolically in accord with the flagellation of Christ. Cedar, used for the vertical member of the

Cross, was also employed in the cure for leprosy. The hopeful message of the painting can be seen in the contrast between the light illuminating the foreground and the murky, desolate landscape behind—a device signifying Christ's triumph over death. Miraculously present for this Crucifixion, John the Baptist intones, "I shall decrease so He shall increase." Men and women are enjoined to humble themselves in order to renew their lives in God. The static doctrinal and symbolic right half of the painting contrasts with the extreme human suffering and emotion to the left, seen in the grieving figures of St. John, the Virgin, and Mary Magdalen. Grünewald's painting and religious views seem to have stressed a communal response to tragic but elevating religious experience. Psychologically and aesthetically, each figure, like the composition as a whole, is an asymmetrical, uneasy synthesis of polarities.

Through the images we have seen, it is possible to trace the changing conceptions of Christ, from his depiction as a humble messianic shepherd, through the kinglike God to be revered from afar, to the God-like king who could be loved as a benevolent ruler, and finally to the Man of Sorrows, whose own compassion evoked the pity of suffering humanity. The transformation of sacred art proceeded differently for Apollo and the Buddha. Apollo's effigy began as sacred art and terminated in the profane imagery of a beautiful youth. The Buddha's early interpretation progressed from a humane individuality toward the sacrosanct impersonality of the 6th and 7th centuries. To comprehend the effectiveness of Greek, Indian, and Christian artists in uniting form and idea, one may exchange in the mind's eye the head of the Reims *Christ* for that of the *Apollo* at Olympia, the Lotus throne of Buddha for Christ's role in the Conques relief, the nude figure of Apollo for the *Beau Dieu* of Amiens Cathedral—or finally, transfer the San Vitale Christ to the Grünewald altar painting. . . .

2

The Sacred Mountain in Mesopotamia, Egypt, and the Aegean

Vincent Scully

When Hugh Ferriss conceived of his skyscraper masses as riding high over the Metropolis of Tomorrow, . . . [h]e might have thought of his buildings . . . as ziggurats, like those that once towered over the cities of Mesopotamia, which were the very first cities of all constructed by mankind. . . . The ziggurat of Ur, a vast mass of brick moldering in the plain, is still the best preserved of them all and has been the most spectacularly reconstructed in model form [Fig. 2-1]. . . . [T]he ziggurat of Ur, along with those of the other Mesopotamian cities, was built with no natural mountains in view on the flat sea-level land of the lower Tigris-Euphrates valley. It was intended to connect the earth and the sky, which, in Mesopotamian myth, had been forcibly separated long before.

 . . . [T]he ziggurats were climbed by a priest-king, who sacrificed to his people's gods on the summit. The king was the protector of the city and the builder of its walls. Those walls were everything; they were the city's major protection against all the other cities, with which it was more or less perennially at war. So the wall was honored in Sumerian architecture, its mass exaggerated, its face embellished. Ur's ziggurat still shows those qualities. Its walls are all organized in vertical planes; the mass *lifts* hugely. . . . There is no sense whatever of a human body, only of the mountain. The walls advance to buttresses and recede into deep niches in multiple planes; their surfaces are enlivened by pilasters, ac-

From *Architecture: The Natural and the Manmade* by Vincent Scully, copyright © 1991 by Vincent Scully. Reprinted by permission of St. Martin's Press, Incorporated.

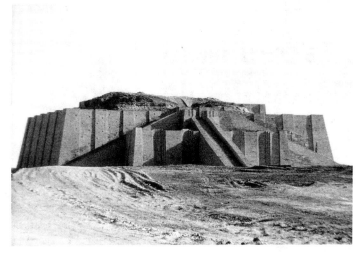

Figure 2-1. Ziggurat of Ur. 3rd millennium B.C. Reconstruction.

centuating the mountainous, thrusting bulk of the mighty brick masses in every possible way.

The stairway rises as if ascending a high, broad mountain, wide-shouldered, blotting out the sky. It is a heroic stair, and with it the concept of the epic hero arises. He is the king, and is identified in particular with Gilgamesh, a king of Uruk, whose incomparable epic dominates the literature of the ancient East until the destruction of Assurbanipal's library at Nineveh in the late seventh century B.C. Gilgamesh builds the walls of Uruk and scales the heights of the Lebanon to obtain cedars for his temple doors. He finds a friend and loses him to the captious gods, seeks immortality and sees it stolen by a serpent—ubiquitous symbol of the earth's power—and finds at the end that only his work in the city remains. . . .

The city thus affords all the immortality that human beings can attain, and the king is the most qualified of humankind to achieve long-lasting works within it. It is he who ascends the sacred mountain, like Gilgamesh or Naram-Sin on his stele, the king who climbs the ultimate conical peak, rising to the sun and the moon, and wears the regal, godlike crown, conical and bull-horned itself. The king must do this because nothing is to be hoped for from the gods. They are heartless and wholly irresponsible. Unlike Jehovah, who, dangerously unbalanced though he abundantly shows himself to be, nevertheless signs a covenant with his people guaranteeing his relatively sane behavior under certain conditions, they, the Mesopotamian gods, never sign anything. Their flood is

brought about for no particular reason. They are mad and have no justice in them.

Not so in Egypt. There, gods and men alike are governed by the concept of ma'at, which is justice itself. The king, Narmer, more or less contemporary with Naram-Sin, need only act out the idea of power; he need not struggle to achieve it. His relief carving is flat rather than cylindrical and muscular like that of the Sumerian king. He is not an epic hero but the very embodiment of cosmic justice. He rules over an ordered land. There are no warring cities in it; in Narmer's day, really no cities at all. It is one great agricultural structure, watered by the never-failing periodicity of the Nile's flood. The land is always fertile. It must be ruled by a single centralized authority to ensure the proper irrigation of all its fields.

The afterlife will naturally be just the same, for how else could existence be? There, too, the farmers will lead the animals out along the narrow paths between the rectangular fields and settle them down with their fodder for the day as they tend the always-productive land. They are workers on an agricultural assembly line, and they can rest at ease only during the flood, hunt and fish and think about the life to come. Then, however, they have their other great task, which is to build the Pharaoh's permanent habitation, his pyramid tomb. We may assume, I think, that despite the view of the matter held in later ages, they did so willingly, since the Pharaoh's immortality clearly had something central to do with the quality of their lives on earth and, in their view, hereafter. The reliefs and paintings in Egyptian tombs show the whole structure: the Nile flowing through the ordered fields with their people; the hawk, Horus, unblinking, looking toward the east, riding across the whole of Egypt in the Sun Boat of Ra.

The tombs are laid out in the sand on the west bank of the Nile, on the higher desert at the side of the setting sun. By the early third millennium King Zoser of the Third Dynasty decides that his tomb should be a mountain, visible to all those working in the fields below it. So his architect, Imhotep, who was to be honored as a sage throughout Egyptian history, steps the tomb up and back to shape a mountainous mass, not of brick, as in Mesopotamia, but of cut stone. Still, the influence of Mesopotamia is obvious at Saqqâra, but there is no stairway, no temple on the top, no drama. . . . Once again, heroic action is not required. The image of the Pharaoh, his *ka*, resides down below. He himself is probably with the sun, and the emblem of his immortality, his mountain, dominates the skyline where the sun goes down.

Nevertheless, the wall around the sacred precinct at Saqqâra is Mesopotamian enough, with setbacks and pilasters on the Mesopotamian

model, though linearized and flattened by the smooth certainties of Egyptian sensitivity. The plan, too, shows the Egyptian difference. While the manmade mountain rises within a walled enclosure, as at Ur, everything else is totally unlike Mesopotamia. The plan is utterly abstract, static, and fixed; there is no struggle embodied in it. The entire Mesopotamian plan is pushed in and out, embodying every kind of change over time and endless competition between various sacred precincts for building room. The Mesopotamian plan is thus urban, center-city in every fundamental way, responding to pressures from every side; the Egyptian is the unstrained emblem of a permanent conceptual order imprinted on the open desert and oriented precisely north–south.

But entry into Zoser's precinct shows that the principle of imitation is also at work there. It involves the impermanent architecture of vegetable materials. The engaged columns along the entrance passageway are carvings in stone of reeds bound together and capped with clay, a technique of building still to be seen in Egyptian villages today. The buildings representing the Pharaoh's *heb-sed* festival (they have no interiors) imitate the kind of vaulted swamp architecture of reeds that can still be seen in the community houses of the marsh Arabs of Iraq. In the North Building, near the Pharaoh's tomb chamber, the walls are set with engaged papyrus stalks; their buds open in a bell. From these, the stepped pyramid hulks massively near at hand, a manmade mountain right enough.

But directly opposite the entrance passage to the sacred enclosure and on axis with the pyramid itself, there is a wall crowned by cobras. . . [Fig. 2-2]. At Saqqâra, the serpents mark a critical point of vantage. From their wall, the pyramid shows exactly on axis, therefore in pure profile. In this view, its mass wholly dematerializes, since nothing about it causes the mind's eye to supply it with any other sides, let alone the other three it actually possesses. It seems instead to step back like a weightless stairway, mounting to the heavens. It is a flat folded plane, and it is climbing into the sky itself, carrying Zoser with it, one supposes. . . . Its magic conquers gravity and enforces belief in transcendence.

That triumph over matter, with its escape from every terrestrial limitation and even from earthly weight, seems to have dominated Egyptian thinking about the pyramid from that time onward. Its mass is progressively smoothed over. . . . It achieves its climactic grouping at Gizeh, where, at enormous scale, the avoidance of the appearance of weight is almost entirely achieved from every viewpoint, not only from an axial one [Fig. 2-3]. The four planes of the pyramids' faces slant back and recede, disappearing to a point in the sky. In a perspective view, the mind of the observer will supply only one other side rather than two. One thus "sees" the pyramid as a tetrahedron. Already some of the reality of

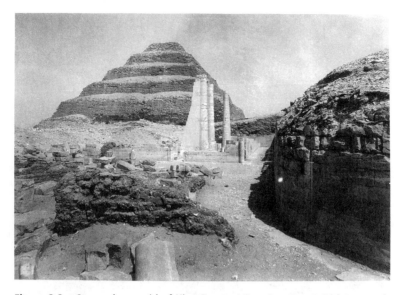

Figure 2-2. Stepped pyramid of King Zoser at Saqqâra, Egypt. Older part of temple and pyramid from south. Photo by Bildarchiv Foto Marburg/Art Resource.

the mass is disappearing. On closer approach to a single face, the entire plane slants weightlessly away. . . .

Originally, all the faces of the pyramids at Gizeh were sheathed in gleaming white limestone, blindingly bright, sending out reflections far across the plain. The cult was of Ra, the sun, and the pyramids were indeed transformed into pure sun's rays, pure light. . . .

It was into light itself that the Pharaoh was, at least symbolically, loaded. One thinks of the obelisk, Ra's major symbol, capped with a pyramidion: It is as if the pyramids at Gizeh capped mighty obelisks, buried, directed toward the sun. Indeed, the entire group can be seen as a battery of missiles aimed at the sun, taking position at just the right spot for a clear shot at it, on the great bank of desert that rises above the Nile plain at the point where it begins to widen out to the delta. . . . And what must have seemed to the Egyptians to be the special magic of the site supplied that battery with a gunner. An outcropping of rock suggested the form of the Sphinx, the lion-bodied Pharaoh. He bears Chephren's face and rises above Chephren's valley temple below his pyramid. . . . It is the critical position in relation to the whole group, which deploys in echelon behind the Sphinx while he gazes unblinking into the eastern sun, rising across the Nile.

Below him, Chephren sat in his temple in multiple effigies, all alike,

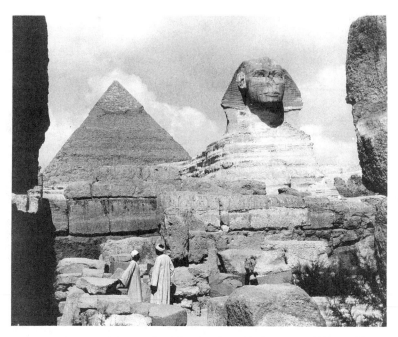

Figure 2-3. Pyramid of Khafre (Chephren) at Gizeh, Egypt. 2500 B.C. Photo by Pan American World Airways.

his head supported by the unblinking hawk, so that he too became a Horus capable of staring at the sun. There is no decoration in the temple, nor in any of the pyramids at Gizeh—no imitation whatever of natural forms. It is all abstract, as unadorned as a rocket motor; its magic is mechanical, perfect; its only imagery is of light. . . .

. . . Menkare and his queen, of the third pyramid, await the moment of transcendence with absolute confidence. There is nothing in the history of art so wholly at peace with the triumphant self as their faces are, unless it is the face of Chephren with his totemic hawk, which was too godlike for later times. During the Middle Ages, a puritanical emir turned his cannon on the face of the Sphinx; its expression of total assurance filled him with holy rage. Menkare and his wife share the Sphinx's calm. Why should they not? They had conquered death, laying their battery of human intelligence unerringly on the sun.

Mankind has never felt so confident again. The mood faded in Egypt itself almost at once, with the end of the Fourth Dynasty, and the single most consistent movement in Egyptian architecture thereafter was a kind of regressive return to the security of the earth and the imitation of its forms. A sail up the Nile to the site of the New Empire city of Thebes on the east bank brings us to a point where the western cliffs across the

river opposite the city open into a vast shape, today called Qurnain, "horned," which is capped by a roughly pyramidal mound on the cliff's summit between the horns [Fig. 2-4]. The whole formation strongly suggests the horned-disk headdress that is worn by the cow goddess, Hathor, the earth goddess, herself. The horns also resemble an inverted pyramid, and directly below them the Middle Kingdom Pharaoh Mentuhotep IV placed his tomb. In it, the pyramid had dwindled markedly in size and was surrounded by deep colonnades. The manmade pyramid was now content to reflect the natural form in the earth.

In the tomb of Queen Hatshepsut of the Eighteenth Dynasty, placed right next to Mentuhotep's, the pyramid disappeared completely, and the tomb was cut deep back into the cliff itself. Hatshepsut would seem to have positioned herself as closely as she could to the magical shape in the cliff, but, not placed to reflect the inverted pyramid and perhaps not caring to do so, returned to the earth entirely instead. Before her chamber, she laid out broad garden parterres, prefiguring in plan those of seventeenth-century France but probably planted thick with trees. So Hatshepsut's tomb is in one sense entirely natural in its manmade correlatives of tomb as cavern and garden grove as orchard and forest.

Finally, the mound on the summit of the cliffs, when it is approached from the other side, marks the Valley of the Kings, where later Pharaohs

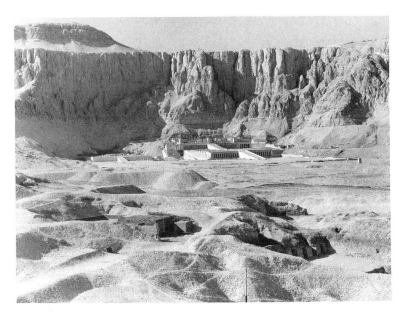

Figure 2-4. "Qurnain" with Tomb Temple of Queen Hatshepsut at Deir-el-Bahari, Egypt. c. 1480–1450 B.C. Photo by Hirmer Fotoarchiv, Munchen.

were laid to rest in the body of the earth. . . . From the valley, the mound is nippled and strongly resembles the breast of Hathor herself. The dismantling of the magical machine that re-created the rays of the sun could go no further. One returns to the sacred mountain in its traditional form. The whole process suggests an abandonment of what can only be called inventive technology in favor of ancient organic traditions embedded deep in the consciousness of mankind.

Thebes itself lay across the river. It contained at least two large temples of Amon, a local god, primarily of fertility, thus of the proper flow of the Nile and the growth it brought forth. One of Amon's temples lies along the riverbank, stretching downstream as with the river's flow. . . . The god's house is upstream; the court before it is defined, indeed choked, by fat, soft-looking columns imitating the forms of papyrus plants bound together with their buds closed. . . . Amon's temple is all vegetable growth of river plants, while a current like that of the Nile flows from the narrow darkness of his sanctuary outward to court after court, hall after hall, added over the generations. The hypostyle hall uses open papyrus columns [Fig. 2-5], like those engaged in the wall at Saqqâra. Their smooth bells spread broadly to mask the impost blocks they support, upon which the beams of the ceiling were placed. Hence, as seen from below, the ceiling would have seemed to float like the sky.

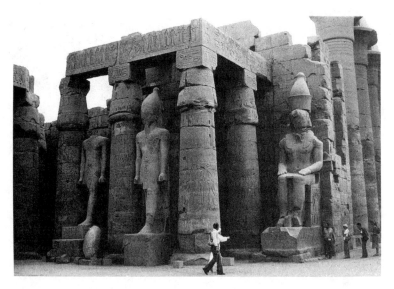

Figure 2-5. Temple of Amon at Luxor, Court of Ramses II. c. 1280–1260 B.C. Photo by Eugene Gordon.

In the temple at Luxor, the hypostyle hall was never finished, leaving the two rows of high columns standing alone. But inland, in the Temple of Amon at Karnak, which was also part of ancient Thebes, the central columns of the hypostyle hall were surrounded by multiple rows of the short, fat, closed-bud columns that were needed to set them off. . . . The entire complex must have been experienced as a great swamp, like the swamps of Egypt before the all-powerful Pharaoh was able to drain the land and control the Nile's flow.[1] We are wholly in the hands of older gods once more. The innermost row of short columns supports clerestory windows that bring light from above into the central row. More than ever, the sky above the high central columns would have seemed to float, elevated as it was above the major source of light itself. So the current flows sluggishly out through the choked vegetation and rushes triumphantly at last through the final gates, like the cliffs of the Nile upstream, and along the Avenue of Rams before it. The force of the Nile has been released, flowing from the god. Amon gives forth the waters of fertility to the waiting land. That is why his image is often rendered ithyphallic; he fertilizes with his flow.

Once shaped, the great New Empire temple type hardly changed over the centuries, except perhaps to insist ever more richly upon the vegetable softness of its column forms. . . .

By [Roman] times[s], the old cult of Ra and of his sacred mountains of light had long since receded into the past; indeed, the slapstick account of the building of the pyramids written by Herodotus in the fifth century B.C. shows us that its every meaning had been forgotten long before. But during the second millennium B.C., the cult of the sacred mountain as such continued with unabated force throughout the Ancient East and in the Aegean.

Minoan Crete was apparently its purest sanctuary, and its deepest traditions would seem to have directed all the major rituals of religious and political life in that sea kingdom. All the Cretan palaces are oriented toward sacred mountains and adjust their courtyards to them. Knossos, the very seat of kingship, is oriented on Mount Jouctas, cone-shaped and cleft, where, in later myth, the Cretan Zeus was buried. The palace at Phaistos is directed toward Mount Ida, wide-horned, where Zeus was born. So in Crete, unlike Egypt and Mesopotamia, the sacred mountains were there in natural form. They did not need to be constructed by mankind. Instead, the manmade forms were laid out to complement and receive their mass with open courtyards from which they dominated the view. There, in their sacred presence, the major rituals of kingship took place.

At Knossos, a traveler coming from the northern shore of Crete is led along a single-file pathway toward the north side of a long, rectangular courtyard [Fig. 2-6]. There, a short stair mounts directly to the central

Figure 2-6. Central court and Mount Jouctas at Knossos, Crete. Staircase and passage leading to the Chamber of Sacred Pillars. c. 1600–1400 B.C. Photo by New York Public Library Picture Collection.

axis of the court, with a columned portico rising up above it on the right-hand side. The view from this spot is directed in a strong diagonal across the court toward the southern propylon, beyond which a mounded hill rises, with Mount Jouctas lifting full and silent beyond it.

Beneath the summit of that mountain was a cave sanctuary of the goddess of the earth, and she, as embodied in Cretan ceramics . . . , wears a headdress that is both conical and horned, so reproducing her mountain's mass and profile. The roofs of the palace, certainly flat, may also have been crowned with horns, as its excavators thought, and as it is shown in frescoes and gems. The goddess would seem to be the old earth mother of Paleolithic times brought up to date, big-breasted as of old but svelte and elegant, though still the being from whom the horned animals, the food of mankind, are born. She is also the Earth-Shaker, mother of terrors.

At Knossos, the southern propylon, the most elaborate gateway to the palace, is directly on axis with the mountain, as is the range of rooms behind it. One of these contains the pillar cult of the goddess, set deep in the earth. Another is the throne room . . . , where the king sat in a little throne just big enough to hold him. Through its bucket seat and high back, a deep ripple like an earthquake tremor runs, while long ripples flow as well through the frescoes on the wall behind it, and fires seem to spring up from the earth below. Knossos is, in fact, placed at a

point of maximum seismic disturbance, and the king, representing his people, received that force in his own body.

If we believe Greek myth he may also have been, at least at times, bull-masked as Poseidon, Earth-Shaker, the goddess's consort, bringing on the earthquake through her power and in a sense sacrificing himself to her. So as the horned beasts of Paleolithic times ran along their cave walls deep in the womb of the earth, and as the horned dancers took up their burden for them in places shaped by men, so here the major event for which the courtyard was formed was the great bull dance, an ultimate refinement of all the rituals that had been directed to the earth since Paleolithic times. The bull charged straight. The spectators on the flat roofs of the palace could see him and the horned mountain at the same time. He brought its power down into the courtyard, where human beings received it and hugged it to themselves, seizing the horns and propelled by them through the air like birds. . . .

At Phaistos, there was no throne room, so that the axis of the courtyard could itself run directly toward the mountain [Fig. 2-7]. . . . We can understand how the Greeks associated the former with death—did it recall or suggest the conical tholos tombs of the Mycenaean lords?—and the latter with birth, as the mountain opens in a kind of exalted physical release and joy. To celebrate the axis of view to Mount Ida, the doorway in the court at Phaistos that leads toward the mountain is flanked by

Figure 2-7. Central court at Phaistos, Crete. c. 1500 B.C. Photo by Bildarchiv Foto Marburg/Art Resource.

niches in which round columns are engaged. . . . It is a rich manipulation of column and wall not to be found again until Roman times. Of course, as from much of the court at Knossos, the view of the mountain itself would have been blocked from the doorway by the mass of the buildings, but that did nothing to mitigate the potent magic of the alignment or the fact that all of it was perfectly visible from farther out in the court and from the roofs — from which, as at Taos or Puye, the essential ceremonies were in any case always best viewed.

The relationship of humanity to nature is made abundantly clear: Nature's mountains dominate, as does the goddess who surmounts them and whose body in fact they are. The manmade courtyard opposes no countersculptural presence to the natural forms but simply receives them in its hollow, just as, in their rituals, the dancers receive their horned force. So mankind is dependent and, as it saw itself, youthful. . . .

Note

1. The germ of this concept is in Wilhelm Worringer, *Egyptian Art*, London, 1928, esp. pp. 62–63.

3

The Interpretation of the Second Commandment

Avram Kampf

Thou shalt not make unto thee a graven image, nor any manner of likeness of anything that is in the heaven above, or that is in the earth beneath.
(Exod. 20:4; Deut. 5:8)

The second commandment has been interpreted strictly many times in Jewish history. Even when interpreted liberally, however, it casts a long shadow over the Jew's relationship with representational art in any form. It should be observed at the outset that, even if strictly interpreted, the commandment does not infringe upon the huge area of art which is not representational: that is, all abstract geometric or non-objective art.[1] But close examination of literary sources and archeological evidence makes obvious that, in practice, the commandment was never literally observed. The implications of talmudic Law regarding the arts of painting and sculpture were never clear cut. On the other hand, although there was no outright forbidding attitude expressed in the Talmud, the position of the sages had a continuously retarding and discouraging effect on the practice and development of art. However, the negative attitude of the rabbis was based not only on their equivocal feelings about the second commandment but was influenced also by their ascetic frame of mind which held the study of the Torah as being the only truly worthwhile intellectual pursuit.

While reading the second commandment in context, we can easily

From *Contemporary Synagogue Art: Developments in the United States 1945–1965* by Avram Kampf, copyright © 1966 Union of American Hebrew Congregations Press. Reprinted by permission of the publisher.

conclude that the Lawgiver, when He forbade the making of graven images, had in mind images made for the purpose of worship.[2] Otherwise, one would be hard put to explain the presence of the sixteen-foot-high carved olivewood cherubim in the biblical Tent of Testimony and in the Temple of Solomon (I Kings 6:23–35); also the sculpture of the twelve cast oxen which carried on their backs the molten sea (II Chron. 4:3–5); or the lions which, according to the Bible, guarded Solomon's throne (II Chron. 9:17–19). Hardly compatible with a strict interpretation of the second commandment is Ezekiel's blueprint of the restored temple, the walls of which were to be decorated with "cherubim and palmtrees; and a palmtree was between cherub and cherub and every cherub had two faces; so that there was the face of a man toward the palmtree on the one side, and the face of a young lion toward the palmtree on the other side; thus was it made through all the house round about" (Ezek. 41:18–20).[3]

David Kaufmann, a well-known nineteenth-century scholar and pioneer in the study of Jewish art, declared that "the fable of the enmity of the synagogue to all art till the end of the Middle Ages and well into modern times must finally be discounted in the light of the facts of life and the testimony of literature."[4] He added that "with the disappearance of the fear of idolatry, which had been the strongest reason for the law, the fear of enjoyment of the work of art gradually disappeared among us."[5] At that time (1908) his claim seemed exaggerated and his assumption based on too limited evidence. In the main, he seemed bent on normalizing the relationship of the Jew toward art. Giving the loving care of the collector and the careful scrutiny of the scholar to any artifact or artistic document that came to his attention, he seemed too much guided by his own ardent admiration for these objects. His rejection of the widely held view that Jews had no art (because according to the second commandment they were not supposed to have any) was based on his knowledge of a number of Hebrew illuminated manuscripts that had come into his hands (among them the famous *Haggadah* of Sarajevo[6]), his awareness of wall paintings in eastern European synagogues, and his knowledge of specimens of Italian synagogue art.[7]

He had also studied the Jewish catacombs discovered at Monte Verde and the Villa Torlonia in Rome, and the richly decorated mosaic floor of a fourth-century synagogue in Hammam Lif, North Africa, which had been accidentally discovered in 1883 by a French army captain.[8]

Most scholars in Kaufmann's era did not fully realize that a revision of the traditional view of art in the synagogue had already been in the making for some time, and that Kaufmann's approach was the result of a re-evaluation of traditional Jewish attitudes toward art in the light of the nineteenth-century scientific approach of Jewish scholarship.

In 1870, Leopold Löw's book, *Graphische Requisiten und Erzeugnisse*

bei den Juden,[9] had appeared. Löw, an eminent rabbi and scholar, examined post-biblical literature up to his own day, analyzing the diverse interpretations of the second commandment and the various communal disputes that had arisen from time to time as a result of the prohibition of figurative art. He found the results of his investigation both encouraging and depressing: on the one hand, Jews exhibited a need for and receptivity toward the artistic products of their time and surroundings; on the other hand, however, the attitudes of Jewish theology had a partially thwarting, discouraging effect on these endeavors. . . .

In the light of these . . . findings, it gradually became clear that no one normative interpretation of the second commandment, true for all times and all places, ever existed. The problem shifted from establishing the one exact attitude of Judaism toward the image to understanding the wide range of ways in which the prohibition against images has been observed at various times and places under various conditions [Fig. 3-1].

Scholars discern two opposing attitudes on this question, each achieving dominance under different circumstances. During periods of national crises, for example, as during the time of the Maccabees and the

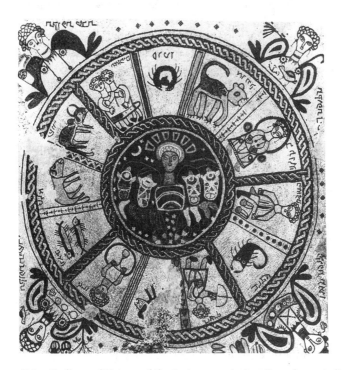

Figure 3-1. *Zodiac and Figures of the Seasons,* central section of mosaic floor, synagogue of Beth Alpha. Sixth cent. c.e. Photo by Art Resource.

wars with the Romans, nationalistic feeling ran high and the extreme view of prohibition prevailed. Every image was considered a symbol of the foreign invader. National and religious elements united in their opposition against the Romans when the great eagle on top of Herod's temple was pulled down in Jerusalem, and the community was prepared to offer itself for slaughter rather than permit Roman standards bearing an image to appear in the streets of the city (Josephus: *Antiquities*, XV, 8:1–2; *Wars*, I, 33:2–3). After the destruction of the Temple, such extreme views could no longer be enforced, and as the leadership passed to the rabbis, a more discerning and analytical view on art made itself felt. Yet, basic differences remained. Rabbi Menahem ben Simai, for instance, "would not gaze even at the image on one *zuz*," since it carried the imprint of the Roman Emperor, whereas Rabban Gamaliel II had in his upper chamber a lunar diagram, and frequented a bath house where a statue of Aphrodite was set, a matter that was of some concern to his colleagues. Two rabbis of the third century, the father of Samuel the Judge and Levi, prayed in the synagogue of Shaph-weyathib in Nehardea, Babylonia, in which a statue was set up. "Yet Samuel's father and Levi entered it and prayed there without worrying about the possibility of suspicion! It is different where there are many people together" (Abodah Zarah 43b).[10]

In their debates the sages differentiated between statues which were intended for a religious or political purpose (such statues were venerated in the ancient world) and those which were made for pure ornamentation. They prohibited the use of the former ones; and restricted the latter ones to the cities. "Rabbah said: There is a difference of opinion with regard to statues in villages, but regarding those which are in cities, all agree that they are permitted. Why are they permitted? They are made for ornamentation" (Abodah Zarah 41a). The Aramaic paraphrase of the Pentateuch, known as Targum Jonathan, expressed the outlook of the third century toward figurative representation in its rendering of Leviticus 26:1, which prohibited idols and graven images: "A figured stone ye shall not put on the ground to worship, but a colonnade with pictures and likenesses ye may have in your synagogues, but not to worship thereat."[11] In the same century we also find talmudic reference to actual synagogue decoration. "At the time of Rabbi Jochanan they began to have paintings on the walls and the rabbis did not hinder them."[12] It is, in fact, from this very century that many of the artworks in ancient synagogues come to us, most of them made under Greco-Roman influence. The third-century expression of grudging permissiveness is characteristic of this period with its more lenient interpretation of the commandment.

Salo Baron sums up the talmudic attitude as follows: "The talmudic teachers certainly did not encourage the painting of nude women on synagogue walls, as was done in Dura (the Egyptian princess personally

fetching Moses from the river). The text indicates, on the contrary, that the practice under the impact of Greco-Roman mores had become so deep rooted that the rabbis could not avoid legalizing it, even for Palestine."[13]

It was the considered opinion of the rabbis of the third century that all impulses toward idolatry had been eradicated by the beginning of the Second Temple period.[14] The hold of idolatry had also been weakened among the pagans.[15] Recent studies have shown that, due to the great demographic changes which occurred in Israel after the war with the Romans and the revolt of Bar Kochba, Jewish craftsmen, in order to be able to compete on the open market, had adopted their neighbors' methods of ornamentation. They were makers of trinkets of gold and silver and glass vessels. Scriptural as well as archeological evidence also points to the fact that these Jewish craftsmen were engaged in the making of images and idols and participated in the construction of basilicas. They did so in order to make a living. The Sages, who trusted the craftsmen implicitly, took their economic situation into account and constantly widened the meaning of the second commandment. The first tanna to whom a ruling about idolatry is attributed is Rabbi Eliezer in the following Mishnah: "None may make ornaments for an idol, necklaces or earrings or finger rings" Rabbi Eliezer says: "If for payment, it is permitted" (Mishnah Abodah Zarah 1:8).[16] Indeed, at Beth Netopha in Judea, a workshop has been unearthed containing the remains of lamps engraved with the emblems of the *menorah* and *shofar*, and beside them images of horsemen and nude women.

The ups and downs, the dominant liberal or fundamentalist reactions to the arts, were determined by the subtle interplay of internal and external forces. External pressures and strong central control brought about a hardening of the rabbinical attitude. Relaxation of tension, free intercourse with the environment, and economic considerations brought about an adaptation to the cultural possibilities offered by the surroundings and a more lenient interpretation of the second commandment. Later on we find iconoclastic tendencies in Christianity and Islam reinforcing such tendencies in the Jewish world.

These constant reversals of attitude toward art among the Jews continued into the Middle Ages and, in fact, were still apparent as late as the nineteenth century. On the whole, the attitude of suspicion and discomfort with the image remained. This outlook became deeply ingrained, and any image evoked an almost instinctive negative reaction. However, the motivation for the prohibition had shifted by the early Middle Ages. It was not because of its associations with idolatry that the image was resented, but because it disturbed *Kavanah*, the intense devotional aspect of worship. Thus, while Maimonides (twelfth century) permitted figures in the synagogue in sunk relief, painted on a board or

tablet or embroidered on tapestry, he used to close his eyes while praying near a wall where a tapestry hung so that he would not be disturbed by it.[17] Authorities continued to hold opposing viewpoints: Rabbi Ephraim ben Isak of Regensburg permitted the decoration of the *bimah* and the chair of circumcision within a synagogue with representations of horses and birds, while Rabbi Eliakim ben Joseph of Mainz is mostly remembered for removing the pictures of a lion and snakes from the stained-glass windows of the synagogue of Cologne, so that it should not appear that Jews worshipped them.[18] In the thirteenth century, Rabbi Meir of Rothenburg prohibited the illumination of festival prayer books with pictures of animals and birds, also on the grounds that they distracted the attention of the worshipper.[19] However, it is quite clear from the large number of illuminated manuscripts which have come down to us that the prohibition was not very effective. In the fifteenth century, Rabbi Judah Minz of Padua opposed the installation of a *parokhet* in his synagogue. The *parokhet* was donated by one Hirsh Wertheim: it was richly embroidered with pearls, and was ornamented with the image of a deer.

About a hundred years later a stormy controversy broke on the island of Kandia, then under Venetian rule, when a wealthy and influential member of the community, who had repaired the synagogue there, ordered a sculptured crowned stone lion to be made for the top of the ark, near an inscription carrying the name of the donor. In order to resolve the conflicting views which arose over this sculpture, it was decided to ask the advice of rabbis in various parts of the world. David Ibn-Abi Zimra in Cairo, Joseph Karo in Safed, Moses di Trani in Jerusalem, Elijah Capsali in Constantinople, and Meir Katzenellenbogen in Padua were consulted. They sided with those who opposed the installation of the lion.[20]

On the other hand, in the Jewish ghetto of Florence, many Jews had their houses painted with frescoes containing scenes from the Old Testament; wealthier ones had medallions struck, and some rabbis even had their portraits painted. In the Jewish quarter of Siena above the fountain opposite the synagogue stood a statue of Moses sculpted by the fifteenth-century artist, Antonio Federighi.[21] Visiting Jews from Posen found it offensive (1740).[22]

In the synagogues of Poland built in the seventeenth, eighteenth, and nineteenth centuries we find the burgeoning of a vital folk art. The community firmly believed that such art enhanced their synagogues, and furthermore that it had been carried out with the approval of the great scholars and founders of the community who had desired to adorn the synagogue. It was a great *mitzvah* to do so.[23] This permissive attitude was not confined to Poland alone; any visitor to the old Jewish cemetery near Amsterdam marvels at the representational figures found on many gravestones there.

We have already noted that even the strictest observance of the commandment leaves room for all art which is not representational. The splendid thirteenth- and fourteenth-century Spanish synagogues preserved in Toledo, with their geometric and arabesque designs, showing exceptionally fine proportion and taste, are good examples. It is not design, texture, rhythm, or color which are viewed with suspicion, but rather the preoccupation with them, the quest for beauty alone and the world of material appearances as such. The idea of representational art as a humanistic endeavor and discipline in itself, divorced from religious and magical concerns and distinct from other domains of life—art as a product of imagination which reflects on reality—was an approach to art either unknown at this time or susceptible to distrust because it was not controllable. Appearances were thought to hide rather than to reveal the essential nature of things. Because the idols were considered an illusion and because representational art also can be easily understood as an illusion, representational works were suspect and discouraged.

The intensely religious experience does not need to be supplemented by art. It creates its own art in that it constantly reconstructs its world and perceives the beautiful as an emanation of the divine. "The whole earth is full of His glory" (Isa. 6:3). "The Heaven is My throne and the earth My footstool" (Isa. 66:1). Religious experience as such is independent of art. Religion as an institution may use art to aid the worshipper to commune with God. But when Jewish religious tradition relied heavily for the transmission of its ideas on the oral word and on the written text, and when study and discourse were themselves a part of worship, representational art was excluded from the religious value system which was in the main preoccupied with the knowledge of Torah. It was not primarily a basic inner incompatability between the monotheistic world view and the representational image that brought art so much into disfavor with the rabbis; it was the preference for the written word as a tool for instruction and for the transmission of social and moral values that depend heavily on the spoken word.[24] For the purpose of reinforcing the religious experience, Jews have always used the art of music. They knew the value of the musical memory and its capacity, the ability of rhythm and harmony to sink deep into the hidden recesses of the soul and to bind the individual to his group and tradition. "He who reads the Scriptures without melody and the Mishnah without song, of him it can be said as is written: Wherefore I gave them also statutes that were not good" (Ezek. 20:25).[25]

It has been suggested that Judaism's perception of the divine as outside of nature brings about a natural preference for speech and religious poetry as art forms.[26] According to this assumption, God reveals Himself not in any concrete form, "for ye saw no manner of form on the

day that the Lord spoke unto you in Horeb out of the midst of the fire" (Deut. 4:15). It is through the medium of the ear that the Jew encountered the Divine, whereas other people to whom God appeared in nature perceived Him through the medium of the eye. One kind of perception necessarily leads to the development of the art of the spoken word in religious communication and the other to the use of the plastic arts.

Hermann Cohen developed this idea further, and pointed to the incompatibility between the plastic arts and the monotheistic view as it emerged. For him the conflict was basic. The second commandment is an attack on art springing from the very nature of the oneness, the invisibility, and unimaginability of God.[27] These ideas are worth serious consideration, especially since they are not offered in support of a particular point of view or to sound a note of apology, but in an attempt to penetrate the historical setting which gave birth to a certain attitude.

The God concept of a people naturally has a decisive influence on its art. A faith that proclaims one God of justice and mercy Who cannot be seen and Who uses an unseen medium like the voice inevitably deprives plastic art of one of its great incentives and opportunities. In the cultural climate of the ancient world, there existed an abundance of gods who were visible to all in some concrete form.[28] Jews became aware of art as an independent activity only after the first centuries. However, the die had been cast, and even when the battle against idolatry was won, and the belief in the efficacy of idols had become deflated, the deeply ingrained negative attitude toward art could not wholeheartedly be revised. Feelings of suspicion and instinctive deprecation of appearances remained. Monotheism is a highly abstract idea and conflicts with man's great need for concreteness. Therefore, to avoid any temptation to compromise, plastic expression continued to be shunned. It is the nature of the plastic image to assert itself, and it is more prone than any other symbol man uses in his communication with the Divine to stand between the worshipper and reality and "catch the mind in the accidents of the symbol and confuse it instead of furthering its approach to reality."[29]

Post-talmudic Judaism accepted the Talmud as normative. Attitudes existing in talmudic times were not viewed as limited in validity to their time, but were accepted generally as binding for all times. Judaism enlisted those arts which would advance its central concern: To do the will of God as commanded in the Torah.

This God is one. There is no other. He is the God Who created heaven and earth. He reigns supreme over all, is everlasting, stands outside nature and time, yet intervenes in the affairs of man. He is the God of justice and of mercy. He is holy and demanding. He has created man in His own image. The central belief and concern of Israel flows from this God concept. Since man is made in the image of God, Who is just and

merciful, man must live up to this image and not deny it. Man must practice justice and mercy. He must have respect for himself and others, whether weak or strong, a native or a stranger, a master or a slave. The foundation of the concept of the rights of man, brotherhood of man, and the dignity of man is anchored in God and receives its sanction from Him. Man, by living up to this image, becomes the co-worker of God and helps Him realize His divine plan. Israel, which entered a covenant with the Lord, accepted His Torah and His commandments and must try to become a holy people, a light to the nations. Ethical concerns thus become the central theme of Judaism, which idealizes the realm of morality and holiness rather than the realm of art and philosophy. Judaism created art values only in the realm of the psalm and prophetic speech. Common to both art forms, however, Grätz observed, is the fact that their essential characteristic is truth, not poetic fiction or playful fancy.[30] Judaism also created an historical narrative, "which had the advantage not to be silent, gloss over, or beautify the shameful and unmoral of the heroes, kings, and nations, but tells the events truthfully."[31]

Ethical values have become so all-pervasive, then, that all other values have to conform to them, may not stand in contradiction to them, or compete with them. Nor can any other value be considered apart from them. To the intensely religious person, an amoral, neutral value does not make sense. If he cannot integrate it into his scheme of thinking and feeling, it threatens him. Thus, he tends to close his eyes to works of art.

Since the knowledge of the Lord leads to the imitation of His ways, the rabbis elaborated in great detail the ways of truth and justice that man should follow. Religious vision had to be expressed in right living. The attainment of the beautiful was not to be found in the harmony of the form, but in the articulation of human needs and of right conduct in accord with the laws of the Torah, which were interpreted and reinterpreted as circumstances changed. Rabbinical interpretation of the Law is considered as binding as the Law itself. The bondage in Egypt, the wandering in the desert, the encounter with the Lord and the prophecy have created a persistent theme, a mode of living, feeling, and thinking. Confronted with works of art the rabbis weighed them against human needs. "When Rabbi Joshua b. Levi visited Rome he saw there pillars (apparently meaning statues) covered with tapestry in winter so that they should not contract and in summer they should not split. As he was walking in the street, he spied a poor man wrapped in a mat, others say in half an ass' pack."[32] He could not but be aware of the contrast between the concern for the statue and for the man. Art was obviously seen by him as a luxury that one could do without; only actual human needs really mattered.

Rabbi Hama ben Hanina, the wealthy amora of the third century,

pointed out to Rabbi Hoshaiah II a beautiful synagogue in Lydda, to which his wealthy ancestors had contributed. His colleague exclaimed: "How many lives have thy ancestors buried here? Were there no needy scholars whom that treasure would have enabled to devote themselves to the study of the law?"[33] R. Abin reproached a friend on similar grounds for installing a beautiful gate in his large school house and applied to him the verse: "For Israel hath forgotten his Maker and builded palaces" (Hos. 8:14).[34]

Throughout these ethical concerns there is an awareness of means and ends, a scale of values in which human needs predominate. The Talmud, which has very little to say about the architecture of synagogues, points to the necessity of making the cult objects things of great beauty that will appeal to the human eye. "This is my God and I shall glorify Him" (Exod. 15:2) from the Song of Moses was interpreted by the rabbis as follows: "This is my God and I will adorn Him—adorn thyself before Him in the fulfillment of precepts. (Thus) make a beautiful *sukkah* in His honor, a beautiful *lulav*, a beautiful *shofar*, beautiful fringes and a beautiful scroll of the Law, and write it with fine ink, a fine reed (pen), at the hand of a skilled penman, and wrap it about with beautiful silks" (Shabbat 133b).[35] This seems to be a call for art and beauty based on God's word, and it has been quoted often and is known as *Hiddur Mitzvah* (adornment of the Divine Commandment). It is interesting that a dissenting view is expressed in the Talmud: Abba Saul reading the Hebrew ואנוהו (I will adorn Him) as a combination אני והוא (I and He have to act alike) adjusts the passage to the primary concern of Judaism, the relationship of man to God, and he interprets "I will be like Him: just as He is gracious and compassionate, so be thou gracious and compassionate."

Judaism's real concern is not with objects, which are only means to an end. "One may even sell a Torah if one wants to continue one's studies or wishes to marry."[36] The battle against idolatry was extended from the idol, the god of wood and stone to any object which man erroneously made his ultimate concern.

Notes

1. Ernst Cohn-Wiener, *Die Jüdische Kunst* (Berlin, 1929).

2. The full text reads as follows: "Thou shalt not have other Gods before Me. Thou shalt not make unto thee a graven image, nor any manner of likeness, of any thing that is in heaven above, or that is in the earth beneath, or that is in the water under the earth; thou shalt not bow down unto them, nor serve them; for I the Lord thy God am a jealous God, visiting the iniquity of the fathers upon children unto the third and fourth generation of them that hate Me" (Exod. 20:3–5).

3. Yehezkel Kaufmann, with his unusually sharp insights, comments on these seeming contradictions as follows: "Moses did not repudiate the accepted belief of his age that

man's relation to God expresses itself through a cult. To be sure, Mosaic religion did not have images of YHWH, but this is not owing to a radical rejection of images. The fact is that neither in the Torah nor in the prophets is the matter of representing YHWH a crucial issue. Both the desert calf and the two calves of Jeroboam are considered by their opponents to be fetishes, not images of God. The ban on making idols and other fixtures follows as a separate prohibition from the ban on having other gods. The images are thus not conceived of as representations of other gods, but as objects which in themselves belong to the category 'other gods'; they do not symbolize, they *are* other gods. Israelite religion never knew of nor had to sustain a polemic against representations of YHWH. Intuitively, it rejected representations of God because such images were regarded in paganism as an embodiment of the gods, and as such, objects of a cult. This idea was to Israel the very essence of idolatry; hence from the very onset it rejected without a polemic representation of YHWH. This tacit decision was the crucial moment in the battle against idol-worship.

"But the biblical objection to the employment of figures in the cult is not primary or fundamental. Later zealots objected to every sort of image, but this was evidently not the early position. Israelite religion rejected from the first figures worshipped as gods; it did not forbid cultic figures which were not objects of adoration." *The Religion of Israel* (Chicago, 1960), pp. 236–237.

Buber agrees essentially with Kaufmann, but approaches the problem from a different angle. See Martin Buber, *Moses*, Oxford, East and West Library, 1947, pp. 124–127.

The Hebrew God was originally called a "god of way" differing from all other solar and lunar "gods of way" in Mesopotamia in that He guided only Abraham and his own group and that He was not regularly visible in heaven, but permitted Himself only occasionally to be seen when He willed so. Various natural processes were sometimes seen as a manifestation of this God.

Moses revived this conception of the God, which had been forgotten by the Hebrew tribes in Egypt. "Thus it can be understood that clouds, and smoke, and fire, and all kinds of visual phenomena are interpreted by Moses as visual manifestations from which he has to decide as to the further course through the wilderness. . . . But always, and that is the fundamental characteristic, YHWH remains the invisible One. . . . For this reason He should not be imaged, that is, limited to any one form; nor should He be equated to one or other of the 'figures' in nature; and precisely because He makes use of everything potentially visible in nature. . . . The prohibition of 'images' and 'figures' was absolutely necessary for the establishment of His rule, for the investiture of His absoluteness before all current 'other gods.'

"No later hour in history required this with such force; every later period which combatted images could do nothing more than renew the ancient demand. What was immediately opposed to the founderwill of Moses makes no difference; whether the memories of the great Egyptian sculptures or the clumsy attempts of the people themselves to create, by means of some slight working of wood or stone, a reliable form in which the Divinity could be taken with them. Moses certainly saw himself working a contrary tendency; namely, that natural and powerful tendency which can be found in all religions, from the most crude to the most sublime, to reduce the divinity to a form available for and identifiable by the senses. The fight against this is not a fight against art, which would certainly contrast with the report of Moses' initiative in carving the images of the cherubim; it is a fight to subdue the revolt of fantasy against faith. This conflict is to be found again in more or less clearcut fashion, at the decisive early hours, plastic hours, of every 'founded' religion; that is of every religion born from the meeting of a human person and a mystery. Moses more than anybody who followed him in Israel must have established the principle of the 'imageless cult,' or more correctly of the imageless presence of the Invisible, who permits Himself to be seen."

4. David Kaufmann, *Gesammelte Schriften*, edited by M. Brann (Frankfurt am Main, 1908), "Zur Geschichte der Kunst in den Synagogen." Also see his very important

article, "Die Löwen unter der Bundeslade von Ascoli und Pesaro," which appeared in 1897, in the *Erster Jahresbericht der Wiener Gesellschaft für Sammlung und Konservierung von Kunst und Historischen Denkmäler des Judentums.*

5. Ibid.

6. Kaufmann, *Die Haggadah von Sarajevo,* edited by D. H. Müller and J. V. Schlosser (Wien, 1898), "Zur Geschichte der Jüdischen Handschrift Illustration"; *Gesammelte Schriften,* Vol. III, "Die Bilderzyklen im duetschem Typus der alten Haggadah Illustration" and "Beitrage zur Jüdischen Archäologie."

7. "The Italian Synagogue of Padua contains such an abundance of magnificent silver work that its description and reproduction would justify a special undertaking." "Etwas von Jüdischer Kunst, Aus der Pariser Weltaustellung," *Israelitische Wochenschriften,* Jahrgang 9, 1878.

8. Kaufmann, *Gesammelte Schriften,* Vol. III, "Beitrage zur Jüdischen Archälogie."

9. Löw, *Graphische Requisiten und Erzeugnisse bei den Juden* (Leipzig, 1870).

10. Geiger points out that the trust Halakhah has in the community is unconditional.

11. C. Roth, Ha'omanut Ha'yehudit Massadah (Tel Aviv, 1959), p. 19. Samuel Krauss, *Synagogale Altertümer* (Vienna, 1922), p. 348.

12. S. Baron, *A Social and Religious History of the Jews,* Vol. II (Philadelphia, 1952), p. 13.

13. Ibid., pp. 13–14.

14. E. E. Urbach, *Israel Exploration Journal,* Vol. IX, Nos. 3 and 4 (Jerusalem, 1959), "The Rabbinical Laws of Idolatry in the Second and Third Centuries in the Light of Archeological and Historical Facts." In this paragraph his account is closely followed. Urbach cites Talmud Yoma 69 and Sanhedrin 64 as well as the apocryphal Book of Judith for the weakening of idolatry: "For there has not arisen in our generation, nor is there today, a tribe, a family, a clan or a city that worships idols made by human hands as there was once in olden times" (Judith 8:8).

15. There was a widespread feeling that idolatry did not constitute a danger to the people, since it was so obviously false. A pagan gave expression to this view in a discussion with R. Akibah. "You know in your heart as I know in mine that there is nothing real in idolatry" (Avodah Zarah 55a). Urbach, loc. cit.

16. "The Jewish craftsmen based the defense of their professional activities on the well-known fact that the Gentiles themselves considered the idols to have no efficacy. Their arguments were acceptable to the authors of the Agadah and Halakhah, who expressed them in their own peculiar way. Recounting a conversation between Moses and God after the incident of the golden calf, the Tanna Rabbi Nehemia puts the following words into the mouth of the collocuters: (Moses) said: Lord of the universe they have provided assistance for You, how can You be angry with them? This calf which You have made will be Your assistant. You will make the sun rise and it the moon, You the stars and it the constellations, You will make the dew fall and it the wind blow, You will bring down rain and it will cause plants to grow. The Holy blessed be He answered: Moses can you be as misguided as they?! See, it is worthless! Moses retorted: Then why are you angry with your children?" *Exodus Rabbah* 43:6, quoted from Urbach, loc. cit.

17. Rachel Wischnitzer, "Judaism and Art," *The Jews, Their History, Religion and Culture,* edited by J. Finkelstein (Philadelphia, 1949). Bevan comments on the attitude of Maimonides: "This reason is plainly an afterthought, in order to provide a justification for a feeling which has originally been created by the prohibition, authoritative in early generations, and which remained instinctive in the Jewish community, when the condemnation could no longer be based on the original ground. Some other ground had to be found for it. The new ground is really absurd. Ordinary psychology would tell us that a detail of decoration repeatedly before the eyes of the worshippers would become unnoticeable with familiarity." E. Bevan, *Holy Images,* London, 1940, p. 63.

18. Löw, *Graphische Requisiten und Erzeugnisse bei den Juden* (Leipzig, 1870), p. 33. Löw presents many other examples of conflicting attitudes.

19. Ibid., p. 38.

20. Ibid.

21. Franz Landsberger, *Einführung in die Jüdische Kunst* (Berlin, 1935), p. 34. Cf. Cecil Roth, *The History of the Jews in Italy* (Philadelphia, 1946), p. 391.

22. Alfred Grotte, *Der Morgen*, Berlin, Jahrgang 4, No. 2, June, 1928, "Die Kunst im Judentum und das 2. mosaische Gebot."

23. "Rabbi Dober Minkes of Zitomir tells us: Many pious men from the synagogue in which I pray asked me to explain whence the permission derives to paint, in the synagogues of the big cities, paintings of animals and birds in low relief and high relief around the Holy Ark. Doubtlessly, it was done according to the wishes of the great scholars of the past who were (holy) like the angels (ראשונים כמלאכים). There are also synagogues which have all their walls covered with paintings of birds, animals, and the zodiac. It is also an everyday occurrence for them to embroider the *Parokhet* for Sabbath and festivals and the Torah covers with silk, gold and silver threads, and all kinds of designs of animals, and birds, lions, and eagles. It would seem that they transgress the commandment prohibiting images and pictures and that they may open themselves to suspicion of idolatry. And how do they bow down to the Holy Ark? And how do they kiss such a *Parokhet*? Might one not surmise that they bow down and kiss an image? And if, God forbid, this would be prohibited, the great ones of our own generation and of former generations, who did not do things according to their own understanding but followed their teachers, would not have allowed this. Doubtlessly it is a *mitzvah* to do paintings and decorations to elevate the synagogue (מקדש מעט), and there is no fear that they act according to alien custom." Quoted from Yizchak Z. Kahana, "The Art of the Synagogue in the Literature of the Halakhah," *The Synagogue*, edited by Mordechai Hacohen (Jerusalem, 1955), in Hebrew.

24. "The auditory sphere may claim an exceptional position in the development of the superego of the individual. In the building of that new agency of the superego, certain experiences and impressions are necessary. Purely optical impressions without words by themselves would be insufficient for the establishment of ethical judgments. For the preliminary stages of superego formation, language audibly perceived is indispensable. The nucleus of the superego is to be found in the human auditory sphere." Theodore Reik, *Mystery on the Mountain* (New York, 1959), p. 168.

25. Talmud, Megillah 32a, quoted from Peter Gradenwitz, *The Music of Ancient Israel* (Norton, 1949), p. 83. A rabbi of the third century demanded that the ears of those listening to secular music should be cut off.

26. Grätz, *Die Konstruction der Jüdischen Geschichte* (Berlin, 1936), pp. 13–14.

27. Hermann Cohen, *Die Religion der Vernunft* (Köln, 1959), second edition, pp. 61–63.
 "The contrast between the One God and the many gods is not confined to the difference in numbers. It expresses itself in the difference between an unperceivable idea and a perceptible image. And the immediate response of reason to the concept of the One God is confirmed in this antagonism to the image. Every image is a reflection of something. Of what primal image can the image of God be a reflection?
 "Is there then such a thing as a primal image of God in an image? The images of God must be images of something else to which they assign the significance of a god. Here again, there arises the contradiction between the single being of God and all the alleged beings. The images of God cannot be reflections of God, they can only be reflections of objects of nature.
 "Thus, of necessity, there arises within prophetic monotheism the opposition to art, which is the primal activity of the human spirit, namely the creation of images which are reflections of natural objects filling the universe. This is the process of art among all peoples. Let us ask ourselves how we can understand the anomaly which exists between the monotheistic spirit and all human consciousness at this turning point of culture.

"The question does not only concern the original tendency of monotheism, but also the anomaly of historical influence. No people in the history of the world, not even the most developed, ever withdrew from it. How can we grasp the fact that the prophets resisted the glorious creations, the magic art of Babylon and Egypt, and mockingly derided it? In all other instances, art is a universal tendency of man, and stands in effective reciprocal relationship to poetry. How could the monotheistic spirit develop its might in poetry while maintaining a resistance toward the plastic arts?

"We cannot solve this question here fully. Only when we discuss the monotheistic concept of man, can we attempt to do so. Here, our question concerns only the single God who represents the only Being. Therefore, no image of Him is allowed. It would have to be a primal image; furthermore, *the* primal image; therefore, an image which must be a reflection of something.

"The gods must be destroyed because they are not beings but images. To serve such gods is to serve images. The service of God is, however, the service of the true Being. The fight against the gods is, therefore, a fight against appearance, the fight of primal Being against images which have no being.

"Thus the Decalogue progresses from the prohibition against other gods to the prohibition against images. And this prohibition does not confine itself to the sentence: 'Thou shalt not bow down unto them, nor serve them,' nor to: 'Thou shalt not have other gods before Me,' but the attack on art becomes a direct one: 'Thou shalt not make unto thee a graven image, nor any manner of likeness, of anything that is in heaven above, or that is in the earth beneath, or that is in the water under the earth.'

"Polytheism is attacked at its roots, and these are not seen in the immediate sanctification of natural phenomena, but only in the worship of that which man's mind produces with man's hands. Only through art can that 'which is in heaven above, or that which is in the earth beneath, or that which is in the water under the earth,' become a misleading primal image. 'Thou shalt not make unto thee a graven image,' means: the picture must be a reflection of God. However, there is no image. He is at most but a primal image of the spirit, of the love, of reason, but not an object of representation" (pp. 61–63).

"It is a futile objection that the one who worships the image does not mean the image, but only the object it represents. This objection betrays a misunderstanding of true monotheism. Since it differentiates itself from all image worship, the single God cannot be thought of as an object in a picture. Even if worshippers of images mean only the object represented in the image, monotheism teaches that God is not an object who can be imagined. *AND IT IS THE PROOF OF THE REAL GOD THAT THERE CAN BE NO IMAGE OF HIM.* He can come into consciousness through reflection only as primal image, as primal thought, and primal Being" (p. 66).

28. "In the ancient world there were on the evidence of Pliny more gods than human beings, or as Rabbi Isaac put it: If they wrote down the names of every single one of their idols, all the hides in the world would not suffice them." E. E. Urbach, loc. cit.

29. Bevan, *Holy Images*, p. 13.

30. Grätz, *Geschichte der Juden*, Introduction. (The English translation omits the introduction.)

31. Ibid. See also Hermann Cohen, *Die Religion der Vernunft*, ed. cit., p. 43.
 "Plastic art becomes the analogy to nature. Poetry, on the contrary, becomes the primal language of literature and, through its forms, makes the spiritual thought more inward, as plastic art could never do."

32. Quoted from Wischnitzer, *The Messianic Theme in the Paintings of the Dura Synagogue* (Chicago, 1948), p. 9.

33. Quoted from Baron, *A Social and Religious History of the Jews*, II, p. 284.

34. Ibid.

35. See also Nazir, 2b.

36. Megillah, 27a.

4

Northern Romanticism and the Resurrection of God

Robert Rosenblum

Friedrich and the Divinity of Landscape

The alpha and the omega of this eccentric Northern route that will run
the gamut of the history of modern painting without stopping at Paris
may be located in two works: Caspar David Friedrich's *Monk by the Sea*
[Fig. 4-1], a picture whose seeming emptiness bewildered spectators when
it was first exhibited at the Berlin Academy in the autumn of 1810; and
a characteristic Mark Rothko of the 1950s [Fig. 4-2], whose image of
something near to nothingness was equally disconcerting to its first au-
diences. If these paintings look alike in their renunciation of almost
everything but a somber, luminous void, is this merely an example of
what Erwin Panofsky once called "pseudomorphosis,"[1] that is, the acci-
dental appearance at different moments in the history of art of works
whose close formal analogies falsify the fact that their meaning is totally
different? Or does this imply that there may be a true connection between
Friedrich and Rothko, that the similarity of their formal structure is the
result of a similarity of feeling and intention and that, indeed, there may
even be a tradition in modern painting that could bridge the century and
a half that separates them? . . .

. . . [T]he *Monk by the Sea* strikes an alien, melancholic note, strange
not only in the presence of so dense, so haunting, and so uninterrupted
an expanse of somber, blue-gray light above a low horizon, but in the

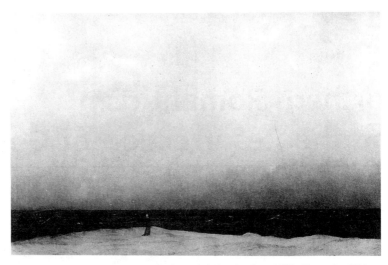

Figure 4-1. Caspar David Friedrich, *Monk by the Sea*. 1809. Photo by Bildarchiv Foto Marburg/Art Resource.

disturbing absence of any of the expected components of conventional marine painting. Indeed, as Marie Helene, the wife of Friedrich's artist-friend Gerhard von Kügelgen, complained, there was nothing to look at— no boats, not even a sea monster.[2] By any earlier standards, she was right: the picture is daringly empty, devoid of objects, devoid of the narrative incident that might perhaps qualify it as genre painting, devoid of everything but the lonely confrontation of a single figure, a Capuchin monk, with the hypnotic simplicity of a completely unbroken horizon line, and above it a no less primal and potentially infinite extension of gloomy, hazy sky. Just how daring this emptiness was may even be traced in evolutionary terms, for it has recently been disclosed in X-rays that originally Friedrich had painted several boats on the sea, one extending above the horizon, but that then, in what must have been an act of artistic courage and personal compulsion, he removed them, leaving the monk on the brink of an abyss unprecedented in the history of painting[3] but one that would have such disquieting progeny as Turner's own 'pictures of nothing' and the boundless voids of Barnett Newman.

 That the only figure who contemplates this bleak vista is, in fact, a monk may suggest a tradition other than marine or genre painting in which to locate Friedrich's picture, a tradition exemplified in such a work as Richard Wilson's *Solitude* of 1762, in which a pair of monks take their lonely places in a landscape made all the more melancholy by the presence of weeping willows.[4] Still, even the incipient Romanticism of this moody

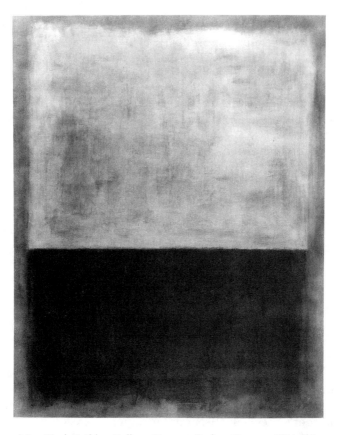

Figure 4-2. Mark Rothko, *Yellow, Orange, Red on Orange.* 1954. Oil on canvas, 115″ × 90¾″. The Pace Gallery, New York.

landscape, which harks back to Salvator Rosa and which reverberates with the unworldly, ascetic associations evoked by the presence of two monks,[5] seems contrived and impersonal by comparison with the uncommon starkness and intensity of Friedrich's solitary monk before nature. . . . Friedrich's painting suddenly corresponds to an experience familiar to the spectator in the modern world, an experience in which the individual is pitted against, or confronted by the overwhelming, incomprehensible immensity of the universe, as if the mysteries of religion had left the rituals of church and synagogue and had been relocated in the natural world. It has almost the quality of a personal confession,[6] whereby the artist, projected into the lonely monk, explores his own relationship to the great unknowables, conveyed through the dwarfing infinities of nature. For modern spectators, Friedrich's painting might even fulfill the transcen-

dental expectations of religious art although, to be sure, it conforms to no canonic religious subject and could therefore be considered in no way a religious painting by pre-Romantic, that is, pre-modern standards.

Friedrich's dilemma, his need to revitalize the experience of divinity in a secular world that lay outside the sacred confines of traditional Christian iconography was, as we can still intuit from his works, an intensely personal one. . . . Friedrich's intentions . . . are closely paralleled in theological terms by the writings and preachings of another German Protestant of his generation, Friedrich Ernst Daniel Schleiermacher, who was born in 1768, just six years before the artist.[7] Living in Berlin, which had become in the eighteenth century one of the strongholds of anti-Christian sentiment, Schleiermacher hoped to revive Christian belief in drastically new terms. In 1798 he published anonymously a treatise, *Reden über die Religion an die Gebildeten unter ihren Verächtern* (On Religion: Speeches to Its Cultured Despisers), a plea to preserve the spiritual core of Christianity by rejecting its outer rituals and by cultivating a private experience of piety that could extend to territories outside Christian dogma. And his own preaching concentrated on *Selbstmitteilung*, that is, a kind of personal unbosoming of subjective responses before the mysteries of divinity, a communication of feeling that offers a theological counterpart to Friedrich's monk. Just as Karl Barth was later to find in Schleiermacher the figure of a reformer of modern theology who tried to adopt the moribund conventions of the Church to the new experiences of the modern world,[8] so too could Friedrich be considered a pivotal figure in the translation of sacred experience to secular domains. Indeed, Schleiermacher's theological search for divinity outside the trappings of the Church lies at the core of many a Romantic artist's dilemma: how to express experiences of the spiritual, of the transcendental, without having recourse to such traditional themes as the Adoration, the Crucifixion, the Resurrection, the Ascension, whose vitality, in the Age of Enlightenment, was constantly being sapped. . . .

Because Friedrich . . . imposed upon everything he drew and painted an explicit or implicit sense of supernatural power and mystery in nature, it becomes especially difficult to categorize his various works as either religious or secular in character. They are, in fact, both, and nowhere more tellingly than in those paintings which are nominally Christian. Of these, the most conspicuous is the so-called *Tetschen Altar*, a work commissioned in 1807 by the Count von Thun-Hohenstein for a private chapel in Bohemia [Fig. 4-3]. It is presumably a Crucifixion (and its frame, designed by Friedrich, even includes such traditional Christian symbols as the Eye of God and the Eucharistic wheat and wine), but it is one so thoroughly unlike traditional paintings of this subject that it quickly offended such a critic as Friedrich von Ramdohr, who, after seeing the

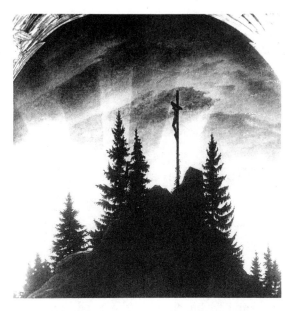

Figure 4-3. Caspar David Friedrich, *Cross in the Mountains.* 1808. Photo by Bildarchiv Foto Marburg/Art Resource.

painting exhibited in Friedrich's studio in the winter of 1808, wondered whether it was "a happy idea to use landscape for the allegorizing of a particular religious idea, or even for the purpose of awakening devotional feelings." He concluded that it was really "an impertinence for landscape painting to seek to worm its way into the church and crawl upon the altar."[9]

If the conveying of the spirit of the Crucifixion through the almost exclusive means of landscape seemed heretical to Ramdohr, he left unnoticed an even more surprising innovation in the *Tetschen Altar*, namely, that the Crucifixion itself is not a representation of a flesh-and-blood Christ on the Cross, but rather of a gilded crucifix, that is, a man-made object, a relic of Christian ritual and art of a sort that might be found on a pilgrimage route in the forest. As a result, the painting, surprisingly, could be interpreted as belonging entirely to a modern world of empirical observation, although a world whose component parts have been selected and organized so carefully that each element is charged with meaning. Friedrich himself, in a text edited by Semler, a writer sympathetic to these new interpretations of landscape, described the Christian implications of his painting, which could, theoretically, be only a secular scene of a crucifix viewed against a sunset: "The cross stands high on a rock, firm and unshakable like our faith in Christ. Fir trees surround it, lasting

through the seasons, like our hopes in Him who was crucified."[10] Thus, even without the presence of the crucifix that faces the concealed sunset, as Friedrich's thoroughly secular woman faces the sunrise, the landscape itself, in its dramatic contrast of the closeness of firm rock and tree against the remoteness of a pervasive luminosity whose setting source is hidden from us, would suggest some uncommon event in nature, composed in terms of an emblematic polarity of dark and light, near and far, palpable and impalpable. . . .

Transcendental Abstraction and Abstract Expressionism

. . . American [artists] in the 1940s . . . were constantly searching for a universal symbol that could encompass an irreducible truth. Like so many Romantics, they wished to start from scratch. . . . What was sought by these "Myth Makers" (as Rothko was to refer to Still and this group in 1946)[11] was virtually a new pictorial cosmogony and a new, elemental style that could come to terms with the need for, in Rothko's words, "tragic-religious drama."[12] And in the years just before and after the apocalyptic conclusion of the Second World War, this need for purification and regression must have been . . . acute. . . .

[Mark Rothko] belongs fully to this tradition, carrying as he does the annihilation of matter and the evocation of an imprecise yet mystical content to an extreme. . . . Like Newman and, in fact, like Pollock, Gottlieb, and Still, Rothko evolved the archetypal statement of his abstract painting—those hovering tiers of dense, atmospheric color or darkness— from a landscape imagery of mythic, cosmological character; but he was also attracted to what he was later to describe as ". . . pictures of a single human figure—alone in a moment of utter immobility,"[13] a description that, tellingly, could apply to many paintings by Friedrich himself. By 1950, Rothko had reached that stark format he was to explore, with variations, for the remaining two decades of his life, an image that . . . locates the beholder at the brink of a resonant void from which any palpable form is banned. Instead, there are metaphorical suggestions of an elemental nature: horizontal divisions evoking the primordial separation of earth or sea from cloud and sky, and luminous fields of dense, quietly lambent color that seem to generate the primal energies of natural light. Rothko's pursuit of the most irreducible image pertains not only to his rejection of matter in favor of an impalpable void that wavers, imaginatively, between the extremes of an awesome, mysterious presence or its complete negation, but also to his equally elementary structure, which . . . is of a numbing symmetry that fixes these luminous expanses

in an emblem of iconic permanence. . . . [U]ltimately, the basic configu-
ration of Rothko's abstract paintings finds its source in . . . Friedrich,
who also placed the spectator before an abyss that provoked ultimate
questions whose answers, without traditional religious faith and imagery,
remained as uncertain as the questions themselves.[14]

The visual richness of Rothko's paintings has often fostered the idea
that they are exclusively objects of aesthetic delectation, where an epi-
curean sensibility to color and formal paradoxes of the fixed versus the
amorphous may be savored. Yet their somber, mysterious presence should
be sufficient to convince the spectator that they belong to a sphere of
experience profoundly different from the French art-for-art's sake am-
bience of a Matisse, whose expansive fields of color may nevertheless
have provided the necessary pictorial support for Rothko's own achieve-
ment (much as Parisian Cubism provided the means for Mondrian's anti-
Cubist, mystical ends). But even without the emotional testimony of the
pictures themselves, there is Rothko's statement of a passionately anti-
formalist and antihedonist position:

> I am not interested in relationships of color or form or anything
> else. . . . I am interested only in expressing the basic human emotions—
> tragedy, ecstasy, doom, and so on—and the fact that lots of people break
> down and cry when confronted with my pictures shows that I *communicate*
> with those basic human emotions. The people who weep before my pictures
> are having the same religious experience I had when I painted them. And
> if you, as you say, are moved only by their color relationships, then you
> miss the point![15]

Fortunately, the implicit "religious experience" of Rothko's art—to
use his own phrase—was, on one occasion at the end of his life, made
magnificently explicit in the project envisioned and then realized by
private patrons, Mr. and Mrs. John de Ménil.[16] Already recognizing in
Rothko's art the expression of experiences that lay beyond the aesthetic
and then seeing, in 1964, the dark and somber paintings that the artist
justifiably found to be inappropriate solutions to his commission for dec-
orative work at an elegant New York restaurant, the Four Seasons, the
de Ménils conceived the idea of a separate chapel, to be built in Houston,
Texas, where a group of Rothko's paintings might function in a quasi-
religious way. There Rothko's art could inspire the kind of meditation
which was elicited less and less in the twentieth century by conventional
religious imagery and rites. That Rothko's paintings . . . could not prop-
erly function within the ritualistic traditions and iconographic needs of
a church or synagogue is both a tribute to their originality in the expres-
sion of spiritual experiences and a reflection of the dilemma that riddled

the work of so many artists since the Romantics who tried to convey a sense of the supernatural without recourse to inherited religious imagery.

It was appropriate, then, to the unspecified religious character of Rothko's work that the paintings commissioned by the de Ménils would finally have to be contained within a secular rather than a conventionally sacred shrine, just as the quasi-religious landscapes of a Friedrich, a Van Gogh, or a Mondrian could never have been accepted by the Church, even though their evocation of ultimate mysteries might be far more persuasive than those in orthodox modern Christian art. And it was appropriate, too, that at the opening of what is now called the "Rothko Chapel" (which was originally part of a philanthropic organization, the Institute of Religion and Human Development), there was a wide, ecumenical range of religious leaders from both Western and Eastern faiths. At the dedication ceremony on 27 February 1971, there were present the chairman of the Central Conference of Rabbis, an imam who represented Islam, Protestant bishops, a bishop from the Greek Orthodox Church, and, as personal ambassador of the Pope, a Roman Catholic cardinal. And, in less official terms, subsequent visitors of a Zen Buddhist persuasion could find the uncanny silence and mystery of the chapel conducive to the practice of Yoga meditation.

The idea of a chapel in the modern world that was to convey some kind of universal religious experience without subscribing to a specific faith was, in fact, a dream that originated with the Romantics. Runge himself, after all, had planned his *Tageszeiten* series as a sequence of new religious icons that were to be housed in a specially designed chapel with specially composed music; and Friedrich's *Tetschen Altar*, while alluding to more traditional Christian iconography, would still have been too heretic in its personal interpretation of the Crucifixion to be acceptable anywhere but in a private chapel. More generally speaking, the most passionate religious art of the Northern Romantics—Blake or Palmer, Friedrich or Runge—was usually so unconventional in its efforts to embody a universal religion outside the confines of Catholic or Protestant orthodoxy that it could only be housed in chapels of the artists' dreams or in a site provided by a private patron. And this problem generated by the Romantics is no less acute in the late twentieth century. What Catholic church would hang Newman's *Stations of the Cross*, but what art museum seems sufficiently sanctified to house them?

The Rothko Chapel [Fig. 4-4] perpetuates these Romantic difficulties of providing an authentic religious experience in a modern world of doubt. In both architectural and pictorial terms it does so by allusion to essentially moribund religious traditions. The octagonal plan of the building—first projected by Philip Johnson but then altered by Howard Barnstone and Eugene Aubry—evokes the form of a Catholic baptistery, such as

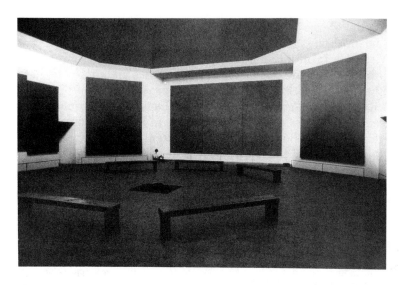

Figure 4-4. Rothko Chapel, Houston, Texas. 1971. Photo by Nicolas Sapieha/ Art Resource.

the eleventh-century baptistery at Torcello which actually inspired it. And the paintings, too, evoke a traditional religious format, the triptych, a format that Tack had almost emptied of its Christian subject in his *All Souls* triptych, whose deep blue voids prefigure Rothko's dark and resonant spaces.[17] On three of the chapel's eight walls—the central, apselike wall, and the facing side walls—Rothko provided variations on the triptych shape, with the central panel alternately raised or level with the side panels. Yet these triptychs, in turn, are set into opposition with single panels, which are first seen as occupying a lesser role in the four angle walls but which then rise to the major role of finality and resolution in the fifth single panel which, different in color, tone, and proportions, occupies the entrance wall, facing, as if in response, the triptych in the apse. It is as if the entire content of Western religious art were finally devoid of its narrative complexities and corporeal imagery, leaving us with these dark, compelling presences that pose an ultimate choice between everything and nothing. But the very fact that they create their own hierarchy of mood, shape, and sequence, of uniqueness and duplication, of increasingly dark and somber variations of plum, maroon, and black, suggests the presence here of some new religious ritual of indefinable, yet universal dimensions. And in our secularized world, inherited from the Romantics, a world where orthodox religious ritual was so unsatisfying to so many, the very lack of overt religious content here may make Rothko's surrogate icons and altarpieces, experienced in a non-

denominational chapel, all the more potent in their evocation of the transcendental.

With this in mind, one may again raise the question . . . are the analogies of form and feeling between Friedrich's *Monk by the Sea* and a painting by Rothko merely accidental, or do they imply a historical continuity that joins them? To which, perhaps, another question might be posed: could it not be said that the work of Rothko and its fulfillment in the Houston Chapel are only the most recent responses to the dilemma faced by Friedrich and the Northern Romantics almost two centuries ago? Like the troubled and troubling works of many artists of . . . the nineteenth and twentieth centuries, Rothko's paintings seek the sacred in a modern world of the secular.

Notes

1. This phenomenon is discussed by Erwin Panofsky in his *Tomb Sculpture*, New York and London, 1964, pp. 25–26.

2. Frau von Kügelgen's comments are found in Marie Helene von Kügelgen, *Ein Lebensbild in Briefen* (A. and E. von Kügelgen, eds.), Leipzig, 1901, p. 161. They are translated in Helmut Börsch-Supan, "Caspar David Friedrich's Landscapes with Self-Portraits," *Burlington Magazine*, CXIV, September 1972, p. 627, note 13.

3. The X-rays, revealing the painting's original state, are illustrated, and their meaning discussed, in Helmut Börsch-Supan, "Bemerkungen zu Caspar David Friedrichs 'Mönch am Meer,'" *Zeitschrift des deutschen Vereins für Kunstwissenschaft*, XIX, 1965, pp. 63–76. The position of the *Monk by the Sea* as prophetic of the existential anxieties of abstract art and as parallel to the equally prophetic innovations of Kleist is provocatively suggested by Philip B. Miller, "Anxiety and Abstraction: Kleist and Brentano on C. D. Friedrich," *Quarterly Review of Literature*, XVIII, nos. 3–4, 1973, pp. 345–54, a translation, with commentary, of Kleist's revision of Brentano's critique of Friedrich's painting for the *Berliner Abendblätter*, 13 October 1810.

4. Wilson's painting is discussed in the exhibition catalogue, *La peinture romantique anglaise et les préraphaélites*, Paris, Petit Palais, 1972, no. 336.

5. The quasi-religious motif of hermits and monks in modern art is considered in Hans Ost, "Einsiedler und Mönche in der deutschen Malerei des 19. Jahrhunderts," in Ludwig Grote, ed., *Beiträge zur Motivkunde des 19. Jahrhunderts*, Munich, 1970, pp. 199–210.

6. Indeed, the painting has been interpreted as a self-portrait in Helmut Börsch-Supan, "Caspar David Friedrich's Landscapes . . . ," p. 624.

7. For particularly perceptive comments on Schleiermacher in the context of the Romantic religious revival, see H. G. Schenk, *The Mind of the European Romantics*, New York, 1969, pp. 111ff. In the literature of art history, the analogy between Schleiermacher and Friedrich has been briefly suggested in Klaus Lankheit, *Revolution und Restauration*, Baden-Baden, 1965, p. 166.

8. See Karl Barth, *Protestant Theology in the Nineteenth Century, Its Background and History*, London, 1972, pp. 425ff.

9. This often quoted criticism is found in F. W. B. von Ramdohr, "Über ein zum Altarblatte bestimmtes Landschaftsgemälde von Herrn Friedrich in Dresden, und Über Landschaftsmalerei, Allegorie und Mysticismus überhaupt," *Zeitung für die elegante Welt*, 17–21 January 1809, pp. 89ff.

10. A convenient English translation of this text is found in the exhibition catalogue, *Caspar David Friedrich, 1774–1840; Romantic Landscape Painting in Dresden*, London, Tate Gallery, 1972, p. 104.

11. Quoted in Sandler, op. cit., p. 167.

12. Ibid.

13. In "The Romantics were Prompted," *Possibilities 1*, no. 1, Winter 1947–8, p. 84; quoted in Sandler, op. cit., p. 175.

14. For many perceptive comments on Rothko and Romantic traditions, including analogies with Friedrich, see Brian O'Doherty, "Rothko," *Art International*, XIV, 20 October 1970, pp. 30–44.

15. In Selden Rodman, *Conversations with Artists*, New York, 1957, pp. 93–94. This important statement was called to recent critical attention in William Seitz, "Mondrian and the Issue of Relationships," *Artforum*, X, February 1972, p. 74, note 3.

16. For some useful accounts of the chapel and its history, see D. de Ménil, "Rothko Chapel," Institute of Religion and Human Development, Houston, Texas," *Art Journal*, XXX, Spring 1971, pp. 249–51; David Snell, "Rothko Chapel—the Painter's Final Testament," *Smithsonian*, II, April 1971, pp. 46–54; J. P. Marandel," Une chapelle œcumenique au Texas," *L'Oeil*, no. 197, May 1971, pp. 16–19; and Brian O'Doherty, "The Rothko Chapel," *Art in America*, LXI, January-February 1973, pp. 14–20.

17. For a general consideration of the triptych as an expressive format, tracing its evolution from figurative to abstract examples (such as that of 1957–58 by Heinz Kreutz), see Klaus Lankheit, *Das Triptychon als Pathosformel* (Abhandlungen der Heidelberger Akademie der Wissenschaften, no. 4), Heidelberg, 1959.

5

The Mechanics of Seventeenth-Century Patronage

Francis Haskell

I

"When Urban VIII became Pope," wrote the art-chronicler Giambattista Passeri, looking back nostalgically from the dog days of the 1670s, "it really seemed as if the golden age of painting had returned; for he was a Pope of kindly spirit, breadth of mind and noble inclinations, and his nephews all protected the fine arts. . . ."[1] In fact, the long pontificate of Urban VIII which began in 1623 marked the climax of a most intensive phase of art patronage rather than the opening of a new era—the sunlit afternoon rather than the dawn. For at least thirty years the austerity and strains of the Counter Reformation had been relaxing under the impact of luxury and enterprise. Intellectual heresy was still stamped out wherever possible: artistic experiments were encouraged as never before or since. The rule of Urban VIII not only led to a vast increase in the amount of patronage, but also to a notable tightening of the reins.

Urban's immediate predecessors, Paul V (1605–1621) and to a lesser extent Gregory XV (1621–1623), had set a pattern which he was content to follow. The completing of St. Peter's, the building and decoration of a vast palace and villa, the establishment of a luxurious family chapel in one of the important Roman churches, the support and enrichment of various religious foundations, the collection by a favoured nephew of a

From *Patrons and Painters: A Study in the Relations between Italian Art and Society in the Age of the Baroque* by Francis Haskell, copyright © 1980 Yale University Press. Reprinted by permission of the publisher.

private gallery of pictures and sculpture—this was now the general practice. In it we can see reflected the contrasts, and sometimes the tensions, between the Pope as a spiritual and temporal ruler and the man as an art lover and head of a proud and ambitious family.

The Popes and their nephews were by no means the only patrons, but as the century advanced their increasing monopoly of wealth and power made them at first the leaders and then the dictators of fashion. This process reached its climax in the reign of Urban VIII and was in itself partly responsible for the relative decline in variety and experiment. For until the election of this Pope change and revolution were of the very essence of the Roman scene. ". . . It [is] a strange and unnaturall thing," wrote a correspondent to Lord Arundell in 1620 towards the end of Paul V's sixteen-year rule,[2] "that in that place, contrary to all others, the long life of the Prince is sayd to be the ruyne of the people; whose wealth consists in speedy revolutions, and oft new preparations of new hopes in those that aspire to rise by new fam.es [families] who, w.th the ould, remayne choaked w.ith a stand, and loath to blast their future adresses by spending to court those that are dispaired of." Exactly the same point was made with much greater force after the twenty-one years of Urban VIII's reign.[3]

These "speedy revolutions" and the consequent rise of new families moulded the patterns of art patronage. As successive popes came to the throne they surrounded themselves with a crowd of relatives, friends and clients who poured into Rome from all over Italy to seize the many lucrative posts that changed with each change of government. These men at once began to build palaces, chapels and picture galleries. As patrons they were highly competitive, anxious to give expression to their riches and power as quickly as they could and also to discomfort their rivals. After the Pope died they were often disgraced, and in any case their vast incomes came to a sudden end, for nepotism no longer took the form of private empires carved out of the Church's territory."There is no situation more difficult or more dangerous," said Pope Gregory XV, who certainly knew what he was talking about,[4] "than that of a Pope's nephew after the death of his uncle." With the end of their incomes went the end of their positions as leading patrons. It was especially noted of Cardinal Alessandro Peretti-Montalto, nephew of Pope Sixtus V, that he was still respected and loved even after the death of that Pope, and that artists continued to work for him.[5] This was evidently not the usual state of affairs.

Rome was a symbol rather than a nation. The nobles who formed the papal entourage still thought of themselves far more as Florentines, Bolognese or Venetians than as Romans or Italians; and as the prestige of painting was at its height, it was a matter of some importance for a

cardinal to be able to produce several painters of distinction from his native city. We are told that Cardinal Maffeo Barberini (the future Urban VIII) "was most anxious to make use of artists from his native Florence," and that Pope Gregory XV "was a Bolognese so there was little chance for anyone from anywhere else. . . ." The artists naturally made the most of their opportunities. In 1621 Cardinal Ludovisi was elected Pope. Domenichino had some years earlier returned to his native Bologna after a quarrel with Cardinal Borghese, but "this news caused him great excitement, as the new Pope was a compatriot of his and the uncle of one of his friends," and so he hurried back to Rome where he was made Vatican architect by the Pope's nephew Ludovico.[6]

Indeed, if we study the careers of the most important artists who followed Annibale Carracci from Bologna at the beginning of the century and introduced a new style of painting to Rome, a very consistent pattern emerges. The young painter would at first be found living quarters, in a monastery perhaps, by a cardinal who had once been papal legate in his native city. Through this benefactor he would meet some influential Bolognese prelate who would commission an altar painting for his titular church and decorations for his family palace—in which the artist would now be installed. The first would bring some measure of public recognition, and the second would introduce him to other potential patrons within the circle of the cardinal's friends. This was by far the more important step. For many years the newly arrived painter would work almost entirely for a limited group of clients, until at last a growing number of altarpieces had firmly established his reputation with a wider public and he had sufficient income and prestige to set up on his own and accept commissions from a variety of sources. Once this had been achieved, he could view the death of his patron or a change in régime with some degree of equanimity.

This essential pattern, which will have to be expanded and modified in later pages, determined the sites of the more significant works of modern art in Rome. There were, first, the great town and country houses, all of which—Aldobrandini, Peretti, Borghese and so on—contained early pictures and frescoes by the Bolognese painters. Secondly, there were the churches. The most important was naturally St. Peter's, whose decoration was under the direct supervision of the Pope, but there were many others which were maintained by rich cardinals and noble families. They fall into two classes—those of which a cardinal was titular head or for which he had a special veneration; and those where he wished to be buried. Both, however, had one feature in common: their antiquity. A titular church was, by definition, one that had been handed down from cardinal to cardinal through the centuries; and in general the Popes and their families, perhaps to refute the charge of being nouveaux-riches, chose to

be buried in the most ancient and venerable of basilicas such as S. Maria Maggiore and S. Maria sopra Minerva.

There was, besides, one other way in which a noble could add to the splendour of Rome and hope to find a suitable burying place for his family: he could build a complete new church. The demand was enormous. New Orders had sprung up to meet the threat of the Reformation—the Oratorians and the Jesuits, the Theatines, and Barnabites and the Capuchins; and the various foreign communities in Rome, the Florentines, the Lombards and many others, vied with each other in the erection of magnificent new temples. Such building, however, takes a considerable time, and the original estimate of the cost is usually well below the final result. It is rare that the man who decides to have a church built will survive to supervise the decoration; it is still rarer that his heirs will take the same interest as he himself did. And so the chapels have to be disposed of to anyone prepared to decorate them. But the great cardinals were interested primarily in furnishing their own titular churches, family palaces or burial places in the older basilicas. Besides, their acute sense of precedence and rivalry made them reluctant to undertake a relatively small feature in a church which had been begun by another cardinal. "Although it was objected to him," we are told of Cardinal Alessandro Peretti-Montalto, "that it was not suitable for him to follow in a building [S. Andrea della Valle] which had been begun by someone else, he despised such human considerations and carried on with his plans to the glory of God. . . ."[7] Much more usually, however, the completion and decoration of new churches were carried out by wealthy but politically unimportant patrons, who were not in touch with the most modern artists of the day and who were thus compelled to fall back on well-established favourites. It is therefore paradoxically true that a well-informed traveller in about 1620 would have found that most of the best modern paintings in Rome were in the oldest churches.

II

Within the general framework that has been outlined there was a wide range of variation possible in the relationship between an artist and the client who employed him. At one end of the scale the painter was lodged in his patron's palace and worked exclusively for him and his friends; at the other, we find a situation which appears, at first sight, to be strikingly similar to that of today: the artist painted a picture with no particular destination in mind and exhibited it in the hope of finding a casual purchaser. In between these two extremes there were a number of gradations involving middlemen, dealers and dilettantes as well as the ac-

tivities of foreign travellers and their agents. These intermediate stages became more and more important as the century progressed, but artists usually disliked the freedom of working for unknown admirers, and with a few notable exceptions exhibitions were assumed to be the last resort of the unemployed.

The closest relationship possible between patron and artist was the one frequently described by seventeenth-century writers as *servitù particolare*. The artist was regularly employed by a particular patron and often maintained in his palace.[8] He was given a monthly allowance as well as being paid a normal market price for the work he produced.[9] If it was thought that his painting would benefit from a visit to Parma to see Correggio's frescoes or to Venice to improve his colour, his patron would pay the expenses of the journey.[10] The artist was in fact treated as a member of the prince's "famiglia," along with courtiers and officials of all kinds. The degree to which he held an official post varied with the patron; though some princes might create an artist *nostro pittore* "with all the honours, authority, prerogatives, immunities, advantages, rights, rewards, emoluments, exemptions and other benefits accruing to the post,"[11] such a position was more frequent with architects than with painters. In most cases within the prince's retinue there was a sliding scale of rewards and positions up which the artist might move on promotion. Thus from 1637 to 1640 Andrea Sacchi was placed in Cardinal Antonio Barberini's household among three slaves, a gardener, a dwarf and an old nurse; in the latter year he was moved up to the highest category of pensioners with writers, poets and secretaries.[12]

A position of this kind was eminently desirable for the artist, and all writers agree on its enormous and sometimes indispensable advantages.[13] There were occasional drawbacks: some artists had difficulty in leaving the service of their employer, and there were obvious restrictions on personal freedom which might be irksome.[14] On the other hand, paradoxical though it may seem, artists placed in these circumstances had unrivalled opportunities for making themselves known, at least within certain circles. For it has already been pointed out that the patron was not wholly disinterested in his service to the arts. A painter of talent in his household was of real value to him, and he was usually quick to sound the praises of his protégé and even to encourage him to work for others. In the absence of professional critics such support and encouragement was by far the easiest way for a painter to become known. "To establish one's name it is vital to start with the protection of some patron," wrote Passeri when commenting on the early life of Giovanni Lanfranco,[15] for it was only the great families who were in a position to get commissions for their protégés to paint in the most fashionable churches, and this was an indispensable stage in any artist's career.

In view of the powerful national rivalries that prevailed in Rome it is not at all surprising that the artist's birthplace played an even more important part in determining his chances of enjoying *servitù particolare* than in obtaining ordinary commissions. Thus we hear of the Florentine Marcello Sacchetti who, on seeing some works by Pietro da Cortona, "asked him about himself and where he came from. And when he heard that [Pietro] was from Cortona, he called him his compatriot," and put him up in his palace.[16] In the same way, at the end of the century, Cardinal Ottoboni provided rooms for his Venetian fellow-citizen Francesco Trevisani.[17] But good manners—a paramount issue for painters in the seventeenth century—could be almost as important as nationality in securing an artist a position of this kind.

Though this sort of patronage was very desirable in a stable society, the conditions of seventeenth-century Rome with its frequent and sometimes drastic shifts of power were by no means ideal for its furtherance. Too close an association with a disgraced patron could prove a serious bar to advancement when conditions changed. And there were always artists who found the restrictions on their freedom uncongenial despite the security they seemed to guarantee.[18] Besides, there were not many families able or willing to support painters on such terms. And so we often find that this extreme form of patronage was extended to an artist only at the outset of his career. Arriving in Rome from some remote city, what could be more desirable than the welcome of a highly placed compatriot offering hospitality, encouragement and a regular income? But after some years, with a considerable reputation and Rome flooded with foreigners willing to pay inflated prices, the position must have looked rather different. Fortunately a compromise was always possible: the artist could live and work on his own but continue to receive a subsidy as an inducement to giving his patron priority over all other customers.[19]

It was much more usual, however, for a painter to work in his own studio and freely accept commissions from all comers. Whether or not an actual contract was drawn up between him and the patron would depend on the scope of the commission, but by examining such documents as have survived we can see the sort of conditions under which these independent artists worked. In the following pages the items most usually stipulated will be discussed in turn.

It was natural enough that the *measurements* and site of the proposed work should be laid down in some detail when a fresco or ecclesiastical painting was required, and only one point sometimes caused difficulties: when an altarpiece was commissioned from an artist living in some distant city, the problem of the lighting in the chapel might become acute. For though the painter was naturally told the destination of his picture, it was by no means certain that he always had the chance

to inspect the site himself and long exchanges would then be needed to clear up the problem.

The size of pictures for private galleries was also a matter for discussion. Those complete decorative schemes that have survived show that in many cases pictures were used to cover the walls of a room or gallery in symmetrical patterns, and that often enough they were even let into the surface. Where this was the case it was obviously important to regulate the exact measurements of any new picture commissioned, and much surviving correspondence testifies to the patron's interest in the question. Again and again artists were commissioned to paint pictures in pairs, and in many instances it is possible to see how this preoccupation with the decorative and architectural function of paintings influenced their composition as well as their size.[20]

The artist was also usually given the *subject* of the picture he was required to paint, but it is difficult to determine how far his treatment of it was actually supervised by the patron. Clearly a great deal depended on the destination of the work. Stringent control may have been exerted over the subject of a religious fresco or an altar painting, but the contracts themselves only rarely go into much detail. Indeed, a surprising degree of freedom often seems to have been left to painters, even in important commissions, and this depended a good deal on the cultural sophistication of Rome. Contracts from smaller provincial centres show far more detailed instructions than those given to painters in the bigger towns.[21] Usually the outlines of the subject would be indicated, and it was then left to the artist to add to it those elements which he found necessary for its representation.[22] Often the request for further iconographical details came from the painter. Thus, in 1665, when Guercino was required to paint an altarpiece for a monastery in Sicily, he was given the measurements and told that the figures were to include the "Madonna de Carmine with the Child in Her arms, St. Teresa receiving the habit from the Virgin and the rules of the Order from the Child, St. Joseph and St. John the Baptist; these figures must be shown entire and life-size and the top part of the picture must be beautified with frolicking angels." Not satisfied with such instructions (which in fact were more specific than usual), he wrote to ask whether the Madonna del Carmine "is to be clothed in red with a blue cloak following church custom or whether she should be in a black habit with a white cloak. Should the rules of the Order which the Child is handing to the Saint be in the form of a book or a scroll? In that case what words should be written on it to explain the mystery? Further, should St. Teresa go on the left or on the right?" He also wanted to know how the picture was to be hung and what the lighting would be like.[23]

In secular works, too, there were difficulties. The artist who was given such a vague theme as the Four Seasons was often in something

of a quandary as to what he should actually paint, and we know that in these circumstances he would usually apply to a scholar or poet for advice, even if not specifically required to do so in his contract. When Prince Pamfili, for instance, commissioned Pier Francesco Mola to paint the Four Elements in his country house at Valmontone, the artist went to a lawyer of some standing in the district and asked to borrow a genealogy of the gods and a Virgil with a commentary so that he could pick suitable myths for representation. Basing himself on these books and on friendly conversations, he then chose to depict the Element of Air by showing "Juno reputed to be the goddess of Air in the act of leaving the clouds; the Milky Way; the rape of Chloris by Zephyr; the rape of Ganymede; and the apparition of Iris to Turnus."[24]

The artist's treatment of a particular subject could be affected in another way. Because the price of a picture or fresco was often determined by the number of full-length figures it contained, he was sometimes told just how many of these he was to include. Urban VIII, for instance, commissioned an altarpiece for the church of S. Sebastiano on the Palatine to represent "the martyrdom of St. Sebastian, with eight figures" which were evidently left to the discretion of the painter.[25]

The commissioning of pictures for a gallery would naturally leave a freer choice, for complete thematic uniformity of decoration was now only rarely insisted on. More and more the movable gallery picture was coming into its own—a largely Venetian innovation of over a century earlier which had made a decisive impact on Roman collecting. Pictures were bought, sold, inherited, speculated in and exchanged with bewildering speed so that biographers often no longer found it worth recording where a painter's works were at the time of writing. In these circumstances neither subject nor size held the vital importance of earlier days, and, with the added stimulus of connoisseurship, collectors were frequently more interested in choosing the work of specific artists than in going into great detail about what had actually been painted. Thus at the very beginning of the century the Marchese Giustiniani, whose taste is discussed in a later chapter, was such a wholehearted admirer of Caravaggio that, when an altarpiece by that artist had been rejected as unsuitable for is intended location, he acquired it for his gallery and hung it among a series of pictures which had been assembled far more for their affinities of style than for any consistency of subject-matter.[26] And some ninety years later another patron, Giovanni Adamo, when commissioning a work from the Genoese painter Paolo Girolamo Piola, gave the size and added only: "As to the subject, I leave it to you whether to make it sacred or profane, with men or with women."[27] We find here the culmination of an undogmatic approach to art which was characteristic of the whole century and which led to an invigorating freedom of experiment and

invention. It was an approach that the more conservative patron could modify by choosing a single theme and commissioning pictures by different masters to be grouped around it—a suitable compromise between the old and the new for which there had been many precedents during the Renaissance. It occurs frequently in royal commissions where a number of painters would be required to celebrate the glories of Alexander the Great, and it was also popular with scholars collecting portraits of great men or reconstructing elaborate temples of learning. It was evidently some such scheme that the Duke of Mantua had in mind when he commissioned two Roman painters to represent for him various episodes from the story of Samson, but ordered them on no account to begin until he had told them just which ones he wanted.[28] And another great patron, the Marchese del Carpio, when Spanish Ambassador in Rome, commissioned a number of artists to draw for him any subject so long as it represented some facet of *Painting*.[29]

Instructions to the artist would also depend on his reputation and temperament. How great, for instance, was the contrast between Pietro da Cortona and Salvator Rosa! Pietro, recognised for years as the most distinguished painter in Rome, indeed in Italy, refused to choose his own subjects and claimed that he had never done so in his whole life;[30] whereas Rosa told one imprudent client who had had his own ideas for a picture to "go to a brickmaker as they work to order"—though this attitude did not stop him asking his friends for suggestions.[31] And, of course, certain artists had acquired a reputation for particular subjects. Thus it was that one collector called on the French painter Valentin, who specialised in Caravaggesque genre scenes, and asked him for "a large picture with people among whom were to be a gipsy woman, soldiers and other women playing musical instruments."[32]

The most effective way by which a patron could keep control over an artist working for him was by insisting on a preliminary oil sketch (*modello*) or drawings, but this practice was a good deal rarer during the first half of the seventeenth century than is sometimes supposed.

It is true that in 1600 Caravaggio agreed with his patron, before executing his altarpieces of *The Conversion of St. Paul* and *The Martyrdom of St. Peter*, that he would "submit specimens and designs of the figures and other objects with which according to his invention and genius he intends to beautify the said mystery and martyrdom,"[33] but this was exceptional, and Caravaggio was already notorious as a difficult character. For quite different but equally understandable reasons, Rubens, who was still only an unknown foreigner, was asked in 1606 to show examples of his painting before undertaking an altarpiece in the Chiesa Nuova.[34] In general, more confidence was shown in the painter's ability, though private and unofficial discussions with the patron must have been

frequent. Even for such an important commission as the altar paintings in St. Peter's, it appears not to have been obligatory for artists to produce *modelli* (though presumably drawings would have been necessary); when Lanfranco wrote in 1640 to Cardinal Barberini asking to be given the chance to paint the altar picture of *Pope Leo and Attila,* he specially mentioned that he would arrange for the Cardinal to see "in tela il disegno," but he explained that he was doing this to illustrate the difficulties of the composition, and in any case the suggestion came from him and not from his patron.[35]

None of the Bolognese artists working in Rome is known to have produced a *modello*, and no certain examples survive even from such a great decorator as Pietro da Cortona.[36] On the other hand, the practice became widespread during the second half of the century, and is particularly associated with the painter Giovan Battista Gaulli, who may have been responsible for introducing it from his native Genoa where it was already well established. One factor is clearly important: Professor Wittkower has pointed out that "most of the large frescoes in Roman churches belong to the last 30 years of the seventeenth and the beginning of the eighteenth century"[37] and it is obvious, as Rubens had shown in Northern Europe, that *modelli* could be exceedingly useful both to patrons and assistants in large-scale work of this kind. Moreover, the iconographical significance of these frescoes was often more complex. Ciro Ferri was required in 1670 to produce a coloured *modello* for the cupola of S. Agnese in Piazza Navona, and after it had been approved he was not to make any changes without special permission.[38] Such stringent control is exceptional, but . . . the Pamfili family, who were responsible for this commission, were never altogether happy in their relations with artists. It is also possible that the insistence on sketches at this period was in some way linked to a growing appreciation of their more "spontaneous" character—an appreciation that naturally accompanied the rise of the *amateur*, though the fashion for collecting them did not become general until the eighteenth century.

After the size of the picture and the subject-matter had been decided, there came the question of the *time limit*, a problem of particular urgency during the whole of the Baroque period. Nearly all patrons insisted that work should be finished as quickly as possible, and as often as not they were disappointed by the artists whom they employed. Some frescoes were, of course, such large undertakings that many years were required for their completion. Ciro Ferri was given four years for the cupola of S. Agnese in Piazza Navona, and Gaulli eight for the vault and transept vaults of the Gesú. Holy Years often provided a special incentive for artists to complete their work in some church,[39] and certain painters had a reputation for exceptional speed. It was claimed that Giovanni Odazzi

worked faster than the notoriously rapid Luca Giordano, and Giacinto Brandi too was famous in this respect. Quick work might entitle the artist to greater rewards—we are told that Gaspard Dughet benefited in this way—but by no means always met with critical approval.[40] It was the Venetians who were especially famous for their speed and the fact earned them a certain amount of contempt elsewhere.

The final clause in any contract naturally referred to the *price* and financial arrangements. Certain formulas were always adhered to. Some proportion of the sum agreed was paid at once as a deposit. This ranged widely from a minimum of about one-seventh to a maximum of nearly a half. If the work was a picture, the artist was very often given a further payment when it was half finished and the remainder on completion, together with a final bonus. And, of course, there were many variations possible in this treatment. In the case of large-scale frescoes, the artist was usually paid at a regular monthly rate.[41]

More interesting and significant than obvious arrangements of this kind is the question of expenses incurred by the artist in his work. "The usual thing is to pay painters for the stretcher, the priming and for ultramarine," wrote an agent to a prospective patron in 1647, and this is confirmed in many other documents.[42] Once again variations were possible[43]—sometimes the painter was responsible for all expenses; on other occasions he was given the canvas and had to pay for the ultramarine himself; very rarely he was told, as in mediaeval days, that the colours he bought must be of the very finest quality.[44] The patron invariably paid for the scaffolding needed for ceiling frescoes, and if the work took place away from the painter's residence he would also provide board and lodging for him. It was claimed of Prince Pamfili, for instance, that he treated Pier Francesco Mola, who was decorating his villa at Valmontone, like one of his own retinue, giving him "fowl, veal and similar delicacies."[45]

Prices for the work itself were regulated in widely different ways: many artists had fixed charges for the principal figures in the composition, excluding those in the background. Thus Domenichino was paid 130 ducats for each figure in his frescoes in Naples Cathedral and Lanfranco 100. This system was very widespread and allowed painters to make regular increases in price as their reputations grew.[46] However, the status of the client was often as important as that of the artist in determining the price. In the 1620s the Sienese doctor and art lover, Giulio Mancini, wrote that a munificent patron would not condescend to go into the question at all, but would reward the artist as he saw fit.[47] It is true enough that we do find some examples of this. In 1617, for instance, the Duke of Mantua wrote to Guido Reni asking him for a painting of *Justice embracing Peace*. He gave the measurements, but made no mention of the

price beyond saying that Guido would be "generously rewarded."[48] And artists were clearly glad to respond to such offers. The somewhat eccentric Paolo Guidotti used to say that he gave away his paintings as "free gifts," but he had no hesitation in accepting the most expensive presents in return.[49] Claude Lorrain was equally shrewd: "Or ce que est pire," wrote Cardinal Leopold de Medici's agent in 1662 about the possibility of buying a picture by him, "c'est qu'il faudra le payer largement car il ne fixe un prix qu'aux gens de médiocre condition."[50] But in fact even by Mancini's date it is probable that such aristocratic largesse was the relic of an earlier age and already in decline. Painting was far more commercialised than these rare instances suggest. "If His Highness wants to be served well and quickly," wrote the Mantuan agent in Rome to a ducal chancellor, "he must, indeed it is indispensable that he should, send some money here to give as a deposit to these painters. They have let it be clearly understood that they will only work for those who give them money [in advance]; otherwise it will be quite impossible to get anything good from them."[51] And against the example of a Claude we must record the uncompromising rigidity with which Guercino enforced his own practice of changing a certain sum for every figure painted: "As my ordinary price for each figure is 125 ducats," he wrote to one of his most enthusiastic patrons, "and as Your Excellency has restricted Yourself to 80 ducats, you will have just a bit more than half of one figure."[52]

The type of patronage so far considered had done little more than modify the practice of earlier centuries: a client in direct touch with the artist; clear instructions as to size and, probably, subject; a well-established and recognised relationship. . . .

Notes

1. Passeri, p. 293. For an enthusiastic contemporary account of art patronage—as of everything else under the Barberini—see the Abate Lancellotti's *L'Hoggidì* first published in Venice in 1627 and often reprinted.

2. Letter from Mr. Coke of 8 October 1620—Hervey, p. 183.

3. Ameyden, *Relatione della città di Roma 1642*—MS. 5001 in Biblioteca Casanatense, Rome. Piety, says the author, diminished under Urban VIII because of the excessive length of the papacy "non per colpa alcuna del Prencipe, ma che la nascita del Pontificato elettivo, et ecclesiastico ricerca mutazione più spesso, acciò molti possono godere de gli onori, e dignità ecclesiastiche, ricerche, e cariche della corte."

4. Quoted by Felici, p. 321.

5. Passeri, p. 27.

6. Ibid., pp. 44 and 132.

7. Panciroli, p. 800, quoted by Ortolani.

8. See many references in Pascoli—I, p. 93, and II, pp. 119, 332, 417, 435, etc.

9. Montalto, p. 295, for the important evidence of Alessandro Vasalli, a painter who

testified on Mola's behalf in his troubles with Prince Pamfili: "Io so che quando una persona di qualche professione è arrollato tra la famiglia de" Principi e tra Virtuosi de Principi con assegnamento di pane sono obbligati a preferir qualche Pnpe o Prnpessa per ogni loro operazione, ma però pagandoglieli le sue opere quello che vagliono e perciò non è obbligato a servire quel Pnpe con la sua Professione, senza una mercede, o salario, ma come ho detto deve preferire quel Pnpe ad ogni altro per il tenor dela loro professione e questo lo so perché così ne gli insegna la ragion naturale e per haverlo anco sentito dire tra Pittori in ordine alla Professione. . . ."

10. Pascoli, II, p. 211—Cardinal Pio sent his protégé Giovanni Bonati to Florence, Bologna, Modena, Parma, Milan and Venice; ibid., II, p. 302—Cardinal Rospigliosi sent Lodovico Gimignani to Venice.

11. The appointment of Gio. Gasparo Baldoini "per nostro pittore" by Cardinal Maurizio di Savoia—Baudi di Vesme, 1932, p. 23.

12. Incisa della Rocchetta, 1924, p. 70.

13. Pascoli, I, p. 93.

14. For the Duke of Bracciano's reluctance to let Pietro Mulier leave Rome see Pascoli, I, p. 180. Pier Francesco Mola and Guglielmo Cortese had to get special permission to leave Valmontone for a few days when they were employed there by Prince Pamfili—Montalto, p. 288.

15. Passeri, p. 141.

16. Ibid., p. 374.

17. See unpublished life of Trevisani by Pascoli in Biblioteca Augusta, Perugia, MS. 1383 and Battisti, 1953.

18. See later, p. 22 ff., for Salvator Rosa and p. 23 note 3 for Benedetto Luti. Paolo Girolamo Piola "amante di sua libertà" wanted to avoid living in the palace of his fellow Genoese patron Marchese Pallavicini when he came to Rome in 1690 and "benchè a gran difficoltà" he got permission to reside elsewhere—Soprani, II, p. 185.

19. Cardinal Flavio Chigi gave Mario de' Fiori a monthly allowance of 30 scudi—Golzio, 1939, p. 267.

20. In relation to Claude see Röthlisberger, 1958.

21. See, for instance, the terms laid down for Saverio Savini in Gubbio in 1608 published by Gualandi, IV, p. 60; or for Mario Minnitti in Augusta (Sicily) in 1617, published by Giuseppe Agnello.

22. Thus in his frescoes for the church of S. Antonino in Piacenza in 1624 Camillo Gavasetti was given the subject by the SS. i Deputati "con libertà al medes.o Pittore d'inventare ed ampliare con prospettive, chori d'Angioli, Sibille, Profeti e come meglio li parerà secondo l'arte e pratica di perito Maestro"—Gualandi, I, p. 91. In 1682 Sebastiano Ricci was required by the Confraternità di S. Giovanni Battista Decollato in Bologna to paint "La Decolatione di S. Gio. Battista con figure et altre conforme richiede il rappresentare detta decolatione"—von Derschau, 1916, pp. 168–9.

23. Ruffo, p. 109.

24. Montalto, p. 290. There is also an undated letter from a certain Vincenzo Armanni (I, p. 215) to Camillo Pamfili with suggestions for the decoration of his villa at Valmontone.

25. The artist was Andrea Camassei—see the receipt published by A. Bertolotti (Artisti bolognesi . . . , pp. 161–2). In this connection it would be extraordinarily interesting to find the contracts for such masterpieces of restraint as Guido Reni's and Poussin's treatments of the Massacre of the Innocents.

26. The significance of this has been pointed out by Friedlaender, p. 105.

27. Letter of 3 February 1690—Bottari, VI, p. 147.

28. Luzio, p. 292.

29. Bellori, 1942, p. 117.

30. Letter from the Savoy Resident in Rome, Onorato Gini, in 1666, summarised by Claretta, 1885, p. 516: "ma prima patto apposto dal Cortona era ch'egli non voleva indursi a far ver una proposta [as regards subject], allegando che non avevane fatta alcuna in tutta la vita e che 'questo sarebbe un non mai volere il quadro.'"

31. Pascoli, I, p. 84.

32. Costello, p. 278.

33. The contract has been published by Friedlaender, p. 302.

34. See later, Chapter 3, p. 70, note 2.

35. Pollak, 1913, p. 26. Letter from Lanfranco in Naples dated 14 July 1640. "In tela il disegno" must certainly mean that the general composition would be sketched in on the canvas. We know that this was a regular practice of Lanfranco's—Costello, p. 274.

36. L. Grassi published in 1957 what he claimed to be a series of *modelli* by Pietro da Cortona for the ceiling of the galleria in the Palazzo Doria-Pamfili, but these have not won general acceptance—see Briganti, 1962, p. 251. Nor is the so-called *bozzetto* for the Barberini Salone, kept in the palace, at all convincing. On the other hand, Professor Waterhouse has pointed out to me the existence of a *modello* by Camassei, *Saints Peter and Paul baptising in the Mammertine prison*, once belonging to the Barberini and now in the Pinacoteca Vaticana—No. 820, formerly 539 m. A number of *modelli* by Andrea Sacchi are also recorded. One of these, for an altarpiece in the Capuchin church in Rome, recently passed through a London gallery (Colnaghi's, May-June 1961, No. 2) and is now in the collection of Mr. Denis Mahon.

37. Wittkower, 1958, p. 218.

38. Golzio, 1933–4, pp. 301–2.

39. Tacchi-Venturi, 1935, p. 147.

40. Pascoli, I, pp. 59, 61 and 132; II, pp. 390 and 395.

41. Many examples of different kinds of payment could be given here. In 1639 Francesco Albani was given an exceptionally high proportion of the total sum as *caparra*—450 out of a 1000 *lire* (Gualandi, I, p. 19). More typical is the case of Pier Francesco Mola who for his frescoes at Valmontone was to be given 300 *scudi* immediately and the remaining 1000 in stages as he worked (Montalto, p. 287); or of Ciro Ferri who was given 50 *scudi* as *caparra* and promised 180 more on completion of an altarpiece in Cortona for Annibale Laparelli (Gualandi, IV, p. 117).

42. "è solito che si paghi a tutti i pittori il telaro, imprimitura, et oltremare . . ."—letter from Berlingero Gessi to Don Cesare Leopardi d'Osimo, dated 10 July 1647, published by Gualandi, I, p. 40. And again: ". . . Sappia che questo è lo stile che si pratica con ogni minimo pittore, cioè consegnarli la tela impresa, e qualche denaro anticipato . . ."—letter from Carlo Quarismini to Conte Ventura Carrara, dated 11 July 1696, in Bottari, V, p. 186.

43. In 1633 Camassei agreed in his contract with Urban VIII (see p. 10, note 1) to pay himself for "tela colore e azzurri"; in 1639 Bonifazio Gozadini promised to supply Albani with the canvas and necessary ultramarine for his altarpiece in the Chiesa de' Servi in Bologna (Luzio, p. 48); in 1657 Prince Pamfili agreed to pay for "il bianco macinato, pennelli, e coccioli smaltini, terra verde, verdetti, lacche fine, e pavonazzo di sole et azzurro oltramare" to be used by Pier Francesco Mola in his frescoes at Valmontone, while the artist was to pay for the remaining colours, paper, etc. (Montalto, p. 287).

44. For instance Camillo Gavasetti agreed in 1624 to use "colori de' più fini" for his frescoes in Piacenza—Gualandi, I, p. 91.

45. Montalto, pp. 287 and 289.

46. See letters from Mattia Preti and Artemisia Gentileschi—Ruffo, pp. 239 and 48.

47. Mancini, I, p. 140.

48. Luzio, p. 48.

49. Faldi, 1957, pp. 278–95.

50. Letter from Jacopo Salviati to Cardinal Leopoldo de' Medici, dated 22 July 1662, published by Ferdinand Boyer, 1931, p. 238.

51. Letter from Fabrizio Arragona, Mantuan agent in Rome, to a ducal chancellor, dated 9 October 1621, published by Luzio, p. 295.

52. Letter from Guercino to Don Antonio Ruffo, dated 25 September 1649, published by V. Ruffo, p. 97.

6

A Matter of Taste: The Monumental and Exotic in the Qianlong Reign

Harold L. Kahn

Between the middle of the 17th century and the end of the 18th century—a period of 150 years—three great rulers dominated most of the known political world. They were not Louis XIV, Catherine the Great, or George III. Rather, they were the Kangxi emperor (r. 1662–1723), his son, the Yongzheng emperor (r. 1723–1736), and his grandson, the subject of this essay, the Qianlong emperor (1736–1796). They were members of an ethnic minority, the Manchus, from the forests and plains of northeast Asia, who had conquered China in 1644 and created the last dynasty to rule the Chinese people. These three men stood astride the Chinese world order, governed more people than anyone had before in history, created the second greatest land empire of all time—a realm that eventually reached the Pamirs on the west, Vietnam in the south, Mongolia, Korea, and the Russian frontier in the north, and in total area was more than 600,000 square miles larger than the People's Republic of China today. They taxed the most voluminous cotton industry in the world, the most fecund rice crop, the richest silk, tea, and porcelain industries. They administered the world's largest bureaucracy (roughly 20,000 civil appointees in the last decades of the Qianlong reign) dwarfing in size Louis' little court at Versailles; they marched their armies into the great northern deserts and at one point (1792–93) across the Himalayas (a feat not

From *The Elegant Brush: Chinese Painting under the Qianlong Emperors, 1735–1795*, eds. Ju-hsi Chou and Claudia Brown, copyright © 1985 Phoenix Art Museum. Reprinted by permission of the author.

duplicated until 1963); and at home they wrote and painted and collected on a scale not equalled before or since.

It was an age of superlatives—the last brilliant epoch of the old Chinese imperial order. It began with the young Kangxi emperor reimposing order on a nation still riven by doubts and factions and the bitter aftertaste of wars of conquest and dynastic succession. As the chorus in the most famous play of the day, *Taohua Shan* (The Peach Blossom Fan), ruefully sang, "Alas, 'tis never easy to decide/Which be the winning, which the losing side."[1] The age ended in the last decade of the 18th century with the Qianlong emperor, supremely confident and too old, proclaiming to George III in an edict, that "The productions of our Empire are manifold, and in great Abundance; nor do we stand in the least Need of the Produce of other Countries."[2]

This was true; the empire was still politically and economically self-sufficient. But now it was wracked internally by widespread rebellion and corruption and beset by a population so great (ca. 300 million) that long familiar social relations and institutions could no longer bear the strain. China was about to come apart at the seams. Lord Macartney, the leader of a British embassy to the court of Qianlong in 1793–94, and much given to nautical metaphor, noted as much: "The Empire of China is an old, crazy, First rate man-of-war, which a fortunate succession of able and vigilant officers has contrived to keep afloat for these one hundred and fifty years past, and to overawe their neighbors merely by her bulk and appearance, but whenever an insufficient man happens to have the command upon deck, adieu to the discipline and safety of the ship. She may perhaps not sink outright; she may drift some time as a wreck, and will then be dashed to pieces on the shore; but she can never be rebuilt on the old bottom."[3]

But in between Kangxi's youthful, iron-fisted reunification of the realm and Qianlong's octogenarian complacency about it, there grew in size, uneven wealth and complexity as diverse a society as China had ever known. It became more monetized than ever before, and the cities, commerce, and literacy grew; it became more minutely divided in the countryside, with landless peasants, household slaves, tenant and sub-tenant farmers, private smallholders, entreprenurial landlords and absentee landlords, peddlers, bandits, demobilized soldiers, tax farmers, and pawnshop owners and usurers all competing with each other for increasingly scarce resources. The ruling classes constructed networks of patronage, literary style, and philosophical outlook in their country houses and metropolitan offices. Professional artists and writers produced family portraits and funeral orations, pinups[4] and hackneyed verse, and a lot of local history for their patrons; other artists, amateurs (by profession), dabbled in the market but made their name by painting and writing for

each other—landscapes of the mind, vernacular novels to be read in the privacy of their homes while they read the Confucian classics and commentaries and imperial decrees in their public hours. Buddhist bonzes and Taoist charlatans, storytellers and music masters, courtesans and female impersonators, jugglers at country fairs and schemers at court made life rich and perplexing and the question of taste daunting.

Stratigraphies of Taste

... The imperial palaces were filled with curios, the highest examples of specialist craft traditions, but beyond and beneath that, the gulf between "fine" and "folk" art was vast. Ordinary people could not afford to see, let alone buy, Art, but in their crafts they left a stratigraphy of taste — shards of functional necessity and private delight, liturgical affirmations and mechanical skills. Their religious talismans and kitchen gods, demon-defying amulets, infants' booties and adults' sandals, acupuncture charts, funerary paraphernalia, pillows, and tools constitute a rich source for an archaeology of popular aesthetics.[5] And when social historians get round to these matters they are certain to show us a world of taste as much bounded by canonical prescription as the sphere of high art; an aesthetic defined in the first instance by use-value but no less decoratively and regionally distinctive for that. The domestic imagination awaits discovery.

Moving up the social ladder, into the academies, country mansions, urban villas and imperial court, individuals and households needed literacy, leisure, land, and money to maintain themselves at the top. These conferred on those who had them membership in High Culture, an accumulation of values and sentiments that permitted gentlemen and some gentlewomen, courtiers, princes, monarchs—even some merchants—to share an aesthetic that they believed was universal, true, and beautiful. Not all of those commercial people, for example, were boors, and among the Yangzhou rich were merchants who were more at home with scholars than with bankers—men of impeccable taste who were cultured gentlefolk in their own right: amateur historians, textual critics, builders of some of the great private libraries in a country with no public ones, Ma Yueguan's, for example, containing perhaps the preeminent collection of rare Song and Yuan books in the eighteenth century.[6] They were patrons of the leading artists and writers in the realm, versifiers, famous hosts. One imagines that Wallace Stevens would have felt at home among them.

Within the mental walls of High Culture was much diversity. Young 17th century gentlemen made something of a cult of individualism. A bare generation removed from the violent world of dynastic war which destroyed so many of their families' fortunes, they lived for the moment

while proclaiming that they created for posterity. . . . This was the age of great eccentric painters, men who withdrew into "a private world of eccentricity, where they were exempted from social and political responsibilities by the traditional Chinese tolerance of erratic behavior."[7] Chinese history is littered with hermits and angry old men.

By the time of the Qianlong reign, however, the cult of individualism had given way to an orgy of conformity. The state no longer looked the other way at radically idiosyncratic behavior; orthodox taste and conduct were much prized and highly rewarded, and eccentricity, still alive at Yangzhou, was much tamed—a popular posture that could even be indulged in by the emperor dressing up as a Taoist sage. . . . Defiance had been routinized, the venom of the Ming-Qing transition and the following years of consolidation largely drawn. The middle decades of the eighteenth century were marked in social manners, intellectual purpose, and artistic practice by notions of orderliness, by a glittering, complacent, sometimes self-indulgent fascination with "order, regularity, and refinement of life," to borrow G.M. Young's apt description of Victorian England.[8] . . .

The Politics of Monumentalism

The emperor on the throne was both part of the high culture he patronized and above it. He had license to be both greater and different: to flaunt monumentality and indulge, if he chose, in the exotic. It was through precisely these two "modes," the universal and the decorative, that the Qianlong emperor created a legacy of taste for unshakeable imperial pomp, massive projects, and occasional displays of what can only be called elephantine delicacy.

It was practically an imperial requirement to awe—to sponsor that which was monumental, solemn, and ceremonial, literally to be bigger than life. The Qianlong emperor was not exceptional in this respect. Universal kingship, after all, embraced the cosmos, and that grandiose posture demanded suprahuman scale in architecture, ritual, and the performance of the manifold roles required of the emperor. Thus the mausolea and palace cities, encyclopaedias and variorum editions, harems and armies of earlier monarchs set the imperial precedent of doing things big. Qianlong, the quintessential inheritor, completed some of these projects, copied others, and started several of his own devising.

The Qianlong emperor understood as well as any who came before him that monumentalism was essentially a political aesthetic. It did not need to please, only to inspire and command—respect, fear, loyalty, belief. It was a public but not popular art, meant to reaffirm hegemonic sov-

ereignty, omnicompetence, imperial legitimacy and the natural, harmonious order of things. These principles were most notably embodied in the architecture that surrounded the Son of Heaven and made him mysterious. The imperial city in Beijing, walls within walls, comprising almost a thousand palaces, pavilions, terraces and courtyards, pleasances and residence halls, recapitulated the spaciousness and symmetry of the cosmos. Within its 723,600 square meters it encompassed all of humankind, both hid and elevated the emperor, and exhausted, sometimes beyond endurance, generations of officials and courtiers who trod the vast spaces between audience halls in service and submission to the state.

Begun in 1406 by the Yongle emperor, third in the Ming line, and continued, expanded and rebuilt (after frequent fires) by many after him, the imperial city was completed by the Qianlong emperor, and much of the palace complex we know today dates from his time. Construction consumed stupendous quantities of treasure and natural resources—fine hardwoods (*nanmu,* the rarest, grew only in the southwest), marble, ceramic tiles, glazes, clays, gold leaf, mortar, as well as legions of craft specialists and corvée laborers. Thus, for example, the 180-ton slab of seamless marble earmarked for a newly installed dragon way (reserved for the emperor alone) in the Ming, took 20,000 men twenty-eight days to haul from the quarries outside of Beijing to the palace over carefully ice-slickened roads, the only manageable means of transporting such an unwieldy burden.[9] And during his sixty-year reign, the Qianlong emperor spent at a minimum, 76,482,967 *taels* (ounces) of silver on his reconstructions and additions. The ability of the treasury to meet such expenses represented merely another face of the political economy of monumentalism.

The imperial custodians of this culture of mass and ritual order might be frivolous or profound, intellectually curious or dull-witted, sentimental or ruthless, but they approved the claustrophobia of universal sovereignty, its high solemn walls, and its mythic purpose. When the Kangxi emperor fingered his harpsichord, when the Qianlong emperor sat for his portrait by Jesuit painters, the while engaging the missionary Benoist in talk of the French and Russian royal succession, they were dabbling, condescending to be dilettantes. What counted were home truths. Universalism was incompatible with cosmopolitanism, which implies not just tolerance but acceptance of the validity of competing claims. Neither Kangxi nor Qianlong in this sense were cosmopolitans. In their institutional roles as patrons and collectors, ritualists, *patresfamilias* to all humankind, as administrators and militarists, they and other emperors preferred or provoked the grand, reiterated gesture. Their eyes and, one suspects, their hearts were firmly fixed in the past . . .

The quantitative *grande geste* was a signature of the Qianlong reign. The emperor of course was capable of temperance, even of ambivalence.

It took him over six years at the beginning of his reign to determine just how he should come down on the matter of important fiscal reforms initiated by his father. He was concerned lest draconian measures against corruption be misinterpreted as the work of a tyrant.[10] He could be cautious to the point of being dilatory, and for one long stretch in the middle years of his reign appears to have refused to name, even secretly, an heir apparent. And as a paragon of filial piety, he was almost insufferably attentive to his aged mother, the dowager. But his taste for grandiosity would out, as his famous, if militarily questionable, "ten glorious campaigns" attested.

These expeditions, the most spectacular of which was a crossing of the Himalayas into Nepal to chastise recalcitrant Gurka tribesmen, served to show the flag and reassert imperial supremacy on the frontiers. They were expensive: The Taiwan campaign in 1787 alone required the shipment of almost one-and-a-half million piculs of rice to the front; the total cost of all ten campaigns exceeded 151 million silver *taels*.[11] They were legendary in scale. Above all they were inspirational, or meant to be. The emperor on a memorial stele compared himself to Tang Taizong, consolidator of the second empire in the seventh century, and then sent off to Paris, via French East Indiamen at Canton, to have his exploits graven on copperplate. By 1784 sets of the engravings were widely distributed throughout the realm, hung in imperial villas, palace buildings, garden pavilions and temples.[12] Long after the reasons for the campaigns were forgotten, buried in massive campaign chronicles, the formal pantomimes of victory, frozen in these heroic tableaux, celebrated the emperor's virtue and accomplishments in the field. The accomplishments, thus ritualized, *became* the triumphs, transcending mere event and historicity.[13] They were his version of the equestrian statue.

It was not as a warrior, however, but as a collector and patron of the arts and letters that the Qianlong emperor excelled as a monumentalist. Himself a writer and painter, he produced more than 42,000 poems, huge volumes of prose writings, massive collections of state papers. He trained from youth as a painter, well-schooled in classical techniques. The results were at best dubious and have been described as "the sort of picture that Queen Victoria might have painted had she been Chinese," though in all fairness he acknowledged his limitations, insisting that he was a mere copyist, a laborer in the august halls of the academy.[14] . . .

The emperor's two most enduring accomplishments in the field of collecting were the compilation of the great Imperial Manuscript Library (*Siku Quanshu*) and the building of the Imperial Palace art collection. The Library was assembled over twelve years, from 1773 to 1785, employed 15,000 copyists, and in the end numbered 3,462 complete works (out of a total of 10,230 inspected) in 36,000 volumes. It was an act of

both purification and glorification, for it consigned to the fire or to Bow-dlerizers 2,262 books deemed inimical to the dynasty, while it established variorum editions of the rest as an apotheosis of the classical and literary tradition.[15] Seven complete manuscript sets were made and housed in seven great treasure houses constructed for that purpose around the realm.

The Imperial Palace art collection, today divided between the hold-ings in Taiwan and Beijing, and equally awesome in its dimensions, was largely the work of the Qianlong emperor. That part of it housed today in Taiwan includes roughly 8,800 paintings and examples of calligraphy, 27,870 pieces of porcelain, 8,369 pieces of jade, numerous ancient bronzes, and countless curios. The Beijing collection, figures for which are un-available, may be larger. Under Qianlong's auspices the unified collection may have been even greater, for since his time it has been periodically devastated by deliberate destruction (at the hands of the British and French in 1860), rebellion (in 1900 during the Boxer uprising), dispersal (after 1911 when the Manchu rump took part of it off to Manchuria), arson (which destroyed at least 1,157 paintings in 1923), and civil war (1945–49).

The Qianlong emperor, who assembled so much of the palace hold-ings, was clearly an avid, and some say reasonably discerning, collector. He had a keener eye and certainly a more grandiose vision than his forbears.[16] His collection would be the *summa* of imperial taste, an act of historical preservation of what was rarest and best; it would also be an affirmation of splendor; most would be best. His chief supplier was a reluctant Korean salt merchant, An Qi, who appears to have been forced to sell his finest scrolls to the court after a humiliating bankruptcy, the result of a promise to fund privately the reconstruction of a city wall.

This tension between throne and merchant over the disposition and ownership of works of art was not exceptional. The eighteenth century was a collector's century and art changed hands often as merchant princes, art dealers and intermediaries, private individuals, artists and statesmen used paintings and curios as media of exchange, payment for debts, col-lateral for loans, marks of invidious social or intellectual accomplish-ment, gifts, bribes, and hoarded wealth.[17] It is tempting, in this respect, to seek a pattern of competition between private (largely merchant) cap-ital and public (bureaucratic) capital—between a commercial bourgeoisie and the imperial court—for the scarce resources of the art market. It might help explain the remarkable drive by the court under Qianlong to collect art quantitatively as well as qualitatively; it might also explain the art dealers' holding back of authentic works in expectation of better prices from the great private collectors.

Commercial capital was accumulated in vast amounts in the eight-eenth century but it was never permitted to create an independent

bourgeoisie, a middle class with different, independent, more influential tastes than the gentry-imperial culture of court and bureaucracy. Merchant wealth was legally unprotected and always vulnerable to predation by the state. Its sumptuary pretensions were no match for the immense fiscal wealth and cultural hegemony of the throne. Competition was uneven; the market was skewed. And if the art dealers now and then made a killing, their profits, like their paintings, remained subject to expropriation by the state. The emperor's claim to the lion's share of the market was primary and assured. An enthusiast, he could indulge his whims and buy up paintings in job lots; a critic, he could force an owner to present a desired piece to the throne as a gift; an autocrat, he could break a merchant to get what he wanted.

Evidence of the emperor's zeal as a collector can be seen on the paintings he examined. He spent much of his energy as an aesthete writing inscriptions and implanting his more than one hundred state and personal seals all over the masterworks in the collection. This has dismayed art historians and critics ever since, yet there is an explanation for his fervor that transcends bad taste. I have argued elsewhere that there were "extra-aesthetic functions of such exercises. It was not so much the royal prerogative as the royal duty to remain at the head of the arts even if, in the process the art was destroyed. The paintings, after all, were the private possessions of the throne; the imperial script and seals were the possessions of the realm. Their appearance was an assertion not only of artistic sensibility (however warped) but of dynastic grandeur. . . . It could only be hoped that the prince and emperor had taste; it had, however, to be expected that they would leave their marks—preferably, as in earlier ages, with discretion—on the treasures that defined the glory of their reign."[18]

Perhaps the most egocentric aspect of the emperor's lust for collection was the collecting of himself. He had a passion for his own portrait and loved to pose in the roles permitted him as patron and exemplar of the arts and taste—as aesthete, scholar, connoisseur, calligrapher and poet. . . . The iconographic extreme, however, was surely achieved in the portrait of the emperor as the Buddha. . . . It is outrageous, no doubt, but curiously empty of sacrilege. It is, really, little more than a cardboard carnival pose, beyond innocence and incapable of solemnity. In fact there is a kind of ponderous, studied humor to many of these little portraits, as if the Jesuit masters who painted them and the emperor who permitted them were determined to share a private, permissible joke while engaged in the too-serious work of imperial aggrandizement.[19]

A final aspect of the Qianlong emperor's penchant for the monumental was the periodic mobilization known as the imperial southern tour of inspection. Ostensibly organized for reasons of state—to show

the crown and inspect water works—it was largely an exercise in self-importance and flattery. The mobilization of resources for such a trip was massive, the logistics complex. A flotilla of barges and boats had to be requisitioned to carry all the palace ladies and attendants who insisted on following in the emperor's train. One such expedition also required 900 camels and 6,000 horses.[20] The emperor might inveigh against extravagance: All those lanterns and awnings and flower boats were vulgar, the fireworks unnecessary, the woodwind and string ensembles impermissible.[21] But no provincial governor or retired grandee would have dared take the Son of Heaven at his word, and the southern tours remained lavish displays of local wealth and overpreparation. The dignity of the throne would be preserved.

Much else was also preserved on these tours. A fortuitous side effect of the emperor's travels was the renovation of a great deal of important architecture, which had to be repaired and refurbished before the imperial eyes could be set upon it, the preservation of much art, and the removal back to the court of local artistic tribute, landscape and garden styles, and whole colonies of artists, scholars and writers who impressed the monarch en route with their works.[22] In fact the tours may be considered to have redressed the aesthetic imbalance between the Yangtze delta culture and the north: They removed the product from the buyers, the market, as it were, from the merchants. What was not acquired as gifts was purchased by the throne. The currency used was silk and the idiom that of rewards conferred: so many bolts of satin for so many scrolls or annotated collections of verse or antique curios.[23] There was much decorum in the transfer of this cultural treasure and much prestige conferred upon the donors, but in the end the throne was enriched because it could not be ignored.

The Limits of Exoticism

Monumentality, then, served as a magnet. It overwhelmed, as it was supposed to and created in the process the very public it was meant to impress. The court's taste for the exotic, on the other hand, seems to have been limited in influence—a private affair between the emperors and the Western world. The seventeenth and eighteenth centuries were the great age of the Jesuits in China, men such as Ricci and Schall and later the remarkable painter Giuseppe Castiglione (Lang Shining, 1688–1766). They were admired by the emperors and used by them, as interpreters and diplomats, engineers, armorers, astronomers, architects, landscape gardeners. They were appendages of a world-embracing court (the Heaven-embracing expectations of the Vatican sadly beside the point) and sources

of incidental knowledge and pleasure. Beijing in the eighteenth century did not ape or adapt their manners or dress as eighth century Changan did the styles and wares of the Turks and Persians at the outer limits of the Tang empire. Europe in the age of Qianlong was still beyond the horizon to all but a few traders, Catholic converts, and courtiers. Many officials attuned themselves to court tastes without assimilating them. They bought the singsongs (clockwork automata) which the Qianlong emperor prized so much and sent them along to Beijing. They earned points, the emperor wound his clocks, and James H. Cox, the purveyor in London and Canton, and his Swiss counterparts in Geneva, made money.[24] The appropriation of Europe in this fashion was almost an exact stylistic equivalent of the decorative fantasies of Chinoiserie which swept Europe in the same century.

The Yongzheng emperor posed for Castiglione in the manner of Versailles . . . , but knew nothing of it. The Qianlong emperor, much taken with the great houses of Europe as he saw them in his Jesuits' books and his mind's eye, built in a corner of his magnificent summer palace, the Yuan Ming Yuan, an entire Italianate chateau complex. It began as a whim; the emperor wished to have a fountain and he commanded his foreigners to build one. Father Castiglione went to Father Benoist, and Father Benoist, something of a hydraulic engineer, made a working model that delighted his patron. As a result the emperor decided to have himself a villa with all the fixings—palace buildings, formal gardens, an aviary, a maze, reflecting pools and, of course, fountains, lots of them. The style was florid rococo, containing "numerous false windows and doors, excessive ornamentation in carved stone, glazed tiles in startling color combinations, imitation shells and rock-work, . . . pyramids, scrolls and foliage, and conspicuous outside staircases. . . ."[25] To relieve the geometric formalisms, the good brothers, having learned something about Chinese landscaping, added native rockeries and vistas, so that the whole must have seemed a perfectly unreal and hence perfect dream world. Virtually everything was destroyed by British and French soldiers and their officers in 1860 at the end of another of those unequal nineteenth century wars.

The whole was an exchange in superficialities. European monarchs constructed Chinese pagodas and pavilions; Chinese rulers built European mansions. European painters imagined fabulous creatures or simply quaint ones and called them Chinese; Chinese artisans, working from European models and designs sent out in the porcelain trade, rendered Europeans fabulous and funny. If few on either side understood the other, a lot of people profited from the trade in China ware, silks, and tea, and a lot of others derived harmless pleasure from their fanciful borrowings.

There was room for the frivolous and self-indulgent in the great

years of the high Qing. After that, pleasure parks and spinnets would not do. Beleagured nineteenth century court officials looked back nostalgically on the Qianlong reign: Power had been sublime, and if taste had sometimes been ridiculous, it didn't really matter. It was after all the expression of a people still in command of native values. Never again in Chinese history would those values and the taste they generated go unchallenged from without.

The Qianlong emperor, like Kangxi and Victoria, lived too long. His improbable durability—he ruled for the equivalent of two biological generations—became, like theirs, his greatest monument. His longevity was much celebrated, for it reaffirmed the gerontological basis of wisdom (though not necessarily of knowledge) in a culture which prized precedent and regularity as the sources of order and refinement. His life became an Age, to which were attached styles, predilections, norms of behavior, schools of thought, prescribed expectations. It became a cultural as well as political reference point, the last time that a unified and universal Chinese world view would make sense and seem to work. Qianlong was the last of the giants.

Notes

1. K'ung Shang-jen, *Peach Blossom Fan* (Berkeley, 1976), p. 30. I am grateful to Dorothy Ko for help in the preparation of this article.

2. Hosea Ballou Morse, *The Chronicles of the East India Company Trading to China, 1635–1834*, vol. II (Oxford, 1927), p. 248; original in *Da Qing Lichao Shilu*, vol. 1435, p. 15b.

3. J.L. Cranmer-Byng, ed., *An Embassy to China, Being the Journal Kept by Lord Macartney During His Embassy to the Emperor Ch'ien-lung, 1793–1794* (London, 1962), pp. 212–213.

4. Professor James Cahill's term for 17th and 18th century "generalized, semi-erotic portraits of beautiful women." Personal communication, Berkeley, Ca., April 1985.

5. See Tseng Yu-ho Ecke, *Chinese Folk Art* (Honolulu, 1977). For an absorbing discussion of "folk aesthetic" as a problem in popular consciousness, see Ann S. Anagnost, "The Beginning and End of an Emperor: A Counterrepresentation of the State," *Modern China*, vol. 11, no. 2 (April 1985), pp. 149–150.

6. Ho Ping-ti, "Salt Merchants," p. 157.

7. James Cahill, *Chinese Painting* (Skira, 1960), p. 169, referring to the brilliant individualists of the Ming-Qing transition, Kun Can, Hongren, Gong Xian, Zhu Da, Daoji.

8. G.M. Young, *Portrait of an Age* (London, 1957), pp. 5, 7.

9. For these details, see the exquisite and exhaustive new study by Yu Zhuoyun, chief comp., *Palaces of the Forbidden City* (New York, London, 1984), pp. 20–22, 32; for the Qianlong-era expenses, pp. 326–327.

10. Madeleine Zelin, *The Magistrate's Tael* (Berkeley, 1984), pp. 266–277.

11. Zhuang Jifa, *Qing Gaozong Shiquan Wugong Yanjiu* (Taipei, 1982), p. 494.

12. Nie Chongzheng, "Qianlong pingding Junbu, Huibu zhantu'he Qingdai di tongbanhua," *Wenwu* (1980, no. 4), pp. 63–64.

13. This theme is suggestively developed in Sabine MacCormack, *Art and Ceremony in Late Antiquity* (Berkeley, 1981), p. 271.

14. The quote is from Michael Sullivan, "The Ch'ing Scholar-Painters and their World," *The Arts of the Ch'ing Dynasty* (London, 1965), p. 10; the self-appraisal in Sugimura Yuzo, *Ken-ryū Kōtei* (Tokyo, 1961), p. 27.

15. The major work on the intellectual politics of the Imperial Manuscript Library project is R. Kent Guy, "The Scholar and the State in Late Imperial China" (Unpublished Ph.D. thesis, Harvard University, 1980).

16. The Kangxi emperor, by comparison, was an indifferent collector, prey to unscrupulous dealers who appear to have pawned off second-rate scrolls on the court. Thus Gao Shiqi, one of the preeminent late seventeenth century dealers, devised a category in his catalogue, "For presentation to the Emperor," comprised almost exclusively of inexpensive forgeries. See James Cahill, "Collecting Painting in China," *Arts Magazine* (April 1963), p. 70, for this and the following on An Qi.

17. See James Cahill, "Types of Artist-Patron Transactions in Chinese Painting" (Unpublished ms, 1983; cited with permission); also the same author's "Collecting," pp. 66–72.

18. Harold L. Kahn, *Monarchy in the Emperor's Eyes* (Cambridge, 1971), p. 136.

19. The unsigned portraits outnumber the signed ones, by Castiglione, but conform in style and content with them.

20. Gao Jin, comp., *Nanxun Shengdian* (Preface, 1771), *juan* 114:7b.

21. *Nanxun Shengdian*, 2:2b,3a; 3:4b; 4:1a, 85:2a.

22. On the transfer of architectural and interior decoration styles, see Chen Congzhou, *Yangzhou Yuanlin* (Shanghai, 1983), p. 4; on the borrowing of garden styles, Wu Sheng, *Yuan Ming Yuan* (Beijing, 1957), p. 4.

23. *Nanxun Shengdian*, 68:3b,4a,6a; 69:2b; 70:2b; 71:4b.

24. David S. Landes, in his magnificent *Revolution in Time* (Cambridge, 1983), pp. 48–52, 268, may exaggerate somewhat the mandarinate's (as distinct from the court's) fascination with clocks, but his discussion is nevertheless the most critically acute— and most charming—that I have seen.

25. Carroll Brown Malone, *History of the Peking Summer Palaces Under the Ch'ing Dynasty* (Urbana, 1934), p. 141. Cf. also Wang, *Yuan Ming Yuan*, and "Yuan Ming Yuan di guoqu, xianzai he weilai," in *Qinghau Daxue Jiangu Gongcheng Xi* (1979) for details on size and staff of the entire summer palace complex.

7

Katherine Dreier: Art Patron with a Social Vision

Carole Gold Calo

Katherine S. Dreier was an independent, assertive, idealistic woman who for more than twenty-five years zealously dedicated herself to a single cause. Strongly desiring social reform, she was convinced that modern art could be a powerful vehicle for changing and improving society. Her didacticism and her proselytizing spirit were unique in America at a time when patrons and galleries that nurtured an intellectual and artistic elite were losing impetus and when the promotion of international progressive modern art was out of keeping with the new conservatism of the post–World War I era.[1] Although her full vision was never entirely realized, Katherine Dreier did play a significant role in the history of modernism in America.

Dreier had been avidly involved in social reform before she began promoting modern art. From a family long engaged in humanitarian projects, as a young woman she exhibited deep social interest. At twenty-one years old, she became treasurer of the German Home for Recreation of Women and Children, an organization cofounded by her mother and intended to be a refuge for needy women and children. When she was twenty-six years old, she helped found and became the first president of the Little Italy Neighborhood House in South Brooklyn. During that same year she was one of the original directors of the Manhattan Trade School for Girls. After studying social conditions in Argentina, she wrote a book entitled *Five Months in the Argentine: From a Woman's Point of View.*

This essay is adapted from a lecture given at the conference *Breakthroughs: Women in the Visual Arts*, Skidmore College, 1988.

Committed to social reform, Dreier believed in the power of education to effect social change through moral and spiritual transformation.

At the same time, Katherine Dreier was becoming increasingly interested in modern art. She had been studying painting since the age of twelve, and experienced a kind of epiphany in Paris in 1907–8 when introduced to avant-garde developments through the circle of Gertrude Stein. Her visit to the Cologne Sonderbund Exhibition in 1912 only served to deepen her enthusiasm for contemporary art. Another influential exhibition was, of course, the 1913 Armory Show held in New York in which the works of modern European and American artists were exhibited together, exposing the American public to modern art for the first time.

Dreier's first significant attempt to combine her social concerns and her interest in art involved the Cooperative Mural Workshops, which she helped found in 1914 and continued to work with as its president until 1917. The workshops involved a democraticized notion of art. A cooperative venture among artists inspired by the medieval guild system, the workshops encouraged a breaking down of the distinctions between fine and applied art, artist and artisan. According to Dreier:

> Art is a spiritual quality taking its physical form in balance, line, color and will exercise its influence wherever it exists regardless of the outward expression whether it is architecture, sculpture, or painting, or in the humbler form of a utensil.[2]

Clearly influenced by the arts and crafts movement at the end of the nineteenth century, in particular by the ideas of John Ruskin and William Morris, Dreier believed that art could help bring about moral and hence social change. Most important, and crucial to her later activities in promoting modern art, she wanted to help make art a more integral part of everyday life. The artists of the Cooperative Mural Workshops produced primarily murals for private homes and public buildings. Additionally, it was planned that architects, landscape architects, sculptors, potters, cabinet makers, tilers, weavers, and interior decorators would become part of the workshop, although this extensive a group never became an actuality.

Dreier, however, would attempt to realize her vision for art most energetically and effectively through the Société Anonyme, which she cofounded in 1920 with Marcel Duchamp, the leading Dadaist. She had by this time come to the conclusion that it was modern art, specifically abstract painting and sculpture, that would truly communicate the new ideas of this new epoch. Influenced perhaps by the activities of Der Sturm in Germany,[3] The Société Anonyme, Inc., despite its sarcastic title, which literally translates to Incorporated, Inc., was dedicated to the positive

action of promoting modern artists and helping the public understand and appreciate their work. As Dreier stated in a lecture given at the Albright Knox Gallery, Buffalo, in 1927:

> The Société Anonyme . . . took for its aim the educational point of view, which is the promotion of the study of the prophetic in Art, based on the fundamental principles, and renders aid to conserve the vigor and vitality of the new expression of beauty in the Art of to-day.[4]

Dreier and Duchamp asserted that it would be the artist rather than the historian who would be the chronicler of the new age. Both were dedicated to showing, as Duchamp phrased it, "the international aspect" by exhibiting, and after 1923 collecting, the work of artists from every possible country, even if lesser known. For example, the Société Anonyme was among the first to exhibit Kandinsky, Brancusi, and Kurt Schwitters. They also took a chance exhibiting unknowns, for example; the German painter Campendonk; women artists like Marthe Donas from Belgium; and Americans like Patrick Henry Bruce and John Covert.

Although it might at first seem that this undertaking was but a continuation of the efforts of "the grandfather of modern art in America," Alfred Stieglitz in his Gallery 291 from 1908 to 1917, major differences are apparent. Stieglitz's crusade was aimed at an intellectual and artistic elite; Dreier's efforts were clearly populist. Dreier believed strongly that art is universal and has something to say to everyone. She hoped through traveling exhibitions and lectures sponsored by the Société Anonyme to develop a public that would incorporate modern art into its life.

Dreier envisioned the Société Anonyme as an organization like no other. Although various galleries, like the Bourgeois, the Modern, Daniel, Carroll, and Washington Square had actively promoted art during the teens, they were primarily commercial ventures that lost momentum by 1920. Duchamp and Dreier were adamant in providing a noncommercial setting for their exhibitions. As a collector on her own behalf and for the Société Anonyme, Dreier was more didactic and proselytizing than most collectors, among them Walter Arensberg, who played an important role as a patron of modern art and as a host to Dada-type "evenings" in which the avant-garde, including Dreier and Duchamp, participated. Arensberg bought those works that intrigued him with their complexity, whereas Dreier was more deliberate in attempting to trace the various progressive tendencies in both European and American art. Perhaps closest to Dreier and the Société Anonyme was Gallatin's Gallery of Living Art installed at New York University. Here, however, the Société Anonyme set the precedent, for Gallatin's Gallery did not open until 1927 and was not so committed to public outreach.

Dreier, who became the driving force behind the organization after 1921, conceived of the Société Anonyme as a "Museum of Modern Art," and defined it in this way: "We are not a Museum along the old lines of collecting and conserving Art, but are acting as a circulating museum where the movements in contemporary art may be studied."[5] Dreier criticized traditional museums for mostly showing art of the "old masters" and for not being concerned with educating the public. It was their derogatory attitude that preserved the notion of art as precious object to be appreciated by a select few that compelled Dreier to explore a new approach. At the time the Société Anonyme was established, there was no museum devoted exclusively to promoting progressive art. The Museum of Modern Art would not be inaugurated until 1929, with the Whitney Museum following in 1931, and the Guggenheim's Museum of Non-Objective Art established in 1939. Even after the opening of the Museum of Modern Art, which Dreier complained had stolen the Société Anonyme's subtitle, she condemned the director for not taking chances on bright new international talent and instead safely presenting established modern masters.

Throughout the years in her lectures and writings, Katherine Dreier made clear her views on the importance of art. She asserted that only those civilizations rooted in art achieved greatness. She claimed that art is a necessity for our spiritual well-being. Her philosophy, liberally sprinkled with theosophical ideas and affected by the spiritual orientation of Kandinsky, embraced the superiority of a spiritual realm of the "Finer Forces," which had been obscured by the materialism of American society in particular. Madame Blatavsky, the founder of theosophy, asserted that the twentieth century was the era in which the original clairvoyant state would be regained and the brotherhood of man would live in peace and harmony. Dreier agreed:

> The chief mission of art is to lift us out of ourselves—so that by losing all sence [sic] of this material world it may refresh the spirit to once again take up its burden of work. It has this great renewing quality. To those who know how to receive—it gives and they become revitalized.[6]

Furthermore, Dreier contended, art can actually affect society in a broader manner:

> If what we seek is that intangeable something which art brings to ALL SEEKERS—an ENLARGED VISION WHICH FREES and INVIGORATES the SPIRIT then not only is our own leisure well spent—but what we bring to the community will invigorate its Spirit and through this invigoration bring added zest to life.[7]

Art then could provide basic principles which Dreier hoped "a government

will build on . . . which shall express justice for each individual." But it would be the artist who would play the most influential role in this occurrence. In agreement with Theosophist writer Rudolf Steiner, Dreier believed that certain individuals with a "spiritual" or "seeing eye" could communicate their experience of the spiritual state through thought-pictures. Kandinsky would actually lay down specifications for such a spiritual art with line, shape, and color as a vehicle for apprehending the nontangible. It is not surprising that abstract, nonrepresentational art would be viewed as most effective for expressing abstract ideas. Dreier herself fervently hoped that through a new public understanding of and appreciation for modern art, "we can learn to establish a balance that will help to right the wrongs which exist."[8]

Dreier's utopian vision was distinctive in that it centered primarily on the home and the integration of art into the daily lives of the public, for "unless we have Art in the home, we cannot learn its language."[9] Even in the earliest exhibition space of the Société Anonyme in a Manhattan brownstone at 19 East Forty-seventh Street, she attempted to create an intimate setting for art by limiting the number of works placed in the small rooms. The effect was debunked, however, by the Dada pranks of Duchamp and Man Ray in framing the paintings with lace doilies. More effective were the rooms Dreier designed for the blockbuster exhibition presented by the Société Anonyme at the Brooklyn Museum, which opened on 18 November 1926, the largest showing of modern art since the 1913 Armory Show. As part of the installation, Dreier arranged four rooms to simulate the environment of the middle-class home to emphasize her points that art should be integrated into daily life and even modern art can complement traditional decor. The four rooms were furnished as a living room, a dining room, a library, and a bedroom with two additional hallways created in passageways between the rooms. The furniture was chosen from a popular department store, Abraham and Strauss, and was meant to reflect the taste of the times. The works of art were arranged in an informal fashion and were mostly smaller in scale than works hung elsewhere in the main galleries. Dreier's point was that people must live with modern art to benefit fully from its "message."

But it was her own home, affectionately dubbed "The Haven," that Dreier found to be the best example of her vision for incorporating art into everyday life. She had been personally collecting the work of European and American modernists since 1917, and had purchased work for the Société Anonyme beginning in 1923. Her collection had from the beginning been displayed in different living spaces, existing side by side with the more conventional "late Victorian" furnishings.

Dreier had long wanted to establish a permanent museum for the Société Anonyme, but the dream had not materialized. In 1935, she

wrote to William Hekking, former director of the Albright Knox Gallery, Buffalo, about her idea for a permanent home for the Société Anonyme's and her own private collection. For the first time she used the term *country museum*. After learning of Hekking's unexpected resignation from his position at the Los Angeles Museum of Art, Dreier proposed that he head the project. Her idea was to turn her estate in West Redding, Connecticut, into a museum that she believed would be "one of the most important new Ideas in the Museum World."[10]

Museums were mostly situated in the city. Dreier noted the tendency for Americans to move to suburban and rural areas in which cultural stimulation was lacking. She intended her museum to serve the half million residents of the county of Fairfield and the grammar schools, high schools, colleges, and universities in the area. The aim was clearly educational and intended to help people improve the quality of their lives. In a brief outline of the aims of the country museum, it is stated that the museum would strive to help the public better fill their leisure time by aiding in the cultivation of discriminative tastes in the arts. The ultimate goal would be to enlarge community horizons.

The country museum would not be just another art institution. Set in a lovely park, the house would display both Dreier's and the Société Anonyme's permanent collections of modern art with changing exhibitions installed in an adjacent cottage. Lectures, classes, music and dance performances, exhibits related to the community, a library, and a monthly bulletin would truly make this an educational and cultural center in the country. And for Dreier, it would be "SOMETHING COME TO LIFE— A COUNTRY MUSEUM THROBBING WITH CHARACTER AND PERSONALITY, not a vest pocket edition of a city museum.[11]

Dreier continually emphasized the importance of the home as the best environment for the enjoyment of art. In a letter to Hekking written 30 August 1940 she suggested an additional fund-raising strategy:

> There is one point you may have made to Mr. Light and Mr. Warren . . . and that is that the value of a Country Museum like the Haven is that it demonstrates the relation of Art to the Home. As Mrs. Wiley, the architect's wife said, "What makes this so unusual is that you have shown how Art can become one in the home. I have seen many homes—and I have seen many private collections in homes—but they were always assembled in one large room like a museum room—but with you they have become part of the home."[12]

Yet unfortunately, Katherine Dreier's vision for her museum was never realized. Because of fund-raising failures perhaps attributable to the conservatism of the pre–World War II years and because of her own failing health, in 1941 she decided to house the extensive collection of the Société Anonyme and part of her own private collection in the Yale University

Art Gallery. Already anticipating the failure of her dream to materialize, she mused in a letter to Frederick Hartt, 11 July 1939: "Somehow someone will come along someday and present a plan whereby art is brought to the people in such a form that it sinks below the surface and acts as it should like a cake of yeast—fermenting—until the individual is richer for it."[13] Yet Katherine Dreier, in her tireless efforts to promote modern art, did bring art to the people in a manner unprecedented in America during the first half of the century. Her vision, while somewhat naïve and idealistic, does make us think about what role art might and should play in our lives and in our society.

Notes

1. Ruth L. Bohan, *The Société Anonyme's Brooklyn Exhibition: Katherine Dreier and Modernism in America* (Michigan: University of Michigan Press, 1982), p. 28.

2. Katherine Dreier, "Cooperative Mural Workshops," Société Anonyme Papers, Beinecke Library, Yale University, p. 2.

3. Robert Herbert et al., *Catalogue Raisonné of the Collection of the Société Anonyme* (New Haven: Yale University Press), p. 3.

4. Katherine Dreier, Lecture on Modern Art, Albright Knox Gallery, Buffalo (28 February, 1927) Société Anonyme Papers, Beinecke Library, Yale University, p. 6.

5. Katherine Dreier, Draft of Letter to be sent to Private Girls' Schools and Clubs, Société Anonyme Papers, Beinecke Library, Yale University.

6. Katherine Dreier, "Should Art be a Part of Everyday Life?" Société Anonyme Papers, Beinecke Library, Yale University, p. 30.

7. Katherine Dreier, "Does Self-Expression in Art Create Art Appreciation?" Lecture delivered at the Academy of Allied Arts, November 28, 1933, Société Anonyme Papers, p. 2.

8. "Should Art be a Part of Everyday Life?", p. 7.

9. Katherine Dreier, "Modern Art," *Buffalo Arts Journal* 9 (April 1927): 269.

10. Letter from Katherine Dreier to William Hekking, 8 February 1940, Société Anonyme Papers, Beinecke Library, Yale University.

11. Ibid., p. 4.

12. Société Anonyme Papers, Beinecke Library, Yale University.

13. Société Anonyme Papers, Beinecke Library, Yale University.

8

The Structure
of the SoHo Art Market

Charles R. Simpson

New York City is the nation's center for the exchange of art—over one billion dollars worth of all types of art changes hands there annually.[1] Since the early 1960s, when the dominant position of abstract expressionism began to give way to more culturally accessible movements, contemporary American art has broadened its audience and its share of the art market. SoHo is now the principal location for New York's trade in contemporary art, a trade which provides the economic basis of the SoHo community and gives it its cultural orientation.

SoHo developed with the general boom in the art market. Art sales accelerated through the 1960s and peaked in 1968, 1973, and 1979. This expansive atmosphere prompted many uptown gallery staffers to enter the market as entrepreneurs themselves, relying initially upon artists and buyers they could take from their old employers and setting up their new businesses in SoHo where commercial rents were far less than those in the uptown gallery area. At the same time, the established art galleries responded to the art boom by seeking additional space to display and store the larger pieces being produced by contemporary artists. As these galleries expanded their trade, they separated their operations into old master, print, and contemporary divisions, moving the modern works to the cheaper and more available spaces found in SoHo.

The growth of SoHo as an art market has been extraordinary. During most of the 1960s there was no gallery presence at all in SoHo. In 1968

a Park Avenue art dealer, Richard L. Feigen, established the first dealer presence in SoHo when he opened a warehouse to service his uptown showrooms. The same year Paula Cooper, a young woman with experience as a staffer in uptown galleries, saw in SoHo an emerging artist community that could benefit from the local presence of galleries. She established SoHo's first gallery in the fall of 1968 in order to have more ready access to the work of SoHo artists and to take advantage of the large spaces and cheap overhead that her fledgling venture required.

By May of 1975, less than five years after the growing number of residential artists had secured zoning legalization for their combined living and working quarters, eighty-four galleries for painting and sculpture existed in SoHo. In addition, many other galleries and shops had opened to sell photographs, craft articles, and prints. SoHo, by this time known as "downtown" to art buyers, had more galleries handling contemporary art than did the established Madison Avenue district, which had only seventy-four.[2] By 1976 the most influential of the city's art dealers, Leo Castelli, had moved all of his business in contemporary art to his SoHo annex, a business that grossed over $2.5 million a year from the sale of paintings and sculpture.[3] In 1976 New York's first and only auction house devoted exclusively to the work of contemporary American artists, Auction 393, opened on West Broadway, the spine of SoHo's gallery system.

These commercial galleries, managed by professional dealers, constitute the economic foundations of the SoHo community.

SoHo Spaces and the Change in the Presentation of Art

The ambience of SoHo galleries is in striking contrast to that prevailing in the uptown galleries, especially those which sell old masters. In the latter's salesrooms the atmosphere is funereal. The prospective client is ushered across carpeted floors to a viewing room or alcove. This is draped in dark velvet against the distractions of light and noise and features a viewing easel sitting in the isolation of a spotlight. Assistants bring in the "masters," one at a time, and withdraw to leave the client and the empathetic dealer to a moment of communion.

SoHo galleries try to make art viewing an unintimidating secular experience. The dealers, who tend to be younger, have exchanged their three-piece suits for cowboy shirts and casual slacks. The public is encouraged to look around unchallenged and without ostentatious supervision. These dealers try not to crowd their audience, a new clientele for art which includes well-salaried professionals and business people. The dealers try to give the clients time and space to develop their art per-

ception and to establish a comfortable familiarity with new movements without forcing them to articulate their interests to a salesperson prematurely. The appeal of the art itself and the enthusiasm of the other gallery visitors are given time to persuade the potential client. As one leading SoHo dealer explained, "There's a new market down here. There may be a shortage of good artists, but there's no shortage of buyers. Now doctors are buying art. Madison Avenue was a Cardin suit situation, but down here I'm more accessible—just a guy in jeans. I have no back room where assistants bring in a piece and put it on a stand. Here, I leave the client alone to wander around; the client feels freer."[4] While subsequent steps of the selling process are very deliberately directed by the dealer, it is the initial feeling of self-guided and self-determining viewing that softly draws visitors into their first venture in art acquisition. While finding their bearings in the field, these new clients from business and the professions are status sensitive and have not yet developed confidence in their own tastes, so the intelligent dealer does not confront them with anything as disquieting as a purchase decision. . . .

Gallery clients feel a step closer to the artists' studios than they did shopping on more elegant Fifty-seventh Street. Sidewalks strewn with packing crates for art, frame and canvas stores here and there, people carrying art portfolios—these impress upon the buyer that in SoHo one has arrived at the source of contemporary art, the creative furnace. . . .

The crowds which sustain the excitement of Saturday gallery-hopping in SoHo find the area an attractive setting for their dining and entertainment. Restaurants, bars, cabarets, and discotheques have sprung up to meet this demand, spreading from block to block along with the expanding gallery core. SoHo wandering has become an alternative to museum going, an alternative with a social dimension. The urbane audiences who have come to associate themselves with the contemporary in fine art, dance, experimental video, jazz and electronic music, can all satisfy their tastes in SoHo. The art galleries, which often lend their spaces to performing artists, encourage the public to interact with art through exhibits of kinetic "touch" sculpture and holographic light installations. The SoHo marketplace for fine art has evolved into an amusement park and performance area where many degrees of identification with art are possible and where the expression of this identification as a life-style can find support.

The Print Market

Most individuals in the casual Saturday crowds do not buy original oils or sculpture. Many are content to demonstrate their sensitivity to visual imagery by selecting SoHo as their place to drink and dine and by carrying

cameras. They do, however, sustain SoHo's emerging restaurant and boutique trades.

The first level of art buyers consists of young, college-educated people starting marriages, households, and professional careers. When they can afford art, they often want what is contemporary. They buy original prints and drawings from several print outlets which flourish in proximity to the galleries which carry paintings and sculpture. Well-known artists occasionally produce work for the print market when their other sales are slow. Some SoHo artists have developed careers as lithographers and serigraphers, typically producing one new work a month in their own recognizable style. The works are usually printed in a limited series of 100 or 150, then hand numbered and signed by the artist. Artists who market this work through a gallery can earn a regular income of up to a thousand dollars per design. Galleries that subcontract the reproduction sell each copy for $50 to $200, raising the price as a design sells enough to become scarce.

Print galleries, especially those which carry less expensive art posters advertising exhibitions, find they are able to make as much profit from the framing—an integral part of the buyer's expression of taste— as from the sale of the art itself, so they have their own frame shops which they refer to as "ateliers."[5] Most print buyers are interested in decorating their apartments with art work. Back in their college days, they were among the half-million students who annually take introductory art history courses, and they probably bought their first cardboard-matted reproductions at the college bookstore.[6] Their college introduction gave them notions of what art is, notions with status connotations opposed to popular taste, ideas which have since deterred them from using furniture-store pseudoart or sentimental kitsch as decorative devices. With signed, gallery-purchased prints or drawings they can make an aesthetic identification with the dynamic trends in society as well as bolster their own claims to individuality. If their careers mature at a faster rate than their expenses, they may celebrate their achievements by graduating into the market of one-of-a-kind originals.

While these modest investors in the decorative arts usually restrict themselves to the poster, print, and drawing market, some of them are introduced in this way to art speculation. Print galleries keep listings of the latest prices at which their stock items have changed hands. The original plates are guaranteed to have been destroyed to insure the rarity of the prints, which differentiates them from a mass culture item and makes speculation in them possible. Print investors can share the excitement of the bigger art speculators, but with less risk. Their conversation in the print galleries often echoes that of stockbrokers at lunch: "I could have bought a Buffet in Paris in 1960 for $100, and now look at

the price." Buffet prints and reproductions are now a standard item in the office decor of dentists and certified public accountants in New York.

The print market closely approaches a mass market, reaching out into the suburbs with chain store operations such as the Circle Gallery system. Such systems maintain their flagship galleries in SoHo for prestige and send their salesmen on tours to place art in the furniture stores of elite suburban shopping malls. One SoHo print and poster gallery has a large part of the General Services Administration's business and supplies federal offices with wall decorations. Only the highest government officials have access to the loan services provided by the National Gallery of Art in Washington. Lesser officials make do with prints and reproductions.[7]

The Studio as Salesroom

Artists and collectors have a tradition which legitimates the buyer's going directly into the artist's studio to look over and consider the purchase of works of art. This arrangement enables the collector to buy art at a lower price, because the dealer, who often marks up the price of a work by 100 percent to cover his commission and costs, is eliminated. Lacking the institutional props of the gallery to certify worth, moreover, artists are inclined to accept less for a work sold in the studio. . . .

Buyers who visit studios are not merely hunting for bargains. They seek to test their perceptions as collectors in the studio, where their taste is unmediated by the commentary of a dealer. In buying art at its source, the collector is claiming to be able to discern the significant work in a crowd of uncertified and unknown pieces. Only the experienced collector has the self-assurance to rummage through studios making judgments. Being among the first to discover, show, and promote a work which later wins significant recognition is the special satisfaction sought by such collectors. Each studio visit, they hope, will unearth an unknown and undervalued masterpiece.

Selling out of the studio is most commonly a tactic of the younger artists who as yet lack outlets in professional galleries. Such artists choose to sacrifice some of the privacy of their working and living arrangements in order to display both their art and themselves to the collector. The collector is allowed "backstage" and extended the privileges of supposed familiarity.[8] Extending Erving Goffman's terminology to cover long-term relations rather than situational interactions, admittance backstage allows the collector to play the role of "teammate" as well as that of "audience." This provides important gratification and legitimation for the collector.

Familiarity, however superficial, with the lives of artists can signify the collector's acceptance into the art world as a fellow cognoscente. Artists with a history of minor critical recognition but without affiliation with a major gallery may cultivate a group of buyers whom they see in their studios on a regular basis. These buyers become friends and promoters of the artist and, while settling on their purchases, extend their visits into afternoons of conversation about the art world. Having been granted social entrée, these buyers have been known to remain patient and loyal for many years while the artist struggles to establish himself.

Even buyers who shop for their art in galleries are not immune to curiosity about the human origins of the art they contemplate. Dealers are quick in making use of this interest. They report that they frequently help sell a client on a program of serious art collecting by introducing the client to one of the gallery's artists during a visit to his SoHo loft. Artists are expected to be on call for such performances. The glimpse of art in-the-making and the acquaintance of a well-known artist often seem to confirm the client's decision to invest in art. The studio visit, managed by an astute dealer, can become a collector's rite of passage into the art world.[9] . . .

The New Art Buyers

The majority of the new art buyers who support the proliferation of SoHo galleries for contemporary painting and sculpture are people with earned wealth who are new to the pleasures of living with art. They are surgeons, corporate lawyers, and upper-management personnel—individuals who have succeeded within meritocratic institutions. They use contemporary art to express their own achievement of status. In collecting avant-garde art, they find their new sense of social position reflected in works which stress innovation rather than tradition and a radically individual, rather than a collective, social vision. The new middle-class buyers approach art from what they feel is a plateau in their prosperous careers. Art collecting poses a new adventure in self-expression for them, one legitimized by the recent trend toward corporate sponsorship of new art.

Art, commissioned or chosen from the storage racks of artists in SoHo and elsewhere, has become integral to the environment of corporate offices as well as government buildings. Such art is being used to differentiate the white-collar worker from lower prestige strata, and to humanize the image of bankers and executives. This trend has its origins in the decision of the Chase Manhattan Bank to build a new office tower

in lower Manhattan in the late 1950s. The bank's chairman, David Rocke-
feller, said of this move, "We wanted to get away from the marble columns
outside banks and from the image that bankers are glassy-eyed, hard
hearted people. So we first determined that we would have a contemporary
type of architecture." The severity of the building "called for paintings
and sculpture that could be thought of as built-in, decorative features."[10]

Chase embarked on a program of art purchasing, largely of contem-
porary pieces, not only for the new Chase Manhattan Plaza but for its
eight overseas offices. More than 4,700 works of art by 1,550 artists have
been purchased in this one corporate program alone. Said Rockefeller,
"The collection [was intended to] provide enjoyment and education for
members of our staff and visitors and serve as a means to give encour-
agement to contemporary artists.[11] Other corporations have developed
similar programs, especially for their headquarters.

For those who are conscious of rank, it is gratifying to work with
an original painting on the wall, quite apart from the artistic experience
itself (which, presumably, is not considered overly distracting). The gra-
dations of artistic "value," from less expensive prints to more expensive
paintings, from smaller to larger, are easily reconcilable with the other
symbols of achievement and position which orient the inhabitants of the
office world. However, art in the office is not merely a parallel symbol
system communicating degrees of power; art adds a dimension to the
humanity of the office occupant. It says, "Here is a person aware of values
greater than, or at least in addition to, mere money." It is for this reason
that, while their art collections are often among corporations' better in-
vestments (Chase's collection has doubled in value), corporate spokes-
persons are at great pains not to discuss their collections in profit-making
terms.[12] In the bureaucracy, art has come to represent a system of hu-
manistic prestige parallel to more obvious gradations in rank and income.

The new art buyers are not moved by the ownership history of a
piece, a consideration which enthralls collectors of old masters. The latter
authenticate their purchases and add relish to their ownership with re-
search into the twists of a marketing pedigree. Dealers report that new
buyers seek to develop an interest and knowledge in a still developing
line of art. Some go to great lengths to anticipate new trends. Hanns
Sohm, a middle-aged German dentist, for example, collects the eviden-
tiary material documenting "happenings," performance art, and other
creative events—scripts, posters, programs, photos, and newspaper re-
views.[13] He has succeeded in making collectible items from such inten-
tionally uncollectible and untradeable occurences as Charlotte Moor-
man's avant-garde festivals and the events of Red Grooms.

Recently, new collectors have been buying the highly technological
art of the new realists, which includes deliberately ordinary urban scene

painting, popular-culture iconography, and large, Byzantine-sized por-
traits of anonymous individuals. This work is accessible and appealing
to those whose success allows them to objectify the familiar objects of
contemporary culture, but whose lack of alternative historical awareness
blunts the critical edge of their response.

The buyer of contemporary avant-garde art acquires assurance more
quickly and moves in a more volatile and more exciting market than does
the collector of old masters. In the contemporary-art market, prices and
reputations can change quickly. It takes time for artists to achieve rec-
ognition as "twentieth-century masters," and that recognition seldom
comes during the artist's lifetime. Critics and art historians are more
concerned with the formation of a consensus about the prestige of art
accumulated from the past. They resist certifying the most recent work.
The largest-selling college art-history textbook devotes a mere 26 illus-
trations out of 1,268 to post–World War II art.[14] With less critical opinion
to guide the buyer and, in the case of a still productive artist, with the
number of works in the market still uncertain, it is difficult for a con-
sensus to emerge about the merit or fair price of an avant-garde piece.
A buyer with strong enough convictions to take risks can more easily
become influential as a collector of contemporary, rather than of older,
art.

The buyer of contemporary art finds much cheaper prices than would
a collector of old masters. Realizing that the experience of acquisition
excites the buyer as much as looking at his purchases, SoHo dealers try
to keep the young collector in the lower price brackets so that, within a
given budget, the buyer can multiply his purchase anticipations and
completions. The newer the artist, the cheaper the prices, so new collectors
are steered toward less established artists. Explained one dealer,

> In one case a twenty-six year old real estate investor came to me wanting
> a program of collecting. He told me he had $10,000 to spend. I told him to
> buy five pieces, one each at two month intervals. This sustains the excite-
> ment of constantly buying. He took six weeks to buy his first work, at $1,500.
> He waited two months more, and decided he really wanted a piece that cost
> $8,000. I tried to dissuade him, and told him to think about it. Then I let
> him go ahead. It was such a good piece that I knew I could sell it and get
> his money back if he got into trouble.

Knowledge of the contemporary art market is acquired by a collector
in the pleasant context of studio and gallery visits, viewing, discussing,
and gossiping with artists and dealers. For the executive or the psychoan-
alyst, acquiring this knowledge can be a relaxing break from work. More-
over, there is always the chance that a piece will undergo a spectacular
appreciation in value. Jackson Pollock's painting *Lavender Mist*, for ex-

ample, set the record for rapid appreciation when the National Gallery of Art paid over $2 million for it in 1976. Pollack had died in 1956, and the following year his widow sold the painting, on the installment plan, to a collector for a mere $1,500; it was this same collector who made the sale to the National Gallery.[15]

The contemporary-art market is the most volatile of art markets because public institutions and major private buyers invest far less in it than they do in the old masters. The highest prices for paintings are paid by public institutions which are, for the most part, inhibited from acquiring avant-garde or disturbingly modern pieces.[16] The highest price paid to date for a work of art was "about $8 million." It was paid in 1974 by the National Gallery of Art in Washington for a painting by seventeenth-century French artist Georges de La Tour. Second- and third-highest prices also went for old masters, $5 to 6 million paid by the same museum for a Leonardo da Vinci in 1967 and $5.5 million paid by the Metropolitan Museum of Art for a Velazquez in 1970.[17]

Wealthy entrepreneurs in industry and finance constitute the most prestigious collectors in the private realm. They collect for reasons of largess, tax advantage, and personal expansiveness, usually lending their acquisitions for public display and eventually donating them to museums. Dr. Armand Hammer, chairman of Occidental Petroleum Company, for example, recently established a record price for a Rembrandt painting, paying $3.28 million against the bidding competition of J. Paul Getty. Hammer donated this piece to the Los Angeles County Museum, which he supports in a rivalry with the Norton Simon Museum of Art in Pasadena.[18]

These wealthiest collectors avoid the contemporary market entirely, thus leaving it unstabilized by the commitment of the largest private collections. They consider it to be too speculative and lacking in critical certification. Norton Simon, owner of the world's largest private art collection, spends up to $20 million each year acquiring art for holdings worth "several hundred million dollars."[19] But Simon will not buy in the avant-garde market. Neither would Getty, a collector who was willing to pay $1 million for a Rubens painting.[20] The principal motivation for investing in the prestigious old master market is not a desire to profit through speculation but the wish to demonstrate that one has financially and, one hopes, culturally arrived. These investors certainly have no inclination to express symbolic attachment to a disruptive and historically scornful avant-garde.

There is, along with the main body of middle-class buyers of contemporary art, a handful of prestigious buyers who contribute some buoyancy and glamour to that market. SoHo's largest dealer reports that less than ten of his buyers are in that class.[21] Collectors like taxi-fleet owner

Robert Scull would be included in that category. For the most part, however, American collectors remain reluctant to commit large amounts of money to the work of living American artists. Many of the largest buyers are European industrialists secure enough in their aristocratic credentials to be able to indulge a taste for the American avant-garde. Of these, Dr. Giuseppe Panza DiBiumo may invest the most. He is a Milanese industrialist living in a 225-year-old ancestral home of fifty rooms. One entire room is devoted to the display of the work of a SoHo minimal sculptor, another to a constructionist. DiBiumo and the German industrialist Professor Peter Ludwig "have the most outstanding collections in the world today of American art," according to SoHo dealer Leo Castelli.[22] With its many European clients and branches of European galleries, SoHo has become an international art market.

The inadequate backing by art historians and the major collectors and museums, subjects contemporary art to the ups and downs of the general economy. After a boom in both stock market prices and art prices through 1973, both markets began to slip, and by the spring of 1975, dealers faced hard times. Popularly styled, if not priced, galleries were openly discounting their art up to 60 percent in department-store-like sales. Dealers generally believe that the art market follows a curve that is parallel to the stock market. When the nervous small collector runs short of cash and tries to unload his art, the market is further depressed and the efforts of the dealers to hold the posted prices fail. In the spring of 1976, one year after the slump, a general economic recovery had carried the art market with it, and Parke-Bernet reported sales up 40 percent over the previous year.[23] Record-high interest rates and inflation in 1979 sent speculators into art in such numbers that the auction houses were setting record prices for major works in all categories.

Conclusion

Artists and buyers meet in a stratified SoHo art market, where the ideology of unrestricted creativity must come to terms with the aesthetic outlook of a new art buyer—the successful manager, business person, and professional—the upper tier of the middle class. This buyer is unlike the economic aristocrats who use art to link themselves with older aristocracies of birth through the display and public donation of certified masterworks.

The new art buyer seeks an aesthetic experience and market product which meets five requirements. (1) It must affirm that the investor's awareness is superior to that of those individuals presumed to be immersed in mass culture. It should obviously depart from older art tra-

ditions and folk or ethnic themes, none of which have much meaning to the arriviste perspective. (2) It must be avant-garde in style, and so be expressive of the optimism and orientation toward the future that accompanies occupational achievement. (3) The art should be a contemporary product, so that its acquisition may offer the buyer a socially involving adventure in the art world, an adventure which provides a break from the routinized aspects of a successful career. (4) The art should be conceptually accessible in nonart terms, as having a pleasing design, as enhancing domestic or office decor, or as having familiarity of imagery. The conception must not, of course, be embarrassingly obscure so as to leave its owner with little to say about it. It may be bold in form, even graphic, but in a way that is so clearly artistic that it is secure against the label of "bad taste." (5) The art should be presented by its seller in an interpretive context that convincingly depicts its aesthetic and economic advantages.

Because the contemporary art market is comparatively deficient in the reputational investment of art historians, in the showcasing activity and prestige lending of major museums, and in the acquisitional interests of the largest collectors, the tastes of the new art buyers have a dominant influence on SoHo art.

Notes

1. Mayor's Committee on Cultural Policy, *Report of the Mayor's Committee on Cultural Policy*, October 15, 1974 (New York), p. 8. This report outlines the economic benefits of art and culture to the city's economy, and indicates that two-thirds of the galleries exclusively devoted to painting and sculpture and belonging to the nationwide Art Dealers Association of America are located in New York City.

2. *Gallery Guide*, the monthly listing of exhibits and the most ubiquitous advertising vehicle for the art market, showed these numbers in its May 1975 issue (vol. 5, no. 7). Published by Art Now, Inc., Kenilworth, New Jersey.

3. Richard Blodgett, "Making the Buyer Beg—And Other Tricks of the Art Trade," *New York Times*, October 26, 1975, sec. D, p. 1.

4. All quotations of SoHo residents are from my interview files. Subjects will be identified in the text by relevant personal and occupational characteristics where appropriate. They will remain otherwise anonymous. Subsequent quotations from interviews with SoHo residents will not be footnoted.

5. One SoHo poster outlet has a staff of twenty-two, more than that of any gallery for original art, and sales in the "low seven-figures." They have two branch operations. They started selling frames when they discovered that the posters cost far less than the frames. Rita Reif, "Art Posters Drawing in Profits," *New York Times*, May 24, 1976, p. 45.

6. "Market Research Report on Introductory Art History," March 15, 1972, prepared for McGraw-Hill College Textbook Division, cited in Patricia Hill, "Art History Textbooks: The Hidden Persuaders," *Art Forum* 16 (June 1976): 58–61.

7. The General Services Administration is the world's largest builder and landlord and since the administration of John Kennedy has sought to buy and commission art by

American artists for the decoration of its buildings. The program languished until 1972, however, when a decision was made to utilize ½ of 1 percent of the construction costs to commission art for display in or around these buildings. By fiscal 1975 the GSA was spending over $2 million a year for art, much of it outdoor sculpture, a most recent example being Claes Oldenburg's *Batcolumn*, a 100-foot red baseball bat of metal grid construction for the Social Security Administration building in Chicago. See Jo Ann Lewis, "A Modern Medici for Public Art," *Art News* 76, no. 4 (April 1977): 37–40.

8. See Erving Goffman, *The Presentation of Self in Everyday Life* (Garden City, N.Y.: Doubleday, 1959) for a discussion of the uses of entrée to the backstage for performers cultivating an audience.

9. One buyer, hoping to acquire work by Roy Lichtenstein, the well-known American pop artist, described a ceremony in which, after seven years of waiting and of buying lesser works from that artist's SoHo dealer, Leo Castelli, he was finally initiated as a major collector. The ceremony took place at Lichtenstein's studio in the Hamptons. Having brought the buyer into the presence of the artist he admired, Castelli asked him to choose from among several recently completed works. A selection of other than the "right" work for his particular collection, the client was led to believe, would mean failure in his test as a collector. The client carefully made his selection. After a pause, the artist and the dealer beamed their approval. Closing the $50,000 to $70,000 deal was then merely the psychological denouement of a moment of social solidarity. Blodgett, "Making the Buyer Beg."

10. Leonard Sloane, "Collecting at the Chase: Fine Art Stands for Good Business," *Art News* 78, no. 5 (May 1979): 49.

11. Ibid.

12. Robert Metz, "The Corporation as Art Patron: A Growth Stock," *Art News*, 78, no. 5 (May 1979): 40–47.

13. Sohm was featured in December 1975 at the Institute for Art and Urban Resources, 108 Leonard Street, N.Y.C., in their series on contemporary art collectors.

14. Hill, "Art History Textbooks."

15. Grace Glueck, "Art People," *New York Times*, October 15, 1975, sec. C., p. 18.

16. When the Australian National Gallery in Canberra bought the American abstract expressionist artist Willem de Kooning's *Woman V* in 1974, and Jackson Pollock's *Blue Poles* for $2 million in 1972, there was criticism on both aesthetic and economic grounds. Critics felt such purchases were a mistake in priorities when people were starving around the world. *New York Times*, October 14, 1974, p. 16.

 Closer to home, the General Services Administration expenditures for art dropped nearly 90 percent between fiscal 1976 and 1977 as a result of public pressure on Congress, and of Congress on the GSA, against George Sugerman's *People Sculpture* selected for Baltimore. See Lewis, "A Modern Medici."

17. Grace Glueck, "Art People," *New York Times*, May 14, 1974, p. 32.

18. Judith Cummings, "Record $3.28 Million paid for a Rembrandt," *New York Times*, Sept. 30, 1976.

19. Grace Glueck, "Art People," *New York Times*, Mary 14, 1974, p. 32.

20. D'Lynn Waldron, "A Billionaire Makes His Dream Come True," *New York Times*, November 3, 1974, p. 11.

21. Blodgett, "Making the Buyer Beg."

22. Ibid.

23. Carol Lawson, "The Bulls Return to the Art Market," *New York Times*, March 28, 1976, p. 33.

9

Art and Freedom in Quattrocento Florence

Frederick Hartt

. . . The present study is an attempt to examine one of [the] classic styles, unpredictable in origin and meteoric in development—the early Florentine Renaissance—in terms of the continued crisis which in the first three decades of the Quattrocento confronted the entire population of Florence, including the artists, with a series of difficult and fundamental decisions, on whose outcome depends to a surprising degree the whole subsequent development of Renaissance and post-Renaissance art and culture. . . .

. . . [B]y common consent, the earliest fully Renaissance work of art seems not to have been a painting but a statue, the *St. Mark* (Fig. 9-1) carved in marble by Donatello for the niche of the *Arte dei Linaiuoli e Rigattieri* on the exterior of the grain exchange of Orsanmichele in Florence, between 1411 and 1413,[1] ten years or so before the newly discovered earliest work of Masaccio.[2] Although the surrounding niche was carried out by the minor masters Perfetto di Giovanni and Albizo di Pietro still working in a florid Gothic tradition, it emphasizes by contrast the revolutionary nature of Donatello's statue. The dignity and intensity of the characterization, the forcefulness of the pose and glance, the sense of the three-dimensional structure of the body under the drapery masses, all proclaim this statue as a direct ancestor of the powerful figures of Masaccio. H. W. Janson has written that this statue "is in all essentials

From *Essays in Honor of Karl Lehmann*, ed. Lucy Freeman Sandler, copyright © 1971 by The Institute of Fine Arts, New York University. Reprinted by permission of the publisher.

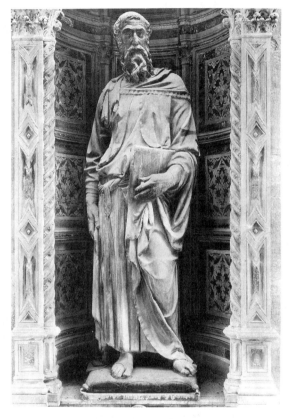

Figure 9-1. Donatello, *St. Mark*, Orsanmichele, Florence. Photo by Alinari/Art Resource.

without a source. An achievement of the highest originality, it represents what might almost be called a 'mutation' among works of art."[3]

But what of painting meanwhile, surely the leading art in the Florentine Trecento? One may look in vain for a painting datable in the second decade of the fifteenth century which shows a glimmer of the new style. The Florentine pictorial *botteghe* were numerous and active, turning out fantastic quantities of panels and frescoes in a number of personal styles, often highly accomplished and sometimes of the greatest beauty, all generally comprised under the loose category of the late Gothic. Gherardo Starnina, Lorenzo Monaco, Niccolò di Pietro Gerini and Lorenzo de Niccolò, Mariotto de Nardo, Francesco d'Antonio, Rossello di Jacopo Franchi, the Master of the Bambino Vispo, the Master of 1417, the young Giovanni dal Ponte, Bicci di Lorenzo, continue working as if Donatello had never

created the *St. Mark*. Traditional or visionary architectural settings, Giottesque or fantastic landscape backgrounds, Trecentesque or International Gothic figures and drapery, constitute the repertory of these busy and frequently prosperous practitioners who were not to be deflected from their course until the arrival of Gentile da Fabriano in Florence in 1421 and the first revelations of Masaccio soon thereafter. But when these two formidable revolutionaries had disappeared from the Florentine stage, few of the older artists still alive showed any real recognition of the new possibilities open to the art of painting, and systematically exploited by the sculptors.[4] Not until the first dated works of Fra Angelico, Fra Filippo, and Paolo Uccello in the 1430's does painting begin to occupy in earnest the position Gentile and Masaccio had conquered for it, and not until the middle of the century were the last defenders of the late Gothic subdued in Florence.

The sudden mutation, as Janson puts it, that brought forth Donatello's *St. Mark* is no harder to understand than the astonishing discrepancy between the nature, aims and values of sculpture and painting in the early Quattrocento, a divergence about which no deterministic theory can inform us. In trying to account for this extraordinary split I became conscious of a guilelessly simple fact: all the surviving paintings of the 1420's in Florence were altarpieces and frescoes for the interiors of churches or of chapels within churches, or else street tabernacles, and all were intended for the aesthetic enhancement of worship or the provocation of solitary prayer and meditation. All the statues, and there was a host of them, were destined for the exteriors of two churches of predominantly civic character, and all were addressed to the imagination of the man in the street. Some, in fact, were placed hardly above the street level. To put it simply, in the second decade of the Quattrocento, Florentine painting was characteristically other-wordly, even mystical, dominated by the churches and even the monasteries (Lorenzo Monaco, the leading master, was a monk in the important Camaldolite monastery of Sta. Maria degli Angeli), while contemporary sculpture was increasingly humanistic and naturalistic, dominated by the guilds or by committees chosen by and responsible to the guilds. Between 1399 and 1427 no less than thirty-two over-lifesize male figures made their appearance in the center of Florence, eighteen on the Cathedral and fourteen at Orsanmichele, representing the work not only of the great masters Donatello and Ghiberti, and somewhat lesser artists such as Nanni de Banco and Nanni de Bartolo, but relatively standardized practitioners like Niccolò de Pietro Lamberti and Bernardo Ciuffagni.[5]

The saints at Orsanmichele and the prophets and evangelists at the Duomo share a surprising degree of emotional intensity, resulting in expressions which range from the deeper inner reflection of Ghiberti's *St.*

Matthew . . . to the violent excitement of Donatello's *St. Mark* . . . , with his disordered locks, rolling eyes, quivering features and writhing beard. The poses vary from the classic balance of Ghiberti and Nanni de Banco, reminiscent of Greek and Roman philosopher portraits . . . , to the extreme turbulence of Donatello's prophets from the Cathedral campanile. But in each case the ideal person is depicted less as a static monument to sanctity, with uncommunicative features in the manner of Gothic cathedral sculpture, than as subject to a psychic state provoked partly by what he perceives in the outer world, partly by his inner contemplation of himself. These saints and prophets seem aware of opposition from without, against which they must summon up the full resources of their personalities. Sometimes they show confidence in their strength, sometimes alarm at the suspicion of their inadequacy, but always their reactions to the world they confront betray a profound realization of the conflicting forces among which they must struggle to maintain an equilibrium. The fact that these unprecedented characterizations owe their existence to their role as protectors and defenders of the guilds suggests a brief reconsideration of the familiar features of the Florentine state.

At the opening of the fifteenth century, Florence was an artisan republic exclusively controlled by the guilds. There were seven major guilds and a constantly varying number of minor ones, some of whom— the so-called *arti median* or median guilds—were eventually admitted on sufferance to the major group.[6] Through the Guelph party, the only legal party in Florence, traditionally but by no means consistently the supporter of the Papacy, the guilds controlled the government of the republic.[7] The great humanistic scholars and writers of the early Quattrocento were guild members and so, by no means incidentally, were all the artists. The painters belonged to the guild of physicians and pharmacists,[8] the sculptors, insofar as they were metal workers, to the guild of silk merchants; both were counted among the all-powerful major guilds. Sculptors who began and continued as stonecutters were relegated to the secondary guild of the masters of stone and wood.

In a series of brilliant studies, summed up and expanded in an indispensable book,[9] Professor Hans Baron has shown in detail how this guild republic, long vigorously maintained through the passing dictatorships, famines, pestilences, financial crashes and revolts of the Trecento, had found itself around the year 1400 engaged in a life and death struggle with a wholly different polity which threatened to engulf it—the fast-growing, militant duchy of Milan. Florentine writers, Baron has shown, spare no words to express their hatred of the Milanese tyranny (whose people are not "citizens but subjects born in subjection")[10] nor their fear of conquest and consequent loss of liberty. By intrigue and threat quite as often as by actual force, the first Duke of Milan, Giangaleazzo Visconti,

had absorbed almost all of northern Italy save for the republic of Venice, and had even surrounded Florence to the south controlling the road to Rome, his overlordship being acknowledged by Siena and Perugia, while his control over Lucca and Pisa cut off Florence from the sea and threatened to strangle her trade. The historic liberties of the Florentine people seemed to be doomed. In Baron's words, "From then on the Florentine Republic, protected no longer by membership in any league except for her alliance with Bologna, and enjoying that protection only as long as Bologna could avoid surrender, was left alone to confront one of those challenges of history in which a nation, facing eclipse or regeneration, has to prove its worth in a fight for survival."[11]

At this very moment, Baron pointed out, an apologist for the Duke, the humanist Saviozzo da Siena, compared Giangaleazzo to Caesar encamped on the Rubicon before his march to Rome, and prayed for the success of the enterprise in the name of every true Italian, while deprecating the "detestable seed, enemy of quietude and peacefulness which they call liberty."[12] Poised on the edge of the precipice, Florence was saved by a wholly unexpected event. In the hot summer of 1402 the plague, that faithful companion of Renaissance armies, swept through Lombardy and on September 3 carried off Giangaleazzo himself at the Florentine frontier. In a matter of months the jerry-built Milanese empire had collapsed and Florence again found herself at the head of a league of city-republics in defense of liberty.

His death had been, so people believed, heralded by the appearance of a comet.[13] The Florentines in their joy repeated the verses from Psalm 124. 7–8:

> . . . the snare is broken, and we are escaped. Our help is in the name of the Lord, who made heaven and earth.[14]

But, divine intervention or no, the Florentines had been ready for the battle. As Scipione Ammirato puts it, "This, at the end of twelve years, which now with suspect peace, now with dubious truce, now with open war had tormented the Florentine Republic, was the end of Gio. Galeazzo Visconti first Duke of Milan, most powerful prince, who had no impediment to the occupation of Italy greater than the Florentines: whence both then and later it was noted with great wonder, how against such forces could resist a single people without a seaport, without discipline of war, not helped by the ruggedness of mountains, nor by the width of rivers, but only by the industry of men and the readiness of money."[15] In the words of the great Chancellor of later date, Lionardo Bruni, "What greater thing could this commonwealth accomplish, or in what better way prove that the *virtus* of her forebears was still alive, than by her own efforts

and resources to liberate the whole of Italy from the threat of servitude?"[16] And it is indeed *virtus*, which might be defined not so much as virtue but as the kind of courage, resolution, character in short, that makes a man a man, which flashes from the eyes of these statues of marble and bronze. In Gregorio Dati's history of Florence, written soon after 1406, we read that "to be conquered and become subject, this never seemed to the Florentines to be a possibility, for their minds are so alien and adverse to such an idea that they could not bring themselves to accept it in any of their thoughts ... a heart that is free and sure of itself never fails to bring it about that some way and remedy is found."[17]

But in only a few years a new menace appeared, from the south this time, in the person of King Ladislaus of Naples. Burning to become a new Caesar, Ladislaus received the submission of papal Rome and all of Umbria in 1408 and in 1409 took Cortona, on the borders of the Florentine state. In 1413 he sacked Rome and stood master of central and southern Italy, poised in 1414 for the attempt to surround Florence to the north, and supported incidentally by the same insidious voices who had prepared the propaganda for Giangaleazzo.[18] To these the aged Niccolò da Uzzano answered "that for the protection of our liberty we must shoulder anything,"[19] and the Florentines in the early summer of 1414 refused any compromise with the tyrant. And then, as before, Florence was saved by a portentous occurrence, accompanied this time by earthquakes. In August, struck by a violent fever and raving that Florence should be destroyed, Ladislaus died in Naples. His empire collapsed, and his sister and successor, Giovanna, instantly sent envoys to make peace with the Florentines.[20] Oddly enough, Ammirato records no feeling on the part of the Florentines that they had again profited by divine intervention.

Florence then embarked upon a period of unexampled prosperity. During the ensuing peace, Poggio Bracciolini found the city "full of every opulence and the citizens universally most abundant with money,"[21] and Cavalcanti wrote, "Our city was on the height of worldly power and its citizens with their sails filled with proud fortune."[22] And then it started all over again. Defeated in the north and defeated in the south by the intervention of sudden death, the menace of absolutism sprang up anew in the north, in the person of Filippo Maria Visconti,[23] who followed in the steps of his ambitious father, Giangaleazzo. The non-aggression pact signed by the Florentines in 1420, apprehensive over their prosperity and disregarding the advice of Niccolò da Uzzano and Gino Capponi, was all Filippo Maria needed to absorb Genoa on the one hand and Brescia on the other. When in 1423 he seized Forlì, on the borders of the Florentine Republic, the time had come to act. The Florentines prepared for war, and although the Pope tried to mediate, they sent defiant messages to both Rome and Milan.

Then, alas, ensued a succession of military disasters, culminating in the fantastic rout of the Florentine forces at Zagonara in July 1424, and the destruction of a whole army at Valdilamone in February 1425. Despite universal dismay in Florence, the Republic pulled itself together and faced the threat of invasion. Antonio de Meglio, the herald of the Republic, wrote inflammatory verses. "Still we are Florentines, free Tuscans, Italy's image and light. Let there arise that rightful scorn which always in the past emerged among us when the time was ripe; do not wait any longer, for in procrastination lies the real danger."[24]

The tremendous challenge before the Florentines and their response in terms of *virtus* to the danger threatening their *libertas* goes far to illuminate the new content we have observed in the race of heroes that populate the center of the city. The fourteen (originally thirteen) niches at Orsanmichele had been assigned to the various guilds since 1339, with only two statues completed before 1400. But immediately after the collapse of Giangaleazzo in 1402 began the march of the statues. In 1406 the council of the Republic quickened the pace by giving the guilds ten years to fulfill their obligations at Orsanmichele.[25] After a lapse of nearly two generations the statues were suddenly recognized as a civic responsibility. Work went on through the war with Ladislaus, the ensuing peace, and into the thick of the second Visconti crisis. In fact, after the long series was nearly done in 1425, the very year of the worst Florentine defeat, the powerful wool manufacturers' guild, the *Arte della Lana*, seems to have considered its Trecento statue of St. Stephen lamentably out of date, and commissioned Ghiberti to replace it with a more modern one in bronze at about ten times the cost of marble.[26] And from 1416 to 1427 the same guild, which had charge of all work for the Cathedral of Florence, commissioned from Donatello and Nanni di Bartolo the great series of prophet statues for the Campanile.[27] Right through the three crises the ancient guild of *Calimala*, the dealers and refiners of imported cloth, once but no longer more powerful than the *Arte della Lana*, financed Ghiberti's great doors for the Baptistery. This even though in 1427 the immense cost of the warfare, which had emptied the Florentine treasury and devastated its banking system, had necessitated as we shall see new and radically altered forms of taxation. In this imposing series of sculptured images, unprecedented in any of the Italian cities since antiquity, paralleled outside of Italy only by the vast sculptural programs of the Gothic cathedrals of France, England and Germany, the new classic style makes its appearance, mingled at first in Ghiberti with strong Gothic elements, but forthright from the start in Donatello and Nanni de Banco in its commitment to a new conception of the freedom and dignity of the human person.

However seductive, contentions concerning the relations between stylistic development and political history are notoriously difficult to demonstrate beyond a certain point. Luckily, however, we possess several examples in which the character of specific works, involving notable stylistic innovations, seems bound up with events involving the cherished *libertas*. In 1401, with Giangaleazzo breathing down their necks, the officials of the committee for the Baptistery of the guild of *Calimala* proclaimed a competition for the enormous and extremely expensive second set of doors for the Baptistery, to be executed in gilded bronze. Not until 1402, perhaps not until after the death of Giangaleazzo in September, and possibly even in March 1403 (our style), was the competition judged and Ghiberti declared the winner.[28] But the figures to be included were doubtless laid down by *Calimala*, and the story is therefore told in more or less the same way by both the principal contestants. The fact that the deliverance of Isaac from death by divine intervention was chosen out of all possible Old Testament subjects seems worthy of note. In both Ghiberti's and Brunelleschi's reliefs the knife is about to be plunged into Isaac's throat when the angel appears. Of course the sacrifice of Isaac traditionally prefigures that of Christ, but the desired salvation of the state from mortal danger is by no means impossible as a secondary meaning. In Ghiberti's relief the feeling of unexpected deliverance is marked and especially touching, in the joyous upward glance of the kneeling youth. . . . One might note how, in Gregorio Dati's history of the events of the war with Galeazzo, written as we have seen only four years later, the hand of God is constantly discovered intervening for the Republic.[29]

In Donatello's graceful, still Gothic marble *David* of 1408–9, designed for one of the buttresses of the Duomo . . . , the connection between a triumphant Scriptural victor and the contemporary political scene is reinforced by three separate factors, an iconographic attribute, an exact inscription, and a noteworthy historical event. The youthful champion of the chosen people stands, staring out into space, above the severed head of the defeated tyrant. Due to Janson's enquiries,[30] the wreath about David's brow has been identified by Mr. Maurice L. Shapiro as amaranth, a purplish plant whose name in Greek means "non-fading." It was considered the fitting crown for the undying memory of heroes, and was therefore used by Thetis to cover the grave of Achilles. The amaranthine crown is held out in the New Testament as the ultimate reward of the faithful.[31] Now the statue once bore in Latin the following inscription, "To those who bravely fight for the fatherland the gods will lend aid even against the most terrible foes."[32] In other words, with divine aid a child has put to flight the potent enemy of the people of God. The relevance of the statue to Florence and its political and military situation is especially

marked because there are no statues of the youthful, victorious David (as distinguished from the adult King) before this time, and from this time on they are legion.[33]

Lest anything be lacking to reinforce its significance, in 1416, two years after the overthrow of Ladislaus—our second Goliath—the Signoria demanded the statue urgently and without delay from the *Arte della Lana*, so that it could be set up in Palazzo Vecchio in the council halls of the Republic, where it stood for many years. Interestingly enough the same thing happened in Florence almost a century later when the *David* of Michelangelo, also intended for a buttress of the cathedral in 1502, was set up after its completion in 1504 in front of the Palazzo Vecchio itself, as a kind of symbol of the embattled Republic under Piero Soderini, then engaged in the last and tragic phase of its struggle for survival against tyranny. By no means accidentally, Michelangelo's *David* is not only one of the most noble but also one of the last works of art in Florence to embody that classical notion of human dignity and completeness whose origin in Renaissance art we are considering here.

But Donatello's marble *David* is by all accounts not a fully Renaissance work, nor, incidentally, does the blank physiognomy of the entranced victor betray any traces of the deep antinomy of shifting emotional states that darkens the faces of the saints of Orsanmichele or the prophets of the Campanile. What shall we say of the *St. George* of 1415–16?[34] In spite of the obstreperously Gothic niche (probably, as Janson contends, not planned by Donatello), this is a Renaissance statue in the completeness of its individuality, the forthrightness of its stance, the magnificence of its forms. . . . The warrior saint stands supporting his great shield and looking out on a hostile world with the supreme bravery of a man born a coward. Despite all that Vasari, under fashionable Michelangelesque influence, had to say about its "vivacità fieramente terribile," this is a reflective, gentle face, with delicate nose, pinched, nervous brows, sensuous mouth, even a weak chin. Yet with divine guidance he has put on the whole armor of the spirit and summons up all his inner forces to confront the enemy. In this work Donatello's analysis of spiritual duality, of the inner battles of the mind, has reached an even greater stage of development than in his *St. Mark*.[35] As in Castagno's *St. Theodore*, so deeply influenced by Donatello, the Christian Psychomachia is translated "from the language of traditional symbols into that of individual experience."[36]

We do not, of course, see the work as originally intended. Janson has shown that the right hand originally held a sword or a lance (the former would seem more probable, considering that the saint is shown on foot and that a lance would have jutted unreasonably into the street) and that the head probably wore a helmet,[37] understandably, considering

that the figure was done for the guild of the *Corazzai* or armorers. But how did such a modest guild, not even counted among the *Arti Mediane*, possess itself of a fine niche at Orsanmichele? In the absence of specific knowledge, I suspect that after the close of the second war for the survival of the Republic, the stock of the armorers in political circles had gone sharply up. In any even, we note that only after King Ladislaus had appeared on the borders of Tuscany in 1408 does the definitive change take place between the late Gothic and the early Renaissance in Florence. From 1410–12 the still medieval masters Bernardo Ciuffagni and Niccolò di Pietro Lamberti find themselves replaced at Orsanmichele by Donatello, Ghiberti, and Nanni di Banco, the founders of the new style.[38] In 1409, in fact, Lamberti is willing to accept the rather humiliating assignment of procuring the marble at Carrara for the *St. Mark* to be executed by the still youthful Donatello.[39]

In these new works part of the forces of the self are directed outward toward a world of obstacles and dangers, the other part inward, assessing with deep anxiety the resources of individual character—like divisions within the Florentine Republic itself, acutely conscious of the threat to its liberties, and quite as deeply of its own inadequacy to meet the challenge. Bitterly had Domenico da Prato cried that Florence's deepest sorrow was caused not by the enemy from without but by the poison in the hearts of her own sons. No new Brutus would arise among a people who knew only the maxim, "Let us make money and we shall have honor."[40] But Rinaldo de' Gianfigliazzi was to say, after the rout of Zagonara, "It is in adversity that men who want to live a free life are put to the test; in times of good fortune everybody can behave properly,"[41] and Niccolò da Uzzano, "Virtue reveals itself in adversity; when things go smoothly anybody can conduct himself well. Liberty is to be valued higher than life. The spirit cannot be broken unless one wills it so."[42] These searching estimates of the resources of human character differ profoundly from the still medieval longing for divine deliverance in 1402.

From an historical point of view, perhaps the most extraordinary aspect of Donatello's *St. George* is not the statue itself so much as the relief on its base. ... On a grim terrace of rocks, with the opening of a cave on one side and a delicate arcade on the other, St. George on a rearing horse plunges his spear into the dragon's breast, while the captive princess folds her hands in prayer. If the *St. George* statue can stand as a symbol of the Republic at war, this relief may count as an allegorical reenactment of the battle. But the relief is executed in a style the like of which had not been attempted since the first century of our era. The figures, landscape elements and buildings are not, as in medieval reliefs— and still in early Ghiberti and the neighboring reliefs of Nanni de Banco at Orsanmichele—set forth almost in the round against a uniformly flat

and inert background slab. Rather they are projected, as it were, *into* the surface of the marble to varying degrees of depth corresponding, not to the actual shapes of the represented objects, but to the play of light across bumps and hollows. Donatello is thus enabled to suggest, by the manipulation of tone, steady recession into depth, distant hills, trees, clouds, a building in perspective, and an all-over play of atmosphere. He was aided, of course, by the position of the relief in a never-changing diffused light on the north side of Orsanmichele, and the effects he obtained were undoubtedly much more delicate before the marble had been corroded by exposure to five and a half centuries of rain and wind.

While Janson is correct in pointing out that the building is not accurately constructed according to the rules of one-point perspective,[43] it certainly represents the closest approach to such perspective construction before the days of Masaccio. But, even more important, Donatello has grasped in this relief the essential idea on which not only one-point perspective but every other important principle of Renaissance and later art was to be based up to and including nineteenth century Impressionism— namely, that the represented object has no autonomous existence, ideal, tangible or both, for the artist, who is bound to represent it only as it appears to one pair of eyes at a single moment, from a single point view and under a single set of atmospheric and luminous conditions. The supremacy of the individual implied in this concept is by far the most startling aspect of Donatello's early production. In fact, the basic optical revolution of Renaissance art may be said to have first taken place in the mind of this young man as he contemplated the fine marble slab specially procured from the Opera del Duomo for this relief for the north side of Orsanmichele in February 1417—even a few months earlier if, as seems to me inescapable, the subtle and unprecedented luminary and atmospheric effects carried out with such success in marble were first prepared for in a clay model in which experimentation would have been easier and failure quickly remedied. Regardless of the fact that the analogous optical achievements of the Van Eycks could only have been accessible to the Italians at a much later date, even the earliest reasonable dating for the Hand G miniatures of the Turin-Milan Hours leaves this enormous intellectual conquest securely in the hands of Donatello.[44]

There is a peculiar propriety in the fact that this new conception of the supremacy of the individual should make its first appearance in a work of art celebrating the heroic encount of a single armed knight against the forces of evil at a moment when the Florentine republic had just won so striking a battle for individual freedom. Baron notes that, "as late as 1413, the psychological interpretation of freedom as the spark struck by equality in competition seems to have been still absent from the mental armory of Leonardo Bruni,[45] so soon to become the greatest apologist for

freedom. Yet only a year later he began the first volume of his history of the Florentine people in which, referring to the ancient Etruscan city-states under Roman domination, he said, "For it is Nature's gift to mortals that, where the path to greatness and honor is open men easily raise themselves up to a higher plane, where they are deprived of this hope, they grow idle and lose their strength."[46] In 1427 the general of the Florentine forces, Nanni degli Strozzi, was killed in combat against Filippo Maria Visconti. Bruni was asked to write a eulogy in his honor. Shortly thereafter Bruni became Chancellor of the Florentine Republic, and not until 1428 was he able to finish the work which he modeled on Thucydides' account of Pericles' oration for the first Athenian citizens to fall in the Peloponnesian war. The secret of Florentine greatness, according to the Chancellor at this moment, lay in the fact that "Equal liberty exists for all . . . , the hope of winning public honors and ascending is the same for all, provided they possess industry and natural gifts, and live a serious minded and respected way of life; for our commonwealth requires *virtus* and *probitas* in its citizens."

But this is not all. Florence, Bruni says, is the great home of writing in the vernacular, the *volgare*, and her Italian speech is the model for the peninsula. At the same time it is Florence alone who has called back the forgotten knowledge of antiquity. "Who, if not our Commonwealth, has brought to recognition, revived and rescued from ruin the Latin letters, which previously had been abject, prostrate and almost dead? . . . Indeed even the knowledge of the Greek letters, which for more than seven hundred years had fallen into disuse in Italy, has been recalled and brought back by our Commonwealth with the result that we have become able to see face to face, and no longer through the veil of absurd translations the greatest philosophers and admirable orators and all those other men distinguished by their learning.[47]

And now let us return to the statues of Orsanmichele. These are the saints of God, chosen to do His work, to carry His banner or His sword.[48] They are also the guardians of the guilds in the maintenance of the Republic, and its spiritual defenders in the battle for the survival of free institutions. As such, they partake of the *virtus* and the *probitas* which were the ideal of the Florentine citizen and the dignity and reflectiveness of the classical philosopher orator or writer.[49] In them becomes explicit the awareness of the historian concerned with the perpetuation of all that is most noble in man. Not only do their cloaks begin to assume the folds of Roman togas, but as soon as the vocabulary of classical architecture is again available, the saints appear in niches framed by Roman orders, as in Donatello's *St. Louis of Toulouse* done for the Parte Guelfa in 1423. . . .

It is doubtless this new equation of citizen-hero-philosopher-saint

that sustains Masaccio in setting forth with such grandeur the formidable apostles of the Brancacci Chapel, classic exponents of the dignity of the *volgare*, and exemplars of the corporeal massiveness and ample fold structure of Donatello and Nanni de Banco. But what is the meaning of the rarely treated subject of the *Tribute Money* (Matthew 17. 24–27), given such unusual prominence among the frescoes of the Brancacci Chapel (Fig. 9-2), equated with the most exalted apostolic acts of baptism, preaching and healing?

By 1425 the immense burden of the war had emptied the Florentine treasury and the Florentine economic scene was darkened by a rapid succession of bank failures. A new form of taxation was essential in order to support the war, and in 1427 the Signorìa adopted the *Catasto*, the first attempt at an equitable form of taxation in modern history, and in some respects the ancestor of modern income and personal property tax systems—complete with declaration, exemptions and deductions.[50] But the Signorìa did not come to this measure without a fight. In fact the first proposals for the *Catasto* were made by Rinaldo degli Albizzi on February 19, 1425, and repeated again and again throughout that grim spring. It is in this very spring and summer that I have dated, on a combination of stylistic and documentary evidence, the *Tribute Money* of Masaccio as well as the neighboring scenes in the Brancacci series.[51] Although Baron makes surprisingly little out of this fact, the Pope himself, successor of St. Peter, resided temporarily in Florence just before the opening of the final war against Filippo Maria Visconti, from 1419–21, on his way to take possession of the papal throne as the first ruler of a Papacy reunited after more than a century of exile and schism.

The *Tribute Money* not only announces taxation as a civic duty

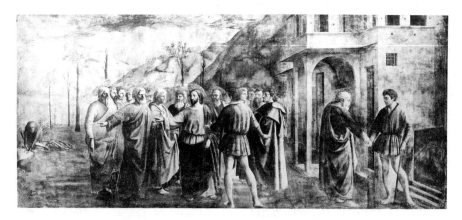

Figure 9-2. Masaccio, *The Tribute Money*, Brancacci Chapel, Florence. c. 1425. Photo by Alinari/Art Resource.

divinely revealed but reinforces the traditional Guelph policy of Florence as the Florentine ambassadors were doing at that moment to the Pope newly reestablished in Rome. "To eternity we will persist to preserve our liberty, which is dearer to us than life. And to that effect we will not spare our substance, our sons and our brothers, but put forth without reserve our lives and likewise our souls."[52] The doctrine of divine approval of taxation for the purpose of defense, embodied in Masaccio's *Tribute Money*, persisted in the interpretation of this very passage from Matthew as late as the 1450's when St. Antonine of Florence set down his immense universal history, the *Opus Chronicorum*.[53] Confronted with the dilemma of apparent submission to earthly authority on the part of Him Who is subject to no one. Antonine rationalizes the situation by the following quotation from the Gloss: "not as a sign of subjection does the Church give tribute to kings . . . for the Church is not subject to them, but as a subsidy and occasion for defence, therefore it should not be given to them if they do not defend."

Only in the light of the tragic necessity of Florence in 1425 can we understand this monumental rendition of what might otherwise seem a trivial occurrence in the narration of the Gospels. Masaccio has set the solemn group in the midst of the Florentine countryside, with the range of the Pratomagno in the background, and all the atmospheric effects he had learned from Donatello's eight-years-earlier *St. George* relief now greatly expanded and enriched. He has animated the features of the apostles with the earnestness and excitement of the Florentines themselves, confronted with the awesome task of finding the means of preserving their Republic and its threatened liberties, and receiving from supernal authority the new solution and the mission to proceed with it.

Turning to the adjacent wall of the Brancacci Chapel, we find still another fresco dealing with taxation, representing at once the equable distribution of its benefits to the community and the punishment meted out to those who will not share in time of common need. . . . The apostles under Peter are distributing alms to men, women and children, while in the foreground (now so badly damaged as to be easily overlooked) lies the body of Ananias, who held back a part of the price of a farm, and was struck down by God at Peter's feet (Acts 4. 34–37; 5. 1–6). I know of no more eloquent visual sermon on the benefits of taxation or the dangers of evasion. The setting is not specified in the Scriptural account, but Masaccio has placed the scene in an ordinary village in the country surrounding Florence and peopled it with pure *volgare* types, including St. Peter himself.

The moving picture of the little Republic standing alone on the edge of the abyss might tempt one to all sorts of parallels. But this was neither the Battle of Britain nor yet Valley Forge. Despite Bruni's proud boast,

all classes in Florence were not free. The fate of the oppressed wool carders who tried in 1378 to effect an entry into the guild system and were mercilessly crushed is eloquent testimony to the exclusiveness of the all-powerful guilds and the essentially oligarchic nature of the Florentine state. Perhaps the Florentine situation in the 1420's might better be compared with that of the Athenians at Thermopylae or at Salamis. Both Florentine and Athenian societies were controlled by mercantile classes which enjoyed internal liberties unprecedented in their eras, however little they were willing to extend these same liberties to the classes on whose labors their commercial prosperity rested; both societies were driven to extreme measures to raise from their essentially non-military citizenry the forces necessary for the repulsion of better armed and organized autocracies. What is most important for us as art historians is that ancient Athens and Quattrocento Florence, so threatened and so triumphant, were the matrices of the two most completely humanistic revolutionary styles in the history of art. And, as a corollary, the art of their enemies presents a totally opposed spectacle of individual absorption in the general scheme, material luxury, efficient, mechanical regularity of organization and uniformity of detail. For the art of Milan and Naples was Gothic and remained so until the second, Albertian phase of the early Renaissance provided Roman Imperial forms to celebrate the ambitions of mid and late Quattrocento dynasts in both centers. Outside of Florence, the first Renaissance style of the great sculptors and Masaccio is accepted, among major Italian centers, only in Venice, the Florentine ally in the struggles against monarchic absorption. In Florence the early Renaissance is a republican style; its more rigid Albertian phase is never universally welcomed, and Alberti and Piero can develop their full potentialities only in centers of princely rule. The Florentine Renaissance is sapped from within by late Quattrocento tyranny reflected in the "Gothic" art of Botticelli; revived heroically in the second Republic in the defiant masterpieces of Leonardo and Michelangelo for the seat of republican government, the Renaissance is corroded under the Medici dukes in the nightmare art of the Mannerist crisis, and supplanted altogether under the principate by the neo-Gothic Maniera which becomes in the Cinquecento the normative style of the European courts.

It would be satisfying to record that the Florentines won their struggle against Milanese tyranny. Actually nobody won. Unlike his predecessors, Filippo Maria Visconti did not just die. The battle see-sawed on for years, but at least the Florentines did not lose and by virtue of the alliance with Venice were able to preserve for a while their cherished independence. The struggle eventually shifted, as struggles have a way of doing, into other levels with other participants and other principles.

The decisive, eventually victorious threat to Florentine freedom arose, as Domenico da Prato had foreseen, not from external threats but from inner weaknesses. In the end it was not foreign but domestic tyrants who undermined the liberties of the Republic in the name of stability.

The solution of every crisis in human affairs leads inevitably to a new crisis. Locked in the bonds of time and his own mortality, man can cope with perils from within and from without only through clear-eyed recognition. Eventually the Florentines lost their liberties through not having recognized in time the subtle threat of the Medici. But their finest hour, to quote Winston Churchill, had still been faced, and in the civic art of the first Florentine Renaissance we have the enduring embodiment of their decision.

We know far too little as yet about the relation between artist and patron in the early Renaissance to pronounce any dogmas, but in this instance it is clear that artists and patrons were intimately allied. The artists, themselves guild members, must have been as concerned as any other Florentines over the fate of their society, as deeply committed to its continuance,[54] as aware of its limitations and dangers, and as influential in the growth of its ideals, all of which are reflected and paralleled in the content and style of the first great artistic achievements of the early Renaissance. To return to Masaccio's *Trinity*, we behold in the naturalism of these citizens and their rough, human dignity the *probitas* and *virtus* which the Republic exalts; in the classic architecture that enframes them a fitting reference to enobling antiquity and the universal spread of humanistic ideals; in the resignation of the sacrificed Christ to Whose mercy they appeal the ideal of Stoic behavior under adversity; in the simple articulation of the structure leading from man to God, their confidence in the righteousness of their cause and their belief that God helps those who help themselves; in their control over form and space and design the firmness of their moral and intellectual victory over the enemy and over the inner man.[55]

But I am well aware that the foregoing arguments can do no more than hint at the depth and complexity of the factors involved in the appearance of the early Renaissance style in Florence. In the last analysis such matters are as elusive and as mysterious as the nature of creativity or the origins of man's will to resist.

Notes

1. The evidence is ably analyzed by H. W. Janson, *The Sculpture of Donatello*, Princeton, 1957, II, pp. 17ff.
2. The Cascia di Reggello altarpiece, dated 1422; see Luciano Berti, "Masaccio 1422," *Commentari*, XII, 1961, pp. 84–107.

3. Op. cit., II, p. 19.

4. I would like to repeat here the acknowledgment of my indebtedness to Professor Richard Krautheimer for the notion of the continued stimulus of sculpture on painting in the early Quattrocento (see *Castagno*, note 33). Antal, op. cit., p. 305, noted that "at the beginning of the century upper-bourgeois rationalism was most strikingly expressed in religious sculpture, both statues and reliefs, whereas its full expression in painting came somewhat later," without ever telling us why. He has noted (p. 332) the infiltration of some Masaccesque elements into the style of Francesco d'Antonio in the 1429 organ shutters for Orsanmichele. He might have added the somewhat stronger influence of Masaccio in the Grenoble altarpiece by this same master, and the numerous allusions to Masaccio in the work of Giovanni dal Ponte, adduced in part by Salmi, *Masaccio*, Paris, 1935, fig. CCII.

5. The list includes the *St. Luke*, by Nanni di Banco, the *St. Matthew* by Bernardo Ciuffagni, the *St. Mark* by Niccolò di Pietro Lamberti, and the *St. John* by Donatello, all for the facade of the Duomo; the *Isaiah* by Nanni di Banco, the marble *David* and the lost *Joshua* by Donatello, the *King David, Joshua* ("Poggio Bracciolini") and *Isaiah* by Ciuffagni, all for the main fabric of the Duomo; the beardless and bearded prophets, *Zuccone, Jeremiah* and *Abraham* by Donatello, the *John the Baptist* and *Abdia* by Nanni di Bartolo called il Rosso and the prophet by Giuliano da Poggibonsi, all for the Campanile; and finally the *St. Peter* by Ciuffagni, the *St. James* by Lamberti, the *St. John the Baptist, St. Matthew* and *St. Stephen* by Ghiberti, the *St. Matthew, St. George* and *St. Louis of Toulouse* by Donatello and the *Quattro Santi Coronati, St. Eligius* and *St. Philip* by Nanni di Banco, all for Orsanmichele.

6. Antal, op. cit. pp. 16ff., provides a very able introduction to the intricate and shifting structure of the guilds. Of particular importance is his insistence that from 1251 onwards the ". . . guilds had become fighting organizations in the fullest sense of the word." This is one of the most useful and objective sections of the entire book.

7. Despite the characteristically restrictive and opressive role of the *Parte Guelfa* traced by Antal, Baron (op. cit., I, p. 15) cites a surprising redefinition of the *Parte Guelfa* by Leonardo Bruni in 1420 when its Statute was being revised: "If you consider the community of the Guelphs from the religious point of view, you will find it connected with the Roman Church, if from the human point of view, with Liberty — Liberty without which no republic can exist, and without which the wisest men have held, one should not live." For recent bibliography, see ibid., II, pp. 445–446, notes 8 and 9.

8. For the Statues of the *Arte dei Medici e Speziali*, see C. Forilli, "I dipintori a Firenze nell' Arte dei medici, speziali e merciai," *Archivio storico italiano*, II, 1920, pp. 6–74.

9. Baron (op. cit.) has demonstrated full awareness of the importance of his new emphasis for the cultural history of the Renaissance, and in several places invites the application of his ideas to the interpretation of the new art of the Quattrocento, e.g., I, p. 29, "On the other hand, the factor which produced a sudden and incisive change in the art of the first two or three decades of the Quattrocento was the emergence of a new ideal of man, together with the discovery of the laws of anatomy, optics and perspective, knowledge of which was needed to express that ideal and could largely be gained in the school of antiquity," and p. 174, "those who recall Donatello's *St. George* of 1416 — the first book of Bruni's *Historiae Florentini Populi* had been written the year before — will be certain that even the arts did not remain entirely untouched by the political climate of the time of the Florentine-Milanese struggle."

10. Baron, op. cit., I, p. 145, quoting from Gregorio Dati, *L'Istoria di Firenze dal 1380 al 1405*, ed. L. Pratesi, Norcia, 1904, p. 14 (supplemented by comparisons with ed. G. Manni, Florence, 1735, p. 5).

11. Baron, op. cit., I, p. 27.

12. Ibid., I, p. 29, quoting from A. D'Ancona, "Il concetto dell'unità politica nei poeti italiani," *Studi di critica e storia letteraria*, I, 1912, p. 41.

13. Scipione Ammirato, *Istorie fiorentine*, Florence, 1647, II, p. 889.

14. Ibid., II, p. 893.
15. Loc. cit.
16. Baron, op. cit., p. 186, quoting from Lionardo Bruni, *Laudatio*, L. fol. 150v–152r.
17. Baron, op. cit., I, p. 159, quoting Dati, op. cit., ed. Pratesi, p. 74 and Manni, p. 70.
18. Baron, op. cit., I, p. 320.
19. Ibid., p. 322.
20. Ammirato, op. cit., II, p. 971.
21. Ugo Procacci, "Sulla cronologia delle opere di Masaccio e di Masolino tra il 1425 e il 1428," *Rivista d'Arte*, XXVIII, 1953, p. 12, quoting *Istorie di M. Poggio fiorentino tradotta di latino in volgare da Jacopo suo figliuolo*, Florence, 1598, p. 135.
22. Procacci, op. cit., p. 12, quoting Giovanni Cavalcanti, *Istorie fiorentine*, Florence, 1838–39; ed. di Pino, Milan, 1944.
23. Eloquently characterized by E.M. Jacob, op. cit., p. 26, as "living in a sort of artistic Kremlin with agents watching everybody...."
24. Baron, op. cit., I, p. 336, quoting messer Antonio di Matteo di Meglio (called Antonio di Palagio), "Rimolatino per lo quale conforta Firenze dopo la rotta di Zagonara," in Guasti, *Commissioni di Rinaldo degli Albizzi*, II, pp. 78–80.
25. Richard Krautheimer, *Lorenzo Ghiberti*, Princeton, 1956, pp. 71–72. This was, of course, one of the innumerable unmet Renaissance deadlines, but it gives an index of the urgency of the need for the statues.
26. Ibid., p. 93.
27. The evidence is summarized and analyzed by Janson, op. cit., II, pp. 33–35.
28. Krautheimer, op. cit., p. 41.
29. Baron, op. cit., I, p. 144.
30. Janson, op. cit., II, p. 6.
31. Janson, op. cit., II, p. 7.
32. Ibid., p. 4.
33. There is, however, Taddeo Gaddi's fresco of the 1330's in the Baroncelli Chapel at S. Croce (Janson, op. cit., II, p. 6). A partial list of the later Davids would include Donatello's bronze, Castagno's shield in Washington, the Martelli *David* by Bernardo Rossellino in the same gallery (for the attribution, see my "New Light on the Rossellino Family," *Burlington Magazine*, CII, 1961, pp. 387–92). Pollaiuolo's little panel in Berlin, and Verrocchio's bronze, not to speak of Michelangelo's colossal marble statue and his lost bronze.
34. I follow Janson's dating, op. cit., II, pp. 28ff.
35. Vividly stated by Janson, op. cit., II, p. 29.
36. If I may be permitted a self-quotation; *Castagno*, p. 233.
37. Janson, op. cit., II, pp. 26ff.
38. This radical change was noted by Krautheimer, op. cit., p. 72.
39. Janson, op. cit., II, p. 17.
40. Baron, op. cit., I, p. 336, quoting "Risposta di Ser Domenico al prefato Messer Antonio, in vice della Città di Firenze," Guasti, op. cit., p. 81.
41. Baron, op. cit., I, p. 338, quoting *Commissioni di Rinaldo degli Albizzi per il Comune di Firenze del MCCCLXCIX al MCCCCXXXIII*, ed. C. Guasti, Florence, 1867–1873, II, pp. 145–9.
42. Baron, loc. cit.
43. Janson, op. cit., II, p. 31.

44. The Hand G miniatures, if by Jan van Eyck, would date between 1422 and 1424 according to the closely reasoned account in Erwin Panofsky, *Early Netherlandish Painting*, Cambridge (Massachusetts), 1953, I, pp. 232–46, but esp. p. 245. If I understand correctly, the recent, still unpublished, researches of Miss Dorothy Miner tend to confirm this dating. A University of Pennsylvania student, whom I have since been unable to identify, pointed out to me the important fact that Donatello's optical predilections are evident as early as the marble *David*, not to speak of the *St. Mark*, in the handling of projections and hollows. The formal repertory of Donatello's relief betrays no hint of northern influence, but seems to derive from the landscape forms current in Florence at the end of the Trecento, especially in the workshop and following of Agnolo Gaddi.

45. Baron, op. cit., p. 367.

46. Ibid., p. 368, quoting Leonardo Bruni, *Historiarum Florentini Populi Libri XII*, ed. Santini, p. 36.

47. Baron, op. cit., I, pp. 352 and 364, quoting Leonardo Bruni, *Laudatio*, ed. Baluzius, pp. 3–4.

48. God the Father appears in the gable of Donatello's *St. George* and in the gables above all three of Nanni's statues for Orsanmichele, blessing the saints below.

49. For the classical sources of the *St. Matthew*, see Krautheimer, op. cit., p. 342.

50. The most valuable recent treatment of the history of the *Catasto*, rich in new material, is to be found in Ugo Procacci's study cited in note 21 above.

51. For reasons to which I alluded in *Castagno*, p. 163, n 16, but which are not ready for publication.

52. Procacci, op. cit., p. 15, quoting *Commissioni*, II, p. 332.

53. St. Antonine of Florence, *Opus Chronicorum*, Lyon, 1589, I, p. 220.

54. Frequently the artists appear as designers of weapons and systems of defense and offense, as Brunelleschi against Lucca, Leonardo against Pisa, Michelangelo against the Medici.

55. As E.F. Jacob pointed out (cf. note 6, *Italian Renaissance Studies Edited by E.F. Jacob*, p. 47), "A great civilization is not built upon magnificence alone. Self-denial, forethought and forebearing are needed, qualities which historians are not always ready to concede to the makers of the Italian Renaissance." He continues to quote Leonardo (*The Notebooks of Leonardo da Vinci*, ed. Edward McCurdy, London, 1956, I, p. 87), "You can have neither a greater nor a less dominion than that over yourself."

10

The Disasters of War

Fred Licht

The Third of May [Fig. 10-1], is the monumental crystallization of a long, scrupulously assimilated experience. The stages of this experience are recorded, incident by incident, in a series of prints known collectively as *The Disasters of War (Los desastres de la guerra)*. The *Disasters* are at once the beginning and unrivaled climax of modern graphics. The testimony to chaos, bestiality, and terror, the rejection of conventional consolations that are given a general, universal monument in *The Third of May* are given personal and particularized form in the *Disasters*.

Most of the scenes recorded in the *Disasters* probably had their beginnings in notations made on the spot. All of the pages have an inevitability and an impetuousness that give them the double impact of being at once truthful testimony of all that is vulnerable, vile, insane, and cruel in man and an urgent exorcism of such knowledge regarding the nature of the human beast. Unlike the pages of the *Caprichos*, these scenes were not etched in order to shake and waken the beholder. They were created because his art is the only defense and the only sustenance left to an artist in the face of what Goya witnessed. These plates obviously had to be created by the artist without any further thought about their ultimate purpose. Goya never intended them for publication during his lifetime. They were not presented to the public until more than fifty years after the artist had died and more than seventy years after he had first engraved them. It may be possible that Goya hoped once—as many artists

From *Goya: The Origins of the Modern Temper in Art* by Fred S. Licht, copyright © 1980 John Murray, Ltd. Reprinted by permission of Universe Publishing.

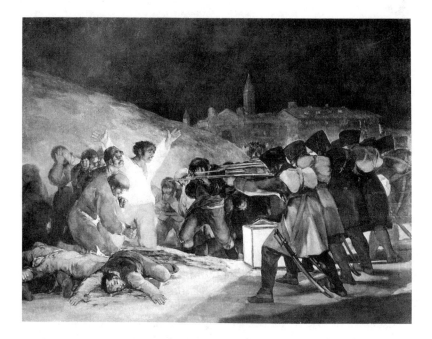

Figure 10-1. Francisco Goya, *El Tres de Mayo, 1808* (Third of May, 1808). 1814. 8'8¾" × 11'3⅞". Museo del Prado, Madrid.

and writers have hoped since—that the time might come when mankind would reach a level of sensibility at which the mere record of the insensate and purposeless cruelties of war would serve as a salutary warning to all men. If he ever entertained such vain hopes, we are not informed of them, and certainly he seems to have abandoned such ideas after the restoration of the Bourbons revealed itself as even more degrading and regressive than the Napoleonic regime. . . .

. . . More than any other graphic series by Goya, the *Disasters* are dedicated to observed actuality transmitted with gruelling directness. The subject matter is of so urgent a nature that it seems to find its own, direct mode of expression just as panic will find relief in a cry of terror rather than in a sequence of coherent words. The artistry of Goya lies in the indomitably sensitive perception that functions even in the face of the most sickening heaps of mutilated corpses. If there is one motto that can stand as the key to the entire series, it must necessarily be "I saw this" ("*Yo lo vi*"), the caption of Plate 44. . . . Just as he abdicated his right as interpreter while painting the portrait of the royal family, so here, while confronting blind bestiality and things that "One cannot look at" ("*No se puede mirar*"), the caption of Plate 26 . . . , he rejects the

artist's prerogative to do anything but bear witness. There are horrors that must not be tampered with, a pain so intense that even compassion is insulting. To go beyond the mere description of such terror and such anguish is to belittle it. There are no inferences to be drawn from it, there are no lessons to be learned from it, there is no hope of ever achieving the absolute, the categorical ruthlessness and self-sufficiency of such an experience. Henry James's father called such an experience a "vastation," a gratuitous demolition of all that had once been pleasurable or meaningful in life, a realization of the stark anarchy that reigns in the outside world as mindlessly as it does in the interior world of irrational lusts and fears.

In many ways, Goya, in the *Disasters*, resembles more the few photographic news reporters of genius and dedication of the 20th century than he does any of his contemporaries or predecessors. Like the news photographer, Goya seeks to bear witness to the fundamental nature of man's eternal warfare against himself, he seeks to bring to the attention of the fatuous and the forgetful the fact that the world is divided into two races: the complacent and the wretched. Both states of mind are equally incompatible with the dignity man might achieve. And both states have lost the juncture between them that once lay in the common belief that it was God's ordained will that misery and heedless selfishness should live side by side.

The analogy between Goya and the modern news photographer goes beyond a mere similarity of purpose: that of bearing witness to the essential realities of our world. The means that Goya employs and the novel relationships that bind him to his subject as well as to his finished work are also comparable. For like his later colleagues, Goya "focuses" on a *motif* in a way that is much closer to the procedures of a sensitive photographer than it is to earlier printmakers. In order to achieve the maximum of expressive content, the photographer must control (by means of focal length, aperture, etc.) our manner of perception without tampering with the facts that are perceived. Motif takes precedence over composition. He is free to move his camera to achieve as great an impact as possible. But the great news photographer cannot arrange the elements of his image. Like the news photographer Goya rejects the harmony sought by all previous image-makers and substitutes immediacy of testimony to observed fact. Whereas earlier artists (and many of Goya's successors as well) were concerned with their ability to transform realities into a pleasing and instructive picture, Goya (in his *Disasters*) and the modern news photographer convey observations. Their quality can be judged primarily by their intuitive ability to find the most highly charged view of things as they are. One enters on earlier images guided by the artist in the

intricacies of his artifice. Goya and news photographers do not allow us time to gradually enter their pictorial space but aggressively arrest our attention with the immediacy of a blow.

A visual comparison illustrates better than words Goya's peculiar modernity of attitude toward ascertainable reality. When one glances at *A Harvest of Death: Gettysburg July 1863* [Fig. 10-2] and then turns to Plate 18 of the *Disasters*, [*Enterrar y callar* (Bury them and shut up)], the similarity of intent, the equally brutal sobriety and the shocking immediacy of the two images clearly establish a common denominator between the two images.

If one adds to this visual experiment . . . , Jacques Callot's view of a battlefield, [*La Revanche des paysans* (The Peasants' Revenge)], Goya's proximity to photography becomes even more striking. Callot's calligraphy, his obvious arrangement of rhythms and accents, declares itself immediately. Goya's image seems as incontrovertible as the image produced by an impassive camera shutter. Naturally, this is not to say that either Goya or a gifted photographer is deprived of personality and of highly individualized emotional and intellectual reactions. One can recognize a Goya print as being Goya's just as one can recognize the authorship of a photograph by Paul Strand. But now the personal element in art is included almost inadvertently in the images that are produced. The artist strives after anonymity, and if his personality shows just the same, it is projected in spite of himself and not through any carefully studied stance. . . .

It might be argued that the violence and intransigent brutality of

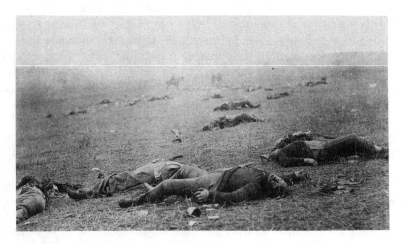

Figure 10-2. T. H. O'Sullivan, *A Harvest of Death: Gettysburg, July 1863.* Collection, The Museum of Modern Art, New York. Given anonymously.

Goya's subject matter are what give his work its peculiar modernity and inescapable directness. But one need only revert to Callot's magnificent *Troubles of War (Misères et malheurs de la guerre)* to see that subject matter itself is not sufficient to explain the extraordinary power of Goya's prints. In subject matter, Goya is hardly different from Callot, whose work may well have provided not only an inspiration but also the very title of Goya's work. Goya's *Disasters* represents the discovery of an entirely new pictorial idiom. Thematically, the two series of prints, Callot's and Goya's, stand in much the same relationship as the Old and New Testament. The basic subject of argument is the same in both series. Both artists deal with inhumanity as the two Testaments deal with man's salvation. But just as the New Testament introduces a new logic into the system of salvation and posits a new view of the sacred history of man and of God, so Goya's new dispensation is based on a totally new conception of the conflict between hoped-for moral order and actual immorality.

For Callot, mankind is still the elect among all the creatures of the Lord. Even in his iniquity, he can receive absolution; even hanged or broken on the wheel, he remains true to his origins, which are "in the image of God." For Callot, living in an age that believed human justice to be the product of divine inspiration, atrocious punishments were part of a logical scheme of things. The arsonist paying his debt to society by being quartered enters into a sensible frame of divine retribution with which the artist has no quarrel. The rather detached virtuoso effects with which Callot renders the most hair-raising scenes of pillage, torture, and death do not in any way contradict his subject matter. On the contrary, they are eminently suitable for the purpose he has in mind of illustrating the terrible but rational drama of man's transgression and God's retribution. One can (and perhaps should) take exception to Pierre-Paul Plan's description of Callot's work in his monograph on the artist: "*Ce sont toujours des guignols divertissants qu'on nous montre avec le talent le plus surprenant*" ("We are shown entertaining horrors with the most surprising talent").[1] Yet there is, in essence, a quality of the spectacle about Callot. He is a witty, observant stage director who, because of his enormous flair, can make his actors do the most astonishing things. In one extraordinary passage . . . , an elegant figure kneeling by the side of a body stretched out on the ground raises in his hands what looks like an intricate, arabesque heap of ribbons. When we look more attentively and have recourse to a magnifying glass, however, we realize that the ribbons aren't ribbons at all but the fresh entrails of the eviscerated corpse on the ground. Still, even after we have made this macabre discovery, the elegance of the visual episode tempers the latent horror, so that it hardly disturbs us. Callot represents cruelties with such aplomb that he conveys to us, through the sheer beauty of his design, the beauty of a world in

which even grisly occurrences take on a logical coherence, a rational consequentiality that takes the edge off their horror. From this point of view, Callot is able to do justice to the ideal of human dignity and goodness at the same time that he also presents to us the fact that, all too often, this ideal is violated by the wickedness of sinners.

Plate 14 of the *Disasters* [*(Duro es el paso* (Hard is the way)] is quite typical of the general vision that Goya presents. We are not told, as we were by Callot, that the men who have already been hanged or are about to be executed deserved their punishments because of their crimes. Nor does Goya go to the other extreme of enlisting our sympathy by telling us that they were unjustly sentenced and executed. Both these appeals would depend on a stable and reliable standard of justice. Instead, Goya insists on our making a choice without allowing us recourse to logic or conventions of legal justice. We are told only that two men have been hanged and that a third is being dragged up a ladder to be killed in the same manner. The legal aspects of the case or its moral rationalization matters as little as does the age-old boys' cry, "He kicked me first!" "Who killed whom" and "Who killed why" are matters that needn't concern us—which, indeed, if one looks at Goya's plate, *shouldn't* concern us. We are not given the chance to judge the case. Either every fiber within us calls out to stop the killing or else we seek cowardly refuge by trying to "get the facts straight so that we can judge." But there is no time to get the facts straight. Few plates in the *Disasters* are so urgent as this one. The impact is instant and physical. . . .

Plate 15 [Fig. 10-3] can be considered either the germinal point of departure from which *The Third of May* grew or a reduction of the painting. The present state of research on Goya does not permit us to decide these fine points of chronology. In a more compact but less dramatic form, Goya transcribes the vision of wasteland in which an endless succession of victims bound to stakes are executed by bands of soldiers. The means used for evoking the essential sensation of endlessness are as impressively simple as they are novel. They derive from spatial experiments initiated in the *Caprichos*.

Pictorial space, since the early Renaissance, has been a closed system. Even the most daringly elaborate ceilings by Tiepolo remain, in their essentials, hermetically closed off. The limits of the field of vision are extremely important, and it is from this very assured understanding of the pictorial limits that the structure of each composition is derived. Even if the central vanishing point of the perspective lies outside the frame of the image, the position of this central point can be logically deduced from the given data of the composition. In those cases in which the frame cuts across an entering or exiting figure so that more space is suggested than is actually visible within the borders of the frame, the

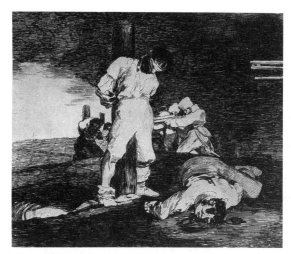

Figure 10-3. Francisco Goya, *Y no hay remedio* (And it can't be helped), Disasters of War, Plate 15. Etching. The National Gallery of Art, Washington, D.C., Rosenwald Collection.

system of spatial construction remains unharmed—just as an actor who is about to leave the stage can either call back something to the actors who are still on stage or engage in conversation with invisible characters beyond the teasers without damaging the coherent unity of the stage set. Whenever such a peripheral and fragmentary figure occurs, it reinforces rather than diminishes the basic principle of a finite space gravitating around an equally fixed (if not always visible) center. In this respect, Renaissance-Baroque pictorial space is harmoniously congruent with Renaissance-Baroque systems of universal space. Both systems have a single point of perspective in common. From this simple point, all forces radiate outward and to it all forces ultimately return. Pictorial space is therefore a universe scaled down in size to make it comprehensible to the human mind. It demonstrates the same logic, the same beneficent will toward order that are the central principles of a divinely ordained cosmos. . . .

Goya's space no longer grows from a fixed center, and without a fixed center we cannot take our bearings in the directionless world he shows us. In Plate 15 of the *Disasters*, as well as in most subsequent pictures, there is the emphatic notion that the event not only is insane in its blind cruelty but that it occurs in a universe equally bereft of reason, direction, or meaning. It is an abyss that stretches to all sides of us and even opens menacingly behind. . . .

The grouping of Plate 15, for instance, is such that we understand immediately that we are looking at only one link of an endlessly repe-

titious chain of the same event. To the right of the image, from where the rifle barrels project, the madness of killing continues, and in the obscure darkness of the horizon the procession wends its hopeless way. Here, in opposition to the Renaissance tradition, we *are* made aware of spaces that are larger and possibly more important than the space we have actually before us. The rifle barrels cannot be compared to the customary figure cut across by the frame—always an incidental figure. In Goya's hand, the cut-over figure is one of the two protagonists in the universal drama of killing and being killed. That this protagonist should be invisible to us as a human force and appear only as a bunch of gun muzzles heightens the panic to an intolerable degree. When we look at Goya's picture, it is as if there is nothing in the world, nothing to either side of us, but mechanically executed murder. Our eye as well as our imagination is impelled outside the frame of the picture itself, and one has the uncanny sensation engendered by all invisible threats. The real danger lurks just around the corner or behind one's shoulders, and one feels exposed on all sides. . . .

The similarity that exists between Goya and later photographers has already been touched on. But again a comparison with photography is instructive. The spirit of Goya's image is close in spirit to an anonymous photograph made during World War II. . . . The photographer has selected a fragment showing a series of corpses hanging from trees in a deserted avenue. We are told nothing of who is hanged. Nor do we know whether or not the cause for which they lost their lives was meaningful. We are simply shown the aftermath of a mass execution. No further information is given. The esthetic corollary lies in the fact that no deliberate structure is given, either. No controlling perspective ties the elements together. No compositional climax tells us that what we are looking at has importance and has a decipherable meaning that can be measured against an ascertainable moral scale of values.

A concomitant of this kind of seeing is the destruction of that which, for lack of a better expression, one must call the hierarchy of composition. In all the innumerable compositional schemes invented by artists in the four centuries of the Renaissance-Baroque tradition, a distinction is made between central and peripheral parts of a composition. . . .

In the *Disasters*, the entire field of the plate is potentialized, and every form within this field, whether it be a void or a volume, plays a part that becomes progressively more equal in value to every other form within the same field. Naturally, the development of this kind of composition is very gradual. In the *Caprichos*, the tenor of almost every one of the plates is extravagantly bizarre so the dislocations of space are not as noticeable because they form part of the decidedly nightmarish nature of the whole series. Now, in the *Disasters*, Goya's themes are drastically

real, and divergences from our standards of normal experience become
more strikingly evident.

Plate 33 of the *Disasters* [*Que hay que hacer mas?* (What more can
one do?)], for instance, partially illustrates Goya's handling of forms in
this new manner. Each form is the equal of all others without any great
distinction being made between animate and inanimate, protagonists and
bystanders. The left leg of the martyred Spanish partisan simply disap-
pears from view (it is impossible to see what happens to it even in those
parts that are in full view) and merges with the tree that rises in the left
upper background, so that the major configuration of the plate is a gi-
gantic V shape described by the tree, the left leg, the man's crotch, and
then upward again through the right leg to the bandolier of the soldier
on the right. Each one of these forms is given equal value in the visual
dynamics of the image. Tree and man are equally charged with the horror
of the scene, and the figure of the martyr is no longer exalted as having
lived and died under special dispensation. What is true of the major
structure of the painting is also true of the relation between the active
participants of the scene and the witnessing bystanders. Both in position
and in execution, the figure of the man on the extreme left is every bit
as significant within the total expressive content of the plate as is the
tortured victim.

Still life and costume are given equally important functions, as
happens here with the swords and scabbards. The sword hewing into the
body of the naked man is not held up, as it so often is in similar scenes
of Christian martyrs being beheaded or maimed. It is seen instead as if
it were at rest. But the scabbard worn by the man on the right comes
into play with the bandoliers of the two figures on the left, bringing into
the picture a lunging swing, which comes to its climax at precisely the
right point: where the naked sword meets naked flesh. Patterning be-
comes almost as important as composition here, and pattern depends on
the impartial repetition of forms. The word "impartial" is especially im-
portant in this context because it is the visual impartiality with which
Goya renders objects that enables him to achieve a surface appearance
of moral impartiality. These plates are sober and devoid of melodrama.
The last twist of the knife consists not so much in showing us more cruel
forms of torment but in demonstrating the seeming irrelevance of what
is happening.

Baroque artists frequently, avidly show us scenes of torture and
murder. But in every case, the artist takes a moral stand and either
interprets the scene as God's judgment on the wicked or orchestrates his
compositions so that we are immediately moved to pity. This pity is then
given suprapersonal meaning by being resolved in divine consolation:
The martyred saint is given his glorious reward as his soul flees the earth

and finds refuge and redress before God's throne. So compact and orderly is Baroque composition that the dream of cruel death and glorious resurrection can be swiftly and convincingly told within the same picture.

Goya's martyrdoms distinguish themselves by not being sacrificial in nature. No purpose is being served by all this anguish and blood. All things and all occurrences are equal in value and have no way of revealing a higher purpose in either death or life. If there is to be a point to all this slaughter, then we must find it for ourselves. Observed experience is insufficient. By seeming impartial in his construction of figures and events observed, Goya goads us into taking a spontaneous and purely personal position. No one who witnesses the bland ferocity of these events can escape taking sides, and by taking sides, one involuntarily gives significance to human life and death even though life and death are without *a priori* values. The visual syntax of Goya's patterns marks more than a revolution in esthetics or in the perceptive sensibility of modern artists. It is demanded by an equally revolutionary moral purpose. It proclaims that the only true meaning of existence arises from our instinctive rebellion against the meaninglessness we witness in nature and in history [Fig. 10-4].

. . . Goya buries the comforting myth of man being made in the image of God, of man being the incarnation of the highest good and the highest beauty of the universe. The body of man, for untold centuries represented

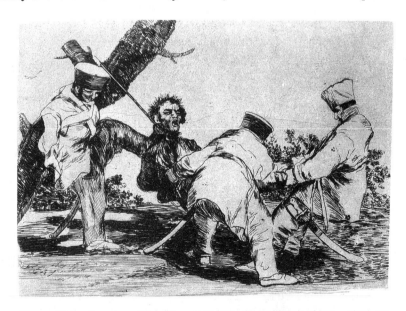

Figure 10-4. Francisco Goya, *Por qué?* (Why?), Disasters of War, Plate 32. National Gallery of Art, Washington, D.C., Rosenwald Collction.

as an object of reverence, is for the first time rendered as corrupt and repulsive, bereft of nobility, and bearing no trace of the spirit that once inhabited it. . . .

The figure of a corpse sinking into its tomb (Plate 69 . . .), while writing the word "Nothing" ("*Nada*") on its own tombstone, marks the furthest point in Goya's desperation. The later plates of *The Disasters of War* return to a more familiar, though not always understandable, form of expression. Some comment on the futility of human charity, on clerical abuses, on the heart-rending scenes of famine that came in the wake of war, and some are startling indictments of those who remain complacent in spite of the horrors they witness.

One of these plates stands out as the most prophetic and fearsome because its allegory is couched in hideously realistic form. In Plate 62 [*Las camas de la muerte* (The beds of death)], Goya makes his supreme statement concerning the condition of modern man, and he does so in the simplest, most emphatic manner possible. A great mass of corpses (the debris of a bombardment? of famine? of pestilence?—it hardly matters) has been laid out in the nocturnal streets preparatory to being carted off to the communal grave. Each of the corpses is hidden in its shroud, but one is not quite dead. Unconscious, impelled only by the terrible energy that animates all of us without reason or purpose, this zombie has arisen from the heap of cadavers and wanders blindly off into the night. There is nowhere to go, and even if there were, he couldn't see his goal because the shroud falls over his eyes. Yet on he walks with the clumsy steadfastness of a golem. Life is converted into mere locomotion. . . .

. . . The degradation of the human figure under the impact of torment and agony can best be illustrated by drawings that Goya executed either during the period in which he was working on the *Disasters* or slightly later. Dealing with the torture chamber, the most impressive of these drawings . . . shows a man tied to two racks, and so torn and twisted is he by pain and by the antagonistic pull exerted by torture instruments that it becomes impossible to tell front from back. By comparison, earlier depictions of torture by Callot or Magnasco or Urs Graf are merely piquant bits of gallows humor.

Similar deformations occur in other plates of the *Disasters* as well as in *The Third of May*. The human body is no longer a manifest ideal shape that demands respect. It becomes, instead, a vehicle for expression that can be changed about and used with an almost offhand indifference. Naturally, earlier periods had changed the proportions of figures and rendered them with varying degrees of realism. But the essential respect for the human body as an expression of divine order is basic to all artists from Giotto on. The change in attitude in Goya (and in a different way also in the work of Goya's contemporary, John Flaxman) can best be

compared with the change that occurred at the time of the disintegration of the ancient classical world. The human body loses its integrity and becomes a mere abbreviation, a form that is reminiscent of the body but no longer praises its beauty or shows any interest in the organic coherence of its various parts. . . .

In the face of these grim admonitions that seem to be beyond hope and beyond appeal, and in the face, also, of the fact that Goya never tried to publish the *Disasters* during his lifetime, one cannot help but ask if they are addressed to anyone at all. Why admonish the world, if you believe that your reprimands will go unheeded because it is the fate of mankind to be either killer or victim? A page from a martyr who lived in our own day and age may help us. In her memoirs, Nadezhda Mandelstam writes: "I have often asked myself whether it is right to scream out when you are beaten and people trample on you. Wouldn't it be nobler to burden oneself in demonic pride and to face the torturers with disdainful silence? But I have arrived at the conviction that in this last scream there are the last traces of human dignity and confidence in life. By screaming, a man defends his right to live, sends a message to those who are still free, demands help and resistance, and expresses his hope that there is still someone left who can hear. When nothing else remains, one must scream. Silence is the ultimate crime against humanity." Goya's own deafness was the smallest part of his tragedy. It is our deafness that brings his tragedy to its climax.

Note

1. P.-P. Plan, *Jacques Callot, maître graveur* (Brussels and Paris, 1914).

11

The Birth of Socialist Realism from the Spirit of the Russian Avant-Garde

Boris Groys

I

Increasing attention has recently been devoted by students of Soviet culture to the period of transition from the avant-garde of the 1920s to the Socialist Realism of the 1930s and 1940s.[1] This transition had not previously seemed problematic: it was usually regarded as the result of the crushing by Stalin's conservative and despotic regime of the "true, contemporary and revolutionary art of the Russian avant-garde" and the propagation of "backward art," reflecting the low cultural level both of the broad masses of the Soviet population and of the Party leadership, in the spirit of nineteenth-century naturalism. As the materials of that period have come to be more closely studied, such a purely sociological explanation of this transition has ceased to be satisfactory.

Firstly, an essential difference, which is justly stressed by Soviet art criticism, cannot but be observed between nineteenth-century realism, which Soviet art history customarily calls 'critical realism', and the art of Socialist Realism in their approach to the subject represented: Socialist Realism has a positive relationship to its subject, its aim, often affirmed, being "to hymn Socialist reality," not to keep it at arm's length and treat it objectively and "realistically." . . .

Socialist Realism shows the exemplary and the normative, which

From *Culture of the Stalin Period*, ed. Hans Gunther, copyright © 1990 School of Slavonic and East European Studies, University of London. Reprinted by permission of St. Martin's Press, Incorporated.

are worthy of emulation. Nevertheless, it cannot be considered a new version of classicism, although classical elements may indeed be found in Socialist Realist artistic compositions. Although antiquity and the Renaissance were highly praised by Soviet critics, the art of Socialist Realism is without the direct antique stylisation so characteristic, for example, of the art of Nazi Germany, which is in many other respects quite similar. Socialist Realism judges the reality created in the Soviet Union to be the highest achievement of the entire course of human history and does not, therefore, oppose the antique ideal to the present as a "positive alternative" or "a utopia already once realised,"[2] as has so often been done in West European modern art. Socialist Realism is just one of the ways in which world art in the 1930s and 1940s reverted to the figurative style after the period of relative dominance of avant-garde trends. . . .

All this indicates that the Socialist Realism of the Stalin period is an original artistic trend with its own specific stylistic features, which cannot simply be translated into other artistic principles and forms familiar from the history of art. . . .

. . . The specific quality of Socialist Realism is that it seeks by artistic means that are sufficiently close to conventional nineteenth-century realistic painting—above all the Russian Peredvizhnik school—to express a completely different ideological content in completely different social and historical conditions, which naturally leads to a fundamental disruption of the form of traditional realistic painting itself. Thus, difference of form proves to be bound up with a definite purpose in regard to content, to ignore which may result in a quite inadequate interpretation of the formal difference, as has often happened in the past.

A similar situation occurs in relation to the art of the Russian avant-garde. This is often regarded in an aestheticised, purely formal, stylistic light,[3] although such a view is opposed to the objectives of the Russian avant-garde itself, which sought to overcome the traditional contemplative attitude towards art. That, today, the works of the Russian avant-garde hang in museums and are sold in galleries as "works of art" like any other works of art should not make us forget that the artists of the Russian avant-garde strove to destroy the museum, to wipe it out as a social institution, ensuring the future currency of the modern idea of art as the "individual" or "hand-made" production by an artist of objects of aesthetic contemplation which are then consumed by the spectator. As they understood it, the artists of the Russian avant-garde were producing, not objects of aesthetic consumption, but projects or models for a total restructuring of the world on new principles, to be implemented by collective actions and a social practice in which the difference between con-

sumer and producer, artist and spectator, work of art and object of utility, and so on, disappeared. . . .

. . . Like the art of the Russian avant-garde, the art of Socialist Realism wanted to go beyond the bounds of the traditional "artist-spectator-aesthetic object" relationship and become the direct motivating force of social development. The collectivist project of Socialist Realism was expressed in rejection of the artist's individual manner, of direct perception of nature, the quest for "expressiveness" and "picturesqueness" and, in general, all that is characteristic of traditional realistic art and, in particular, of the art of the Russian Peredvizhniki. As a result, Socialist Realism is often judged to be traditional realism of "low quality" and it is forgotten that Socialist Realism, far from seeking such artistic quality, strove, on the contrary, to overcome it wherever it reared its head. Socialist Realist pictures were regarded by Socialist Realism itself as at once works of art and utilitarian objects—instruments of Socialist education of the working people—and as a result could not but be standardised in a certain way in accordance with their utilitarian function.

In this elimination of boundaries between "high" and "utilitarian" art Socialist Realism is the heir not so much of traditional art as specifically of the Russian avant-garde: Socialist Realism may be said to be the continuation of the Russian avant-garde's strategy by other means. This change of means is not, of course, fortuitous and will be singled out for special examination later. But it cannot be regarded merely as something imposed from outside, artificially breaking off the development of the avant-garde, which otherwise would have continued in the spirit of Malevich or Rodchenko. It has already been noted that, in any case, by the end of the 1920s the artists of the Russian avant-garde had begun to return to representational principles. While Malevich had adopted a new interpretation of traditional painting, Rodchenko, El Lissitsky, Klutsis and others were increasingly devoting themselves to photo-montage, which in the framework of the avant-garde aesthetic, signified in fact a turn towards figurativeness while preserving the original avant-garde design.

This design, which consisted in moving from portraying life towards artistic shaping of life, is also the motivating force of Socialist Realism. The Russian avant-garde adopted from the West a new relationship, developed within the framework of cubism, to the subject of art as a construct and made it the basis of a project for the complete reconstruction of reality on new principles. . . .

. . . Behind the external, purely formal distinction between Socialist Realism and the Russian avant-garde (a distinction made quite relative by the photo-montage period and by the art of such groupings as OST), the unity of their fundamental artistic aim—to build a new world by

the organisational and technical methods of "Socialist construction," in which the artistic, "creative" and utilitarian coincide, in place of "God's world," which the artist was able only to portray—should, therefore, be revealed. While seeming initially to be realistic, the art of "Socialist Realism" is, in fact, not realistic, since it is not mimetic: its object is to project the new, the future, that which should be, and it is for this reason that it is not simply a regression to the mimesis of the nineteenth century, but belongs wholly to the twentieth century. The central issue of Socialist Realism remains, incidentally, why and how the transition took place from planning in the spirit of the avant-garde to planning in the spirit of realism. This transition was connected both with the immanent problems of avant-garde art and with the overall process of Soviet ideological evolution in the 1920s and 1930s, which can be described here only in the most general terms.

II

... [T]he decisive step towards interpreting art as transformation rather than representation was taken by Malevich in his works and writings. ... Malevich's *Black Square* marked the recognition of nothingness or absolute chaos lying at the basis of all things. For Malevich the black square meant the beginning of a new age in the history of man and the cosmos, in which all given forms of cosmic, social, psychological or other reality had revealed their illusoriness.

Malevich possessed a contemplative and mystical nature and rejected technical progress and social organisation on more than one occasion as attempts artificially to impose definite goals on life after the traditional aims of Christianity had been discredited. At the same time Malevich concluded from his discovery that a new restructuring of the world with the object of restoring lost harmony and a kind of "aesthetic justification of the world" was necessary.[4] Malevich's "arkhitektony" or "planity" were conceived as projects for this restructuring and his suprematist compositions were at one and the same time direct contemplations of cosmic internal energies and projects for a new organization of the cosmos. ...

The logical conclusion from the concept of Malevich's suprematism as the "last art" was drawn by, among others, the constructivists Tatlin and Rodchenko, who called for the total rejection of easel painting in favour of direct design of the new reality. This rejection undoubtedly arose from the immanent logic of avant-garde artistic development and may be observed to a greater or lesser extent in the West: for example, in the activities of the Bauhaus which, it may be noted, did not come into

being without Russian influence, the Dutch group De Stijl and others. However, the radicalism of the constructivist position can be explained only by the specific hopes aroused in artists by the October Revolution and its slogan of the total reconstruction of the country according to a single plan. If, for Marx, philosophy had to move from explaining the world to changing it, this Marxist slogan only confirmed for the artists of the Russian avant-garde their goal of relinquishing portrayal of the world in favour of its creative transformation.

However, these parallels between Marxist and avant-garde attitudes show in themselves that the artist with his "life-building" project was competing with a power that also had as its goal the total reconstruction of reality, but on economic and political, rather than aesthetic, principles. The project to transform the entire country—and ultimately the entire world—into a single work of art according to a single artistic design through the efforts of a collective united by common artistic conceptions, which inspired the Russian avant-garde during the first post-revolutionary years, meant the subordination of art, politics, the economy and technology to the single will of the artist: that is, in the final analysis to the will of one Artist, since a total project of this kind cannot result from the sum of many individual efforts. Marx himself, in an observation constantly quoted in Soviet philosophy and art history, wrote that the worst architect was better than the best builder bee, since the former had in his head a unified plan of construction.

. . . The rejection by the avant-garde of the artistic autonomy traditional of the modern age and the "bourgeois" relationship between "artist and spectator," understood as "producer and consumer," led in effect to the demanding of total political power for the artist in order to realise his project. . . .

The artists of the avant-garde are commonly accused of neglecting the human factor in their plans for reconstructing the world: that is, the fact that the generality of the Russian population then held utterly different aesthetic ideas. In essence, the avant-garde intended to make use of the political and administrative power offered it by the Revolution to impose on the overwhelming majority of the population aesthetic and organisational norms developed by an insignificant minority of artists. This objective certainly cannot be termed democratic. However, it should not be ignored that the members of the avant-garde themselves were hardly aware of its totalitarian character.

The artists of the avant-garde paralleled Marxism in believing that public taste is formed by environment. They were historical "materialists" in the sense that they thought it possible, by reconstructing the world in which man lives, wholly to rebuild his inner mechanisms of perception and judgment as well. . . . The artistic engineers of the avant-garde dis-

regarded man because they considered him to be a part of element of social or technical systems of, at best, of a single cosmic life, so that, for a member of the avant-garde, to be an "engineer of the world" also automatically meant being an "engineer of human souls." The avant-garde artist was above all a materialist in the sense that he strove to work directly with the material basis in the belief that the "superstructure" would react automatically. This avant-garde "historical materialism" was also connected with its purely "aesthetic materialism." The latter consisted in maximum revelation of "the materiality of material," "the materiality of the world itself," concealed from the spectator in traditional painting, which used material in a purely utilitarian way to convey a definite content.[5] . . . In practice, the art of the avant-garde . . . assumed an increasingly propagandist character that was not creative in the sense of productivism: avant-garde artists, lacking direct access to the "basis," turned increasingly to propagandising "Socialist construction" implemented by the political leadership on a "scientific foundation." The principal occupation . . . became the creation of posters, stage and exhibition design, and so on—in other words, work exclusively in the sphere of the "superstructure." . . .

III

Apart from the immanent laws of artistic development whereby, following a period of intensive development in a particular direction, art usually changes course when the impression forms that this development has entered a cul-de-sac and begins to move in a completely different direction, the reason for the changed character of the visual material with which the avant-garde had worked lay primarily in the changed position of the artist in Soviet society as it continued to evolve. Avant-garde art was a reductionist art that adhered to a new principle—it was advancing from Malevich's black square as the sign of absolute zero and absolute rejection of the world as it is. The art of the 1930s was confronted by a "new reality," the authors of which were political leaders, not the artistic avant-garde. If avant-garde artists had at first striven to work directly with the "basis," utilising political power in a purely instrumental way, by the 1930s it had become clear that work with the basis could be implemented only by the political authority, which did not brook competition.

A similar situation developed in philosophy. While Marxist philosophy had proclaimed the primacy of practice over theoretical cognition, this primacy was understood initially to denote the gaining by the philosopher of political power with the aim of changing the world instead of knowing it. But as early as the late 1920s and the beginning of the 1930s

the primacy of social practice could only be understood as the primacy of decisions by the political leadership over their theoretical interpretation, which led to the ultimate liquidation of the philosophical schools that had earlier emerged.[6] Similarly, artists, nurtured on the principle of the primacy of transformation over representation, could not but recognise, following their own logic, the dominance of the political leadership in the strictly aesthetic sphere as well. The artists left this sphere in order to subordinate political reality to themselves, but in so doing they destroyed the autonomy of the artist and the work of art, thus subordinating the artist himself to political reality "at the second move." Having made social practice the sole criterion of truth and beauty, Soviet philosophers and artists inevitably found themselves obliged to recognise political leaders as better philosophers and artists than they themselves, thus renouncing the traditional right of primacy. . . .

To write or "depict" the truth meant for the Soviet criticism of that time—and, indeed, still does—to show the objectives towards which social practice was in reality striving, not to impose objectives upon society from outside, as formalism tried to do, or to observe the movement of society towards these objectives as this really happened, which "uninspired naturalism" did. However, such a purpose presupposes that social practice develops not spontaneously, but with the object of realising certain definite ideals in the mind of the "architect" of this process, who is distinguished from "the very best bee." Naturally, the political leadership and, specifically, Stalin were seen in the role of architect.

It was, indeed, to Stalin that the avant-garde role of creator of "the beautiful in life itself," that is, the task of "transforming" rather than "representing" life, passed during the 1930s. The political leadership responded to the demand by philosophy and art for political power in order to realise in practice their plans for reconstructing the world by appropriating philosophical, aesthetic and other significance to itself. As the artist of reality, transforming it in accordance with a unified plan, Stalin could, by the logic of the avant-garde itself, demand that others standardise their style and direct their individual efforts towards bringing it into harmony with the style of the life given shape by Stalin. The demand to "paint life" has meaning only when that life itself becomes a work of art. The avant-garde had previously rejected this demand, since, according to the formula "God is dead," it no longer perceived the world as the work of God's art. The avant-garde artist laid claim to the vacant place of the total creator, but in fact this place had been filled by the political authority. Stalin became the only artist, the Malevich, so to speak, of the Stalin period, liquidating the avant-garde as a competitor in accordance with the logic of the struggle—a logic which was not foreign to avant-garde artists, either, who willingly resorted to administrative intrigues.

Socialist Realism, with its collectivist ideas, strove for a single, unified style, as did suprematism, for example, of the analytical art of Filonov. It should not be forgotten that the stylistic variety of the avant-garde was associated with constant splits and struggles among leading artists, which are reminiscent in this respect of the struggle during the early stages of evolution of the Communist Party. Within each fraction, however, discipline and the striving for standardisation prevailed, making, for example, the faithful disciples of Malevich almost indistinguishable. Such standardisation inevitably resulted from the ideology of the avant-garde, which scorned individualism and the objective for an artist of a "unique manner" to good effect and stressed adherence to the "objective laws of composition": the new world could not be built on a polystylistic basis and the cult of personality of the single, unique artist-creator was, therefore, deeply rooted in avant-garde theory and practice. Of course, individual variations were always possible within the framework of a school, but these were as a rule explained by the necessity for broadening the sphere of reality that was embraced, that is, in terms of the individual nature of the specific task and not that of the artist.

A similar situation confronts the student of the art of the Stalin period. Contemporary artists were in essence "followers of Stalin" (by analogy with "followers of Malevich"), who all worked in the "Stalinist style," but with variations depending on whether their task was to portray the great future, hymn the workers of factory or field, struggle against the imperialist inciters of war or depict the building of Socialism in this or that particular national republic. In all these situations style underwent definite changes, while at the same time the general trend was nevertheless towards elimination of these subject-related differences. Thus, artists, particularly during Stalin's last period, described in detail and with pride how they had succeeded in freeing themselves of all tokens of individual style and even of the characteristic "non-typical" principle of the subject represented.[7]

The criticism of the Stalin period constantly demanded that artists bring their vision closer to the "normal" vision of "normal" Soviet people, the creators of the new life. In the last years of Stalin's rule the "team method" of manufacturing pictures, directed at completely overcoming the individuality of a particular painter, was widely practised. Thus, the Soviet artist of the Stalin period did not occupy the position of a realistic reflector of the new reality. . . . The artist of Socialist Realism reflected not reality itself, but the ultimate goal of its reconstruction: he was at once passive and active in that he varied and developed Stalin's thinking on this.

The difference between Socialist Realism and the avant-garde consists of the first instance not in their relationship to art and its goals,

but in the area of application of this new relationship: while the avant-garde . . . directed itself towards forming actual material reality, Socialist Realism set itself above all the goal of forming the psychology of the new Soviet person. The writer, following Stalin's well-known definition, is "an engineer of human souls." This formulation points both to continuity with the avant-garde (the writer as engineer) and to a departure from it, since a new area of application is provided for the avant-garde principle of engineering design after responsibility for projecting reality itself has been assumed by others. At the same time this role proved to be still more an honorary one, since the initial slogan of the Five-Year Plan, "technology decides everything," was soon replaced by another—"the cadres decide everything."

However, the problem of projecting the New Man presents the artist with tasks other than those of projecting material reality. In the absence of what might now be called "genetic engineering," the artist is inevitably tied to unchanged human appearance—from which, in essence, also emerges the necessity of turning again to traditional painting. This represents not only the statement of achieved successes, but also an acknowledgement of certain limits. It is in this sense that Socialist Realism is "realistic": realism here stands opposed as realpolitik to the utopianism of the avant-garde. The task of educating the New Man proved significantly more difficult than had been initially supposed. . . .

Practically all art criticism of the Stalin period was devoted to endless analysis of the poses and facial expressions portrayed in Soviet pictures in relation to the psychological content they conveyed. . . . [I]n time artists and critics jointly elaborated a distinctive and quite complex code for external appearance, behavior and emotional reaction characteristic of the "true Soviet man" which embraced the most varied spheres of life. This highly ritualised and semanticised code enables any Soviet person brought up inside Stalinist culture to judge from a single glance at a picture the hierarchical relationships between the figures, the ideological intentions of the artist, the moral characteristics of the figures and so on. This canon was elaborated over many years before gradually disintegrating. In many paintings and in articles on them, wherein were defined the poses and facial expressions that should be considered "flabby," "decadent" and bourgeois or, conversely, energetic, but energetic in the Soviet rather than in the American or the Western style, that is, with a genuine understanding of the prospects for historical progress, which pose could be considered inspired, but not exalted, which calmly brave, but not static, and so on, a new canon was painfully worked out in light of the recognition that direct reliance on the classical models of the past was impossible. . . .

. . . [T]he appearance of man in art is directly linked by Tugendkhol'd

to the discovery of the relative independence of the superstructure from the level of production. Man and his organising attitude towards technology are at the very heart of the definition of the new social system, which is thus in part given a psychological foundation. The extreme expression of this new "cult of personality" in art is, of course, the concentration on the figure of Stalin as the creator of the new life *par excellence.*

It is also Tugendkhol'd who notes that the decisive move towards the portrayal of man was connected with the death of Lenin, when "everyone felt that something had been let pass."[8] In future it was to be the image of Lenin and, later, Stalin that stood at the centre of Soviet art as the image of the ideal, the exemplar. The numerous portraits of Lenin and Stalin, which may seem monotonous to the contemporary observer, were not monotonous to the artists and critics of that period: each was intended to "reveal a side of their multi-faceted personality" (recalling somewhat Christ's iconography, in which different, dogmatically inculcated means of presenting the personality of Christ in its various aspects are contained). These portraits were associated with a definite risk to the artist, since they represented not only an attempt at an external likeness, but also a meaningful interpretation of the personality of the leaders that had no less ideological and political significance than a verbal or literary interpretation. Characteristically, a portrait was invariably condemned as a failure both when the critics failed to find this type of clear-cut interpretation in it and when the interpretation was seen as "unoriginal."

By the end of Stalin's rule Socialist Realist art had begun to move increasingly evidently towards the creation of an integral, monumental appearance for Soviet cities and, ultimately, a unified appearance for the entire country. Plans were drawn up for the complete reconstruction of Moscow in accordance with a single artistic concept and painting was being increasingly integrated with architecture while conversely, buildings of a functional character—factories, underground stations, hydroelectric stations, and so forth—were taking on the character of works of art more and more. Portraits of Lenin and Stalin as well as of other leaders, not to mention the "typical workers and peasants," gradually became increasingly depersonalised and depsychologised. The basic canon was already so formalised and ritualised that it was now possible to construct a unified reality from elements created in preceding years.

Of course, this new monumental style bore little external resemblance to the avant-garde, yet in many respects it realised the latter's aims: total aestheticisation of reality and the rejection of individualised easel painting and sculpture that lacked monumental purposes. . . .

. . . In the profoundest sense Socialist Realism remained the heir of the avant-garde to the end. Like the avant-garde, it regarded the present age as the highest point of history and the future as the embodiment of

the aspirations of the present. Any stylisation was, therefore, foreign to it and, for all the monumentality of their poses, Lenin was represented without any feeling of clumsiness in jacket and cap and Stalin in tunic and boots.

This teleological perception of history led inevitably to an instrumentalisation of the artistic devices of the past and to what, seen from the outside, was taken as eclecticism, but was in fact not eclecticism. The art of previous ages was not regarded by Soviet ideology as a totality, which should not be arbitrarily dismembered. In accordance with the Leninist theory of two cultures in one culture, each historical period was regarded as a battleground between progressive and reactionary forces, in which the progressive forces were ultimately aimed at the victory of Socialism in the USSR (even if the clash took place in the remote past), while the reactionary forces were striving to block this. Such an understanding of history naturally led to quotation from the past of everything progressive and rejection of everything reactionary, which, viewed externally, seems to be extreme eclecticism, since it violates the unity of style of each era, but which, in the consciousness of Soviet ideology, possessed the true unity of everything progressive, truly popular and eternal and rejected everything ephemeral and transitory associated with the class structure of society.

Ideas of the progressive or reactionary quality of a given phenomenon have naturally changed with time and what is or is not subject to quotation has changed correspondingly. Thus, in the art of Socialist Realism quotation and "eclecticism" have a semantic and ideological, rather than an aesthetic, character. The experienced Soviet spectator can always readily decipher an "eclectic composition" which, in fact, possesses a unified ideological significance. However, this also means that Socialist Realism should not be conceived of as a purely aesthetic return to the past, contrasting with the "contemporary style" of the avant-garde, too.

The real difference between the avant-garde and Socialist Realism consists, as has already been stated, in moving the centre of gravity from work on the basis to work on the superstructure (avant-garde work on the superstructure being assumed by Stalin), which was expressed in the first instance in projecting the New Man as an element of the new reality rather than in merely projecting its purely technical, material aspects.

If, thereby, Socialist Realism finally crushed the avant-garde—to regard the avant-garde totally superficially as a purely aesthetic phenomenon, which contradicts the spirit of the avant-garde itself—at the same time it continued, developed and, in a certain sense, even implemented its programme. Socialist Realism overcame the reductionism of the avant-garde and the traditional contemplative standpoint associated with this reductionism (which led to the success of the Russian avant-

garde in the "bourgeois" West) and instrumentalised both man and the entire mass of culture of the past with the object of building a new, total reality as a unified work of art. The practice of Socialist Realism is based not on a kind of primordial artistic contemplation, like Malevich's "Black Square," but on the sum total of ideological demands, which in principle make it possible freely to manipulate any visual material (this circumstance, it may be noted, enabled preservation of the principles of Socialist Realism even after Stalin's death, although, visually, Soviet art has also undergone definite changes).[9]

By the same token Socialist Realism took the principle, proclaimed by the avant-garde, of rejecting aesthetics to its extreme. Socialist Realism, free of any concrete aesthetic programme—despite the external strictness of the Socialist Realist canon, it could be instantly changed in response to political or ideological necessity—is indeed that "nothing art" the avant-garde wanted to become. Socialist Realism is usualy defined as art "Socialist in content and national in form," but this also signifies "avant-garde in content and eclectic in form," since by national is meant everything "popular" and "progressive" throughout the entire history of the nation. Avant-garde purity of style is, in fact, the result of the still unconquered attitude of the artist towards what he produces as an "original work" corresponding to the "unique individuality" of the artist. In this sense the eclectic may be regarded as the faithful expression in art of a truly collectivist principle.

The collectivism of Socialist Realism does not, of course, mean anything like democracy. At the centre of Socialist Realism is the figure of the leader, who is simultaneously its principal creator (since he is the creator of Socialist reality itself, which serves as the model for art) and its main subject. In his turn Stalin as leader, has no definite style—he appears in different ways in his various persons as general, philosopher and theoretician, seer, loving father of his father and so on. The different aspects of Stalin's "multi-faceted personality," usually incompatible in an ordinary person, seem eclectic in turn, violating standard notions of the original, self-contained human personality: thus, Stalin—as a figure in the Stalin myth, of course—unites in himself the individual and the collective, taking on superhuman features which the artist of the avant-garde, although he, too strives to replace the divine project with his own, nevertheless lacks.

If, at first glance, the transition from the original style of the avant-garde to the eclecticism of Socialist Realism appears to be a step backwards, this is only because the judgment is made from a purely aesthetic standpoint based on the unity of what may be called the "world museum." But Socialist Realism sought to become the world museum itself, absorbing everything progressive and worthy of preservation and rejecting

everything reactionary. The eclecticism and historicism of Socialist Realism should, therefore, be seen not as a rejection of the spirit of the avant-garde, but as its radicalisation: that is, as an attempt ultimately to identify pure and utilitarian art, the individual and the collective, the portrayal of life and its transformation, and so on, at the centre of which stands the artist-demiurge as the ideal of the New Man in the new reality. To repeat: overcoming the concrete, historically determined aesthetic of the avant-garde meant not the defeat of the avant-garde project, but its continuation and completion insofar as this project itself consisted in rejecting an aestheticised, contemplative attitude towards art and the quest for an individual style.

Notes

1. H. Günther, "Verordneter oder gewachsener Kanon?" in *Wiener slawistischer Almanach*, vol. 17 (Wien, 1986), pp. 305–28.

2. Annemarie Gethmann-Siefert, "Das klassische als das Utopische. Überlegungen zu einer Kulturphilosophie der Kunst," in *Über das Klassische* (Frankfurt a.M., 1987), pp. 47–76.

3. Lodder links this aestheticisation of the Russian avant-garde in the West with the Berlin exhibition of 1922. Christina Lodder, *Russian Constructivism* (Yale University Press, 1985), pp. 227–30.

4. K. Malevich, "God is not cast down," in K. Malevich, *Essays on Art* (Copenhagen, 1968), vol. 1, pp. 188–223.

5. H. Gassner, *Alexander Rodschenko. Konstruktion 1920* (Frankfurt a.M., 1984), pp. 50–51.

6. Ijegosua Jachot, *Podavlenie filosofii v SSSR (20–30 gody)* (New York: Chalidze Publications, 1981).

7. Yu. Neprinchev, 'Kak ya rabotal nad kartinoi *Otdykh posle boya* (Moscow: *Iskusstvo*, July-August 1952), pp. 17–20.

8. Ya. A. Tugendkhol'd, op. cit., p. 31.

9. For example, *Aspekte sowjetischer Kunst der Gegenwart*, exhibition at the Museum Ludwig (Cologne, 1981).

12

Can Political Passion Inspire Great Art?

Michael Brenson

The most provocative topic in the art world this year is once again the relationship between politics and art. Instead of speculating on suspected artist-dealer-curator-collector-critic-media conspiracies—although there is, of course, still plenty of talk about that—citizens of the fastest and most fashion-plagued art world anywhere are now talking about social responsibility, ideology, nuclear war and changing the world.

Why this has happened now, and whether the quality of the political art that is the subject of widespread critical and curatorial attention is commensurate with the sound and fury that has surrounded it are two of the questions raised by the latest art and politics revival.

Evidence of art that is political in content or ambition is everywhere. It was featured in the two winter exhibitions at the New Museum of Contemporary Art: "The End of the World: Contemporary Visions of the Apocalypse" and "Art & Ideology." It has been or is being featured in a number of university art galleries in Boston and New York. Many of the major figures identified with political art, including Robert Colescott, Leon Golub, Barbara Kruger and Nancy Spero, have recently had one-person exhibitions in New York. The first retrospective devoted to Leon Golub, who is the cornerstone of the present interest in political art, will open at the New Museum next fall.

There have also been articles, benefit exhibitions and group exhibitions presenting artists' responses to the threat of nuclear war, as well

as a symposium on "War in Art" at Cooper Union last February. The poster for "Artists Call Against U.S. Intervention in Central America" contained a petition signed by well over 1,000 artists, poets and performers. Artists Call also organized benefit exhibitions at more than 20 New York exhibition spaces, including the prominent Leo Castelbi, Paula Cooper, Terry Dintenfass and Marion Goodman Galleries.

Such political issues, however, as well as political involvement on the part of artists, are hardly new phenomena: What is new both in the current political art and the debate which surrounds it—is that the definition of "politics" has expanded to the point where, at the moment, it seems as if it might supercede [sic] and swallow up all artistic criteria. Within some art and art-critical circles, "political" now applies to cultural imagery, the functioning of the art market, the artist's attitude towards any subject and the creative process itself. In other words, the word "political" has become a filter through which all art can be perceived and judged.

Although the intense debate about politics and art has produced insights into the intersection of culture and art and experiments in new forms of expression, it has also unleashed a potential for dogmatism and intellectual intimidation that poses real dangers for art and artists. For example, it can lead some artists to mistake moral outrage or a correct ideological stance for artistic achievement; it can lead others to pull back from the issues of the day altogether. An attempt to sift through current political art is therefore essential.

Since the road to first-rate art has never been paved with good intentions, or good theory alone, the first question is what makes for good, or great, political art. Historically, examples of such art are surprisingly rare, testifying to the difficulty of transforming political outrage or themes into work that has anything but the most perfunctory effect. It is a telling paradox that the most enduring political art has probably been made by those who were not primarily political artists. When Goya etched his "Disasters of War" and in 1814 painted his "Third of May 1808," whose theme is the savage reprisals of the occupying French forces to the Spanish resistance, he was more than 60 years old, with a lifetime of art and the broadest experience of people behind him. Picasso, like Goya, was steeped in the history of art and concerned throughout his life with the entire human condition. When he painted "Guernica," he was 56, and all that he had lived and painted and thought about up to then went into it. "Guernica" and the "Third of May" remain such huge moral statements— such strong reminders of the need for a vigilant political conscience— because of the human and artistic wisdom that went into them.

In the 20th century, perhaps for the first time, schools and even entire directions in art emerged from and remained in the service of a

specific ideology. Of all the examples of 20th century political art, none was more wholly political than Agitprop, the art of revolutionary propaganda in Russia after the Revolution. Agitprop involved a great many artists, including Kasimir Malevich, Liubov Popova and Alexander Rodchenko, who produced all kinds of work for use in daily life, from posters to porcelain to buses and trains.

One of Agitprop's modernist traits was that it identified social change with artistic experimentation. Still, what survives from Agitprop is less the esthetic intelligence that informs some of the works than its extraordinary purpose and hope, which hangs over 20th century art like an artistic Eden. Since Agitprop rejected traditional forms of art and worked outside the commodity system in the service of an all-consuming dream, aspects of it will probably always reappear in art that sees itself as revolutionary. For example, Mike Glier's paintings of "Women Calling" are like Agitprop posters in the way they try to direct people toward a simpler, less stereotyped society. But Agitprop is a form of propaganda art, and such art is invariably facile outside a shared system of belief.

At about the same time, a number of artists in Germany were making political protest art that grew not out of a revolutionary dream but the nightmare of the Great War and which could hardly be more disabused. The work of George Grosz and, to a much greater degree, Otto Dix and Max Beckmann, has aged well because of its independence and the artistic intelligence behind it. In part because of the corrosiveness with which someone like Dix exposed the face of war and the social and political life of post–World War I Germany, Expressionism will continue to be an essential language of rage and protest. It informs the work of the contemporary American artists Peter Saul and Robert Colescott, who have been making art with political content since the 1950's. It is also present in the paintings of a younger artist like Sue Coe, who builds her jagged compositions and distorts her figures in order to communicate her outrage at violence to women.

The 1930's also produced American Social Realism, which was, in part, a response to the oppressive political and social conditions of the Depression. Artists such as Ben Shahn, Raphael Soyer and Jack Levine wanted their work to be an indictment of society and an instrument of social change. They tended not to preach but to try to use their realistic technique to convince the public of the violence of power and the plight of the common man.

Social Realists considered realism the language of hard truth, and with it produced a body of modest but admirable work. However, a very similar style was used for very different purposes in Soviet Social Realism, which followed in the wake of Agitprop, but which remains the epitome of art serving a monolithic state ideology.

Very little political work being produced today suggests either broad artistic or human knowledge. Of the many dangers of political art, one of the most lethal is that it grants artists the license to believe that what matters is only the immediate outrage of the present.

The claim of one prominent political artist, Hans Haacke, that "so-called political art is scrutinized much more carefully" and that it is much harder for political artists to "get away with mediocre works" is patently unjustified. There is no better evidence of this than the high visibility of his own factual commentaries. His "Isolation Box," displayed at the Graduate Center of the City of New York Mall as part of Artists Call, is an eight-by-eight-by-eight-foot wooden box with a sign on it saying: "isolation box as used by U.S. troops at Point Salines Prison Camp in Grenada." This kind of simplistic piece tells us far less about troubled United States Caribbean waters than the searching non-political paintings by Eric Fischl, which use a black-white tension in the Caribbean as a starting point for an exploration of turbulent emotional and sexual currents.

If it is to appeal to more than a coterie of already convinced sympathizers, political art needs more than theory and a correct point of view. Unfortunately, very little of it produced today has the complexity and mastery to be able to stand on its own merit.

It is impossible to cover the entire territory of contemporary political art. However, it is clear that the most global political issue, the danger of nuclear arms, has produced the broadest range of work. A 1983 painting-sculpture by Robert Morris, called "Untitled," which wound up on the covers of *both Arts* and *Art in America* this month—a highly unusual coincidence—is rare in its combination of commitment and introspection. By giving the painted conflagration in the center of the work a lyrical majesty, Morris makes clear that the idea of a definitive holocaust is also, from a visual artist's point of view, fascinating and compelling. Because of the seductive beauty of the fire storm beginning to build in the central panel, the skulls in the relief above the painting and the defiant fists in the relief below have a complexity and impact that otherwise they would not have.

Beverly Naidus's "This Is Not a Test," an installation in "The End of the World" exhibition, is an example of the kind of sophomoric good will with which so much anti-nuclear art is informed. Consisting of the most primitive kind of ramshackle shelter, with a bed and a lamp inside, it is almost a strong work. The care and craft with which the hut has been pieced together in the service of a transient and troubling statement is undermined, however, by a writing stand in front of the hut on which visitors can write down their thoughts. Suddenly we are back in college and the work becomes tacky.

A major impetus for political art now is feminism. Feminist artists

tend to reject existing political and artistic systems and, as a result, to produce work in alternative artistic media. Perhaps the most prominent feminist art depends heavily upon photographs and words, in part in an attempt to expose what is seen as this culture's ideological brainwashing through advertisements and the popular media; in part to create works that are not beautiful objects and therefore less capable of being "coopted" into the art world gallery, museum and commercial system. One of the assumptions in the commercial-art based work of Erika Rothenberg and Barbara Kruger is that what goes on in advertisements is instrumental to the repression of women and to the national tolerance for such events, let's say, as the invasion of Grenada or the mining of Nicaraguan ports.

Barbara Kruger, whose work is presently touring Europe, is the most forceful feminist artist working with the techniques of commercial art. Kruger takes stereotyped photographed images, then blows them up and crops them. Then she adds words. Her works are attempts to question not only general cultural attitudes, but also the conditions in which art is made and sold. She is most involved with questions of class. "I am not concerned with issues if they are not going to be anchored by some kind of analysis or consideration of class," she has said.

In the work of hers that has been acquired by the Museum of Modern Art, the words "You Invest in the Divinity of the Masterpiece" appear in three sections across a photograph of Michelangelo's "Creation of Adam" on the Sistine Ceiling. The painting is a work by a man, of men, that has come to symbolize the divine spark for everyone. Kruger's work is angry and mocking of what some artists and critics see as a mythology of the masterpiece and the genius. The "You" in the work is both declarative and accusatory. Rubbing the two together is clearly intended to create a spark that will make viewers reflect on their own position with regard to the work and to the conjunction of words like "invest" and "masterpiece."

No matter how sharp the insight behind it, however, Kruger's didactic work quickly becomes predictable. At best, it could become a political fact, a kind of moral deterrent. As of now, however, her work remains uneven, and so limited in its intellectual and emotional range that a little bit of it goes a long way.

The work of Nancy Spero, another feminist artist and a founder of the women's art movement, has far greater breadth. Spero studied art and makes use of it, particularly the Primitive and Oriental art traditions. For some time, she has been involved with scrolls which often tell stories about the mistreatment of women. Her 125-foot long "Torture of Women" scroll includes many Amnesty International reports of the brutalization of women alongside an ancient Sumerian myth which expresses, in the artist's words, "what must have already been the timeless fear, hatred and cruelty directed toward women."

Juxtaposed with the words, in different-sized type and in what ap-

pear to be disordered and even disoriented patterns, is a lot of empty space and a number of Spero's confused, victimized or defiant figures. In Spero's art, the mistreatment of women and human violence in general is identified with men. Despite her rage, however, and a tendency toward overstatement, her work is not as dogmatic, not as superior in its viewpoint as it may seem. These are works which cry out at us, but which also cry out to us. The balance between outrage and need, defiance and silence is almost impossible to maintain. As much as what she is saying, her attempt to maintain that balance makes her work important.

The best political art has always been art first and politics second. Picasso knew, for example, that it was only by making the bombing of the Spanish town of Guernica into art that people could relate to the bombing enough to experience it as a terrible political act. It is too early to know whether the Swiss painter Gregoire Muller will produce first-rate political art, but the way he used his esthetic intelligence against a political subject in his recent exhibition at the Oil & Steel Gallery makes him an artist worth following. His images of violence in the Middle East and the Philippines create a sense of familiarity on two normally mutually exclusive levels: political events and the history of art. In a painting such as "The Death of Ninoy," based on a newspaper photograph of the assassination last year of Philippine opposition leader Benigno S. Aquino Jr., (known to his supporters as "Ninoy"), esthetic intelligence is used against the content to make people feel something strong and terrible, which is a prerequisite to inspiring any political action.

Because of his recent political paintings, Leon Golub has become a subject of widespread interest and even reverence after being virtually ignored for around 15 years. Since 1976 he has been making paintings of terrorists, interrogators and mercenaries. They are big, bold and sometimes beautifully painted canvases with a texture that is raw and sensual at the same time. The paintings usually contain a group of men either just standing around, like men in a bar waiting restlessly for a television football game to begin, or involved in acts of depersonalized violence. In one painting, someone is being stuffed into a car; in another, a naked man is masked and bound in front of what looks like a torture machine. There are no buildings or landscapes in these paintings and the background is usually just one color.

Because the people in these works seem human and there is no specific sense of person and place, Golub's works are not morality plays. Although the images and titles bring to mind images of violence in Africa and Central America, there is no feeling of superiority on the part of the artist toward the victimizers and the subject matter. These works do not present evil as the property of one system, one sex, one race. The thugs in his paintings could be him, and they could be us.

What gives Golub's works their timeliness is that many of the threads

not only of current political art but of important contemporary art in general are woven into them. Along with their immediacy and their political subject matter, they are rooted in the history of art—they bring to mind 19th-century history painting, Color Field painting and Abstract Expressionism. They are also rooted in the popular media: trying to understand the mechanisms of sadism and torture, Golub rummages through newspaper photographs, sports pages and pornographic magazines. It is there that he finds his faces, postures, gestures and many of his compositional ideas. Ordering different aspects of our culture by means of a hard-won knowledge of pictorial composition gives his work a scope that almost no other body of contemporary political work in this country has or even seems to feel it needs.

And yet, it is only from such a synthesis of immediate observation, craft and the lessons of time—from the testing of political facts against one's own experience—that convincing and forceful political art can emerge.

13

The Mother and Child in African Sculpture

Herbert M. Cole

One fruitful approach to understanding African art is to examine common, recurrent images for the light they shed on artistic values and wider cultural patterns. The mother-and-child figure group is prominent among these thematic images, along with sculpture of the couple, the aggressive male, and the equestrian.[1] For many Westerners the mother-and-child is the most compelling, affective, and comprehensible of the four. . . . Due in part to the omnipresent biological model of a mother with her baby and in part to the common Christian icon of the Madonna and Child, the maternity image is easy for us to understand and appreciate in world art. Information on siting, use, value, and meaning in specific cultures contributes to a fuller understanding of the theme and its place in African thought. Variations of form and object type that are evident in the exhibition are briefly accounted for here, where we also survey the uses and contexts of the imagery.

Social and ritual contexts of mother-and-child imagery in Africa are rich and deep. Stereotypes of "an adoring mother embracing her baby" and "a mother with child as fertility figure" are partially wrong, as stereotypes so often are, or at best too limited in terms of the history and psychology of childhood in sub-Saharan Africa. African contexts for this imagery and its varied ascribed meanings suggest that it is erroneous to take the maternity theme for granted or to explain it in simple terms.

Poses, forms, and styles of mother-and-child figures vary greatly

This essay was originally published in an exhibition catalog of the Los Angeles County Museum of Art, 1986. Reprinted by permission of the author and the publisher.

across Africa and within specific ethnic groups. Probably the most common rendering is a seated mother with a supine child lying across her thighs, partially supported by her hands. The child may or may not be shown suckling. Common, but less frequent is the child on the back of a seated or standing woman. Many standing women hold children in front or in the more usual carrying positions, on hip or back, the former active and temporary, the latter passive and secure. African children are tied to their mothers' backs with cloth, freeing the women for other responsibilities. Occasional sculptural groups show a mother with two or, more rarely, three or four children. The positions and relative activity of children range from placidly recumbent to aggressively active, clutching the mother. . . .

Unfortunately we lack specific data on the meanings of many of these poses and positions. What is important to realize, however, is that differences in posture often reflect subtle differences of value within and among cultures. These specifics can be elucidated locally in some instances, while in other examples they may be variations that simply reflect the sculptors' virtuosity, perhaps their boredom with prevailing conventions stimulating innovative solutions. This condition surely prevails[2] among the prolific Yoruba sculptors, for their varieties of pose greatly exceed those known from any other people [Fig. 13-1].

Many maternity images are strongly conventionalized in position and style, showing economical simplification and anatomical distortion, for example, emphasis on the torso and particular focus on an enlarged head. Standardized treatment of faces and other body parts stems less from imitation of life forms than from inherited sculptural concepts. Kongo maternities (and others) are often rendered in an iconic, cross-legged posture that is more idealized and honorific than observed. . . . These recurring conventions often reveal ritual needs of a cult in which a known object of specific form takes precedence over both artists' and patrons' aesthetic concerns. Rarely is a sculptor asked to make a likeness of a particular person; rather he is commissioned to replace a decaying or lost image or to provide a new, "finer" one to embellish a shrine. Thus the politics of religion often prevail over creative impulses. Even so, each sculpture is a fresh artistic solution, a unique product of an individual artist, his time, and locale. Occasionally artists are able to stretch the limits of inherited forms, expanding the corpus of variations on a theme and perhaps establishing new conventions. In these respects the art of Africa is no different from that of any other place.

Mother-and-child figures have a long history on the continent. While the earliest representations are undoubtedly lost to us, two-dimensional paintings on the rock surfaces of Tassili and nearby sites in the now-dry Sahara Desert date back four or five thousand years. The earliest known

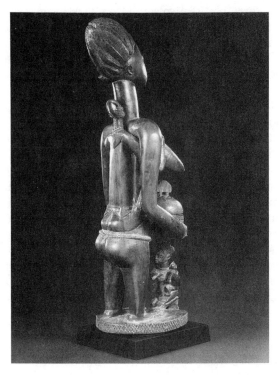

Figure 13-1. *Yoruba figure with bowl.* Wood, height 31¾″. Pace Gallery, New York.

sculptural renderings are terra-cottas ascribed to the Nok cultures of northern Nigeria, dated between 500 B.C. and A.D. 200. The next and most important prehistoric cluster of maternities occurs in the so-called Djenne corpus of terra-cotta sculptures from the inland delta of the Niger River in Mali. Djenne images are naturalistic or conventionalized. Some are lifelike renderings of infants and their mothers in natural poses, while others, showing a mother with one or two diminutive, but adult (e.g., bearded), offspring are clearly symbolic. Again precise uses and meanings are unknown. Djenne terra-cottas date from the thirteenth through fifteenth centuries A.D. Wooden mother-and-child figures probably have been carved for several millenia in many parts of the continent, but nearly all surviving carvings date from the late nineteenth and twentieth centuries.

This vast ethnographic corpus provides the great majority of images available for exhibition and study. Most of these works can be elucidated by quantities of anthropological and art historical data. While a majority are wood carvings (the prevailing medium for sculpture in Africa), a

number of fine terra-cottas also come from this recent period, along with mother-and-child images in ivory, sun-dried clay or mud, brass/bronze, and occasional examples in iron, stone, fiber, and applique beadwork. Virtually all were made by well-trained professional artists, most of them male, though in the case of Akan terra-cotta figures from southern Ghana . . . by female ceramic sculptors.

We are fortunate to know the names and working dates of a few of the artists represented in this exhibition. A father and son, both prominent artists from modern Ghana, each carved many pieces for Asantehene, paramount chiefs of the Asante nation. The father, Kwaku Bempah, died in 1936, while his son, Osei Bonsu, chief carver for three successive Asantehene, died in 1977 after a sixty-year career. Bempah's work . . . probably came from an Asante shrine, while Bonsu's . . . is a secular piece executed around 1930 as part of an ensemble of sculptures associated with a popular drumming group and its principal drum, elaborately carved in relief. This mother-and-child probably represents a queen mother of the Asante state for which it was commissioned (see Ross 1984). Bonsu often aggrandized and updated his figures, showing them seated in fancy European chairs rather than on the traditional Akan stool.

Despite our knowledge of several Asante, Yoruba, Dan, and Igbo artists' hands, it seems to have been uncommon for much attention to be given by patrons to personal artistic styles. The object itself is usually of primary importance, having a role that can be fulfilled satisfactorily by a mediocre work or a masterpiece. While our attention here is on what we (and surely the original patrons and users of these sculptures) consider finely executed pieces, it is well to realize that not all African sculptors produced great works of art. The continuing ritual demand for shrine sculpture, including mother-and-child groups, coupled with carvers' differing levels of skill, account for many ordinary works along with the few that may be considered great.

As a rule maternity imagery has a spiritual connotation and use, while in rare instances it appears in wholly secular contexts, as the Bonsu Asante example shows. Most maternity images are freestanding wood sculptures destined for shrines administered by ritual specialists, although the group also may embellish common objects, some of which are utilitarian, such as chairs and stools, architectural elements, combs, and bowls, as well as masks and wooden gongs.

The prevalence and recurrence of the maternity group attests to its importance in African life and thought, although it has uneven geographical distribution. The sculptors and patrons of the Kongo and Yoruba peoples, for example, have been very prolific advocates of the theme [Fig. 13-2]. Among these two groups, especially the Yoruba, countless variations in pose, size, shape, object type, medium, and even style occur.

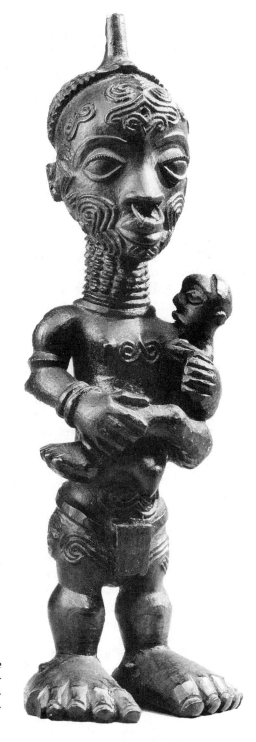

Figure 13-2. *Standing female figure with child*, Lulua Tribe, Congo-Kingshasa. Wood, metal ring, height 9¾". The Museum of Primitive Art, New York. Photo by Charles Uht.

Virtually every kind of Yoruba object features the theme: doors, house-posts, masks, dance staffs, political emblems, and a host of shrine imple-ments, such as bowls, stools, and freestanding statuary. By contrast neighboring and other West and Central African cultures, among them Benin, Fon, Lega, and Kalabari Ijaw, for whom the biological imperative of motherhood is no less important, have exploited the theme far less fully or not at all. Among the Edo of Benin, the Kuba, and the Fon, cult of male kingship are strong, thereby perhaps discouraging the mother-and-child theme; yet Cameroon, Yoruba, and Akan courtly societies, where many such images are known also have powerful male kings. So we are left with an enigma. Nor does any apparent correlation between matri-lineal or patrilineal descent account for the prevalence and distribution of the theme, for it occurs unevenly in each. Pluralism in cultural pref-erences and local forces of tradition seem to be the best explanations for random distribution patterns, although these are not very satisfying rea-sons. Clearly biological and demographic reality are not the same as artistic and symbolic reality. Productive women, those with many chil-dren, are highly valued among all African agricultural peoples, while image making is discontinuous. (Almost no figural sculpture of any kind is made by nomads and pastoralists.) Even research on this topic promises to yield little, at least as far as the rarity of absence of the theme is concerned, since normally people are unable to account for why they do not subscribe to ideas that may be common elsewhere. Our best approach, then, is to examine the context and content of mother-and-child sculptures in those cultures that accord them real value.

Basic to the elucidation of our theme are the identities of the mothers and children represented in art, regardless of the type of object on which they appear, though it is easier to say who they are not than who they are. We can be certain that they are rarely portraits of particular people either living or dead. Even if they are ancestral images (and these occur less frequently than early writers would have had us believe), they are usually generic, symbols of lineage or clan forbears, the generalized and idealized incarnate dead. In other cases the woman may be the primordial mother of a specific clan or of the human race, the legendary founder of the people. It is probable that most Dogon maternities . . . may be so identified (although field data are scanty), and it is certainly true of some large Senufo examples, known as Ancient Mother. The Senufo data are especially appropriate here, inasmuch as Glaze's and Bochet's studies indicate clearly that these sculptures refer primarily to a complex of ideas about culture and social relationships rather than to the biological unit of a mother with her baby. While suckling refers to nurture, it is not so much mother's milk for her child as it is Ancient Mother's protection and guidance of all Senufo males' passage through the twenty-one-year ini-

tiation and education cycle. Initiation imparts the "milk of knowledge," resulting in graduates who are "complete human beings" (Bochet in Vogel 1981: 45–46).

In the dualistic opposition between nature and culture so characteristic of African thought, the image of a mother and child refers more to culture than to nature, yet it also implies their interdependence. This is probably true of most examples of our theme, which, among other reasons, deserves the designation of archetype. Senufo sculptured figures are schematic, not lifelike or naturalistic, and Bochet sees such abstract forms as appropriate for conveying ideas and symbols. Ancient Mother is the primary feminine aspect of deity, the genetrix, and her "child" is culture itself in the larger sense, educated adult males in the narrower.

The status of women in tropical Africa is a topic often not well understood. Women are considered inferior beings, subservient to their men, but paradoxically this is not the case except perhaps in a limited political sense. More often than not paramount chiefs and other visible leaders are male, but this need not detract from the power or even the manifest authority of women in everyday life. An Akan proverb, cited often by men, epitomizes the stature of women in this matrilineal society: "The hen knows very well when it is dawn, but she leaves it to the cock to announce." Titled older women exercise political as well as social power; among the Yoruba such aged mothers are the guardians of cult secrets and indeed the mysteries of life. They are considered owners of the gods and "owners of the world" (Drewal 1977a: 551). Women are the custodians of many authority symbols and occupy ritual offices (e.g., queen mother) which help to uphold chieftancy institutions. Females wield great social and economic power individually and through their voluntary associations, and they are frequently considered owners of the compounds in which their husbands and other family members dwell. Women in many cultures are ritual specialists, priestesses, and diviners, respected and consulted by members of both sexes. Thus the prevalence of both female and mother-and-child imagery in the African sculptural corpus derives in part from the valued status of women and also from the fact that many gods and spirits are considered to be female. Informative surveys of African sculpture reveal in fact that female figures substantially outnumber those of males.

Maternity images are associated with many categories of spirits. These include varied nature deities, such as earth, forest, or river spirits, gods of divination, and the supernatural doubles of living people. Sculptures too are usually symbols, not themselves deities, and they arise from man's need to create an orderly relationship between the tangible world and the imagined, supernatural world beyond. Africans, like other peoples, conceive of spirits and gods in their own image, often idealized,

rarely given specific idiosyncracies of personality or age. A more perfect exemplar of the feminine aspect of deity than the generative, protective, nurturing mother with child cannot be imagined. Rather more mundane identities do exist for some of these female images, for example, among the Yoruba, where many are considered worshippers rather than gods themselves or symbols of them.

It is noteworthy that we rarely see expressed any intimate emotional bond between the mother and her child, even when the the baby is suckling, and seldom is a child given any real personality by the sculptor except perhaps as an extension of its mother's personality (Fagg in Vogel 1981: 125). The history of childhood in Africa helps account for these factors. First, the rates of infant mortality until recently were very high in sub-Saharan cultures. Second, children, especially infants, no matter how earnestly desired by parents, were often regarded more as useful property than as individual personalities. (Twins and triplets as well as babies with physical disabilities were allowed to die as aberrations in some cultures, while in others twins were revered.) Often a child was not raised by its biological parents. Sometimes children were pawned, sold into slavery or given to cults. High infant mortality also accounts for the phenomenon of the changeling, the child believed born to die, often just as its parents begin to cherish it. A changeling was believed to appear on earth several times successively for short periods, dying and being reborn, plaguing its parents with its mysterious actions and causing them considerable anguish and expense for sacrifices to avert death. It is for these reasons, we may suppose, that Wodaab Fulani mothers are enjoined against talking to their first- and second-born infants during their first year or calling them by name (Beckwith and Van Offelen 1983: 123). If many of these practices seem unusual or even cruel to us today, we need to realize that many of the same attitudes were held in Europe and America in the not very distant past. Such notions run counter to our relatively recent romantic ideas about childhood, our pampering of children and our treatment of them as individual personalities from birth. Children dominate the lives of many American parents, something unthinkable in Africa. A lack of personality in the child and an expression of emotional and psychological distance between mother and baby, often noticeable as well in Christian Madonna-and-Child images seem comprehensible therefore, and even logical. When a mother could not count on her infant's living, she protected herself perhaps with her reluctance to form an emotional attachment. It seems that the makers of mother-and-child images were sensitive to that.

This is not to say that African children lack nurture and attention, for indeed the opposite is true. In part because they are highly valued, children are looked after by a network of extended family members: older

siblings, aunts, grandmothers, mothers' cowives, and servants. Compounds, as dwelling units, often house several dozen people, most of them related to the child's biological parents. Infants are normally suckled by their own mothers but many other people also provide love and care, so that a child normally grows up knowing many "parents," some of them more intimately than his biological ones.

Further correlations between the content of mother-and-child figures and the functional "lives"[3] of these sculptures in ritual contexts help to expand our appreciation of both the complexity of the theme and its multiple meanings. What can be said, for example, about the stereotypical label given such sculptures as "fertility figures"? The topic is important, of course, because human productivity is crucial to the continuity of the race. It is certainly true that many shrines and cults strongly emphasize the fertility of women, their health during pregnancy, and the survival of the infant. Human fertility and health are dominant practical and spiritual preoccupations nearly everywhere on the continent. Yet the biology of maternity serves the more important social state of motherhood and fatherhood, the creation of a family. It is not an exaggeration to say that in Africa a female is not recognized as a real woman until she is a mother and that her ideal status is as the mother of many children. The prevailing ethic in most African cultures, even today, is a large family. A man with two or more wives gains prestige not only from his evident economic success but from the consequently greater numbers of offspring. Children are social and economic assets. They are also expected to honor their living parents and on their parents' deaths to mount proper burials, large and lavish, which in fact are often delayed funerary festivals that in turn ensure ancestral beneficence. The effects of ancestral intervention in the living world are widely acknowledged and indeed help to maintain the institution of ancestor veneration or worship. Ancestors stimulate the productivity of their children and of their children's farmlands as well. Ancestral cults are therefore in part fertility cults.

Several mother-and-child images from Cameroon Grassland kingdoms commemorate royal female ancestors . . . , sometimes, though rarely, specific individuals who take their places in ensembles of statuary housed in royal treasuries. Royal ancestor and retainer figures are honored, well attended, and sometimes given sacrificial offerings, although they are not the focus of the ancestral cult per se. They are memorials rather to the wealth and dignity of a court and the strength of a king and his dynasty, and they are occasionally brought out as display pieces and backdrops to rituals of kingship, such as installations and royal dances (see Northern 1984). Female figures in this genre represent a chief's favorite wives or his "queen mother" (who is, in fact, his sister). They celebrate womanhood, fertility, and maternity. Typically these sculptured

women are dressed with male attributes of royal status: ivory bracelets and anklets. Here we see the not uncommon coalescing of sociopolitical and spiritual meanings; they are largely inseparable in African thought.

Statuary is less common in lineage-based ancestral cults, however, than it is in the larger, more community-oriented cults of tutelary deities that cut across lines of kinship. The latter are female or male gods responsible for the general protection and well-being of the people. Tutelary deities are often associated with aspects of the local world—earth, rivers, forests, and prominent natural features, for example—and they are accorded broad powers, positive and negative, which affect daily life. They bring or withhold children, crops, disease, protection from witchcraft or hostile neighbors. In return for blood sacrifices, they guide, succor, uphold morality, and help to regulate human behavior.

On a continent with high rates of disease and mortality and in agricultural economies requiring labor-intensive planting, weeding, and harvesting, it is not surprising that human fertility is a dominant concern of many community cults, and of course statuary representing the mother-and-child logically symbolizes this concern. The images are normally generic. They may be named for the deity, or they may be considered his or her children, messengers, servants, and/or worshippers. They take their place beside images of couples, equestrians, aggressive males, other human figures, and occasionally animals and refer especially to the protection, nurture, and productivity expected of wives and mothers. They represent the mysterious power of woman as child-bearer and the critical role of wife and mother in the family. Ensembles of family members are quite common in shrines as projections of idealized domestic life, for the gods in their realm are considered to lead lives parallel to those of real people here on earth. Other mother-and-child figures may represent the mystical, potentially threatening powers of "old mothers," women actually past childbearing age who gain authority with advancing years. Shrine images often implicitly fuse the many perceived and actual female roles.

The Igbo earth goddess, Ala, appears larger than life size in *mbari* houses. Two children sit on her lap or beside her, yet she has the pendulous breasts of an old woman. As the major Igbo tutelary deity, Ala presides over community morality and health. As the greatest of mothers she yields or withholds children, crops, and animals. She nurtures, yet she kills swiftly and without mercy when offended, "swallowing people" being lowered into their graves. She incarnates cyclical regeneration: life, death, and rebirth. The knife she holds aloft signals her ambivalence: with it she generously peels yams for her children, with it she controls crowds and kills. As the most inscrutable eminence among Igbo nature gods, she is considered an authoritative, rich, and titled elder: a "man among women."

All villagers and many deities are her children. She is feared and revered. She demands many sacrifices, the most important one being the clay *mbari* temple in which she sits, having been modeled of the very sacred earth she incarnates. The ambiguous, even tautological character of this mother-and-child, as earth, goddess, and symbol, affirms its centrality in Igbo culture (Cole 1982).

Akan, Agni . . . , Urhobo, Igbo, and Yoruba mother-and-child sculptures and those of many other peoples across the continent fulfill sacred purposes: the embellishment and attention-getting focus of important cult shrines. They are commissioned by the priests or priestesses who oversee cults, or they are provided by the community of cult members or by individual worshippers on whose behalf the deity has successfully interceded. Their iconography varies considerably: the child is suckling in some instances and not in others; the women are seated, kneeling, or standing. Local preferences and the choices of sculptors themselves account for this variety [Fig. 13-3].

Much the same is true of figural sculptures found in the shrines of diviners, those individuals who interpret the will of the gods to man. Yoruba, Baule, Igbo, Senufo, Kongo, and other diviners and doctors maintain contact with spirits whose desires are made known through divination (a form of fortune-telling), these desires in turn passed on to the clients who consult the specialists. The greatest variety of mother-and-child images is found in the shrines and work places of Yoruba diviners, for they often embellish bowls, tappers, and even divining trays; sometimes freestanding figures are also found. Henry Drewal has clarified the complexity of these implements and the value of their iconography: "Images of women in ritual contexts and mother and child figures represent much more than symbols of fertility. They communicate sexual abstinence [of a nursing mother], inner cleanliness [because her menses are suppressed, and therefore], ritual purity, female force, and spirituality" (1977b: 5).

The Yoruba also incorporate mother-and-child icons in less strictly spiritual contexts, such as houseposts and large doors carved in high relief from single planks of wood. Houseposts normally adorn palace courtyards; equestrians and mothers with children are favored themes, both being references to royal authority and dignity. In some instances the mother is the king's senior wife, his queen, whose job it is to place the king's crown upon his head for important rituals (Fagg and Pemberton 1982: 160), a clear instance of the importance of women. As houseposts, such female figures uphold, both literally and figuratively, the power and sanctity of divine kingship with their own mystical strength as mothers of the people. The women shown on doors may or may not be royal. A door in the exhibition . . . , carved by the renowned artist Arowogun (d.

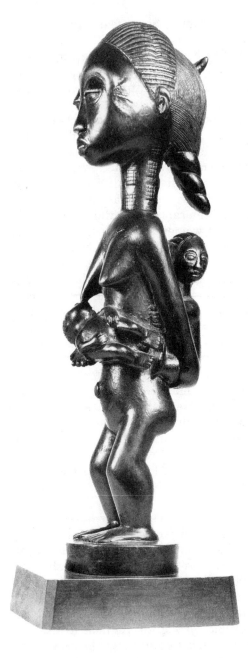

Figure 13-3. *Mother and child figure,* Baule, Ivory Coast. Wood, height 18″. Museum of African Art, Washington, D.C. Photo by Eliot Elisofon.

1956), expands upon our theme in remarkable ways. Among the many anecdotal, descriptive vignettes of domestic (or palace) life, all rendered in high relief, are a couple copulating, a woman in parturition, and a more ordinary rendering of a mother with her baby tied to her back. Sculpted scenes of intercourse and childbirth are quite rare on the continent. We are fortunate to be able to include in the exhibition the only known Fang carving of the latter theme . . . , although its specific use is not known.

Many Yoruba maternities in divining and other contexts show women kneeling, a position of respect, devotion, and even submission to the gods. This posture is appropriate when we recall that most women in Yoruba sculpture represent royal wives or worshippers, not gods themselves. Among the Senufo, by contrast, diviners' sculptures of maternities, as well as male figures and equestrians, symbolize bush spirits whose guidance and favor the diviner seeks for her or his client.

Thus sculptures embellish and aggrandize divination rites among the Yoruba and other peoples, as they do the shrines of tutelary deities, where they serve as display pieces, evidence of the spiritual and material success of the ritualist, and an advertisement of sorts for his or her expertise. Accomplished and therefore wealthy diviners and cult priests, not to mention kings, are more likely to have statuary than mediocre or impoverished ones, so it can to some extent be considered an index of wealth, prosperity, and authority. This also suggests that the very existence of sculpture in a shrine may at times be arbitrary. Where maternity and other images are found, the shrine is normally of some prominence and power, and its owner is a person of higher than average status.

Conclusion

Mother-and-child imagery is metaphorical and value laden far beyond its limited, if correct, biological reference. To see such imagery merely as a collection of fertility figures or as specific mothers with their babies is an oversimplification. Moreover, the richness of African thought is undervalued by such simplifications. This prevalent, recurrent icon is an archetype: Great Mother as earth and water, childbirth and initiation as repetitions of cosmogeny, the mother as symbol of compound or village and her children its inhabitants, the genetrix as the source of social institutions. Unquestionably African thought and symbolism accord with those of the rest of the world in creating of this icon a universe far greater than the sum of its parts. Dynamic and regenerative, the mother-and-child symbol lives on to reflect the verities and complexities of African spiritual thought and the continuity of culture itself.

Notes

1. The couple and the equestrian were the subjects of earlier exhibitions and brochures in the museum's Ethnic Arts Series.
2. Here, as elsewhere in this brochure, we have a problem with verb tense because of the multiplicity of historical and current realities in Africa. Past or present tense may be chosen for the sake of stylistic consistency when it would be more accurate to mix them in discussing a particular phenomenon.
3. Given the anthropomorphism of African sculpture and the idealized human situations in which it is found, it is more appropriate to speak of the "life" of a sculpture than its "function," the latter being the common anthropologic term.

Bibliography

BECKWITH, CAROL, and MARION VAN OFFELEN. 1983. *Nomads of Niger*. New York: Abrams.

BLIER, SUZANNE PRESTON. 1982. *Gestures in African Art*, exh. cat. New York: L. Kahan Gallery, Inc.

BRAIN, ROBERT, and ADAM POLLOCK. 1971. *Bangwa Funerary Sculpture*. London: Duckworth.

COLE, HERBERT M. 1982. *Mbari: Art and Life among the Owerri Igbo*. Bloomington: Indiana University Press.

COLE, HERBERT M., and DORAN H. ROSS. 1977. *The Arts of Ghana*, exh. cat. Los Angeles: Museum of Cultural History, University of California, Los Angeles.

DREWAL, HENRY J. 1977a. "Art and the Perception of Women in Yoruba Culture," *Cahiers d'Etudes Africaines* 17 (no. 4): 545–569.

————. 1977b. *Traditional Art of the Nigerian Peoples: The Ratner Collection*, exh. cat. Washington, D.C.: Museum of African Art.

FAGG, WILLIAM, and JOHN PEMBERTON III. 1982. *Yoruba Sculpture of West Africa*. New York: Knopf.

GLAZE, ANITA J. 1981. *Art and Death in a Senufo Village*. Bloomington: Indiana University Press.

NORTHERN, TAMARA. 1984. *The Art of Cameroon*, exh. cat. Washington, D.C.: Smithsonian Institution Traveling Exhibition Service.

ROSS, DORAN H. 1984. "The Art of Osei Bonsu," *African Arts* 17 (no. 2): 28–40.

VOGEL, SUSAN M., ed. 1981. *For Spirits and Kings: African Art from the Paul and Ruth Tishman Collection*, exh. cat. New York: Metropolitan Museum of Art.

ZAHAN, DOMINIQUE. 1970. *The Religion, Spirituality and Thought of Traditional Africa*. Chicago and London: University of Chicago Press.

14

The End of the Century and Conflicting Fantasies of Femininity

Susan P. Casteras

I. Some Competition from Femmes Fatales and Goddesses

There were ultimately two developments that appreciably altered the basically placid course of the imagery of women toward the end of the nineteenth century. One was the social revolution affecting womanhood that had fermented since the 1850s and peaked in the 1890s, the undisputed heyday of the New Woman. In bloomers and on bicycles, this new creature arrived, exhibiting much of the "unwomanly" deportment—aggressiveness and athletic ability as well as an intellectual bent—that was deplored as unfit, offensive, and "fast." . . .

An upheaval in the conduct of the hitherto compliant and ultrarespectable middle-class lady was thus occurring in some quarters from the 1870s onward, for as she stepped out of her protective chrysalis she challenged . . . the prevailing "natural" order of femininity.

The other development was in some respects a "counterdevelopment" that created a rather schizophrenic situation in society and in the art produced in the last twenty-five years of Victoria's reign. At the same time that middle-class codes of morality were generally being liberalized for women (in the realm of courtship, education, physical freedoms, etc.), there was also a strong reform crusade that battled in the 1870s and 1880s against public immorality. An outgrowth of Josephine Butler's

From *Images of Victorian Womanhood in English Art* by Susan P. Casteras, copyright © 1987 Associated University Presses. Reprinted by permission of the publisher.

efforts (and those of others) to repeal the Contagious Diseases Act, this feminist-inspired phenomenon urged not only female chastity, but also male purity. Thus, the daring New Woman, the sensuous female aesthete, and the decadent tendencies in general of either sex posed a threat to both middle-class ideologies and this new spirit of reform. As a result, in the 1880s in particular legislation was enacted that began to restructure sexual policies that affected Victorian society—for example, the age of consent for females to marry was raised to age sixteen and new laws monitoring brothels and homosexuality were also debated. Given this situation, it is not surprising that a few different types of females prevailed in art, the foremost in popularity being Eliza Lynn Linton's retiring, "simple and genuine girl of the past." . . .

In opposition (although not necessarily so in real life) to this female was the more progressive, even avant-garde, woman who appeared especially in the pages of *Punch* as an intellectual, a sallow advocate of aestheticism, or a vigorous athlete.

In contrast to these types was another major factor that transformed the imagery of women during this period, namely, the appearance of the *femme fatale*—a daring Venus who seemed both to threaten and mesmerize the public imagination—from about the 1870s onward. Similarly, toward the end of the century a legendary, colossal, and sometimes monstrous feminine counterpart joined the ranks and literally loomed large in art. . . . [I]n these final pages a juxtaposition of some of the most common fantasies with more "realistic/sentimental" images of womanhood perhaps offers the truest index of the Victorian culture's underlying attitudes toward females. Freudian psychoanalysis had not yet liberated human psychology, but examination of certain persistent icons during this period proves to be a very revealing retrospective probe of the psyche of this era.

The imagery of the wayward woman and the less reviled New Woman found a formidable competitor in the *femme fatale*, still another shadow side of Victorian femininity. The fascination in art with malevolent females and enchantresses was long-standing, of course, and in the nineteenth century had literary origins in works by Keats, Baudelaire, Gautier, and Swinburne. The evil woman of imaginary but colossal deeds of depravity (not of mere behavioral transgressions of society's rules) also interested some of the Pre-Raphaelites (mostly Rossetti), and on the continent decadent and Symbolist writers and artists were even more intrigued by her. Baudelaire's cruel and aloof female, one whom men approached with a mingling of fear, disgust, awe, and desire, materialized into a late-century creature who reveled in deceiving, enticing, and destroying males in literature or art. In real life, such individuals as Lily Langtry, Cora Pearl, and perhaps even Sarah Bernhardt at times fulfilled

distinct from that of the innocuous aesthetic female). Rossetti's females are rarely openly "come-hither" in their behavior but nonetheless communicate, with their mystical silence, half-closed eyes, sensuous mouths, and mesmerized stares, a sense of magnetism, expectancy (more charged than that found in innocent courtship images), and even potential danger. However, this alluring woman is ultimately unattainable, for the wall, bower, or toilette table that often literally holds her back reinforces the strange paradox of her being both sexy and yet soulful, desirable, and inaccessible. These women are being held back from perhaps unleashing a fearful sexuality, an implication more subtly conveyed in Brown's *The Stages of Cruelty*, which uses a more classic version of the courting barrier. Yet Rossetti's women ultimately seem to qualify more as tantalizing cult objects and as devotional icons than as courtship images or anything else, fusing the enchantress simultaneously into a very private metaphor for the artist (who know and loved many of the women he painted) and a public, recognizable fantasy of feminine sexuality.

Rossetti also painted a string of destructive women like Lucrezia Borgia, La Belle Dame sans Merci, and Astarte Syriaca. . . .

Burne-Jones . . . preferred to treat the legendary rather than the contemporary female, extending Rossetti's mood of fatal indolence into the realm of the mythological in a work such as *Laus Veneris* (Fig. 14-1), finished in 1878. One critic deemed the subject of Venus with her

Figure 14-1. Edward Burne-Jones, *Laus Veneris*. 1873–75. Oil on canvas, 48 × 72". Laine Art Gallery, Newcastle-upon-Tyne. Photo by The Bridgeman Art Gallery/Art Resource.

this role, but they were no match for the countless menacing, sometimes almost lurid, permutations of the *femme fatale* that riveted the attention of contemporary painters and authors.

In England the origins of this type are to be discovered primarily in the works of Rossetti, who was perhaps the most prolific purveyor of sirens awaiting men at balconies or in boudoirs. Rossetti rewove the strands of superficial *Keepsake* images of this sort into a haunting private icon of alluring womanhood, and the theme of the enshrined or embowered female recurred in his poetry, as in an 1860 poem entitled "The Song of the Bower."[1] The visual corollary to this notion found expression in numerous canvases of the 1860s, the first appearance of this new temptress in his *oeuvre* occurring with *Bocca Baciata* . . . of 1859. . . . The original was branded coarse and sensual, and on the back lines in Italian from a sonnet by Boccaccio were, in translation, "The mouth that has been kissed loses not its freshness, but renews itself even as does the moon."[2] Fanny Cornforth of *Found* modeled for the 1859 version, but here, as he often did, the artist seems to have conflated the facial and physical characteristics of several women he knew. The dreamy figure is posed against a backdrop of marigolds, which may symbolize cruelty or despair. Furthermore, her paradoxical combination of innocence and temptation is alluded to in the pure white rose in her hair with the snakelike decorations on her sleeve and the apple (suggesting Eve's sin) on the ledge. Like later examples, this precursor of the *femme fatale* gazes inscrutably at an unseen lover from a richly patterned background niche. *Bocca Baciata* also established the basic format of subsequent pictures, placing a voluptuous, mesmerizing female with her symbolic accessories against an elaborate background, one which seems to press against the picture plane and thus heighten the lady's erotic appeal to her suitor and the spectator as well.

Another work in this category is Rossetti's *Regina Cordium* . . . of 1866, a rephrasing of the closeup, phlegmatically sexy woman holding a floral attribute and dreamily staring out at the viewer. Like *Bocca Baciata*, she is separated from the audience by a low barrier and occupies a rather narrow space with flowers (the full-blown roses and other blossoms signifying her sensuality) and other props that presses her uncomfortably between a suffocating backdrop and a formidable frontal obstacle. The duality of this female—her powerlessness because she is restrained and yet her omnipotent control of men through love and libido—is an important undercurrent in Rossetti's poetry as well. In these selected examples by this artist and myriad others, one quintessential type emerges from the different personalities and personifications: a larger than life, full-lipped, and voluptuous woman (typically with magnificent tresses), who is both indolent and withdrawn in private reverie (yet in a way quite

attendants to be oppressively morbid, describing the central figure as "stricken with a disease of the soul . . . eaten up and gnawed away with disappointment and desire."[3] Similarly, the novelist Henry James in a review of this picture concluded that Venus possessed "the aspect of a person who has what the French call an 'intimate acquaintance' with life" and that she and her languid, rather vacant-looking companions were all disarmingly "pale, sickly, and wan."[4] Such a reaction not only allies Burne-Jones's creatures with prostitutes and wanton females; it also conjured up the sort of criticism that had been leveled against the female aesthete for her cult of wanness and ennui. The theme itself was derived both from the medieval legend of Tannhäuser and from contemporary fascination with the subject in works by Swinburne, William Morris, and Richard Wagner. Swinburne's poem entitled "Laus Veneris" (published in 1866) in fact describes in smoldering detail the goddess's deep and dangerous sleep as well as how her beautiful mouth and hair could sear a lover's flesh. Suspended in a state of exquisite languor, she inflicts both pleasure and pain on her admirers and seems nearly consumed by her own sexual passions: "Her gateways smoke with fume of flowers and fires,/ With loves burnt out and unassuaged desires."[5] Burne-Jones knew Swinburne well and may have intentionally alluded to his friend's earlier interpretation of this subject. Certainly the artist reiterates here the theme of seduction and places the recumbent Venus in a densely packed Rossettian niche, Swinburne's "Horsel" or claustrophobic chamber of love. In the background is a tapestry with Cupid present and a scene depicting knights about to be snared as amorous victims by waiting sirens. The viewer too functions somewhat as an intended victim and voyeur, but *Laus Veneris* projects torpid seduction and not innocent courtship.

Enchantresses and sorceresses were among the inversions of femininity which appeared in the art of the last quarter of the century, and the evil idol of perversion was commonly found, for example, in the work of continental artists like Jan Delville, Edvard Munch, Felicien Rops, and Gustave Moreau. In England this perverse feminine transformation surfaced in the sometimes pornographic and often bizarre drawings of Aubrey Beardsley. His ca. 1896 drawing for *A Christmas Card* . . . , for example, an illustration for the *Savoy* magazine, qualifies—in spite of its title—as a sinister variation of the traditionally beatific and benign Christian image. The "Virgin" and child wear more or less modern clothing, the Virgin being more of a "darkling Venus" than a revered saint. The writhing fur trim on her robe, like the serpentine curls and spiky "thorns" that mimic an aureole, all mark her as alien and apart from typical Mary figures. The blending of the traits of the Madonna with those of the *femme fatale* recalls Walter Pater's famous comment about

the Mona Lisa as a woman who embodied both religious and irreligious qualities simultaneously. Furthermore, there are plucked flowers on her gown signifying defloration, a detail reminiscent of that on the garb of the fallen woman. . . .

While images of women as hybrid monsters or vampires are rare in Victorian art, the bestial cruelty of the *femme fatale* was a frequent theme, especially in numerous designs by Beardsley (who was himself notoriously odd in matters relating to sex). The occupants of his boudoirs were often mysterious and dangerous, and it was not only his brilliant use of line and black-and-white graphics that shocked audiences. Equally fascinating was his creation of figures that were simultaneously heterosexual and androgynous, promiscuous and celibate, alluring and repulsive, malignant and innocent. Among his most famous images is *The Climax* . . . , which originally appeared as an independent drawing in 1893 and was among the illustrations for Oscar Wilde's play *Salomé*. The "sinful" subject, expressed in crisp and sinuous line, perfectly embodied the *art nouveau* style. It also typified the *fin de siècle* obsession with the voracious *femme fatale* who tortured men. Here Salome floats in an almost orgasmic encounter with Ioakanaan, the title of the drawing a sexual allusion to this moment. Salome is portrayed as rather triumphantly caressing the severed and bleeding head of John the Baptist, holding it aloft like some sort of trophy, her heartlessness a quantum leap from the demure conduct of courtship pictures. As in *A Christmas Card* . . . , the woman's hair is snakelike, making her part animal and carnal in her lust for her victim.

This necessary digression has revealed some of the strands of imagery that competed with more conventional subjects of femininity. Rossetti's haunting paeans to embowered womanhood had forged the old formulas of female charm into a new and more blatant context of paradoxical soulfulness and sexiness, while other artists . . . and Beardsley chose to depict far more malevolent embodiments. But there was another pictorial rival to contend with, a category of enigmatic female personifications endowed with a deliberate sense of abstraction and removal from everyday life. Frederic Leighton, George F. Watts, Lawrence Alma-Tadema, and Albert Moore all arrived at their own resolutions of this subject, in general creating remote, monolithic, often rather frigid feminine types that represent universal concepts or mythological legend. There is rarely any evil lurking in the works of these artists—nor are their female protagonists necessarily mortal (although many appear to be Victorian ladies in costumes, particularly in the case of Alma-Tadema). Instead they seem to live in a static world of beauty where passion, rage, and sensuality do not enter, as is the case in Leighton's *The Garden of the Hesperides* . . . of 1892. This is one of the artist's most perfect statements

about the immortality of beauty and the role of females as decorative embodiments in an ideal world of aesthetic transformations. The ancient legend here concerns the island of the Hesperides, where the daughters of Hesperus preside; their song enchants the serpent guarding the tree with the golden apples (and later Hercules undertakes to steal these fruits as one of his labors). As a modern critic has pointed out, this picture "depicts a golden age which we know to be doomed, a garden of Eden forever closed. The myth has profound symbolic implications, and Leighton's painting is an attempt to express this deeper meaning through the forms themselves. The nearest parallel can be found in music, and the picture is an equivalent to the song which the Hesperides are singing, a song of sleep and suspended existence."[6] The symbolism of slumber and of enclosure is created by the repetition of curving forms, from the shape of the canvas itself to the coiled dragon/snake, the maidens encircling the tree, and the movement of the figures' drapery. Even the lush vegetation of the apples echoes this shape, and the balance of forms is nearly perfect in this paradise. Furthermore, the erotic appeal of the three females in their semidiaphanous, variegated robes was apparent even to the late Victorian critic, and the *Art-Journal* described the women sleeping in half-shadow "while down the tree creeps the great guardian python, amorously enlacing in its huge folds the nymph who occupies the centre of the group."[7] This is no bourgeois garden setting, but one that belongs to the gods and to legend, and the conduct of the mesmerized occupants need not comply with the dictates of reality. . . .

While the New Woman in real life and art was perceived as amazonian in many ways, her counterpart in late-century art was equally statuesque or imposing but eminently more classicizing. Often she reigns in an immobile world of myth and represents some ponderous literary, historical, or aesthetic idea. Two examples suggest this aggrandizing effect, one being Leighton's nearly life-size *Lachrymae* (Fig. 14-2) of ca. 1895. The Latin title transforms the popular Victorian saga of a female grieving over lost love into a neoclassical tableau. A stately Hellenic maiden stands in an attitude of dignity and sorrow near a funereal urn that stands atop a Greek pillar. This lachrymose maiden is surrounded by floral symbolism: a fallen laurel wreath evokes the past glories of the deceased, the cypress trees in the background connote death, and the garland of ivy adorning the urn evokes the fidelity of the pair. As the *Athenaeum* reviewer commented when the painting was exhibited in 1895, the "sad blues and black pervade the design, and the softening shadows of the vault seem about to close upon the almost statuesque figure of the mourner."[8] Amid the gloomy foliage behind her is a glimpse of ashen clouds of sunset, every motif and even the coloration serving to complement the lugubrious mood. . . .

Figure 14-2. Frederic Leighton, *Lach-rymae*. c. 1895. Oil on canvas, 62 × 24¾″. The Metropolitan Museum of Art, Wolfe Fund, 1896. The Catharine Lorillard Wolfe Collection.

II. On "A Dream of Fair Women"

The title of Tennyson's celebrated poem "A Dream of Fair Women" serves in these concluding remarks as one way of briefly recapitulating what has been suggested in the previous chapters. In general, the conventional middle-class lady was the undisputed angel of the drawing room, and images abound of her as a helpmate, a paragon of submissiveness, and a spiritualized heroine. The home, revered by Ruskin as a "place of Peace," served both as a lady's sanctuary and her prison, and her daughters too were sequestered and incarcerated within this *hortus conclusus* of feminine virtue and influence. While representations on canvas of her leisure pursuits, accomplishments, fashions, idleness, and social preoccupations often seemed to monopolize artistic interest, it was as the model of contemporary domesticity that she garnered real attention. This goddess of the hearth presided over a wide spectrum of feminine victims, ranging from the impoverished laborer, to the genteel governess, to the "soiled dove." Her young female offspring emulated her actions and also frequently appeared as redemptive figures in art, symbols of delicate purity tinged, however, with latent sexuality as well.

Saccharine vignettes of charitable female activity extended the feminine moralizing and uplifting province of the home, although genuine religious commitment in the form of entering a sisterhood was usually portrayed as an abnormality (interestingly, the celibate spinster was often also hostilely criticized or caricatured). Once again, however, the inner sanctum of the woman, in this case of a postulant or nun, sheltered her uncorrupt nature, yet it was also replete with repressed sexual meanings. The comely young novice, like her secular counterpart in the parlor, was enshrined by artists in an enclosed garden that made her both chaste and inaccessible, a beguiling combination.

The Royal Academy was inundated with portrayals of middle-class courtship from the 1850s onward, and these depictions often reveal a great deal especially about the female partners in love. The shibboleth of Victorian courtesy books was basically a "look, but do not touch" approach, and such prescriptive advice found a visual corollary in the "courting wall" motif in myriad pictures. This barrier typically thwarted lovers in a broad range of amorous situations, thus serving as a surrogate chaperon as well as guaranteeing mutual restraint and, above all, vouchsafing female virginity. In countless images each partner is thus depicted as exhibiting the proper social behavior, with the male making timid overtures and the woman passively and even defensively accepting them from her side of a symbolic architectural impediment. In other romantic circumstances, a woman remained vacantly unexpressive, except in the case when more than one suitor vied for her affections: in this rare in-

stance her face reveals a trace of triumphant pride and even insouciance. Far more numerous were the tableaux of dejected and drooping women who had been misled or doomed in romance by faithless swains. But while courtship in bourgeois, rural, classicizing, fancy dress, and other contexts persisted, images of married life (especially any criticism of the status quo) were much less common, perhaps because marriage was an anticlimax to the pictorial titillations of frustrated expectancy and sexual yearning in trysts and amorous tribulations.

In the realm of the working woman, the sempstress and the governess were viewed as objects of sympathy and also victims of unjust conditions, but their picturesque appeal centered on their lost beauty or stature, not on the real social causes of their misery. Redgrave was a particular innovator in this category, and his depictions of the oppressed teacher and needlewoman popularized the format of a suffering single figure in abject penury. Other sorts of laboring women—from the factories, to the fields, to the stage—proved less appealing subjects, but even images of them are generally colored in rosy tones.

The "martyred" female worker was complemented by the image of elderly helplessness, with various stereotypes of the aged mitigated only by the depiction of the widow as preferably youthful, comely, and vulnerable. The final female casualty was the prostitute, a fallen angel or Ruskin's "feeble floret," who was a shadow on the edge of decorous society that nonetheless was the focus of considerable pictorial attention. The city was the preordained location selected by Victorian artists for the loss of innocence, and images of solitary and pitiable harlots outnumbered those of reconciliation with the prodigal daughter. As with the governess and the sempstress, the attitude toward this destitute creature was mostly one of compassion, although the male artists who invariably produced such representations also seemed to inject a subconscious note of the outcast's covert sexual appeal in spite of her ruin and desolation.

Another unconventional or deviant female in English society was the New Woman, whose appearance was infrequent in paintings, though less so in the pages of *Punch*. As with the athletic woman of the 1890s who often shared this epithet, the New Woman proved a virtual nonentity in paintings, perhaps since her mild-mannered "sister" of the parlor seemed to be vastly preferred by the majority of viewers, both male and female. This phenomenal and strident iconoclast was also seen as responsible for her own life and future (whether that proved happy or not), for she had willfully endorsed the new "modern" creeds and was thus not a fragile victim like the "dark angel" of the prostitute.

Contradictions abound in the degree of reality ultimately . . . for while some works appear to be historical documents in part (like *The Last of England*), others merely treat topical subjects, dispense a stylis-

tically literal but rather frivolous anecdotalism, or penetrate to a more profound level. In still other instances, the final effect is primarily one of totemic significance, as with the garden and courting wall motifs and their accumulations of multivalent meaning through repetition. In addition, there were clearcut male fantasies, whether of airy sprites, allegorical amazons, monstrously heartless *femmes fatales*, or cool goddesses. From this heterogeneity a cohesive cultural mythology about femininity seems to crystallize, invariably overblown, but fascinating nonetheless. It is a fallacy, of course, to scrutinize Victorian paintings and novels as the only commentaries on historical or social realities, since in doing so the actual women of the period are overlooked. Whether Florence Nightingale, a pioneering social reformer, one of the first sisters of charity, a college graduate, or an ordinary lady or laborer, the Victorian female was often lost or embedded in a superstructure of categories and prejudices, telescoped and often trivialized into restrictive sentimental stereotypes.

Yet perhaps there are some latent interconnections between the high-minded housewife in Hicks's painting *Woman's Mission* [Fig. 14-3] and Leighton's somnolent personification *Flaming June* [Fig. 14-4], for each corresponds to a different decade's notion of female sexuality and each is an image created for middle-class consumption. The virginity, respectability, and productivity of Hicks's lady can be understood as a "code" for her virtue, and in this respect she might be construed as a symbolic statement of English stability and national pride at mid-century. On the other hand, the idleness of Leighton's sleeper has connotations of vice and licentiousness. This indolent creature is a by-product of Aestheticism, the New Woman, and a fomenting sexual revolution, yet she oddly slumbers through all this. Her very pose suggests both fecundity and a contorted self-absorption; like some Tennysonian "high-born maiden" anticipating a romantic encounter, she inhabits an inviolable world (perhaps a garden of pleasure instead of a garden of purity) that is far removed from reality. The great English depression and stagnation of economy of the 1890s exerted some paralyzing effects on public morale and faith in the Empire, and perhaps this goddess is in this respect an emblem of the national "state of health," or more aptly, one of listlessness.

In the final analysis, the heroicizing late-century goddesses, like the cozy nests of bourgeois harmony and the forlorn social martyrs and laborers, all sustained an invented myth or fantasy of aesthetic artifice. The fictional image of woman seemed to eclipse her real-life character, and many Victorian pictures thus seem to modern eyes to be "underpainted" with varying degrees of nostalgia, escapism, and wishful thinking. Nevertheless, these divergent approaches cumulatively tended to manufacture an eroticism out of feminine chastity, casting females into one extreme of sexuality or another without a more balanced viewpoint.

Figure 14-3. George Elgar Hicks, *Woman's Mission: Companion to Manhood.*
1863. Oil on canvas, 30 × 25¼". The Tate Gallery, London/Art Resource.

The middle-class lady was thus often the literal substance of mainstream
Victorian art, with the shadow or spectral side of womanhood personified
by the aberrant female, the New Woman, and the *femme fatale;* yet sus-
pended somewhere between these poles was a dimension of femininity
that remained largely untouched by either dialectic. Whether or not these
stereotypes remain unavoidable and eradicable is a question for twen-
tieth-century viewers to resolve, in their attitudes toward art and to
society in general.

Notes

1. For an analysis of the imagery of this poem in relation to Rossetti's art, see Susan P.
 Casteras, "Down the Garden Path: Courtship Culture and Its Imagery in Victorian
 Painting" (Ph.D. diss., Yale University, 1977), 145–53. A literary explication is found,
 for example, in David Sonstroem, *Rossetti and the Fair Lady* (Middletown, 1970), 66–68.

Figure 14-4. Frederic Leighton, *Flaming June*. c. 1895. Oil on canvas, 47½ × 47½". The Moss Gallery, London. Photo by The Bridgeman Art Library/Art Resource.

2. Virginia Surtees, *The Paintings and Drawings of Dante Gabriel Rossetti (1828–1882), A Catalogue Raisonné* (Oxford: The Clarendon Press, 1971), 1:68.

3. F. Wedmore, "The Grosvenor Gallery Exhibition," *Temple Bar* 53 (July 1878): 339.

4. As quoted in Arts Council, *The paintings, graphics and decorative work of Sir Edward Burne-Jones 1833–98* (London, 1976), 53.

5. Algernon Swinburne, "Laus Veneris," in *Poems and Ballads by Algernon Charles Swinburne* (London: John Camden Hutten, 1866), 18. See also the catalogue entry on this painting in Tate Gallery, *The Pre-Raphaelites* (London: The Tate Gallery, 1984), 229–31.

6. Leonée and Richard Ormond, *Lord Leighton* (New Haven and London: Yale University Press, 1975), 131.

7. "The Royal Academy," *Art-Journal* 54 (1892): 188.

8. "Fine Arts: The Royal Academy," *Athenaeum* 68 (4 May 1895): 576.

15

Why Have There Been No Great Women Artists?

Linda Nochlin

Why have there been no great women artists? The question is crucial, not merely to women, and not only for social or ethical reasons, but for purely intellectual ones as well. If, as John Stuart Mill so rightly suggested, we tend to accept whatever *is* as "natural,"[1] this is just as true in the realm of academic investigation as it is in our social arrangements: the white Western male viewpoint, unconsciously accepted as *the* viewpoint of the art historian, is proving to be inadequate. At a moment when all disciplines are becoming more self-conscious—more aware of the nature of their presuppositions as exhibited in their own languages and structures—the current uncritical acceptance of "what is" as "natural" may be intellectually fatal. Just as Mill saw male domination as one of many social injustices that had to be overcome if a truly just social order were to be created, so we may see the unconscious domination of a white male subjectivity as one among many intellectual distortions which must be corrected in order to achieve a more adequate and accurate view of history.

A feminist critique of the discipline of art history is needed which can pierce cultural-ideological limitations, to reveal biases and inadequacies *not merely in regard to the question of women artists, but in the formulation of the crucial questions of the discipline as a whole.* Thus the so-called woman question, far from being a peripheral subissue, can become a catalyst, a potent intellectual instrument, probing the most basic

From *Art and Sexual Politics*, eds. Thomas B. Hess and Elizabeth Baker, copyright © 1971, 1973 ARTNEWS Associates. Reprinted by permission of the author and the publisher.

and "natural" assumptions, providing a paradigm for other kinds of internal questioning, and providing links with paradigms established by radical approaches in other fields. A simple question like "Why have there been no great women artists?" can, if answered adequately, create a chain reaction, expanding to encompass every accepted assumption of the field, and then outward to embrace history and the social sciences or even psychology and literature, and thereby, from the very outset, to challenge traditional divisions of intellectual inquiry.

The assumptions lying behind the question "Why have there been no great women artists?" are varied in range and sophistication. They run from "scientifically" proven demonstrations of the inability of human beings with wombs rather than penises to create anything significant, to relatively open-minded wonderment that women, despite so many years of near equality, have still not achieved anything of major significance in the visual arts.

The feminist's first reaction is to swallow the bait and attempt to answer the question as it is put: to dig up examples of insufficiently appreciated women artists throughout history; to rehabilitate modest, if interesting and productive, careers; to "rediscover" forgotten flower-painters or David-followers and make a case for them; to demonstrate that Berthe Morisot was really less dependent upon Manet than one had been led to think—in other words, to engage in activity not too different from that of the average scholar, man or woman, making a case for the importance of his own neglected or minor master. Such attempts, whether undertaken from a feminist point of view, like the ambitious article on women artists which appeared in the 1858 *Westminster Review*,[2] or more recent scholarly reevaluation of individual women artists, like Angelica Kauffmann or Artemisia Gentileschi,[3] are certainly well worth the effort, adding to our knowledge of women's achievement and of art history generally. A great deal still remains to be done in this area, but unfortunately, such attempts do not really confront the question "Why have there been no great women artists?"; on the contrary, by attempting to answer it, and by doing so inadequately, they merely reinforce its negative implications.

There is another approach to the question. Many contemporary feminists assert that there is actually a different kind of greatness for women's art than for men's—They propose the existence of a distinctive and recognizable feminine style, differing in both formal and expressive qualities from that of men artists and posited on the unique character of women's situation and experience.

This might seem reasonable enough: in general, women's experience and situation in society, and hence as artists, is different from men's, and certainly an art produced by a group of consciously united and purposely articulate women intent on bodying forth a group consciousness of fem-

inine experience might indeed be stylistically identifiable as feminist, if not feminine, art. This remains within the realm of possibility; so far, it has not occurred.

No subtle essence of femininity would seem to link the work of Artemisia Gentileschi, Mme. Vigée-Lebrun, Angelica Kauffmann, Rosa Bonheur, Berthe Morisot, Suzanne Valadon, Kaethe Kollwitz, Barbara Hepworth, Georgia O'Keeffe, Sophie Taeuber-Arp, Helen Frankenthaler, Birdget Riley, Lee Bontecou, and Louise Nevelson, any more than that of Sappho, Marie de France, Jane Austen, Emily Brontë, George Sand, George Eliot, Virginia Woolf, Gertrude Stein, Anaïs Nin, Emily Dickinson, Sylvia Plath, and Susan Sontag. In every instance, women artists and writers would seem to be closer to other artists and writers of their own period and outlook than they are to each other.

It may be asserted that women artists are more inward-looking, more delicate and nuanced in their treatment of their medium. But which of the women artists cited above is more inward-turning than Redon, more subtle and nuanced in the handling of pigment than Corot at his best? Is Fragonard more or less feminine than Mme. Vigée-Lebrun? Is it not more a question of the whole rococo style of eighteenth-century France being "feminine," if judged in terms of a two-valued scale of "masculinity" versus "femininity"? Certainly if daintiness, delicacy, and preciousness are to be counted as earmarks of a feminine style, there is nothing fragile about Rosa Bonheur's *Horse Fair*. If women have at times turned to scenes of domestic life or children, so did the Dutch Little Masters, Chardin, and the impressionists—Renoir and Monet—as well as Morisot and Cassatt. In any case, the mere choice of a certain realm of subject matter, or the restriction to certain subjects, is not to be equated with a style, much less with some sort of quintessentially *feminine* style.

The problem lies not so much with the feminists' concept of what femininity in art is, but rather with a misconception of what art is: with the naïve idea that art is the direct, personal expression of individual emotional experience—a translation of personal life into visual terms. Yet art is almost never that; great art certainly never. The making of art involves a self-consistent language of form, more or less dependent upon, or free from, given temporally-defined conventions, schemata, or systems of notation, which have to be learned or worked out, through study, apprenticeship, or a long period of individual experimentation.

The fact is that there have been no great women artists, so far as we know, although there have been many interesting and good ones who have not been sufficiently investigated or appreciated—nor have there been any great Lithuanian jazz pianists or Eskimo tennis players. That this should be the case is regrettable, but no amount of manipulating the historical or critical evidence will alter the situation. There *are* no women

equivalents for Michelangelo or Rembrandt, Delacroix or Cézanne, Picasso or Matisse, or even, in very recent times, for Willem de Kooning or Warhol, any more than there are black American equivalents for the same. If there actually were large numbers of "hidden" great women artists, or if there really should be different standards for women's art as opposed to men's—and, logically, one can't have it both ways—then what are feminists fighting for? If women have in fact achieved the same status as men in the arts, then the status quo is fine.

But in actuality, as we know, in the arts as in a hundred other areas, things remain stultifying, oppressive, and discouraging to all those—women included—who did not have the good fortune to be born white, preferably middle class and, above all, male. The fault lies not in our stars, our hormones, our menstrual cycles, or our empty internal spaces, but in our institutions and our education—education understood to include everything that happens to us from the moment we enter, head first, into this world of meaningful symbols, signs, and signals. The miracle is, in fact, that given the overwhelming odds against women, or blacks, so many of both have managed to achieve so much excellence—if not towering grandeur—in those bailiwicks of white masculine prerogative like science, politics, or the arts.

In some areas, indeed, women have achieved equality. While there may never have been any great women composers, there have been great women singers; if no female Shakespeares, there have been Rachels, Bernhardts, and Duses. Where there is a need there is a way, institutionally speaking: once the public, authors, and composers demanded more realism and range than boys in drag or piping castrati could offer, a way was found to include women in the performing arts, even if in some cases they might have to do a little whoring on the side to keep their careers in order. And, in some of the performing arts, such as the ballet, women have exercised a near monopoly on greatness.

It is no accident that the whole crucial question of the conditions *generally* productive of great art has so rarely been investigated, or that attempts to investigate such general problems have, until fairly recently, been dismissed as unscholarly, too broad, or the province of some other discipline, like sociology. Yet a dispassionate, impersonal, sociologically- and institutionally-oriented approach would reveal the entire romantic, elitist, individual-glorifying and monograph-producing substructure upon which the profession of art history is based, and which has only recently been called into question by a group of younger dissidents within it.

Underlying the question about women as artists, we find the whole myth of the Great Artist—subject of a hundred monographs, unique, godlike—bearing within his person since birth a mysterious essence, rather like the golden nugget in Mrs. Grass's chicken soup, called Genius.[4]

The magical aura surrounding the representational arts and their creators has, of course, given birth to myths since the earliest times. Interestingly enough, the same magical abilities attributed by Pliny to the Greek painter Lysippus in antiquity—the mysterious inner call in early youth; the lack of any teacher but Nature herself—is repeated as late as the nineteenth century by Max Buchon in his biography of Courbet. The fairy tale of the Boy Wonder, discovered by an older artist or discerning patron, often in the guise of a lowly shepherd boy,[5] has been a stock-in-trade of artistic mythology ever since Vasari immortalized the young Giotto, discovered by the great Cimabue while the lad was drawing sheep on a stone while guarding his flocks. Through mysterious coincidence, later artists like Domenico Beccafumi, Jacopo Sansovino, Andrea del Castagno, Andrea Mantegna, Francisco de Zurbarán and Goya were all discovered in similar pastoral circumstances. Even when the Great Artist was not fortunate enough to come equipped with a flock of sheep as a lad, his talent always seems to have manifested itself very early, independent of external encouragement: Filippo Lippi, Poussin, Courbet, and Monet are all reported to have drawn caricatures in their schoolbooks, instead of studying the required subjects. Michelangelo himself, according to his biographer and pupil, Vasari, did more drawing than studying as a child; Picasso passed all the examinations for entrance to the Barcelona Academy of Art in a single day when only fifteen. (One would like to find out, of course, what became of all the youthful scribblers and infant prodigies who then went on to achieve nothing but mediocrity—or less— as artists.)

Despite the actual basis in fact of some of these *wunderkind* stories, the tenor of such tales is itself misleading. Yet all too often, art historians, while pooh-poohing this sort of mythology about artistic achievement, nevertheless retain it as the unconscious basis of their scholarly assumptions, no matter how many crumbs they may throw to social influence, ideas of the time, etc. Art-historical monographs, in particular, accept the notion of the Great Artist as primary, and the social and institutional structures within which he lived and worked as mere secondary "influences" or "background." This is still the golden-nugget theory of genius. On this basis, women's lack of major achievement in art may be formulated as a syllogism: If women had the golden nugget of artistic genius, it would reveal itself. But it has never revealed itself. Q.E.D. Women do not have the golden nugget of artistic genius. (If Giotto, the obscure shepherd boy, and van Gogh with his fits could make it, why not women?)

Yet if one casts a dispassionate eye on the actual social and institutional situation in which important art has existed throughout history, one finds that the fruitful or relevant questions for the historian to ask

shape up rather differently. One would like to ask, for instance, from what social classes artists were most likely to come at different periods of art history—from what castes and subgroups? What proportion of major artists came from families in which their fathers or other close relatives were engaged in related professions? Nikolaus Pevsner points out in his discussion of the French Academy in the seventeenth and eighteenth centuries[6] that the transmission of the profession from father to son was considered a matter of course (as in fact it was with the Coypels, the Coustous, the Van Loos, etc.). Despite the noteworthy and dramatically satisfying cases of the great father-rejecting *révoltés* of the nineteenth century, one might well be forced to admit that in the days when it was normal for sons to follow in their fathers' or even their grandfathers' footsteps, a large proportion of artists, great and not-so-great, had artist fathers. In the rank of major artists, the names of Holbein, Dürer, Raphael, and Bernini immediately spring to mind; even in more rebellious recent times, one can cite Picasso and Braque as sons of artists (or, in the latter case, a house painter) who were early enrolled in the paternal profession. . . .

When the right questions are finally asked about the conditions for producing art of which the production of great art is a subtopic, it will no doubt have to include some discussion of the situational concomitants of intelligence and talent generally, not merely of artistic genius. As Piaget and others have stressed, ability or intelligence is built up minutely, step by step, from infancy onward, and the patterns of adaptation-accommodation may be established so early that they may indeed *appear* to be innate to the unsophisticated observer. Such investigations imply that scholars will have to abandon the notion, consciously articulated or not, of individual genius as innate.[7]

The Question of the Nude

We can now approach our question from a more reasonable standpoint. Let us examine such a simple but critical issue as availability of the nude model to aspiring women artists, in the period extending from the Renaissance until near the end of the nineteenth century. During this period, careful and prolonged study of the nude model was essential to the production of any work with pretentions to grandeur, and to the very essence of History Painting, then generally accepted as the highest category of art. Central to the training programs of academies of art since their inception late in the sixteenth and early in the seventeenth centuries was life drawing from the nude, generally male, model. In addition, groups of artists and their pupils often met privately for life-drawing sessions

in their studios. It might be added that while individual artists and private academies employed female models extensively, the female nude was forbidden in almost all public art schools as late as 1850 and after—a state of affairs which Pevsner rightly designates as "hardly believable."[8]

Far more believable, unfortunately, was the complete unavailability to aspiring women artists of *any* nude models at all. As late as 1893, "lady" students were not admitted to life drawing at the official academy in London, and even when they were, after that date, the model had to be "partially draped."[9]

A brief survey of contemporary representations of life-drawing sessions reveals: an all-male clientele drawing from the female nude in Rembrandt's studio; men working from the male nude in an eighteenth-century academy; from the female nude in the Hague Academy; modelling and painting from the male nude in the Vienna Academy—both of these latter from the mid-eighteenth century; men working from the seated male nude in Boilly's charming painting of the interior of Houdon's studio at the beginning of the nineteenth century; and Mathieu Cochereau's scrupulously veristic *Interior of David's Studio*, exhibited in the Salon of 1814, reveals a group of young men diligently working from the male nude model.

The very plethora of surviving "Academies"—detailed, painstaking studies from the nude studio model—in the youthful *oeuvre* of artists down through the time of Seurat and well into the twentieth century, attests to the importance of this branch of study in the development of the talented beginner. The formal academic program normally proceeded from copying from drawings and engravings, to drawing from casts of famous works of sculpture, to drawing from the living model. To be deprived of this ultimate state of training meant to be deprived of the possibility of creating major art—or simply, as with most of the few women aspiring to be painters, to be restricted to the "minor" and less highly regarded fields of portraiture, genre, landscape, or still-life.

There exist, to my knowledge, no representations of artists drawing from the nude which include women in any role but that of the model—an interesting commentary on rules of propriety: i.e., it is all right for a ("low," of course) woman to reveal herself naked-as-an-object for a group of men, but forbidden that a woman participate in the active study and recording of naked-as-an-object men *or* women.

I have gone into the question of the availability of the nude model, a single aspect of the automatic, institutionally maintained discrimination against women, in such detail simply to demonstrate the universality of this discrimination and its consequences, as well as the institutional nature of but one major facet of the necessary preparation for achieving proficiency, much less greatness, in art at a certain time. One could

equally well have examined other dimensions of the situation, such as the apprenticeship system, the academic educational pattern which, in France especially, was almost the only key to success and which had a regular progression and set competitions, crowned by the Prix de Rome, which enabled the young winner to work in the French Academy in that city. This was unthinkable for women, of course, and women were unable to compete until the end of the nineteenth century, by which time the whole academic system had lost its importance anyway. It seems clear, to use France in the nineteenth century as an example (a country which probably had a larger proportion of women artists than any other—in terms of their percentage in the total number of artists exhibiting in the Salon) that "women were not accepted as professional painters."[10] In the middle of the century, there were a third as many women as men artists, but even this mildly encouraging statistic is deceptive when we discover that out of this relatively meager number, *none* had attended that major stepping stone to artistic success, the École des Beaux-Arts, only 7 percent had received a Salon medal, and *none* had ever received the Legion of Honor.[11] Deprived of encouragements, educational facilities, and rewards, it is almost incredible that even a small percentage of women actually sought a profession in the arts.

It also becomes apparent why women were able to compete on far more equal terms with men—and even become innovators—in literature. While art-making has traditionally demanded the learning of specific techniques and skills—in a certain sequence, in an institutional setting outside the home, as well as familiarity with a specific vocabulary of iconography and motifs—the same is by no means true for the poet or novelist. Anyone, even a woman, has to learn the language, can learn to read and write, and can commit personal experiences to paper in the home. Naturally, this oversimplifies, but it still gives a clue as to the possibility of the existence of an Emily Dickinson or a Virginia Woolf, and their lack of counterparts (at least until quite recently) in the visual arts.

Of course, we have not even gone into the "fringe" requirements for major artists, which would have been, for the most part, both physically and socially closed to women. In the Renaissance and after, the Great Artist, aside from participating in the affairs of an academy, might be intimate and exchange ideas with members of humanist circles, establish suitable relationships with patrons, travel widely and freely, and perhaps become involved in politics and intrigue. Nor have we mentioned the sheer organizational acumen and ability involved in running a major atelier-factory, like that of Rubens. An enormous amount of self-confidence and worldly knowledge, as well as a natural sense of dominance and power, was needed by a great *chef d'école*, both in the running of the

production end of painting, and in the control and instruction of numerous students and assistants.

The Lady's Accomplishment

Against the single-mindedness and commitment demanded of a *chef d'école*, we might set the image of the "lady painter" established by nineteenth century etiquette books and reinforced by the literature of the times. The insistence upon a modest, proficient, self-demeaning level of amateurism—the looking upon art, like needlework or crocheting, as a suitable "accomplishment" for the well-brought-up young woman—militated, and today still militates, against any real accomplishment on the part of women. It is this emphasis which transforms serious commitments to frivolous self-indulgence, busy work or occupational therapy, and even today, in suburban bastions of the feminine mystique, tends to distort the whole notion of what art is and what kind of social role it plays. . . .

. . . Now, as in the nineteenth century, women's amateurism, lack of commitment, snobbery, and emphasis on chic in their artistic "hobbies," feed the contempt of the successful, professionally committed man who is engaged in "real" work and can (with a certain justice) point to his wife's lack of seriousness. For such men, the "real" work of women is only that which directly or indirectly serves them and their children. Any other commitment falls under the rubric of diversion, selfishness, egomania or, at the unspoken extreme, castration. The circle is a vicious one, in which philistinism and frivolity mutually reinforce each other, today as in the nineteenth century.

Successes

But what of the small band of heroic women who, throughout the ages, despite obstacles, have achieved preeminence? Are there any qualities that may be said to have characterized them, as a group and as individuals? While we cannot investigate the subject in detail, we can point to a few striking general facts: almost all women artists were either the daughters of artist fathers, or later, in the nineteenth and twentieth centuries, had a close personal connection with a strong or dominant male artist. This is, of course, not unusual for men artists either, as we have indicated in the case of artist fathers and sons: it is simply true almost *without exception* for their feminine counterparts, at least until quite recently. From the legendary sculptor, Sabina von Steinbach, in the fifteenth century, who, according to local tradition, was responsible for the portal groups on the Cathedral of Strasbourg, down to Rosa Bonheur, the

most renowned animal painter of the century—and including such eminent women artists as Marietta Robusti, daughter of Tintoretto, Lavinia Fontana, Artemisia Gentileschi, Elizabeth Chéron, Mme. Vigée-Lebrun, and Angelica Kauffmann—all were the daughters of artists. In the nineteenth century, Berthe Morisot was closely associated with Manet, later marrying his brother, and Mary Cassatt based a good deal of her work on the style of her close friend, Degas. In the second half of the nineteenth century, precisely the same breaking of traditional bonds and discarding of time-honored practices that permitted men artists to strike out in directions quite different from those of their fathers enabled women—with additional difficulties, to be sure—to strike out on their own as well. Many of our more recent women artists, like Suzanne Valadon, Paula Modersohn-Becker, Kaethe Kollwitz, or Louise Nevelson, have come from nonartistic backgrounds, although many contemporary and near-contemporary women artists have, of course, married artists.

It would be interesting to investigate the role of benign, if not outright encouraging, fathers: both Kaethe Kollwitz and Barbara Hepworth, for example, recall the influence of unusually sympathetic and supportive fathers on their artistic pursuits.

In the absence of any thoroughgoing investigation, one can only gather impressionistic data about the presence or absence of rebellion against parental authority in women artists, and whether there may be more or less rebellion on the part of women artists than is true in the case of men. One thing, however, is clear: for a woman to opt for a career at all, much less for a career in art, has required a certain unconventionality, both in the past and at present. And it is only by adopting, however covertly, the "masculine" attributes of single-mindedness, concentration, tenaciousness, and absorption in ideas and craftsmanship for their own sake, that women have succeeded, and continue to succeed, in the world of art. . . .

Conclusion

Hopefully, by stressing the *institutional*, or the public, rather than the *individual*, or private, preconditions for achievement in the arts, we have provided a paradigm for the investigation of other areas in the field. By examining in some detail a single instance of deprivation or disadvantage—the unavailability of nude models to women art students—we have suggested that it was indeed *institutionally* impossible for women to achieve excellence or success on the same footing as men, *no matter what* their talent, or genius. The existence of a tiny band of successful, if not great, women artists throughout history does nothing to gainsay this fact, any

more than does the existence of a few superstars or token achievers among the members of any minority groups.

What is important is that women face up to the reality of their history and of their present situation. Disadvantage may indeed be an excuse; it is not, however, an intellectual position. Rather, using their situation as underdogs and outsiders as a vantage point, women can reveal institutional and intellectual weaknesses in general, and, at the same time they destroy false consciousness, take part in the creation of institutions in which clear thought and true greatness are challenges open to anyone—man or woman—courageous enough to take the necessary risk, the leap into the unknown.

Notes

1. John Stuart Mill, "The Subjection of Women" (1869) in *Three Essays by John Stuart Mill*, World's Classics Series (London, 1966), p. 441.

2. "Women Artists," a review of *Die Frauen in die Kunstgeschichte* by Ernst Guhl in *The Westminster Review* (American Edition) 70 (July 1858): 91–104. I am grateful to Elaine Showalter for having brought this review to my attention.

3. See, for example, Peter S. Walch's excellent studies of Angelica Kauffmann or his doctoral dissertation, "Angelica Kauffmann," Princeton University, 1967. For Artemisia Gentileschi, see R. Ward Bissell, "Artemisia Gentileschi—A New Documented Chronology," *Art Bulletin* 50 (June 1968): 153–168.

4. For the relatively recent genesis of the emphasis on the artist as the nexus of esthetic experience, see M. H. Abrams, *The Mirror and the Lamp: Romantic Theory and the Critical Tradition* (New York: Oxford University Press, 1953) and Maurice Z. Shroder, *Icarus: The Image of the Artist in French Romanticism* (Cambridge: Harvard University Press, 1961).

5. A comparison with the parallel myth for women, the Cinderella story, is revealing: Cinderella gains higher status on the basis of a passive, "sex-object" attribute—small feet (shades of fetishism and Chinese foot-binding!)—whereas the Boy Wonder always proves himself through active accomplishment. For a thorough study of myths about artists, see Ernst Kris and Otto Kurz, *Die Legende vom Künstler: Ein Geschichtlicher Versuch* (Vienna, 1934).

6. Nikolaus Pevsner, *Academies of Art, Past and Present* (Cambridge, England: The University Press, 1940; New York: Macmillan, 1940), p. 96f.

7. Contemporary directions in art itself—earthworks, conceptual art, art as information, etc.—certainly point *away* from emphasis on the individual genius and his salable products; in art history, Harrison C. White and Cynthia A. White, *Canvases and Careers: Institutional Change in the French Painting World* (New York: Wiley, 1965) opens up a fruitful new direction of investigation, as does Nikolaus Pevsner's pioneering *Academies of Art* (see Note 6); Ernst Gombrich and Pierre Francastel, in their very different ways, have always tended to view art and the artist as part of a total situation, rather than in lofty isolation.

8. Female models were introduced in the life class in Berlin in 1875, in Stockholm in 1839, in Naples in 1870, at the Royal College of Art in London, after 1875. Pevsner, op. cit., p. 231. Female models at the Pennsylvania Academy of the Fine Arts wore

masks to hide their identity as late as about 1866—as attested to in a charcoal drawing by Thomas Eakins—if not later.

9. Pevsner, op. cit., p. 231.
10. White and White, op. cit., p. 51.
11. Ibid., Table 5.

16

How Wide Is the Gender Gap?

Eleanor Heartney

A decade of progress toward parity was followed by years of low visibility. Now women artists are asserting a renewed militancy in the struggle for equal representation.

In October 1980 . . . , Kay Larson offered a happy assessment of the progress of women's art during the previous decade: "For the first time in Western art, women are leading, not following," she wrote. "And far from displacing men, female leadership has opened up new freedom for everyone." From the vantage point of 1987, this statement seems sadly dated. With hindsight it is possible to pinpoint 1980 as the year before the tide began to turn against the wave of pluralism that carried so many women artists into public view. The '80s, it quickly became clear, were about the reinstatement of painting as a dominant mode of expression and, with it, the tradition of the heroic male artist.

At the museums, the new fascination with emotional, expressive painting also resulted in a focus on men. The most notorious example of this—and the first exhibition since the '70s to spark an organized protest by the Women's Caucus for Art—was the Museum of Modern Art's 1984 "International Survey of Recent Painting and Sculpture," in which a scant 14 women were included among the 165 artists represented.

Meanwhile, those few women who did reach superstar status in the early '80s—artists like Susan Rothenberg and Jennifer Bartlett—did so with art in which gender was not an issue. As Rothenberg remarked in

This essay originally appeared in *ARTNEWS*, Summer, 1987. Reprinted by permission of the author and the publisher.

an interview, "When I'm in the studio, I'm just a painter." Suddenly nothing seemed more passé than pattern and decoration, vaginal imagery, body art, ritual and all the other forms pioneered by women in response to their particular experience.

But today there are signs of a new restiveness among women artists and an unwillingness to let the advances of the '70s disappear into history. The most obvious evidence of a returning militancy is the emergence of the Guerrilla Girls, a group of anonymous women artists whose feisty posters point out evidence of sexual discrimination by art-world individuals and institutions.

Another sign of change: as the romance with Neo-Expressionism cools, avant-garde women artists are making a strong showing in art that borrows and manipulates media imagery. Two of these women, in fact—Barbara Kruger and Sherrie Levine—have made it into Mary Boone's previously all-male stable. Boone says she "took these artists on not to stress statistics, but because they are good artists." Kruger, however, remarks, "My decision to enter that gallery is a symbolic leap."

But how are women artists in general faring in today's art world? What was the legacy of '70s activism and how have women artists responded to the new conditions of the '80s?

The abrupt shift in the status of women artists during the early '80s did not occur in a vacuum: the Reagan Revolution marked a setback for the entire women's movement. The rise of the Moral Majority, the increasing bitterness of the abortion-rights debate and the defeat of the Equal Rights Amendment all demonstrated a growing distance between the goals and assumptions of '70s-style feminists and those of the country as a whole. Even within the women's movement, controversy raged about the consequences of the drive for gender-blind laws, economic equality and the elimination of preferential treatment in cases of divorce, custody and maternity leave. Between 1980 and 1986, membership in the National Organization for Women dropped by one-third.

Within the art world, economic realities were undermining women's hard-won visibility. First, the explosion of the art market, fueled in part by a return to painting after a decade of experimental, often deliberately noncommercial art, was centered on art that was decisively unfeminine. Dealer Ronald Feldman maintains that the deemphasis of women's art during the heyday of Neo-Expressionism was not a matter of deliberate prejudice. "A particular movement came along that was heavily male. It was the first viable movement with an international flavor that came on the market after a very dry period, and collectors and curators just went for it."

At the same time, public funding for the sort of organizations that nurtured the women's art movement was reduced. Ariel Daugherty, Na-

tional Project Director for the National Data Base on Women Artists, has made a study of National Endowment for the Arts funding statistics. "Although in fact the NEA budget has increased," she says, "between 1982 and 1985 the share of the NEA budget going to women artists' organizations dropped by 35 percent."

Among those organizations were many of the women's co-ops and galleries designed to foster a nonjudgmental environment. In retrospect it appears that this nurturing attitude may have left members ill equipped for the businesslike mentality that pervades the '80s art world. Painter Joan Semmel, in her 50s, remarks, "We used to think we could beat the system, and we did for a short time. But when the whole Salle-Schnabel thing came out we weren't ready. There was a whole machine, involving critics, dealers and collectors, and having to do with the strategy and planning that come together behind them. Women haven't wanted to deal with that. I personally can't stand it." Although it appears that younger artists of both sexes are increasingly comfortable with the demands of the market, many artists of Semmel's generation shared her stance toward the commercial world. Often it was less a matter of choice or discrimination than the innocence that existed in a much smaller, more intimate art world. "It didn't occur to me at the beginning that one could make a living as an artist," Mary Frank says, "so I wasn't disappointed when I didn't."

Painter Grace Hartigan believes there is an inverse relation between market strength and female visibility. She recalls, "When I was in New York in the late '40s, there were almost no galleries showing avant-garde art. Everyone was poverty-stricken—there was no fame, no money, no galleries, no collectors. That's when you have equality. Men have no objection to women as creators. It's only when they're all scrambling for recognition that the trouble begins." Hartigan admits that artists like Jennifer Bartlett and Susan Rothenberg are widely accepted, but explains, "If you're an extraordinarily gifted woman, the door is open. What women are fighting for is the right to be as mediocre as men."

Thus women's disappearance from the front line seems less a matter of conscious design or deliberate sexism than a convergence of unfavorable trends. A woman *could* negotiate her way to the top in the early '80s, and when she did it was never really clear why the factors inhibiting other women had not hindered her. Susan Rothenberg asks, "Where are the women I went to art school with? Why wasn't I weeded out? I was married. I had a kid. It wasn't careerist drive. It was just that painting was very important to me."

However, unlike the feminist artists of the '70s, Rothenberg refused to make an issue of her sex, and she painted with an assertive, dramatic stroke that dovetailed with the new taste for gestural, expressive paint-

ing. She found herself making frequent appearances as the only woman in shows of the new painting—a distinction that came to an end in 1984, when she announced she would no longer participate in group shows in which she was the sole representative of her sex.

The tokenism experienced by Rothenberg suggests that there is at least a glimmer of awareness, at an institutional level, that women should not be ignored. Among the Guerrilla Girls, awareness of that glimmer has sparked a campaign for change. Organized in 1985 in response to the abysmal male/female ratio in MoMA's "International Survey of Recent Painting and Sculpture," the Guerrilla Girls, who don gorilla masks in public, have introduced a note of humor into the feminist debate. As a spokesperson recently remarked, "We wanted to make feminism fashionable in the '80s." To this end they have adopted some of their tactics from the entertainment world. They have also managed to keep both their numbers and their identities a tantalizing secret, and they engage in "guerrilla" actions, such as papering SoHo with eye-catching posters identifying the allies and adversaries in women artists' struggle for recognition.

The Guerrilla Girls' anonymity has become a kind of trademark. "One of the problems '70s feminists had," says one, "was that people criticized them for using feminism to further their personal careers. Anonymity was a way to eliminate that objection. Since then, we've discovered there are many benefits. For me, personally, it was wonderful to see a large group of people working together with no problem of ego. And also, now that we're making people uncomfortable, I'm glad we're anonymous."

Another Guerrilla Girl remarks, "It's amusing to see how important it is for people to know who we are so they can decide if they should take us seriously. They want to deal with personalities, not the issues." One Guerrilla Girl target, Mary Boone, remarks, "It's significant that the Guerrilla Girls refuse to identify themselves. I can think of many disgruntled artists who feel they've been victimized, but if they're male there are other reasons."

The Guerrilla Girls say their posters are based on statistics such as counts of feature stories, reviews of solo shows and cover articles in magazines. The results of this research are transformed into snappy charts and posters. One takes various critics to task for not covering enough shows by women. *Village Voice* critic Ellen Lubell took exception to this polemic. "While there is no doubt that some of the parties on the list are indeed guilty, the G. Girls . . . have singled out a symptom, not a cause," she writes. "Critics [in the magazines] usually aren't free to write about whom they choose; they're restricted by their editors, who may in turn be pressured by publishers pressured by advertisers. . . . Critics operate within the same circumscribed art world as artists, a world essentially defined by curators and, of course, galleries."

Whether or not the Guerrilla Girls can generate a change of heart in any of the accused, their tactics are clearly raising the art world's consciousness. "People definitely feel the pressure," says dealer Patricia Hamilton. "It's getting to the point where you can't *not* show women. You look like a jerk. I'm just surprised it's been so long in coming."

Outside New York the urgency of this issue varies considerably. In Chicago dealer Rona Hoffman says, "It's definitely something people discuss, though it's not quite as critical an issue as it is in New York." In Houston, Texas Gallery director Frederika Hunter describes an embryonic market in which sexism is not a problem. "Of the few artists we have in Texas who are really making it, a good percentage are female, and they are well supported," she says. "In New York there is an economic power struggle going on, and women are a new factor in the competition for money. Here we're still figuring out how to survive."

In Los Angeles dealer Michael Kohn says, "Concern over women's representation is entirely imported." He says it is his New York artists who press for the inclusion of women in group shows and that it was the New York critics who made an issue of the number of women in the recent "Spiritual in Art" show at the Los Angeles County Museum of Art.

Other groups are joining in the lobbying efforts to raise institutional consciousness. In New York last fall the Women's Caucus for Art sponsored a march on the Guggenheim Museum and the Whitney Museum of American Art to dramatize their findings on the low proportion of female representation in museum exhibitions and permanent collections. They met with curators there and at the Metropolitan Museum of Art and MoMA to discuss the problem and possible solutions. One of these discussions involved Lowery Sims, associate curator of 20th-century art at the Metropolitan. Sims herself has been actively using her position at the Met to push for greater representation of women and minorities. But as she gives the statistics for the opening show in the new 20th-century wing—of 144 artists there are five blacks, 15 women, three Latin Americans and one Asian—she says sadly, "It's the best we could do."

Sims offers several reasons for this state of affairs. "There's a lack of awareness on the outside," she says. "We don't have a concerned upper class involved in the arts that is actively pressuring for change. Right now the inclusion of women and minorities depends on the goodwill of the curator. And since most of our acquisitions are based on donations from collectors, to really up the numbers the museum needs to have them show some interest. Our first line of acquaintance tends to be those artists brought to our attention by collectors." Thus one line of attack she suggests is to focus on the women who collect art, either singly or as part of a collecting team. "That would be a place to raise some consciousness about the problem," she says.

Among dealers there is disagreement about the degree to which collectors are reluctant to purchase art by women. Paula Cooper maintains that "collectors with mainstream collections don't care about gender—they're interested in quality." However, John Cheim, director of the Robert Miller Gallery, admits, "I do find resistance among collectors to buying art by women. I'm quite shocked by it. I find that there are collectors in their 40s and 50s who have no interest in art by women. They may not say it, but it's understood." He adds, "I think things are better for younger artists. Younger people are buying younger artists—each generation gets better." Ronald Feldman agrees that the situation is changing. On collectors' resistance to women's art, he says, "That was absolutely true until five years ago. Now it's rapidly changing. Women are more visible as artists; the quality is equal to what men are doing; they're getting more coverage. It's almost an equal market."

The pressure tactics of groups like the Guerrilla Girls and the Women's Caucus for Art are based on an implicit acceptance of the values and mechanisms of the art world. Artist Silvia Kolbowski argues that the battle for a bigger piece of the pie obscures the question of whether the pie itself has been properly baked. Speaking of the Guerrilla Girls, she says, "They're not questioning the marketplace. They are accepting the validity of the institutions and structures and seeing how women are measuring up. What's missing is a critique of those institutions." In her own work Kolbowski attempts just such a critique. Borrowing images from advertising, fashion layouts and department-store displays, then recombining and juxtaposing these with bits of text, she explores the implicit messages they convey about femininity, capitalism and the Third World.

Artist Aimée Rankin raises similar questions. "The art world is a focal point for patriarchal fantasies," she says. "The ideal of the heroic genius is by definition male." In her work Rankin uses deliberately kitschy objects—plastic baubles and toys, reproductions of Symbolist paintings, strings of beads and gold-painted leaves—arranged in boxes. Humorous exaggerations of extreme definitions of femininity, Rankin's boxes are nonetheless oddly compelling and seductive. This, she maintains, is also true of clichés about womanliness.

Rankin agrees with Kolbowski that it is important for artists to expose and undermine institutions that perpetuate debilitating notions about gender roles, but she also believes that the Guerrilla Girls' emphasis on numbers is not entirely misplaced. "My decision to work within the system in a more aggressive way comes out of my realization that moving outside the system didn't really change much. Our targets weren't even aware they were being boycotted."

Kolbowski and Rankin are just two of a striking number of women

artists who are appropriating and "deconstructing" media and popular imagery, making art that offers a curious contrast to the sort of feminist art most visible in the '70s. The early days of the feminist-art movement were dominated by art that attempted to explore what was uniquely female in women's experiences. Artists working in this mode included Nancy Spero, Judy Chicago, Miriam Schapiro, Mary Beth Edelson and Carolee Schneeman. Today artists like Barbara Kruger, Sherrie Levine, Jenny Holzer, Silvia Kolbowski and Cindy Sherman seem more interested in examining femininity as a social or psychological construct. They explore the way gender roles are conditioned by external forces, and they challenge a white male social order in which women, like inhabitants of Third World nations, are regarded as "other."

Barbara Kruger, for example, announces in a photocollage, "We won't play nature to your culture"—a defiant refusal to accept conventional differentiations between the sexes. Cindy Sherman, reinventing herself from photograph to photograph, suggests that a culture in which the female is an object of vision for the male viewer denies a woman the possibility of genuine selfhood. Jenny Holzer, in provocative messages ("Protect me from what I want"; "Private property created crime") printed on posters, flashing on electronic signboards or, most recently, engraved on stone slabs, adopts a mélange of voices, ranging from the paternalistic authoritarian voice of politics and advertising to the vernacular street jive of the politically dispossessed, in order to underline the importance of language.

The success of these media critics may be due in part to the corrective they supply to the romantic excesses of a now receding Neo-Expressionist movement. In an interview published in the catalogue of her traveling show, Jenny Holzer suggests that the work of these artists "tends to be about 'real world' subject matter more than a lot of male artists' work. I think this is a funny reversal, because now a lot of men's work, like Clemente's for instance, is about fantasy and mysticism, and it's very personal. It's the women who are doing the hard-headed, subject-oriented things."

She sees this change as a response to the fuller possibilities open to second- and third-generation feminists. "My guess is that the first generation of feminist artists was feeling its way along, trying to find an appropriate means of expression. I also think they were very self-conscious about what they were doing because it was new. Being self-conscious, they would take things close at hand, like their bodies or traditional women's work—repetition, domesticity, boredom—all the things that were women's lot. Now, since the women's movement has been somewhat successful in the United States—there isn't always economic freedom but there is mental freedom—you have the permission and the confidence to

go ahead and do what you want. World politics are a lot more interesting than patterns and repetition and boredom."

Art-world acceptance of women working in this mode may be rooted in the fact that this is unexplored territory, without a tradition of male dominance. The work's success may also be related to these artists' tendency to infiltrate from within, adopting a traditionally male tone and language in order to expose its contradictions, rejecting the earlier generation's tendency toward separatism. Thus Barbara Kruger explains that her aim in joining the Mary Boone gallery is not what it may appear. "The question is how I can be more effective in generating change. I'm not interested in repeating the notion of the great artist, of being the Queen of the Hop. I want to let go of that competitiveness."

But is it possible to subvert the system without being changed by it? Miriam Schapiro has her doubts. She points out, "As Marshall McLuhan said, 'The medium is the message.' I'm afraid the artists who think they can subvert from within may be kidding themselves."

As a veteran of the women's movement, Schapiro is also troubled by other aspects of the younger generation's agenda, particularly their tendency, as they sweep away the myths of gender, to sweep away any positive connotations of femininity as well. "What feminist criticism has provided for the world is a paradigm from which you can extend to larger issues," she says. "My fear is that as this develops there begins to be angst about early feminism. But if you destroy the myth of women in traditional art, you destroy your ancestry—deny your grandmothers. That's a short-sighted view. It throws the baby out with the bathwater." She adds, "There is a predictable historical rule of thesis/antithesis. What I'm arguing for is the middle ground."

The relative success of the female media critics should not obscure the fact that women artists in general have a long way to go to achieve parity with men. While U.S. census data reveal that 38 percent of artists are women, men continue to make up the bulk of visible, practicing artists. And a report by the NEA notes that women artists make a yearly average of only $5,700 from their artwork, as opposed to an average of $13,000 for men. (These statistics include artists in all the artistic disciplines.)

For feminist artists, curators and critics who are veterans of the '60s and '70s, the apparent stagnation of the move for equality has been discouraging. "It's disappointing that the interest in race and feminism hasn't been sustained," says Lowery Sims. "You think that everybody should know what we went through in the '70s, and then you realize— poof—it's gone. I find it appalling that the movement hasn't filtered down to young blacks, minorities and women."

Despite the statistics, however, there have been some permanent

gains. As Joan Semmel points out, "The justification for not showing women artists has changed. Dealers used to say that women artists weren't as good as men. Now they say that collectors won't buy the work. That's progress—of a sort."

The question for women artists in the '80s seems to be: How does one build on gains and avoid the trap of trying to start all over again from square one? Just as many leaders of the larger feminist movement have realized that equality cannot be achieved in isolation from other social and personal goals, so art-world feminists are having to redefine their tactics in order to reach a younger generation for whom feminism is a problematic matter. "I'm reluctant to pigeonhole myself as a feminist," says Carol Hodson, a graduate student of sculpture at the Tyler School of Art in Philadelphia. "I'm wary of the way movements become more important than individual action. It seems to me that any group that's organized becomes generalized."

On the other hand, young women are not unaware of their debt to the activists of the '70s. Hodson's fellow student Virginia Tyler remarks, "I don't think I would be able to step out into the real world if it hadn't been for the '70s. I caught the tail end of the feminist movement—I was the last member of a women's co-op gallery. When I look back, I realize I made a lot of bad pink stuff, but if I hadn't done that I probably wouldn't be doing anything now at all."

In the final analysis, it seems clear that in the art world, as in the "real" world, women have made irreversible strides toward greater equality. It is also clear that these advances are the product of constant, dogged efforts by women themselves to chip away at the barriers surrounding them." We have received orders not to move," one Kruger text reads, parodying the passive role to which women historically have been relegated. In the art world, it appears that these orders are being regularly ignored.

17

Race and Representation

Guy C. McElroy

The ways that America's leading visual artists have portrayed the African-American—as slave or freedman, servant or member of the middle class, minstrel performer or wartime hero, ridiculous stereotype or forceful leader—form an index that reveals how the majority of American society felt about its black neighbors. Naming is a form of power, and visual images have the persuasive power to identify and define place and personality. Whether through portraiture, genre scenes, allegorical history painting, or narrative realism, the work of artists of differing races and ethnic groups has detailed the prevailing negative as well as the rarer positive opinions that one race held for another.

Facing History: The Black Image in American Art 1710–1940 documents comprehensively the variety of ways artists created a visual record of African-Americans that reinforced a number of largely restrictive stereotypes of black identity. The aim of *Facing History* is to provide a panorama that illuminates the shifting, surprisingly cyclical nature of the images white men and women created to view their black counterparts. The repeated use of these pictorial images gave them the powerful immediacy of symbols. Prosperous collectors created a demand for depictions that fulfilled their own ideas of blacks as grotesque buffoons, servile menials, comic entertainers, or threatening subhumans; these depictions were, for the most part, willingly supplied by American artists. This

From *Facing History: The Black Image in American Art 1710–1940*, an exhibition catalog of the Corcoran Gallery of Art, Washington, D.C., 1990. Reprinted by permission of the publisher.

vicious cycle of supply and demand sustained images that denied the inherent humanity of black people by reinforcing their limited role in American society. More fundamentally, these images expressed an inability to comprehend a people whose appearance and behavior were judged to be different from their own, and thus inferior.

The history of African-Americans on the North American continent encompasses the entire history of the United States. Slavery and freedom, the initial optimism and the subsequent brutalities of Reconstruction, the transition of the United States from a rural agrarian economy to an urban industrial nation: the often turbulent history of this country is accurately reflected in the ways that visual artists have chosen to represent black people in their art. In his pioneering study *The Negro in Art* (1941), Alain Locke observed the potential of the visual arts to heal the rupture between the races:

> *The deep and sustained interest of artists . . . in the Negro subject, amounting in some instances to a preoccupation with this, seems to run counter to the barriers and limitations of social and racial prejudice, and evidences appreciative insights which, if better known, might prove one of the strongest antidotes for prejudice.*

In the 1700s, Africans who had been forcibly removed from their native cultures were portrayed in some of the earliest surviving examples of colonial art. Justus Engelhardt Kühn's *Henry Darnall III as a Child* (ca. 1710) established an artistic convention emulated by generations of eighteenth and nineteenth century artists. The servant exists in Kühn's portrait not as a fully realized human being but as the chattel of the son of a wealthy slave owner. He is an accoutrement who embodies the material status of the landed Maryland gentry who were Kühn's primary clientele. Kneeling at the side of the planter's son, he wears the silver collar of servitude. His suppliant position is typical of the image of African-Americans—forcibly uprooted and brought to America—that held sway over the well-to-do elite of landed colonial America.

Strikingly, Kühn's painterly formulation existed simultaneously with a radically different tradition in colonial America. Charles Zechel's portraits testify to the wide popularity painted portraits enjoyed in colonial families of all races. The pretensions of middle-class prosperity inherent in Zechel's miniatures hint at the existence of a small but self-sufficient black middle class in colonial America, most probably composed of free blacks, mulattoes, and servants who were adequately compensated for their work as laborers or domestics. Both Kühn's stylized portraits of wealth and Zechel's straightforward records relate depictions of race to economic status. Kühn's commissioned portraits were enormously pop-

ular with the landed gentry of his adopted Maryland, while Zechel's inexpensive portrait mementos were commissioned by a much wider audience. These two divergent means of recording black men and women were shaped in no small part in terms of social class and economic status. Similar attitudes of class and economics would, in turn, inform many of the subsequent artistic expressions of African-Americans in eighteenth and early nineteenth century America.

With the movement of colonial America toward revolution, the issue of slavery was often enlisted in the service of arguments for or against independence. The operatic tableau created by the expatriate American John Singleton Copley in *Watson and the Shark* (1778) and the romanticized conception of equality envisioned in Samuel Jenning's *Liberty Displaying the Arts and Sciences* (1792) were breathtaking innovations in the nascent American arts. Copley's and Jennings's divergent ideas about the nature of African-Americans served as propaganda that illustrated the ideological arguments then coalescing about the correct economic and social place of black people in America.

Copley's *Watson and the Shark* (Fig. 17-1) introduced polemic overtones into the drama of an actual historical event, skillfully fashioning a morality play with a black man at its emotional apex and black identity

Figure 17-1. John Singleton Copley, *Watson and the Shark.* 1778. Oil on canvas, 71¾ × 90½".

as its subtext. Commissioned by Brook Watson, the painting was meant to serve as a forceful warning to colonial activists in America and Whig opponents in England who favored freedom for the white colonists but tolerated or supported the practice of slavery; the black man in *Watson* is a complex, multidimensional character in the service of a conservative polemic. Samuel Jennings's *Liberty Displaying the Arts and Sciences*, on the other hand, reflected the abolitionist sentiments that formed a large part of the highly vocal intellectual community of postrevolutionary Philadelphia. Unlike the historical event depicted in *Watson*, the composition of this, America's first history painting on an abolitionist theme, provides a schema to enunciate the ideas and values of the Philadelphia abolitionists. However, despite the allegory of its overtly stated abolitionist theme, *Liberty Displaying the Arts and Sciences* avoids outlining black identity by portraying blacks as individual people. Jennings's passive subjects are, by position, action, and characterization, the grateful recipients of the benevolent enlightenment of their white superiors.

In the first quarter of the nineteenth century the United States continued to consolidate its status as a nation, and after the defeat of the British forces in the War of 1812, public self-confidence slowly began to coalesce into a national identity. One of the significant aspects of this new nation was a rural, primarily (but by no means exclusively) Southern-based plantation economy. The minstrel performers who suddenly developed and flourished in the first two decades of the nineteenth century exploited the status of blacks within plantation society, reinforcing hardening perceptions of racial inequality. Minstrelsy provided a type that denied the factual details of the lives that many African-Americans led as self-sufficient individuals, providing an image that contradicted the reality much of the public experienced in both urban and rural communities. . . .

Performed by white men disguised in facial paint, minstrelsy relegated black people to sharply defined dehumanizing roles. Skin the color of coal, ruby lips stretched around an outsized exaggeration of a toothy grin, and the tattered clothing and mawkish behavior of such notable pioneers as T. D. Rice and Daniel Emmet created a convenient label— blacks as buffoons. Music-making, the minstrel performer's one definable skill, reduced the depth of black characterization to that of entertaining clown. The servile mannerisms of the generally rural minstrel bumpkin, or "comic darkey," were sometimes juxtaposed with the natty elegance of a dandy shyster—the Zip Coon character. These characters, seen in widely popular stage productions, objectified the distinctive individuality of African-American communities flourishing in cities such as Boston, Philadelphia, Atlanta, and New Orleans. This lack of individuality could,

in turn, be used to justify the maintenance of an economy supported to a large extent by the labor of an indentured rural black underclass.

John Lewis Krimmel's enthusiastic embodiment of the comic darkey stereotype in *Quilting Frolic* (1813) . . . established a precedent that future artists, seeking to label their scenes as distinctly American, would either wholeheartedly or unthinkingly emulate. Basing his art on English and Dutch genre conventions, Krimmel sought to popularize his scenes by his use of readily identifiable details and stock characters. His minstrel-type banjo player was given a clearly defined position on the margins of the composition. Aside from the overt mannerisms of Krimmel's characterizations, the forceful repetition of black people as absurdly comic entertainers—musically adept but otherwise unskilled—reinforced in the fine arts a harshly restrictive stereotype that would in turn be further promulgated by Currier and Ives and other producers of popular images.

In the developing genre tradition historically associated with the optimism and burgeoning nationalism of the Jacksonian era, African-American subjects would be regularly associated with humorous activities and musical merriment but otherwise depicted as persons who existed outside the social order. The emergence of such a single-minded notion of black identity was not coincidental. These representations were one manifestation of the artistic academy developing in New York City in institutions such as the National Academy of Design and the American Art-Union. The educational, economic, and exhibition opportunities these institutions afforded allowed for a density of artists who, working in close proximity to each other, often influenced one another's work. Their style exceeded the influence and importance of other developing conventions centered in regional centers such as Boston and Philadelphia, where abolitionist sentiments were a much more vocal faction of the intellectual discourse.

The New York School had two main components, Landscape painters, such as Thomas Cole and Asher B. Durand, tried to capture in the American landscape the essence of a philosophical sublime—what is now known as the Hudson River School. Building on Krimmel's successful example, genre painters, such as William Sidney Mount, refined materialist philosophy as a central aspect of American painting through the meticulous inventorying of the minute details of everyday life. Within this philosophy, black men and women were characterized by physical appearance of stereotypical behavior that emphasized their "otherness" rather than by a full spectrum of emotional and intellectual activities. Mount's early work used black subjects as caricatures to establish the particularly American characteristics of a scene, but his mature art, based on observation, evolved into much more personal descriptions of person-

ality and appearance. Throughout his career, Mount expressed profoundly ambivalent feelings about the proper relationship between the races, and in many ways his contradictory attitudes toward the true identity and proper place of African-Americans exemplified the sentiments of his contemporaries in the face of growing racial tensions.

The first work that Mount exhibited at the National Academy of Design, *Rustic Dance After a Sleigh Ride* (1830), consolidated the conventions introduced in Krimmel's *Quilting Frolic*. Images of the antics of African-American men who fiddled for the pleasure of white audiences also evoked highly personal memories for Mount: Anthony Hannibal Clapp, a favorite slave on the Hawkins-Mount plantation, was revered for his musical abilities, and Mount's uncle Micah Hawkins was a composer of popular songs performed by black-faced minstrels. However, the strongly conceived female figure in *Eel Spearing at Setauket* (1845) is one of the rarest heroic portrayals—that of a nurturing woman—of an African-American to be included in painting before the Civil War. Mount's use of a woman in *Eel Spearing* is especially ironic, because it was a black man, not a woman, who taught him the subtleties of spear fishing in the shallows of Long Island Sound. While the artist's memories of his childhood experiences with his fishing companion stimulated the subject for this landscape commission, his pragmatism dictated that the inclusion of a black man in the intimate and powerful position of teacher was an unacceptable risk for a commissioned work. Mount's substitution generated an image of nurturing womanhood that displays all the strengths of what was then one of the few acceptable roles for black women—nanny, kitchen servant, maid—in short, "mammy."

The attitudes of this powerful but inherently conflicted painting would be fully contradicted in Mount's late work. The sketch for the allegory *Political Dead* (ca. 1867) . . . shows how Mount, a stridently conservative Democrat, viewed Emancipation and Reconstruction as moral and political failures. His approach to portraying black people, which began as unthinking cliches and matured into complex, multidimensional portrayals, congealed finally into the bitterness of a separate-but-equal philosophy, and the popularity of his work suggests that the majority of white Americans shared similar uncertainties about both the nature and place of African-Americans in society.

The successful consolidation of Krimmel's ideas in Mount's work confirmed the validity of genre as an appropriate subject for successive generations of artists. Their work reflects the diverse spectrum of sentiment regarding black people that ranged throughout the population before the Southern rebellion. James Goodwyn Clonney's *Waking Up* (1851) . . . continues the conventions of distorting physiognomy and behavior for comic or moral effect. Clonney's sleeping fisherman being teased

awake by mischievous white children wholeheartedly emulates Mount's use of a recumbent black figure in *Farmers Nooning* (1836) [Fig. 17-2]. But while Mount was dedicated to the artistic value of faithfully recording observed reality, Clonney's cartoonish darkey found its inspiration in crude images developed by popular media and minstrel entertainment. *Farmers Nooning* is redolent with a multiplicity of meanings, but Clonney single-mindedly circumscribed the character of his black figure, reinforcing his servile status by reducing him to the plaything of children.

A positive expression of the autonomy of the African-American community can be seen in Christian Mayr's *Kitchen Ball at White Sulphur Springs* (1838), which, while maintaining the detailed contextual observation typical of the American genre artist, presents a black community in the midst of what is most probably the joyful celebration of a wedding. While reminiscent of *Rustic Dance After a Sleigh Ride*, Mayr's dancers and revelers suggest the diverse life of a black middle class. The graceful social interaction in this group of well-dressed men and women (perhaps servants who worked for wealthy landowners) is recorded by the artist in a rich variety of finery and action; in this sense *Kitchen Ball* records

Figure 17-2. William Sidney Mount, *Farmers Nooning*. 1836. Oil on canvas, 20¼ × 24½″. The Museums at Stony Brook. Gift of Frederick Sturges, Jr., 1954.

one of the most compelling realities of nineteenth century African-American life. However, Mayr's scene is a notable exception to an American genre tradition of depicting black people as comic stereotypes that continued uninterrupted until the outbreak of civil war.

With the onset of national conflict, more realistic representations of black people were introduced into the visual arts to further the arguments of the abolitionist cause. For the most part painters avoided describing the events of the war or their effects on society (in sharp contrast to the vivid reportorial drawings, often based on photographic evidence, created by graphic artists to illustrate the accounts of battle and army life that filled the journals and newspapers of the day). Still, their work clearly indicated their feelings concerning abolitionism. The 1861 passage of the Confiscation Act added incentive for Southern slaves to defect from the Confederate war effort they were often forcibly committed to support: upon reaching Union lines, they were designated as contrabands of war and granted immediate freedom. Eastman Johnson's *The Ride for Liberty—The Fugitive Slaves* (ca. 1862), Theodor Kaufmann's *On to Liberty* (1867), and Edwin Forbes's *Contrabands Escaping* (1864) were all based on events the artists witnessed while serving in combat or accompanying Union forces to the front. Whether stylized as noble savages after the French Academic tradition in Kaufmann's version, given the religious overtones of the flight of the Christ child in Johnson's dramatically composed account, or laconically reported by Forbes, black fugitives were portrayed with a new nobility that recognized both the valor required in their escapes and the growing importance of abolitionist sentiment in white society. . . .

Some of the most dramatically heroic descriptions of African-Americans during the Civil War were created by sculptors. Probably because of the influence of prevailing European neoclassical styles on American sculptors, black men and women were often idealized in a manner similar to John Quincy Adams Ward's *The Freedman* (1863). Ward's reliance on convention and stylization lent his subject the unusual status of heroic idealism associated with the noble struggles for freedom by ancient Greek and Roman citizens, creating an appealing symbol of the fight for black freedom. John Rogers, on the other hand, rejected neoclassicism for a vigorous, almost exaggerated realism that translated some of the primary concerns of genre painting, such as accurate detailing and narrative description, into sculptural idioms. Rogers' *The Wounded Scout, Friend in the Swamp* (1864) presented a heroic but politically acceptable image that confirmed the validity and common appeal of abolitionist sentiments. Mass produced in the form of plaster casts and widely circulated through catalogue sales, Rogers' sculptures were his vocal contribution to a cause in which he firmly believed.

Postwar Reconstruction saw a brief flourishing of equality in America, and the first artists to address this subject responded enthusiastically. Kaufmann's *Hiram R. Revels* (ca. 1870) . . . commissioned by Louis Prang Company for reproduction as a mass-circulation print, offers a vivid example of the great strides that some black men and women attained during Reconstruction. Revels, the first African-American to serve in the United States Senate, was elected by the state of Mississippi to fill the same seat that had been occupied by Jefferson Davis prior to the war, and Prang viewed the portrait of the first black official to gain high public office after the passage of the Fourteenth Amendment as a salable subject with possibilities for broad public distribution. Kaufmann's depiction of Revels reveals a man of upstanding character and intelligence, the kind of man who, justifying Frederick Douglass's admonition that every family should purchase a copy of the print for its home or place of business, could reinforce the pride and idealism surging in black communities.

More general in subject, Thomas Waterman Wood's *American Citizens (To the Polls)* (1867) uses genre conventions to commemorate the 1866 elections—the first opportunity for Southern black men to participate in national elections. Wood's ensemble presents four characters— a Yankee, an Irishman, a Dutchman, and an African-American—who manifest what were popularly understood to be their ethnic traits. Staging a variety of types across the shallow space of his canvas, Wood documented the democratization that had suddenly occurred in the United States, noting nevertheless that a pecking order continued to exist in American culture, and, despite the black man's recent receipt of the franchise, he still came last. Wood's watercolor, which is more a vision of the dream of equality than a study of individual identity, maintains the tradition of artists relying on racial and ethnic types to communicate the values of their society.

By the middle of the 1870s the gains black people had made following Emancipation were being sharply challenged by an increasingly violent segment of Americans dissatisfied with the premise of equality enforced by law and determined to limit the rights of blacks, by force if necessary. . . . Poll taxes made voting difficult or impossible in many Southern states, and the 1883 repeal of the Civil Rights Act by the Supreme Court effectively returned the majority of African-Americans to the status of second-class citizens. The increasing disillusionment of the public with Reconstruction was often openly supported in the pages of the popular press. Cartoonists and print artists supplied caustic images that openly embraced racist sentiment or encouraged a view of black citizens as separate and different from their white counterparts. Alfred R. Waud's *The Bug Man at Pine Bluff, Arkansas* (ca. 1871) represents one of the milder examples by print artists who returned with obvious gusto to pre-Civil War

ideas of black people as extremely compliant, servile, or painfully antic characters.

In the fine arts the end of Reconstruction optimism meant a return to an art heavy with romantic nostalgia for an America that was more imaginary than real. Richard Norris Brooke said his *A Pastoral Visit* (1881) "was my first decided success and unfortunately fixed my reputation as a painter of negro subjects." The sentimental scene Brooke recorded in *A Pastoral Visit* was typical of how postwar artists responded to the demand for nostalgic views of the idealized stability of America before the Civil War. Brooke's highly popular painting catalogued types of uplifting black human beings—the preacher, the musician, the laborer, the nurturing woman, the delightful children—that reflected the condescending perspective the white majority often adopted as its members viewed African-Americans from a limited vantage point. Southern born and bred, William Aiken Walker drew on the life and landscape of his environment to create a meticulous but one-sided record of black life and livelihood, and his *Plantation Economy in the Old South* (ca. 1884) expresses a profound nostalgia for a return to prewar plantation life. Although the all-encompassing economic structure of plantation society had been severely shaken by the Civil War, its influence on American society remained pervasive. Walker's landscape, based on his conception of black identity through a radically limited definition of place and activity, literally relegated its subjects to work in the cotton fields, substituting the impoverishment of contract labor for slavery.

As the prevailing tendencies in American art expressed identity through symbols of romantic idealization of subtly degrading nostalgia, painting that accurately described the corporeal reality observed by the artist produced a significant rethinking of how a black person could be personified and what that description could signify. Winslow Homer began his career as a sketch artist for mass-circulation publications such as *Harper's Weekly*. . . . Unlike his contemporary Alfred R. Waud, Homer's approach to African-American subjects matured as his ability to master complex subjects evolved. Based on physical observation, a painting such as *Dressing for the Carnival* (1877) [Fig. 17-3] expressed the artist's romantic appreciation of the pride and strength of character of a familial group he observed intently preparing for the festival variously known as Jonkonnu or Jonkeroo, a traditional end-of-year festival that after the Civil War became a celebration of the freedom granted slaves by the Emancipation Proclamation. Whether in ensemble interactions or in narrative scenes. Homer diligently probed the psychological as well as the physical manifestations of his subjects, reinvigorating the increasingly academic genre tradition with a metaphoric approach to imagery that gave the subtleties of his essentially genre characterization a complex and full voice.

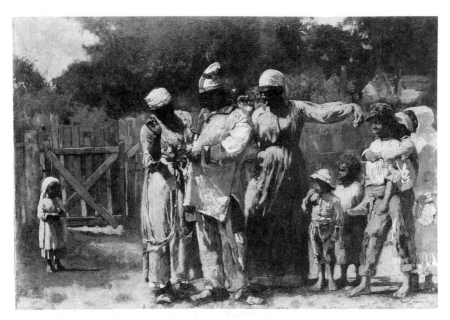

Figure 17-3. Winslow Homer, *Dressing for the Carnival*. 1877. Oil on canvas 20 × 30″. The Metropolitan Museum of Art, Lazarus Fund, 1922.

Another philosophical approach to figuration can be seen in the work of Thomas Eakins. *Will Schuster and Blackman Going Shooting (Rail Shooting)* (1876) portrays a boatman who knowledgeably plies his trade for a well-to-do-class of sportsmen in a way that conveys physical strength, intellectual acumen, and the instincts of a disciplined professional. Eakins was European trained; his approach to painterly subject matter reflected his disciplined, steadfast neutrality. His scientifically rigorous realism demanded that all subjects—white or black—should be recorded objectively irrespective of race, class, or caste. Through both visual image and title, *Will Schuster and Blackman* records the economic and social disparity between two individuals linked only by a business transaction. The sportsman, the probable customer for this painting, is named, while the black man remains anonymous, described only in terms of skin color. The mature works of Eakins and Homer combine sensitive recording of the uniqueness of individual identity with a rigorous description of all aspects of human activity; in this sense they represent a high water mark in nineteenth century artistic expression of African-American identity, offering an alternative to the penchant for typing that, with a precious few exceptions, marked the development of American art.

By the beginning of the twentieth century, the urbanization of the United States had resulted in a dramatic alteration of the social fabric. The migration of rural populations to urban areas fostered a new, socially

conscious form of realism in American art. Rejecting the influence of such persuasive European styles as impressionism, Robert Henri adopted expressionistic representation to paint what he termed "my people"—the largely poor working class of all races who populated America's urban areas. Through the example of his art and the lifelong advocacy of his teaching, Henri exerted a profound impact on a generation of young artists.

Conservative painters such as Wayman Adams responded to Henri by emulating his painterly approach to vigorously conceived portraiture without digesting the philosophical underpinnings of his beliefs in social and racial equality. Although free, the woman described in *New Orleans Mammy* (ca. 1920) is typed by a distancing appellation rather than by the humanizing distinction of name. In both dress and title, the artist links his subject to an economic caste that has a strictly circumscribed societal role. Painted in the twentieth century, Adams's work, which reveals his conception of black identity, is based on nineteenth century patterns—his subject could just as easily have been a plantation slave or domestic servant.

A second, quite different response to Henri's artistic example can be found in the work of social realists such as Reginald Marsh. Marsh's *Tuesday Night at the Savoy Ballroom* (1930) [Fig. 17-4] employs a host of expressive, almost cartoonish distortions to make pointed commentary on the racial prejudice that continued to be subtly enforced in New York despite the apparent gains of the Harlem Renaissance. Intermingling blacks and whites in a densely packed social setting, Marsh's splashily sophisticated crowd is awash with a variety of undercurrents—the fear of racial miscegenation, the desire for continued cultural isolation, the unspoken but constantly present possibility that the premise of the melting pot was flawed—that were still realities despite much of the vibrancy of Harlem culture.

By the time Marsh painted *Tuesday Night at the Savoy Ballroom*, social realism was merely one form of painting in competition with a variety of other, frequently abstract means of artistic expression. With an increasing objectivity that can be traced directly to the introduction of photography as an accepted means of reproducing reality for a mass audience, different ways of thinking about representation, such as social realism, gained legitimacy as valid forms of artistic expression. More important, multiracial organizations such as the National Association for the Advancement of Colored People (NAACP) and the Urban League, through prolonged and vocal, well-organized protests at racial prejudice, dramatically increased public consciousness of the need for racial equality. Depictions of black people can no longer rely on gross distortions of physiognomy or character to achieve racially motivated humor, but the

Figure 17-4. Reginald Marsh, *Tuesday Night at the Savoy Ballroom.* 1930. Tempera on composition board, 36 × 48⅛″. The Rose Art Museum, Brandeis University. Gift of the Honorable William Benton, New York.

symbolic power of visual images remains insidious. Jim Crow, Uncle Tom, Mammy, the Comic Darkey, and Zip Coon no longer dominate images of African-Americans in painting and sculpture, but their ghosts live on in a host of popular mediums, most notably in the violence of action serials and the stereotyped behavior of television sitcoms.

One of the hallmarks of genre painting was the development of conventions and stereotypes for portraying all manner of ethnic and racial distinctions, and many of those stereotypes continue to resonate through our culture. However, the economic and social underpinnings of this country have dictated that greater wealth meant the freedom to digress from type by increasing the distinctions of individual personality. Each racial and ethnic group, with the exception of the African-American, has had the opportunity to shed the overt characteristics of a group identity in favor of an identity based on individuality of choice. While strikingly different, the images of blacks in Justus Engelhardt Kühn's ostentatious portrait of plantation wealth and Charles Zechel's painted equivalent of a photographic portrait both employ economic viewpoints—one author-

itarian, one laissez-faire—to justify racial distinctions. Too often in this country's history, the relentless poverty that until recently has been the fate of many African-Americans has been a primary determining factor in the generation of racial stereotypes.

Acknowledging some of the underlying assumptions that have shaped the abundance of images that we daily digest limits their power over us. Whether based on assumptions of colonial society (*Henry Darnall III as a Child*), the Revolutionary War (*Watson and the Shark*), burgeoning nationalism (*Rustic Dance After a Sleigh Ride*), the extreme trauma of the Civil War (*The Ride for Liberty—The Fugitive Slaves*), or the optimistic racial equality that briefly flourished during postwar Reconstruction (*American Citizens [To the Polls]*), the work of the artists included in *Facing History* recorded more than the superficial dimensions of place and the overt characteristics of physical identity. Political beliefs, economic assumptions, and philosophical or religious credos form the structure that gives these representations continuing credibility, just as similar beliefs initially motivated the creation of the work. However, images need not automatically assume negative connotations or rigid limitations. Although strikingly different in formulation and execution, John Singleton Copley's *Watson and the Shark* and Winslow Homer's *Dressing for the Carnival* vividly show that a visual identity can serve as a tool that heightens perceptions by encouraging self-awareness. Perhaps, from our vantage point at the end of the twentieth century, we can finally begin to recognize the economic and social underpinnings of our racial stereotypes and bury some of the most malodorous of many lingering ghosts.

18

Inventing "the Indian"

Julie Schimmel

No sooner had the first representation of American Indians appeared on canvas than the question was raised as to whether or not it was accurate. From that day until the present it has been the issue most frequently debated in judging portraits of Indian life. During the nineteenth century, in particular, questions about accuracy superseded judgments about artistic merit, so convinced were critics and commentators on Indian habits and customs that "real" Indians could be isolated and identified.

A journalist writing for the *Missouri Republican* in 1848, for example, described "a home scene" of Indian life by Seth Eastman as if it were possible for an artist to create without a point of view. The painting, he wrote, was "quite unlike the vast mass of Indian pictures it has been our bad luck to see—for it is true. There is no attitudinizing—no position of figures in such a group that you can swear the artist's hands, and not their own free will, put them there."[1] Yet George Catlin's self-portrait among the Mandans, painted just a decade later, suggests just how much "attitudinizing" permeated the relationship between whites and Indians. . . . Catlin stands dressed in a contrived buckskin outfit that makes of western garb a fashionable eastern suit. Poised with brush in hand before his easel, he paints the Mandan chief Máh-to-tóh-pa as a reflection of his own self-conscious, controlling image. The artist's stance among a spell-bound crowd of half-nude Indians leads the viewer to believe that

Excerpted from *The West as America: Reinterpreting Images of the Frontier*, ed. William H. Truettner (Washington D.C.: Smithsonian Institution Press, 1991), by permission of the publisher. Copyright © 1991 by Smithsonian Institution.

nothing but reality is being recorded, but Catlin's relationship to his subjects comes straight from the drawing rooms of eastern society, as Indians are submitted to a portrait process that cherishes individuality, material status, and vanity—all notions less highly regarded in Indian culture.

Whether from the spheres of religion, politics, commerce, or ordinary walks of life, white Americans perceived Indians through the assumptions of their own culture. As a result, Indians were seen in terms of what they might become or what they were not—white Christians. Or Indians were not seen at all, at least in terms of the cultural organization particular to Indian tribes or in terms of the negative impact white contact had on Indian culture. . . .

By the time American artists first ventured forth to paint Indians in western territories, the latter had long been perceived in the light of contrasts made between white and tribal cultures. As historian Patricia Limerick states in *The Legacy of Conquest* (1988): "Savagery meant hunting and gathering, not agriculture; common ownership, not individual property owning; pagan superstition, not Christianity; spoken language, not literacy; emotion, not reason."[2] Whether the comparison was represented overtly or not, Indians were judged according to these contrasts, as Fanny Palmer's well-known Currier and Ives lithograph of 1868 makes clear. . . . America's growth is expressed in terms of the Indians' decline. On the left, a white community bustles with activity. The major features of the town are the public school, the foundation of "enlightened" citizenry; the woodsmen, who prepare the way for future settlement; and the telegraph and railroad lines, the technological lifelines of civilization. These last two forms of invention—communication and transportation—most explicitly separate the two Indians on the right from civilization. Astride their horses, which suggest their nomadic life-styles, partially obliterated by smoke from the train, they stand rooted, while lines of so-called progress reach toward the horizon. . . .

Noble but Savage

Artists drew on both [positive and negative] interpretations but more often at first (particularly in the 1830s and 1840s) on an idealized Indian representing the "natural" man conceived by whites as an alternate role model—the independent male who lived beyond the bounds of civilization but who embodied wilderness "virtues." The "dark side," the superstitious, godless "savage" in conflict with white civilization (and a hierarchy of Anglo-Saxon values), emerged in significant numbers on canvas in the 1840s and has persisted to the present.[3]

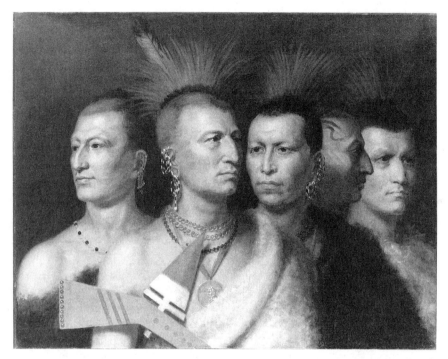

Figure 18-1. Charles Bird King, *Young Omahaw, War Eagle, Little Missouri, and Pawnees.* 1822. Oil on canvas, 28 × 36⅛″. National Museum of American Art, Smithsonian Institution, Washington, D.C. Gift of Miss Helen Barlow. Photo by Art Resource.

Paintings by Charles Bird King from the 1820s and by Karl Bodmer, Catlin, and Alfred Jacob Miller from the 1830s portray Indians as separate from white civilization, as if colonization had not yet introduced epidemics, alcoholism, and tribal disintegration caused by removal from traditional to distant lands. Artists ignored current realities in favor of earlier literary and artistic traditions, which placed Indians in remote and pristine environments. Here were earthly paradises, where life, supported by the beneficence of nature, proceeded in an orderly fashion. At one with their surroundings, Indians were seen as innocent, simple, devoid of guile and deception.

While rarely revealing the ideas that formed their attitudes, painters drew on well-established European intellectual constructs regarding primitivism and the Noble Savage.[4] . . .

[Charles Bird King was among the first to paint numerous portraits of Native Americans.] The consummate Noble Savage portrait, *Young Omahaw, War Eagle, Little Missouri, and Pawnees*, was completed in

1822 in King's Washington studio [Fig. 18-1]. The painting subsumes Indians and their individuality in the artistic tradition and romantic sentiments of the late eighteenth century. Derived from a convention of multiple portraits of the same or different subjects, the four heads, despite the painting's title, are probably based on the likenesses of two Pawnee chiefs, Petalesharro, chief of the Pawnee Loups, and Peskelechaco, chief of the Republican Pawnees, whom King painted when they traveled to Washington with a tribal delegation in late 1821.[5] The partly shaven heads are capped with deer-hair crests, with loops of wampum hanging from their pierced ears. One wears a silver peace medal bearing the image of President James Monroe. The Indians' bare shoulders, buffalo-skin robes, and body decorations imply that they are "primitive," yet their impressive physiques and countenances suggest more. Having seen the Pawnee delegation of which Petalesharro and Peskelechaco were members, one observer pointed to just those features that probably inspired King's multiple portrait: "All of them were men of large stature, very muscular, having fine open countenances, with the real noble Roman nose, dignified in their manners, and peaceful and quiet in their habits."[6] Conceived as Roman nobles, these are men to be admired for physical prowess as well as reason. They represent a race that could perhaps be persuaded by rational argument as well as the formidable presence of the United States government to abandon tribal tradition for a more civilized life-style.

Catlin's 1834 portraits of the chief of the Osage, Clermont [Fig. 18-2], and his wife, Wáh-chee-te, reveal other preconceptions about savage life. . . . The two adults assume conventional poses. Catlin's loose brushwork, pastel pinks and blues, and mottled sky suggest romantic portraiture styles of the day. . . . But Catlin's subjects are placed outdoors; their home is not in the city but in nature. The attire and hairstyles of husband and wife suggest their "natural" state. Both wear animal skins. Wáh-chee-te's hair hangs loosely to her shoulders, while her part is painted with vermilion. Clermont's head has been shaved with the exception of a strip of hair, or roach, decorated with horse hair dipped in vermilion. Each is only partly clothed. He sits bare-chested. She exposes her shoulders, while their child is nude. Civilized customs have not been introduced by barber or dressmaker. Yet neither is the couple uncivilized. Clermont may wear leggings and hold a war club fringed with scalp locks, but his war trophies, brass armlet, and wampum earrings are as decorative as they are menacing. His club is not held aggressively but is cradled in his arms. His threat as warrior is further diminished by his passive seated pose and by the peace medal hung around his neck. Presumably obtained as gifts from the United States government, these medals symbolize white curtailment of Indian power. Wáh-chee-te has been similarly, if more lightly,

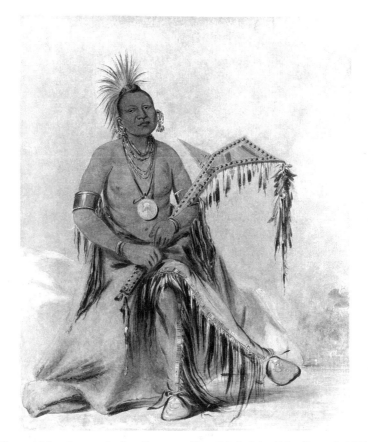

Figure 18-2. George Catlin, *Clermont, First Chief of the Tribe* (Osage). 1834. Oil on canvas, 29 × 24″. National Museum of American Art, Smithsonian Institution, Washington, D.C. Gift of Mrs. Joseph Harrison, Jr. Photo by Art Resource.

touched by civilization. Although still "primitive," her demeanor is gentle. Also, her portrait touches on one of the few points of approval accorded to Indians by whites. As Robert Beverly wrote in 1705 in his *History and Present State of Virginia*: "Children are not reckon'd a Charge among them, but rather Riches."[7] . . .

Scenes of Indian life from the 1830s through the 1850s also suggest that the intellectual concept of the Noble Savage still influenced painters of the American West. Typical of paintings from the 1830s, which frequently presented Indians at one with nature in a sweeping panorama, are Miller's *Surround of Buffalo by Indians*, circa 1848–58 [Fig. 18-3], and Catlin's *Bird's-eye View of the Mandan Village*, 1837–39. . . .[8] A spacious landscape, lit by a golden sky encompassing Indians and buffalo

Figure 18-3. Alfred Jacob Miller, *Surround of Buffalo by Indians*. c. 1853. Oil on canvas. 30⅛ × 44⅛″. Buffalo Bill Historical Center, Cody, Wyoming. Gift of William E. Weiss.

below, evokes an earthly paradise in Miller's painting. To the left, an Indian woman sits mounted on an elaborately caparisoned horse. In the distance, Indian hunters ride to entrap the buffalo herd, a scene Miller described in romantic hyperbole: "The activity, native grace, and self-possession of the Indians, the intelligence of their well-trained horses, and the thousands of Buffalo moving in every direction over the broad and vast prairies, form a most extraordinary and unparalleled scene."[9] In such statements (and paintings) Miller conjures "savages," whose grace and freedom (reason and intuition) put them in tune with nature. But by the mid-1850s others were ready to offer a conflicting view. A traveler in the Southwest, who might have witnessed a similar scene, wrote:

> As horsemen they are unrivaled; they sit very ungracefully, lolling about as if drunk or too indolent to sit up; but when roused to action, their energy is fearful. Their hideous yells—in making which they pass the hand rapidly over the mouth—and diabolical attire, are as appalling as the suddenness and fierceness of the attack. There is really nothing in them to command our admiration.[10]

Scenes of village life could also be viewed with an ambivalence

reflecting cultural stereotypes. In *Mandan Village* . . . earthen huts set amid a verdant landscape shelter "stern warriors" and "wooing lovers" (as Catlin described them). Yet Indians at leisure, whether stern or amorous or asleep on lodge rooftops, might also be scorned by a culture that valued industriousness. The "Bible-toting mountain man" Jedediah Smith, encountering a Sioux camp that must have appeared as inviting as Catlin had found the Mandan village, commented in his journal that the scene would "almost persuade a man to renounce the world, take the lodge and live the careless, Lazy life of an indian."[11] It is well to remember that one person's Noble Savage was hopelessly indolent to another, and that white audiences probably viewed paintings such as *Mandan Village* with mixed reactions. Indians might not suffer from the ills of progress and civilization, but neither did they exhibit the virtues admired by white society.[12]

John Mix Stanley spent more than ten years traveling the West from Oklahoma to California and Texas to Oregon. The field sketches and Indian artifacts collected on his travels were later used in his studio to create "actual" paintings of Indian life. But these now appear to draw more from popular stereotypes than from his experiences. *Barter for a Bride*, painted in Washington, D.C., sometime between 1854 and 1863, is a prime example. . . . Sitting astride a beautiful horse with arched neck and flowing mane, a young (Blackfoot?) Indian presents himself to the father of the intended. The elder wears a feather headdress, and both are clothed in buckskin decorated with quillwork and scalp locks. The prospective bride, in unadorned golden-colored buckskin, lies on her stomach in the grass and gazes at her suitor. Behind her, grouped in a monumental pyramid that predicts a stable, continuous life cycle, are various members of her family. From the spacious landscape at right four mounted figures proceed toward the central group. Two horses drag travois presumably bearing gifts for the father of the bride. The benign landscape promises that the gifts will be plentiful.

Although Indian marriages depended everywhere on economic considerations, there was much diversity in marriage customs among North American tribes.[13] For some the presentation of gifts to the bride's parents, the apparent subject of Stanley's painting, legitimized a marriage. But titillation was equally part of Stanley's image. The provocative young woman reveals her availability rather than her chasteness. She exemplifies an aspect of Indian life described by Prince Maximilian: "Prudery is not a virtue of the Indian women; they have often two, three, or more lovers: infidelity is not often punished."[14] The ceremony uniting man and woman was conspicuously pagan—material goods were exchanged for sexual possession. Such a "barter" may have intrigued contemporary whites, but it was not a practice openly endorsed. . . .

Indian "Massacres" and White "Battles"

Beginning in the 1840s paintings representing a more or less positive view of Indian life were challenged by two other subject categories. These were scenes of Indian-white conflict and, to a lesser extent, images of "doomed" Indians. Patronage no doubt broadened at this point. Bodmer, Catlin, and Miller painted for a limited clientele—the government, selected scientists and adventurers, and, later in their careers, a few easterners and European aristocrats. Revealing a more aggressive attitude toward westward expansion, the taste of the next generation was generally guided by the American Art-Union and popular prints made after conflict paintings. The source of this attitude was the political and social climate of the Jacksonian era.

President Andrew Jackson, in office from 1829 to 1837, argued pragmatically in his second annual address to Congress for the geographical separation of Indians and whites, which he described as beneficial to both:

> The consequences of a speedy removal will be important to the United States, to individual States, and to the Indians themselves. The pecuniary advantages which it promises to the Government are the least of its recommendations. . . . It will separate the Indians from immediate contact with settlements of whites; free them from the power of the States; enable them to pursue happiness in their own way and under their own rude institutions; will retard the progress of decay, which is lessening their numbers.[15]

Typifying Jacksonian Indian policy, these self-serving, widely shared sentiments had already caused passage of the Indian Removal Act in 1830. This legislation provided Jackson with the authority to remove Indians from lands between the Great Lakes and Gulf of Mexico, which were desirable to land speculators, farmers, railroad magnates, bankers, and entrepreneurs of every stripe. Consequently sixty thousand Indians from tribes including the Cherokee, Chickasaw, Choctaw, Creek, and Seminole were removed from traditional lands to Indian territory west of the Mississippi.

Subsequent to Indian removal, Senator Thomas Hart Benton of Missouri and like-minded expansionists urged the country to explore and settle the vast territories of the West. Their desires were finally satisfied when the Northwest was secured in 1846 and the Southwest in 1848, new territories that established the continental boundaries for the nation. Now the dreams of expansion could be met. Opening western land to white settlement, however, ensured Indian-white conflict, since overland trails carried increasing numbers of emigrants through or to lands occupied by indigenous and newly removed Indian tribes. In 1790 the Amer-

ican population of 3.9 million lived within fifty miles of the Atlantic Ocean; by the next half-century 4.5 million Americans had crossed the Appalachians.[16] The presumed necessity of this kind of rapid expansion thrust on Americans (and American artists) the need to resolve racial encounters precipitated by the appropriation of Indian lands. In effect, three different strategies emerged, one without an artistic counterpart (in itself revealing) and two that spawned new iconographies.

Indian removal was a singularly brutal and dramatic moment in the history of the United States, yet no hint of it ever appeared on canvas. Instead artists turned to conflict scenes in which Indians were cast as villains who prevented a peaceful appropriation of western lands. Such scenes gradually made obsolete the group of images first discussed in this chapter, which were often pejorative but not provocative. Conflict iconography (in both painting and literature) was a manufactured response to Indian hating, which gained renewed energy as settlers encroached on Indian land. The third strategy resolved the issue in another way by presenting Indians as doomed relics of the past. After more or less lamenting their fate, paintings in this group concede that the Indians' only recourse was to deliver their lands to a superior white race.

In the context of Indian removal and westward expansion Indians changed from denizens of the wilderness to barbaric savages. As historian Francis Jennings observes in *The Invasion of America* (1975): "Myth contrasts civilized war with savage war by accepting the former as a rational, honorable, and often progressive activity while attributing to the latter the qualities of irrationality, ferocity, and unredeemed retrogression. Savagery implies unchecked and perpetual violence."[17] Indians in battle were consistently viewed as barbarians who staged massacres while whites courageously defended themselves. . . .

Typical of early conflict paintings, which often feature a female victim (see note 3), is *The Murder of David Tally [Tully] and Family by the Sissatoons, a Sioux Tribe*, circa 1823–30, by the Swiss émigré Peter Rindisbacher. . . . On the right, David Tully fights for his life against three Indian warriors who brandish war clubs and tomahawk. Tully's own gun is presumably empty, since he uses it simply as a club. In the foreground, the most feared atrocity against white settlers transpires. A white woman with three children, one apparently torn away from her breast, is assaulted by three Indians. The woman is sheltered by a frail tent that offers no defense against the arsenal of weapons raised against her. The final, dreadful outcome of the encounter is preordained, along with the unprovoked savagery of the Indians and innocence of their victims. . . .

Stanley's statement regarding Indian savagery is more complicated than that of Rindisbacher. At the center of *Osage Scalp Dance*, 1845,

kneels a white woman clutching to her side a partially naked child [Fig. 18-4]. . . . She raises her right arm to ward off a threatened death blow from one of the sixteen muscular warriors who surround her. Brandishing spears, bows, and war clubs, the warriors wear only loincloths and leggings. While the seminudity of the child suggests his vulnerability, that of the warriors indicates their brutality.

The drama of the painting rests with the struggle between the forces of civilization and those of savagery, between the forces of light and darkness, which Stanley so conspicuously indicates when he contrasts the fair skin of the heroine, who is highlighted and dressed in white, and the dark skin of the Indians who surround her. The presumed chief lifts his spear to prevent the raised war club from falling and killing the innocent victims. The rescue of the white woman and child, standard nineteenth-century symbols of civilization, indicates that barbarism has been arrested by the forces of reason. The Indian poised to deliver the death blow is the most menacing, both because of his gesture and suggestive fur breech-cloth. In contrast, the Indian who moves to protect the mother and child is the most civilized, not only because of his stance but because of the medal he wears around his neck. Alone among his fellow tribesmen, he has been visibly touched by white culture. . . .

Figure 18-4. John Mix Stanley, *Osage Scalp Dance*. 1845. Oil on canvas, 40¾ × 60½". National Museum of American Art, Smithsonian Institution, Washington, D.C. Gift of the Misses Henry, 1908. Photo by Art Resource.

Figure 18-5. Carl Wimar, *The Attack on an Emigrant Train.* 1856. Oil on canvas, 54½ × 78¼". The University of Michigan Museum of Art, Ann Arbor. Bequest of Henry C. Lewis.

Conflict scenes presume the innocence of whites, who usually are represented as victims, not aggressors. Typical of this more common image is Arthur F. Tait's *Prairie Hunter, "One Rubbed Out!"* 1852. . . . Clad in buckskin tunic and leggings, a trapper races for his life before a party of Indians, one of whom he has just "rubbed out." Outnumbered, with no place to take refuge, his rifle, perhaps out of ammunition, held downward, his fate appears sealed. In an earlier day, however, independent trappers and those associated with fur companies lived and hunted alongside Indians. Indeed Indians were major suppliers of pelts to the fur companies. . . .

But the fur trade had actually been in decline for twenty years by the time Tait painted *The Prairie Hunter.* The artist views nostalgically a figure that popular writers and printmakers had elevated to a new pantheon of frontier heroes.[18] That he was portrayed in the 1850s at the mercy of "savage" Indians had less to do with history than with increasing demands to remove Indians from the pathway of settlement.

One of the most common subjects found in paintings of the American West at midcentury was the pioneer caravan under Indian attack. So popular was it, in fact, that Carl Wimar painted *The Attack on an Emigrant Train,* 1856, while studying in Düsseldorf (where high drama was

the prevailing style) and brought it home to sell [Fig. 18-5].[19] Intersecting diagonals formally announce the raging conflict between white settlers and Indians. Inside the lead wagon the wounded are tended to, while the able-bodied fire from behind, beside, and inside the wagon. Their shots have successfully hit two Indian assailants. Although the wagon train has been halted by the fierce assault, the battle is no more than a temporary setback to westward travel. A careful count suggests that the intrepid settlers are holding their own. And behind the lead wagon, stretching along the receding diagonal, are three more wagons and inevitably behind these, yet more settlers on the move. . . .

American Expansion, Indian "Doom"

During the same period that paintings of Indian-white conflict appeared with such frequency so did those of another major theme, the doomed Indian. The belief that Indians would succumb to the forces of civilization reaches back to the seventeenth century, but by the nineteenth century what had been expressed as sentiment began to look like fact. . . .

One of the first paintings featuring the doomed Indian, Tompkins H. Matteson's *Last of the Race*, 1847, typifies images with similar titles that followed over the next decades. . . . A tribal elder, surrounded by his family, stands at land's end, contemplating the ominous procession of clouds on the horizon. Generations of Indian life end here, the painting implies. The ocean is an abyss at the family's feet, the setting sun parallels their waning life and power. The mood is contemplative and melancholy. The young male on the right sits with bowed head, while the woman resting near him angrily stares back toward the ground already traveled. A dog looks up at its master, as if to ask "what next?" Aware of sentiment in the East for pictures that constructed a romantic fade-out of Indian life, the American Art-Union offered to its subscribers prints of *Last of the Race* for distribution in 1847. . . .

Valentine Walter Bromley painted *Crow Indian Burial*, one of the most arresting images of the doomed Indian, in 1876, the year Custer was defeated at the Little Bighorn. . . .[20] Unlike many other images of Indian grave sites, this painting does not attempt to document a burial custom. Death as an element of melodramatic narrative is the subject. The wrapped body of the deceased rests on a tree branch in the upper-right corner of the painting. When compared to the grisly scene at the center of the composition, the human seems the easier death. A cadaver-like horse, using its last energy, strains at its lead to drink from a nearby stream. Either the horse will choke itself or die of thirst, a grim metaphor for the plight of western tribes. Bromley reinforces the symbolism with

his representation in the background of an Indian village silhouetted against a lurid sunset. The body of the deceased points directly toward the village, indicating that not a single Indian has been buried but a whole tribe, a whole race.

The material for this painting was supposedly collected by Bromley, an English painter, during a six-month expedition through Colorado, Montana, and Wyoming territories in 1874. The trip had been financed by Windham Thomas Wyndham-Quin, fourth earl of Dunraven, an Irish adventurer wealthy enough to satisfy his desire to hunt in far-off places. Traveling with physician, cook, steward, and artist, Windham perceived the West as a rosy place for future investment. The earl and his company owned land in Estes Park, Colorado, where they planned to establish a hunting lodge, game preserve, and cattle ranch. For Bromley's patron, then, the paintings must have served a dual purpose: they lament the past and the demise of the Indian, but they simultaneously acknowledge that barbaric customs must give way to a more "productive" use of the land. . . .

At the turn of the twentieth century elaborate international expositions—grand entertainments as well as advertisements of the country's developing industrialism—were organized to celebrate American culture. Painters and sculptors often contributed to these expositions images of the West that served as allegorical reminders of the nation's frontier past. James Earle Fraser modeled *End of the Trail* in the 1890s and enlarged it to monumental size for display at the Panama-Pacific Exposition of 1915 in San Francisco. . . . The exposition marked the completion of the Panama Canal and a watershed in California history, separating the state's pioneer past from its future as a center for Pacific commerce. Fraser's sculpture is, in effect, a bow to the modern world. The profile of the despondent Indian and his tired horse describes a series of downward arcs that eloquently reinforce the mood of the piece. A symbolic wind whips the pony's tail and bends the rider's back. Body drained of energy, the Indian slumps lifelessly, his spear, once raised in war and the hunt, hangs downward, as if about to slip to the ground. Even the land beneath horse and man has been shrunk to provide but precarious footing. This particular formulation of the ill-fated Indian has projected a powerful stereotype through the twentieth century. It can be seen today on belt buckles, in advertisements and commercial prints, and, in perhaps its most ironical manifestation, on signs designating retirement communities.

White philanthropists held but one hope for the supposedly doomed Indian and that was acculturation (or assimilation, as it was called). It was presumed that to survive, the subordinate Indian culture must adopt the beliefs and habits of the dominant white culture. President Thomas

Jefferson spoke to such a belief when in 1803 he wrote to Creek agent Colonel Benjamin Hawkins:

> In truth, the ultimate point of rest and happiness for them is to let our settlements and theirs meet and blend together, to intermix, and become one people. Incorporating themselves with us as citizens of the United States, this is what the natural progress of things will, of course, bring on, and it will be better to promote than to retard it.[21]

The acculturation movement sputtered along until the latter third of the nineteenth century, when a spirited alliance of government and religion attempted to enforce the so-called civilizing process. Christian philanthropists inside and outside government wished to lead Indian-white relations away from the sword and toward the Bible. Such tactics were initiated with President Ulysses S. Grant's Indian "peace policy." In his first annual message to Congress in 1869, Grant sought to reverse the policy based on war and removal: "A system which looks to the extinction of race is too horrible for a nation to adopt without entailing upon itself the wrath of all Christendom and engendering in the citizen a disregard for human life.[22] Grant also specified that religious leaders, rather than political appointees or military personnel, would now administer Indian policy. But the system that Grant had in mind was still essentially paternalistic. Referring to the model of the Society of Friends among the Indians, he wrote, "I have attempted a new policy toward these wards of the nation (they can not be regarded in any other light than as wards), with fair results so far as tried."[23]

The next step in the acculturation process, the passage of the General Allotment (Dawes) Act in 1887, again raised hopes, for few comprehended how devastating the results would be. Well-meaning philanthropic organizations insisted on the overthrow of tribalism and communal organization.[24] As a result, reservations were broken up into 160-acre homesteads and distributed to individual families of each tribe. Indians became subject to white law, and Indian children were required to attend English-speaking schools provided by the government.[25] The philanthropic organizations "acted on the assumption that inside every Indian was a white American citizen and property holder waiting to be set free; the job of reform was to crack the shell of traditional tribal life and thus free the individual."[26]

One of few contemporary doubters of this scheme was Senator Henry Teller of Colorado. He and four delegates from the Cherokee and Choctaw tribes submitted to the Senate in 1881 a memorial that concluded: "This experiment has seductive allurements for visionary persons who have not carefully studied the subject, but is full of mischief for us."[27] Their

conclusion was accurate: in 1887 Indians held 138 million acres; by 1934, when the Dawes Act was canceled, that number was reduced to 51 million acres.[28] And Indian culture suffered proportionately. Artist Ernest L. Blumenschein, in an 1899 issue of *Harper's Weekly*, sardonically portrays the future results of Grant's peace policy and the Dawes Act in *Wards of the Nation—Their First Vacation from School.* . . . White-sponsored schools, operating often at great distance from the reservations, had indeed separated Indians from their tribal heritage.

If acculturation came to an unhappy ending, it nevertheless was an attractive concept for some nineteenth-century patrons. Several early images present intermarriage as a means of intermingling races, although these are mostly limited to liaisons between white fur traders or trappers and Indian women. These relationships were commonly recognized as expedient, either because Indian women were the only women available or because they provided a useful link with their tribes. At one of the annual rendezvous of the fur traders, a notoriously bawdy and drunken event, a reluctant participant and lay missionary, William H. Gray, observed: "Today I was told . . . that Indian women are a lawful commerce among the men that resort to these mountains, . . . thus setting at defiance every principle of right, justice and humanity, and law of God and man."[29]

The Trapper's Bride, 1850, by Miller, may, in fact, be a chaste rendering of contemporary reports describing Indian women as "lawful commerce" among fur trappers. . . . In Miller's words, "the scene represents a Trapper taking a wife, or purchasing one. . . . He is seated with his friend to the left of the sketch, his hand extended to his promised wife, supported by her father and accompanied by a chief, who holds the calumet, an article indispensable in all grand ceremonies."[30] The trapper wears garments made from animal hides, which are cut with an eastern flair. Adorned with beads, feathers, and bear-claw necklace, the chief wears more "primitive" dress. He sits astride a horse, which to nineteenth-century viewers might have seemed no more tamed than its owner. The Indian woman occupies a position between the two males, between white and Indian cultures. She appears shy but not precisely demure; Miller describes her as "pensive" and "dreamy."[31] She stands barefoot, literally in touch with nature, dressed in yellow buckskin, which fairly glows with warmth. Other than her hand, the part of her anatomy closest to the trapper is her pelvis. She represents, in other words, a male fantasy, an encounter with the exotic other, the sort of liaison a white Victorian male might contemplate as a means of escaping a confining moral and social environment. Perhaps as proof of this appeal, *The Trapper's Bride* was Miller's best-selling image.[32]

The Trapper's Bride broached the suggestion of union, not only be-

tween races but between nature and civilization. The large tepee in the background defines the apex of a triangle embracing savage life, while the smaller triangle on the left, which includes the groom, a colleague, and an Indian with a peace pipe, represents the ameliorating effect of civilization, a subtheme of most pictures illustrated in this chapter. . . .

The White Man's Indian

The treaty existed as a form of negotiation with the Indians until the early 1870s, when Congress ceased to consider tribes as independent nations. . . .

Nahl painted the astonishing *Treaty with the Shoshone Indians in 1866* at the request of Caleb Lyon, both governor and superintendent of Indian affairs in Idaho. . . . Lyon had mediated a peace settlement with the western Shoshone and white settlers. The negotiations led to Indian cession of lands in southern Idaho in exchange for a reservation on the Bruneau River. The treaty was never ratified by Congress, but Lyon, who had moved to California several months after the negotiations, commissioned Nahl to commemorate the event.[33]

Treaty with the Shoshone Indians was probably painted in the artist's San Francisco studio. In an effort to create an aura of authenticity Nahl drew on various sources. Photographs in common circulation provided models for the woman seated with two prairie dogs in the center foreground and for the man who stands with his hand on his hip to the left of the treaty table.[34] Nahl also included Indian artifacts, each accurate in themselves but not commonly used by the Shoshone. The woman standing along the left edge of the picture is dressed in a fiber-and-feather skirt of California origin; the Indian standing beside the minister wears a Northwest Coast woven cap; and three Pima baskets appear in the lower-right corner.[35]

Nahl's attempt to enhance the authority of the painting with anthropological details is continued in the formal strategy he adopts to represent whites and Indians. In the center of *Treaty with the Shoshone Indians* stands Dr. Hiram Hamilton, a minister, and Governor Lyon. The reverend and the governor, the latter patriotically dressed in red, white, and blue, are woodenly erect representatives of government authority. A military regiment, arranged in tight rows in the background, mimes the posture of the white officials. Between the two white men stands the treaty table, fancifully decorated with an American flag and a spray of peacock feathers. Below the table lies a mound of gifts for the Indians, including trade blankets, beads, peacock feathers, and copper and brass

pots. A few of these pledges of good faith already appear on their recipients, since to the right of Lyon are presumably tribal leaders smoking a pipe of European origin and wearing a calico trade coat.

Once specific anthropological items are identified, the Shoshone who fill the foreground represent little more than popular stereotypes of western Indians. Nahl presents a naive, unruly, and licentious group. Indeed, as many interpreted the state of savagery, the Indians appear to represent the childhood of humanity. Surely Horace Greeley concurred when he wrote in 1859: "The Indians are children. Their arts, wars, treaties, alliances, habitations, crafts, properties, commerce, comforts, all belong to the very lowest and rudest ages of human existence."[36] If the Shoshone understood the consequences of the treaty, it is not apparent in Nahl's presentation. Whites and Indians hardly look at one another, each occupying a separate world.

Animals, both dead and alive, are scattered throughout the crowd of Indians. The mix of skins—raccoon, fox, and cougar—is a reminder of the barbaric yet exotic state of the tribe. The live animals—pairs of fawns, prairie dogs, prairie hens, and cubs—suggest fertility and represent gifts to the white negotiators. Adding to the "primitive" quality of the scene, bare-breasted women are conspicuous in the lower-left corner of the painting, two with children and one confronting the spectator in a bold, suggestive manner.

Nahl distinguishes between civilized and uncivilized peoples to imply the rightness of the treaty just concluded, which supposedly gives to whites land they know how to develop and takes from Indians resources they cannot use productively. The sentiments expressed in 1817 by President James Monroe in his first message to Congress continued to affect Americans long after Monroe's time: "The earth was given to mankind to support the greatest number of which it is capable, and no tribe or people have a right to withhold from the wants of others more than is necessary for their own support and comfort."[37] . . .

Real Indians never inhabited the paintings of white artists. Paintings in which Indians were represented were created to embody whites' attitudes about nature, the right of conquest, and the priorities of civilization. To whites, Indians at odds with Anglo-Saxon culture, refusing to abandon tribal custom and become "productive" citizens, were either primitive, savage, or doomed. Over the nineteenth century Indians had been reduced to a few stereotypes or worse, as Alexander Pope suggests in *Weapons of War*, 1900. . . . In this image Indian culture no longer possesses even the myth of corporeal presence but has been reduced to an aesthetic arrangement of bric-a-brac devoid of function, impoverished of meaning, and displayed against yet another grid of white construction.

Notes

I am indebted to the Office of Professional Development, Northern Arizona University, Flagstaff, for research support toward completion of this essay.

1. Quoted in John F. McDermott, "The Art of Seth Eastman," in *Smithsonian Report for 1960* (Washington, D.C.: Smithsonian Institution, 1961), 584.

2. Limerick, *Legacy of Conquest*, 190.

3. A few major examples are earlier, like John Vanderlyn's *Death of Jane McCrea*, 1804 (Wadsworth Atheneum, Hartford), as well as a number of popular images.

4. Material drawn from Berkhofer, *White Man's Indian*, 72–80.

5. Cosentino, *King*, 63.

6. Quoted ibid., 66.

7. Quoted in Szasz, *Indian Education*, 8.

8. *Surround of Buffalo by Indians* is a later version of a scene Alfred Jacob Miller first conceived in the 1830s.

9. Quoted in Michael Bell, introduction to *Braves and Buffalo: Plains Indian Life in 1837* (Toronto: University of Toronto Press, 1973), 160.

10. J. D. B. S., "Wanderings in the Southwest," *Crayon*, 3, pt. 2 (February 1856): 40.

11. Quoted in Saum, *Fur Trader and Indian*, 95.

12. However George Catlin might criticize civilization and admire Indian life, his distance from primitive culture is suggested by the use of words such as "curious" and "strange" to describe the Mandan village. As Patricia Limerick has written, Catlin "enjoyed denouncing the vices of 'civilization,' but he was fully loyal to its virtues" (Limerick, *Legacy of Conquest*, 185).

13. Frederick W. Hodge, *Handbook of the American Indians North of Mexico* (Washington, D.C.: Smithsonian Institution, Bureau of Ethnology, 1907), 1:808.

14. Quoted in Thomas and Ronnefeldt, *People of the First Man*, 242.

15. Israel, *State of the Union Messages*, 1:334.

16. Rogin, *Fathers and Children*, 3–4.

17. Jennings, *Invasion of America* (1975 ed.), 146.

18. Illustrations, engravings, and chromolithographs after western paintings by Charles Deas, William Ranney, and Arthur F. Tait were widely known in the 1850s (see Amon Carter Museum, *American Frontier Life*, 51–77, 79–107, 109–29).

19. While in Düsseldorf, Carl Wimar gleaned frontier "experience" from a number of sources. *Attack of an Emigrant Train* was apparently inspired by an episode in *Impressions de voyages et aventures dans le Mexique, la Haute Californie, et les régions de l'or* (1851) by the French author Gabriel Ferry (see Rathbone, *Wimar*, 15–16).

20. Perhaps because the painting was commissioned by an English lord, it expresses sympathy for Indians at a time when Americans in general felt little.

21. Quoted in Drinnon, *Facing West*, 83.

22. Israel, *State of the Union Messages*, 2:1199–1200.

23. Ibid., 2:1199.

24. The ground for this act was laid in the early 1880s by various philanthropic associations formed with the intention of aiding the Indians. These groups included the Boston Indian Citizenship Committee, Indian Rights Association, Women's National Indian Association, and, most influential, Friends of the Indians.

25. Prucha, *Indians in American Society*, 23.

26. Limerick, *Legacy of Conquest*, 196.

27. "Senate Debate on Bill to Provide Lands in Severalty, January 20, 1881," in Wilcomb E. Washburn, comp., *The American Indian and the United States: A Documentary History* (New York: Random House, 1973), 3:1695.

28. Limerick, *Legacy of Conquest*, 198.

29. Quoted in Tyler, *Miller*, 31.

30. Quoted in Glanz, *How the West Was Drawn*, 37.

31. Tyler, *Miller*, 43.

32. Ibid., 57.

33. "Caleb Lyon's Bruneau Treaty, April 12, 1866," *Idaho Yesterdays* 13 (Spring 1969): 17–19, 32+. Appreciation is extended to Joan Carpenter, curator of exhibitions, Thomas Gilcrease Institute of American History and Art, for searching the Gilcrease files for information.

34. Appreciation is extended to Paula Fleming, National Anthropological Archives, Smithsonian Institution, for identifying photograph sources.

35. Appreciation is extended to William C. Sturtevant, William L. Merrill, and John C. Ewers, National Museum of Natural History, Smithsonian Institution, for information regarding the Indian tribes portrayed in *Treaty with the Shoshone Indians*.

36. Quoted in Rogin, *Fathers and Children*, 117.

37. Israel, *State of the Union Messages*, 1:152.

19

And/Or: Hispanic Art, American Culture

John Beardsley

... In recent years, for reasons that will be the focus of the first part of this essay, the idea that enduring ethnic distinctions could be a creative force in our culture has won a measure of acceptance. The Smithsonian Institution's Festival of American Folklife and the National Heritage Fellowships administered by the Folk Arts Program at the National Endowment for the Arts, not to mention the folklife programs at the Library of Congress and various universities, have all contributed to an appreciation of the traditional crafts and folk art of various ethnic groups. In a more cosmopolitan realm, however, the position of the ethnically conscious artist remains considerably more problematic. There seems to be an unwritten presumption that the nearer an artist aspires to the level of high art, the more leached out will become the ethnic content of the work. While this is often the case, it does not seem to have the validity of universal law. The second part of this essay will explore the different ways that painting and sculpture of the first rank can be made of traditions, subject matter, and styles that separate themselves somewhat from the often uniform and seemingly arbitrary dictates of taste that we routinely accept as mainstream. If, as we noted in the preface, the artists exhibited here do not comprise a Hispanic school, then neither are they necessarily alike in how—or how much—their particular cultural heritage surfaces in their work. Yet, taken together, they provide the basis

From *Hispanic Art in the United States: Thirty Contemporary Painters and Sculptors*, copyright © 1987 Abbeville Press and Museum of Fine Arts, Houston. Reprinted by permission of the publisher.

for investigating the degree to which an enduring sense of ethnic distinctiveness can enter the legitimate territory of high art. Indeed, it may be that ethnicity, along with other forms of regional or cultural particularity, can now be perceived as one of the primary ingredients in the alchemy that is good art.

In taking ethnicity as part of their subject, this book and the exhibition it documents are both an expression of and a contribution to the continuing debate over what measure of ethnic identification, if any, is most desirable in our society. It has long been expected, even hoped, by many that the patchwork of peoples who settled this land would eventually form a seamless fabric. The failure of this to occur has in the past several decades become the subject of serious inquiry among scholars of immigration and ethnic history. The metaphor of the melting pot was replaced in the work of one writer with that of the wave, with troughs and crests in the history of ethnic self-consciousness.[1]

Although it may now be evident that we have not blended into a homogeneous whole, it is still unclear whether or not this was ever an appropriate and achievable goal, and whether or not it might ever be so again. The promise of assimilation was never unambiguous: from one point of view, it seemed to offer complete equality through the elimination of prejudice and discrimination; from another, it merely deprived people of a sense of self-identity while denying them the full benefits of membership in society. Despite several decades of improvement, it is still not always apparent that the fruits of our society are available equally to people of every race and both sexes. From this perspective, ethnicity confirms our failure to redeem everyone from economic and educational disadvantage. It can arise unself-consciously among the truly isolated, as is the case with such artists as Gregorio Marzán, Felipe Archuleta, and with Martín Ramírez, who was doubly exiled, both culturally and psychologically.[2] It can also surface volitionally, as an expression of resistance to the dominant group, a phenomenon that will be examined in this text for its importance in the emergence of Chicano art in California and Texas especially.

A willingness to assimilate would seem to require a sense of what it is to which a person is assimilating. This, too, has never been terribly clear. Inasmuch as we have a unifying culture now, it is one that is conveyed—even, it seems at times, determined—by the mass media and the advertising industry. It is little wonder that we have seen in the past two decades a resurgence in the will to resist a unified national identity, as one of its traits has come to seem more and more like the tyranny of conformity to the lowest common cultural denominator.

Those who have sought an alternative to assimilation have found a countervailing doctrine in pluralism. . . .

In the turbulent years that began in the middle of the 1960s, the pluralist idea enjoyed its greatest vogue; by the middle of the 1970s, its popularity led to renewed criticism of the original notion and dissent from some of its contemporary manifestations. Most importantly, it was argued that pluralism failed to describe the common values that would unite us in our diversity and that the cultural differences endorsed by pluralism could not only flow from but could also reinforce social inequities.[3] Yet virtually no one rejected pluralism outright. Even critics of the notion have sought a middle way, one that recognizes diversity as a given in American culture but seeks to dissociate it from intolerance and to reconcile it with the need for some measure of national consensus. John Higham has found his unifying faith in a concept he terms "pluralistic integration," in which "both integration and ethnic cohesion are recognized as worthy goals, which different individuals will accept in different degrees."[4] In its suggestion that there is a middle ground between full assimilation and full ethnic particularity, Higham's pluralistic integration embraces ambiguity, hybridization, and inclusiveness, while calling for a reexamination of those values that might hold together an increasingly kaleidoscopic culture.

The debate, then, over the most desirable measure of ethnic self-identification is far from over. Yet despite the limitations of the original notion and the excesses committed in its name, some variation of the pluralist idea—perhaps Higham's—seems destined to become the prevailing model for ethnic relations in our society. We seem to be making peace with and even coming to appreciate the fact that many Americans will continue to take comfort and pride in their sense of kinship with an alternative tradition or national identity long past the second or third generation of family presence in the United States, the time when such feelings have traditionally been expected to wane, without experiencing any diminishment of their Americanness.

The life of this debate is reinvigorated with the appearance of each new group on American soil. It has derived a special measure of strength from the Hispanic presence: not only are they among the first settlers of this country, but their numbers are growing and their culture seems destined to have an increasing impact on the United States. We are somewhat accustomed to viewing art as a reflection of social, economic, and historical forces; indeed, art often does register the tremors of an age. What is less familiar but no less true, however, is that art can serve as a model, as a signpost to the future. The balance of this essay will address the various ways and the differing measures in which these artists have sustained a sense of their distinctiveness despite the pressures of assimilation and mass culture. These ways include, among other strategies,

the continuation or revitalization of alternative traditions; the depiction of historical subjects or those drawn from daily life; and the deployment of competing, often "underground" styles. How these artists have reconciled their particular ethnic heritage with their desire to participate in the larger life of American art should be a source of comfort if not inspiration to the student of American ethnicity.

It is a truism, but one that bears repeating, that ethnic groups are themselves pluralistic. Perhaps in no case is this as pronounced as it is among those who are collected in this country under the term *Hispanic*. American Hispanics are less a people than an agglomeration of peoples: Mexican Americans, Cuban Americans, Puerto Ricans, and numerous others of Central and South American origins, as well as the descendants of the original Spanish settlers of the Southwest. Even among these subsets there is considerable diversity: while there is a tendency to equate Chicano with Mexican American, for example, to many the terms designate people with different points of view on a range of cultural and political issues. Mexican Americans can be separated into those who are descended from settlers who arrived in the land long before it was part of the United States, those who arrived in the mass exodus that followed the Mexican Revolution, and those who are recent emigrés—and these last can be further divided into the legal and the illegal. Each group can be seen to have somewhat different experiences, difficulties, and aspirations. Puerto Rican embraces both those who were born on the Island and their descendants born here; those who live on the American mainland as full citizens as long as they are here; and those who live on the Island in an ambiguous status of citizenship. Puerto Ricans and Cubans both include some people who are more obviously descended from African or European stock than others; the same is true of Mexicans with respect to Indian versus European heritage. The attitudes of these different groups to each other have been conveyed with them all, in some measure, to this country.

Moreover, Hispanics in the United States have made the full range of choices with regard to assimilation. A position at one extreme has been articulated by the writer Richard Rodríguez, whose autobiographical book, *Hunger of Memory*, disclosed his conflict-ridden passage from private to public citizenship. Despite the pain of separation from his family and their particular culture, he ratified both "the value and necessity of assimilation. . . . Only when I was able to think of myself as an American, no longer alien in a *gringo* society, could I seek the rights and opportunities necessary for full public individuality." By comparison, the Chicano author Rolando Hinojosa seems to exemplify one for whom assimilation is not an either/or but a both/and proposition—writing both in English

and in Spanish, and taking for the subject of his novels *Mi querido Rafa* and *Dear Rafe* the bilingual and bicultural lives of the inhabitants of the Rio Grande Valley in South Texas.[5]

Of the less assimilated, a variety of observations can be made about their situations. Some Cubans, for example, constitute a kind of community in exile, retaining the hope of returning to Cuba in a post–Castro era. The ease, both legal and physical, with which Puerto Ricans can pass from island to mainland diminishes for them both the necessity of assimilation and, one assumes, the inclination to do so. Among Mexican Americans, there is some sense of being a conquered people, inasmuch as a number of them live in a land that was originally Mexico, although this is clearly a historical insult rather than a personal one. But for all, patterns of discrimination breed resistance and, for "*los illegals*," dubious legal status perpetuates cultures in isolation.

It was resistance in part that generated the first highly visible artistic episode among Hispanic Americans. This was the art that grew out of *El Movimiento*: the Chicano struggle for civil rights, greater educational opportunities, improved economic conditions, and enlarged political representation. Spearheaded by César Chavez and the organization of the National Farm Workers Association, now the United Farm Workers Union, the movement had its beginnings in a strike called against grape growers on September 16, 1965, in Delano, California. The strike drew national attention and provided the momentum for Chicanos to extend their efforts to other causes. Initially, the movement was a reflection of broader efforts to achieve greater equity in American society, and Chicanos worked in cooperation with black civil rights groups: Rodolfo "Corky" González, for example, issued one of the original manifestos of the movement, *El Plan del Barrio*, at the Poor People's Campaign in Washington, D.C., in 1968. But Chicanos also pursued their cause separately: an independent and openly nationalistic political party, *La Raza Unida*, was formed at a meeting in Crystal City, Texas, by José Angel Gutiérrez and others in 1970.

The cultural agenda of the Chicano movement included a call for bilingual education, the establishment of Chicano studies departments and study centers, and for Chicano control over these and other cultural programs. In general, the intent of these programs was to strengthen Chicano culture by promoting group identification. Many artists joined the cause, painting didactic and exhortative murals on barrio walls and producing political posters. A historian of the Chicano movement, Jacinto Quirarte, has characterized these artists as "primarily concerned with articulating Chicano identity." Their impetus, as he saw it, "was not self-expression . . . or personal recognition, but . . . responding to the needs of the community as defined by the Chicano movement." He described

their public works—that is, primarily their murals—as "a bulwark against the eroding influence of Anglo-American culture"; he said their intent was "to teach the Chicano community about itself, to strengthen it, to nurture it."[6]

Numerous artist groups were formed, both to advance the general aims of the movement and to further the work of member artists. Among the first and most prominent were *Con Safos*, established by Mel Casas and Felipe Reyes in San Antonio in the early 1970s, and The Royal Chicano Air Force (originally the Rebel Chicano Art Front), organized by José Montoya and others in Sacramento. In virtually every major city in California, the Southwest, Texas, and the upper Midwest, however, there was such a group.

To some degree, the sheer quantity of Hispanic artists now to be found in our midst is inconceivable without the movement, for it provided these artists on the margins of our society with a sense of purpose and, above all, with a sense of the validity of their vision, at least within the confines of their own community. Many of the Chicano artists in this study—Carlos Almaraz, Gilbert Luján, Frank Romero, John Valadez, Carmen Lomas Garza, and César Martínez, among others—came of age within the movement and owe some of their early accomplishments to it. (Numerous Hispanic artists of Caribbean or South American origin, it should be said, were never involved with the movement; even among Mexican Americans, there are those—Robert Graham and Manuel Neri, for example—whose careers were well under way by the time the movement emerged.) It was not long, however, before many Chicano artists began looking beyond their own group for recognition and economic sustenance. A still discernible rift developed between those who felt that Chicano art was inextricably linked to its community origins and those who felt that its forms could evolve and its purposes grow beyond its sources in the movement.

The debate between these points of view surfaced repeatedly in the early 1980s, once in a very pointed exchange between art historian and critic Shifra Goldman and artist Judithe Hernández de Neikrug. In a review of an exhibition of mural paintings on canvas by Chicano artists at the Craft and Folk Art Museum in Los Angeles, Goldman charged that the exhibition "placed a framework around East Los Angeles muralism which decontextualizes it and violates its function." In her mind, the exhibition reflected a larger problem then confronting Chicano artists. "What is at stake, basically," she wrote, "is the question of commitment: should Chicano artists, at the cost of economic security and possible artistic recognition, continue to express themselves artistically around the same matrix of social change and community service that brought their movement into existence? Or should they, now that some of the barriers

are cracking, enter the mainstream as competitive professionals, perhaps shedding in the process their cultural identity and political militancy?"[7]

Hernández, a participant in the exhibition, took exception to the suggestion that her cultural identity might be threatened by her professional success: "Why should changes in my work and social-political attitudes be construed as compromising my commitment to . . . Chicanismo, while in another artist the same would be perceived as personal and professional growth? Are Chicano artists so shallow and corruptible that at their first chance at mainstream success they'll forget who they are?" Hernández answered her own question:

> Those of us who have persisted in the face of great odds and pursued our careers as artists will grow in spite of people, like Ms. Goldman, who would eternally chain us to "Chicano art." . . . Our work will mature and change. Chicano art and Chicano artists, I am sure, will always pay homage to the traditions of the Mexicano/Chicano culture. As time goes by, the relevance of our work to a larger international audience will become more and more apparent."[8]

Even as she wrote, Hernández's words were proving true. On the wane was the group solidarity that had been so instrumental in providing Chicano artists with the self-confidence to commence their careers and in launching their art into the consciousness of the wider art community. Emerging in its place was a sense of greater individuation among the artists and a desire to find a place in the company of other, non-Chicano artists, not merely so that Chicanos might avail themselves of the opportunities and rewards open to other artists, but also so that they might know how their work compared, formally and qualitatively, to that of their more mainstream peers. Yet the observation that, even as their work evolved and diversified, Chicano artists would continue to be aware of and pay homage to their own tradition likewise continued to be true.

The recent work of a number of the Chicano artists in California and Texas bears this out. Some of the pastels of John Valadez . . . are intensely personal and enigmatic. Others are literally depictive and very particular, notably his portraits of the blacks, Orientals, and Chicanos who comprise the increasingly disparate population of downtown Los Angeles, where the artist has his studio. Some of the best of these pastels, such as *Fatima* [Fig. 19-1] or *La Butterfly*, convey an uncaricatured and yet unidealized empathy that must surely have its origin in some continuing measure of group identification. The same observation can be made of Carmen Lomas Garza's exceptional gouache paintings; based on the artist's recollections of Mexican-American life in the Texas border country, they convey an emotional engagement that in each case is intensified by the shallow picture space. . . .

Figure 19-1. John Valadez, *Fatima*. 1984. Pastel on paper, 60 × 42″. Peter and Eileen Norton Collection.

Carlos Almaraz can be seen to exemplify by far the most complex position with respect to the multiple inspirations and intentions of Chicano artists today. The sheer virtuosity of his painting overwhelms any other reading of his work—the obvious bravura and exuberance with which he selects his colors and applies the paint to the canvas, bringing his images, as in *Love Makes the City Crumble*, to the point of dissolution but always stopping at that moment when structure and anarchy are in tensest equilibrium. And while many of his images are drawn from the landscape or culture of Southern California or, more recently, that of his

second home, Hawaii, others have an origin in Mexican or Chicano culture. *Europe and the Jaguar* is perhaps the best example of this, an amusing and astute summation of the divergent, even antithetical, characters—the European and the pre-Columbian Indian, the sophisticated and the wild, the sumptuous and the spartan, the effete and the heroic—that struggle for reconciliation in Mexican and Mexican-American culture.

There are broader traditions in Mexico—and Latin America more generally—that also surface in the work of Hispanic artists in the United States. North America knows its southern neighbors largely for their fiestas, fervid celebrations of life and death. While much of this work has the kind of extravagance of color and manner we associate with *carnaval*, the spirit of another festival has also been transmitted to the United States, the observances on November first and second of All Saints and All Souls Days, known as the *Días de los Muertos*. Both a festival of remembrance and a reminder of the vanity and transience of life, the Days of the Dead are marked primarily by the fabrication of elaborate *ofrendas*, home or public altars dedicated to the deceased. These are covered with sugar or plaster skulls, photographs, flowers, food, and candles, much like the one created for this project by Carmen Lomas Garza. Her *ofrenda* derives an added measure of poignancy from its dedication to Frida Kahlo, a painter who has served as an inspiration to many Mexican-American women artists. . . .

The strength of the Latin American religious tradition—paramountly the Catholic church—provokes [various] reactions as well. Pedro Perez's goldleaf constructions, especially *God*, can be interpreted as less than reverent variants of religious images. Even a work like *La Esmeralda (The Queen That Shoots Birds)*, which does not take an obviously religious subject, is at once a parody of and a rival to the elaborately overwrought furnishings of European and Latin American Catholic churches. At the same time, other artists have explored alternatives to the prevailing dogma. Paul Sierra and Carlos Alfonzo have investigated the Afro-Caribbean religious sects of their native Cuba. Sierra's study resulted in a number of paintings of effigies and shrines such as *Cuatro Santos* and *La Famba*. Alfonzo's experience, more personal than Sierra's, is also more internalized and surfaces in his use of certain mysterious, seemingly prophylactic images: the knife through the tongue, the disembodied eye [Fig. 19-2]. . . .

. . . Gronk and Roberto Juarez use style to challenge our visual paradigms, but they do so in an . . . ironic, even subversive way. With their heavy black outlines and broad patches of color, some of Gronk's paintings look like they belong on the side of a subway car; their roots are clearly in a rebellious ghetto culture, their visual language drawn from "lowbrow" sources, cartoons and tabloid illustrations. But an elab-

Figure 19-2. Carlos Alfonzo, *Petty Joy*. 1984. Acrylic on canvas tarp, 72 ×
96″. Collection of Juan Lezcano, Miami.

orate sense of social observation, sometimes affectionately humorous,
sometimes satirical—as in *Cabin Fever* [Fig. 19-3]—imparts a level of
maturity and subtlety to these works that most graffiti does not attain.
Gronk deliberately cultivates ostensibly divergent aims. He recalls his
teenage years: "My life was watching Daffy Duck on TV in the morning
and having Camus in my back pocket. That combination set the whole
pattern of my sensibility early on. It was okay that these two very dif-
ferent elements were coming together. I learned to sabotage seriousness
along the way, and that was the direction I wanted to go in with my
work."[9] Gronk's deployment of an underground style, superficially self-
defeating in depriving his works of "high seriousness," is supremely self-
confident. It plays on and undermines the assumption that the products
of ghetto culture are in fact not worthy of serious attention, while pro-
viding Gronk with the slightly distanced perspective necessary to scru-
tinize his subjects.

On the face of it, the work of Roberto Juarez is another matter
entirely. Juarez paints pictures that, coloristically and compositionally,
are extremely supple. They shift effortlessly from hue to hue, from image

Figure 19-3. Gronk, *Cabin Fever.* 1984. Acrylic on canvas, 72 × 95″. Daniel Boley Collection.

to image, even, in the recent work, from surface to surface—canvas to collaged terry-cloth towel and back again. They are also remarkable in the knowing range of images they recall from the history of modern art: a Cézanne still life in a painting like *Fruit Boat*, or the late series of bird paintings by Braque in *Three Birds*, to cite just two examples. But Juarez overloads his paintings and juxtaposes images drawn from both European and "primitive" sources. The *Two Sister Dolls* have the look of pre-Columbian figures, while *Sun Woman*, with its brilliant colors, its palm trees, and its imposing "native" woman, has an unsophisticated look that seems incompatible with the other works of this artist.

If the existence of such a painting in Juarez's oeuvre is jarring, it is also intentional. This is a highly ironic work. One senses that it is Juarez painting the way he knows an ethnic is "supposed" to paint, depicting in a somewhat crude way—the figure is massive but unarticulated, the torso frontal but the legs in profile—the stereotypes of a less advanced culture. But this is no mere parody; in what one observer aptly describes as "the highly contrived language of innocence," it is Juarez challenging our cultural presumptions, ennobling, through compositional and coloristic intricacy and the sheer magnitude of the figure, the very

stereotype it presents.[10] We are accustomed to our artists drawing on primitive traditions to invigorate their art; we trust them to know how to graft those traditions onto sophisticated art styles. It is another matter when an artist who springs from that tradition does this. We tend to think of it as provincial.

In this sense, the problems Roberto Juarez confronts can be seen as representative of those faced by many of these artists—how to follow their impulse to use deeply ingrained or consciously distinct images and styles without being dismissed by the art establishment as provincial. That establishment is necessarily judgmental, but it is also reflexive and conformist in seemingly increasing measures. We live in the era of the international "art star," evidence that cultural homogenization is becoming a global, not merely a national issue. What differentiates these artists is a quality of resoluteness in the face of this trend. They take the styles and the images of their particular heritage and blend them with styles and images received from an exposure to the larger culture, bequeathing in return an art more allusive, more elaborate, more reverberative than what they found, an art that affirms both the values of universality and particularity. . . .

Geographical isolation and cultural separateness, however, can be more than sources of alternative traditions; they can also keep alive traditions of the prevailing culture that have long since yielded to other tastes. So-called provincial culture is known to be *retardataire*; but, on occasion, discarded traditions arise again from it, transmuted, reinvigorated, and newly apposite. . . . The willingness of . . . artists to persist with out-of-date or not yet rediscovered styles anoints them the guardians of cultural history, with the task of redeeming art from fashion.

Whether preserving or extending the traditions of art, however, the position of so-called marginal artists is supremely paradoxical, for they are presumed to be peripheral, yet they conform more to the historically observed facts of art than do their nationally and internationally conformist peers. They uphold the notions that art can and does manifest regional and national differences and that the characteristics that distinguish the art of one group or region from another are at least as compelling as those that describe them in common. In this sense, not only do those on the margins enlarge the life of art in America, but they also challenge any assumptions about what constitutes the parochial in art and what the cosmopolitan.

Yet distinctiveness, in the context of these Hispanic artists, is seldom if ever synonymous with divisiveness. In finding their elixir in a commingling of styles and images, they draw on the alternating currents of competition and conciliation that invigorate so much of American art and thought. They contribute thereby toward the realization of an ever-more

encompassing, fluid, and unprejudiced definition of our collective culture. Already we are beginning to discern how their particular situations have given rise to some of the most compelling art of our time. However, the achievement of Hispanic artists may ultimately be seen to be as important to American life as to American art. While their work is sometimes ironic, it is never skeptical about the capacity of art to address, perhaps even to help resolve, the larger dilemmas that confront us all as Americans.

Notes

1. Nathan Glazer, *Ethnic Dilemmas, 1964–1982* (Cambridge: Harvard University Press, 1983), p. 17.

2. We documented the phenomenon of the unself-conscious expression of ethnicity in a previous exhibition and its accompanying book, *Black Folk Art in America: 1930–1980* (Jackson: University Press of Mississippi, and Washington, D.C.: Corcoran Gallery of Art, 1982).

3. In particular, Arthur Mann noted that the recent "white ethnic revival [found among people of Eastern and Southern European descent] . . . added to the fragmentation and discord from which it emerged"; he found the "new pluralism" like the "old dualism," with white ethnics banded together against blacks in competition for jobs, housing, and educational opportunities; see *The One and the Many*, pp. 41–42; 32–34. On the notion that cultural differences can perpetuate social inequity, see especially Nicholas Lemann, "The Origins of the Underclass," *The Atlantic* 257 (June 1986): 31–55; and 258 (July 1986): 54–68. Basing his conclusions on a study of Chicago, Lemann states that "in the ghettos, . . . it appears that the distinctive culture is now the greatest barrier to progress by the black underclass, rather than either unemployment or welfare." On the failure of pluralists past and present to describe the common values that might preserve social cohesiveness, see especially chapters nine and ten in John Higham, *Send These to Me*: "Apparently, a decent multiethnic society must rest on a unifying ideology, faith, or myth" (p. 232).

4. Higham, *Send These to Me*, p. 244.

5. Richard Rodriguez, *Hunger of Memory* (Boston: D.R. Godine, 1982), p. 26. Although there is much in his experience with which other ethnics in general and other Hispanics in particular might identify, some of the conclusions he has drawn have provoked dissent, particularly his opposition to affirmative action and bilingual education: "What I needed to learn in school was that I had the right—and the obligation—to speak the public language of *los gringos*" (p. 19). Rolando Hinojosa, *Mi querido Rafa* (Houston: Arte Publico Press, 1981) and Rolando Hinojosa, *Dear Rafe* (Houston: Arte Publico Press, 1985).

6. Jacinto Quirarte, *A History and Appreciation of Chicano Art* (San Antonio: Research Center for the Arts and Humanities, 1984), pp. 281, 192.

7. Shifra Goldman, "Chicano Art: Looking Backward," *Artweek* 12 (June 20, 1981): 3–4.

8. Judithe Elena Hernández de Neikrug, letter in "Reader's Forum," *Artweek* 12 (August 1, 1981): 16. For an earlier and more extended version of this debate, see Malaquías Montoya and Lezlie Salkowitz Montoya, "A Critical Perspective on the State of Chicano Art," *Metamorfosis* 3 (Spring/Summer 1980): 3–7; and Shifra M. Goldman, "Response: Another Opinion on the State of Chicano Art," *Metamorfosis* 3/4 (1980/81): 2–7; both

are reprinted in Jacinto Quirarte, ed., *Chicano Art History: A Book of Selected Readings* (San Antonio: Research Center for the Arts and Humanities, 1984).

9. Gronk in an interview with Julia Brown and Jacqueline Crist, in *Summer 1985* (Los Angeles: Museum of Contemporary Art, 1985), unpaginated.

10. Quotation from Gary Indiana, *Roberto Juarez* (New York: Bellport Press for Robert Miller Gallery, 1986), unpaginated.

20

Naming

Lucy R. Lippard

> So where we are now is that a whole country of people believe I'm a "nigger," and I *don't*, and the battle's on! Because if I am not what I've been told I am, then it means that you're not what you thought *you* were *either*! And that is the crisis.
>
> —James Baldwin[1]

For better or worse, social existence is predicated on names. Names and labels are at once the most private and most public words in the life of an individual or a group. For all their apparent permanence, they are susceptible to the winds of both personal and political change. Naming is the active tense of identity, the outward aspect of the self-representation process, acknowledging all the circumstances through which it must elbow its way. A person of a certain age can say wryly, "I was born colored, raised a Negro, became a Black or an Afro-American, and now I'm an African American or a person of color,"[2] or, "I was born a redskin, raised an Indian, and now I'm a Native American, an indigenous person, a 'skin,' or the citizen of an Indian nation."[3] Each one of these names had and has historical significance; each is applied from outside or inside according to paternalistic, parental, or personal experience. . . .

Three kinds of naming operate culturally through both word and image. The first is self-naming, the definition one gives oneself and one's community, reflected in the arts by autobiography and statements of

racial pride. The second is the supposedly neutral label imposed from outside, which may include implicitly negative stereotyping and is often inseparable from the third—explicit racist namecalling.

Cultural pride is a precious commodity when it has survived generations of social undermining. Yet it also opens rifts no one wants to consider long enough to change. It is easier to think of all Americans moving toward whiteness and the ultimate shelter of the Judeo-Christian umbrella than to acknowledge the true diversity of this society. Too often, self-naming must battle the self-loathing created by the larger society, not to mention suspicion and prejudice between cultural groups.[4] Such internal struggles may be buried deep in a work of art, invisible except when inferred through style and approach. . . .

I write this at a moment in the late '80s when solidarity and coalition-building among the various ethnic groups is a priority. As cross-cultural activity becomes a reality within ethnic categories that appear homogenized only from the outside, it is occurring in both the political *and* the esthetic realms. The project of understanding the intercultural process is perhaps evenly divided between understanding differences and samenesses. Every ethnic group insists, usually to deaf ears, on the diversity within their own ethnicity, stressing the impossibility of any one individual or group speaking for all the others.

We have not yet developed a theory of multiplicity that is neither assimilative nor separative—one that is, above all, relational. In the '70s cultural identity in "high art" was largely suffocated in the downy pillow of a "pluralism" in which the SoHo galleries resembled network television— lots of channels, all showing more or less the same thing and controlled by the same people. The intercultural enterprise is riddled with sociological complexities that must be dealt with before esthetic issues are even broached. There are classes and cultures within cultures, not to mention the infinite individual diversities that disprove both external stereotypes and group self-naming alike. At the same time, the alienation that rides on individualism in this country is unenviable, and an individual "identity" forged without relation to anyone or anything else hardly deserves the name. I have to agree with Elaine Kim when she insists, "Without the reconciliation of the self to the community, we cannot invent ourselves."[5] Art speaks for itself only when the artist is able to speak for her or himself, but the support of a sensed or concrete community is not easy to come by. Much of the art reproduced in this book exposes the vulnerable point where an inner vision of self collides with stereotypes and other socially constructed representations.

In order to confirm identity in the face of ignorance or bigotry, a name may have to be changed, or even *be changing*. In some cultures a person has a secret name, a nickname, a public name, and/or a name

given or earned later in life or on coming of age. In the United States, Native Americans may have an Anglo name and an Indian name in addition to their own inherited and given names; the Indian name may be translated into English and acquired in different ways, according to different tribes and different individual experiences. A name may be received in a vision, conferred by an elder, or taken from an ancestor. (Vine Deloria, Jr., has pointed out that there is nothing "personal" about a name like George Washington, which primarily refers to a genetic line.)[6] Latino and Asian immigrants may anglicize their given names as a gesture toward their new identities as North Americans; African Americans may rename themselves not into but out of the dominant culture by taking a new African or Islamic name, attempting to bypass the history of slavery, just as some women, by renaming themselves after places or within a female line, have attempted to bypass the history of the patriarchy. . . .

The most pervasive and arguably most insidious term artists of color must challenge is "primitivism." It has been used historically to separate the supposedly sophisticated civilized "high" art of the West from the equally sophisticated civilized art it has pillaged from other cultures. The term locates the latter in the past—usually the distant past—and in an early stage of "development," implying simplicity on the positive side and crudity or barbarism on the negative. As James Clifford has written, the notion of the primitive in Western culture is "an incoherent cluster of qualities that at different times have been used to construct a source, origin, or alter ego confirming some new 'discovery' within the territory of the Western self," assuming "a primitive world in need of preservation, redemption and representation."[7]

I should not even have to touch upon this anthropological problem in a book devoted to the contemporary art of my peers, but the Western concept of primitivism denigrates traditions with which many contemporary artists identify and fortify themselves. The term "primitive" is also used to separate by class, as in "minor," "low," "folk," or "amateur" art—distinguished from the "fine," "high," or "professional" art that may in fact be imitating it. There is an inference that such work is "crude" or "uncooked," the product of "outsiders."[8] "Primitives" are those who "naively" disregard the dictates of the market and make art for the pure joy of doing so. In fact, much "primitive" art is either religious or political, whether it is from Africa or from today's rural or urban ghettos. It is not always the quaint and harmless genre, the ideological captive, pictured in the artworld.

And yet, as Jerome Rothenberg has pointed out, "primitive means complex."[9] The West has historically turned to the Third World for transfusions of energy and belief. In less than a century, the avant-garde has run through some five centuries of Western art history and millennia of

other cultures with such a strip-mining approach that it has begun to look as though there were no "new" veins to tap. Where the Cubists appropriated the *forms* of traditional cultures and the Surrealists used their dreamlike *images* to fantasize from, many artists in the '70s became educated about and fascinated with the *meanings* of unfamiliar religions and cultures. The very existence of the international mini-movement called "primitivism" constituted an admission that Western modernism once again needed "new blood." In the '80s the overt rampage through other cultures was replaced by postmodernist "appropriation" (reemploying and rearranging borrowed or stolen "readymade" images from art and media sources)—a strategy warmed over from '60s Conceptual Art and often provocatively retheorized. Some of this work is intended to expose as well as to revise the social mechanisms of image cannibalism. The "appropriation" of anything from anywhere is condoned as a "critical" strategy. Yet as Lowery Stokes Sims has pointed out, such "visual plagiarism" has its limits, especially when it reaches out into other cultures "in which this intellectual preciosity has no frame of reference. . . . Appropriation may be, when all is said and done, voyeurism at its most blatant."[10]

There are more constructive ways of seeing the "primitive." Cuban art critic Gerardo Mosquera has pointed out that "for Latin Americans, the 'primitive' is as much *ours* as the 'contemporary,' since *our* 'primitivism' . . . is not archeological material, but an active presence capable of contributing to *our* contemporary world."[11] Judith McWillie, a white scholar of black Atlantic art, has pointed out that the art of self-educated black artists closely paralleled the works of early modernists. . . .

A name less obviously irritating than "primitive" for the creations of people of color and "foreign" whites is "ethnic art." Although it was originally coined with good intentions and some internal impetus, it has since been more coldly scrutinized as a form of social control that limits people's creative abilities to their culture's traditional accomplishments; both Left and Right have been accused of harboring this "separate but equal" agenda of "ethnic determinism."[12] There are categories and contexts where "ethnic" artists are supposed to go and stay, such as folk art and agitprop, community arts centers, ghetto galleries and alternative spaces. The Los Angeles artist Gronk, whose zany expressionist paintings and performances fit no Chicano stereotypes, says, "If [well-known white artist] Jon Borofsky makes a wall painting, it's called an installation. If I do one, it's called a mural, because I'm *supposed to be* making murals in an economically deprived neighborhood."[13]

The National Endowment for the Arts has a program called "Expansion Arts," which uses its "community-oriented" mandate to fund art that can't get past the mainstream-oriented panels in other granting

categories. (The "Art in Public Places" program also sometimes tries to integrate such projects.) In the United Kingdom and Australia, community arts is a respected domain into which "high" artists can cross while still showing their studio art in the artworld. In the United States, however, there are few such "crossovers" and most of them are white. The short-lived rages for graffiti art in the '70s and again in the '80s demonstrated clearly that the time had come for only a handful of black and Latino artists to move—temporarily—from subways and streets into galleries and museums. . . .

At the very least the "ethnic arts" have often provided a base for self-naming among artists who prefer not to leave their own communities or have, for ideological reasons, turned their backs on the "centers." At their best ethnic arts programs and "specialized" museums like San Francisco's or Chicago's Mexican Museums or New York's Studio Museum in Harlem open channels to new audiences, to an exchange between artists and their communities; they offer parallels to the shelter afforded (mostly) white artists by the national network of "alternative spaces," but with a far lesser degree of economic independence. Yet despite, or because of, their success, they are accused of "ghettoizing" the artists they exhibit. There is, however, no question that culturally targeted funding encourages self-determination and has on occasion provided arenas where truly "multicultural" interaction can take place. The interfaces within even a single racial community may be intricate, providing a linguistic and cultural microcosm of the larger society. African-Americans, for instance—involuntary early settlers of the United States and for two centuries more homogeneous than other "minorities"—now find their ranks swelled with African peoples from Brazil, Colombia, Central America, Cuba, Haiti and other Caribbean islands, who speak Portuguese, French, Spanish, patois, or West Indian English.

For young artists yearning to have their art freed from labels and seen extraculturally (especially those working in abstract modes), contradictions within ethnicity can be baffling on two levels. First, they will encounter people who insist, and may even believe, that color makes no difference, even as artists of color are systematically excluded from galleries and exhibitions. Then they will encounter others, like me, who have sadly observed that within a racist society you will be called on your race no matter how much you try to avoid it, so you might as well stand up and be counted. The question remains whether there is a conflict between recognition of one's full potential as a human being and entrance into the mainstream where that potential may be swept away in the general flow. . . .

Visual artists are conscious, and unconscious, agents of mass dreams,

allowing forbidden or forgotten images to surface, reinforcing aspects of identity that provide pride and self-esteem, countering the malignant imprint of socially imposed inferiority. As namers, artists participate in an ongoing process of call and response, acting in the space between the self- or individual portrait and the cluster of characteristics that supposedly define a community. In the expansion from one to many, from the mirror to its frame, visual images play an increasingly important role. Just as dreams may precede or parallel reality, images often precede texts, and elusive self-images can precede new names, though they are rarely understood at the time they appear. Visual images can also offer positive vision to those whose mirrors are clouded by social disenfranchisement or personal disempowerment. The naming process involves not only the invention of a new self, but of the language that creates the context for that self—a new world.

Yolanda López, a Chicana artist from San Francisco who is education director for the Mission Cultural Center, has concentrated for more than a decade on the positive and negative aspects of images of Mexicans on both sides of the border. . . . She deconstructs some of the most familiar stereotypes in a half-hour videotape called *When You Think of Mexico*. Two narrators, male and female, comment with humor and indignation on the Mexicans in advertising, the media, and Hollywood films. The images range from Frito Banditos (which imply that Mexicans—and revolutionaries in general—are, among other things, out to rob "us"), to the "picturesque and nonthreatening" lazy Mexican asleep under an oversized sombrero and a cactus, to religious symbols borrowed to sell food ("one bite and you'll be speaking Spanish"), to skewed versions of Mexican masculinity (a rooster) and femininity ("the hot little Latin"). The narrator says of "the new Mexican Aunt Jemima" on a corn flakes box that there are some Chicanas who wear their hair parted in the middle or hoop earrings or peasant blouses—"but *all at once?*"

In another section, analysis is focused on the 1956 *Giant*, a self-consciously pioneering movie that offered unprecedented if paternalistic respect to Mexican Americans and looked relatively calmly on interracial marriage. At the film's end a shot of the two grandchildren—one white, one brown—is superseded by a shot of a white lamb and a black kid (goat), demonstrating, says López, that "we are still seen as different species."

Intent on teaching Chicanos to look critically at the way they are represented and controlled, López declares "We have to be visually literate. It's a survival skill." Her prime subject has been the ubiquitous "Brown Virgin" of Guadalupe. López deconstructs her idealization in the Mexican community, scrapes off the Christian veneer, and transforms "La Lupita"

into a modern indigenous image echoing pre-Conquest culture. . . . "Why," she asks, "is the Guadalupe always so young, like media heroines? Why doesn't she look like an Indian instead of a Mediterranean . . . ?"[14]

At the same time, López perceives the Guadalupe as an instrument of social control and oppression of women and Indians. She points out that the Church first tried to supress the "Indian Virgin" and only accepted her when her effectiveness as a Christianizing agent became clear. The Virgin of Guadalupe was the Americas' first syncretic figure, a compromise that worked. She became the pan-Mexican icon of motherhood and *mestizaje*, a transitional figure who emerged only fifteen years after the Conquest as the Christianized incarnation of the Aztec earth and fertility goddess Tonantzin and heiress to Coatlicue, the "Lady of the Snaky Skirt," in her role as blender of dualities. The Guadalupe is a unifying symbol of Mexican "mystical nationalism" equally important to Indians, mestizos, and *criollos* (American-born Spaniards), fusing indigenous spiritual concepts of the earth as mother with "criollo notions of liberty, fraternity, and equality, some of which were borrowed from the atheistical French thinkers of the revolutionary period," and a symbol of the "power of the weak."[15] More recently, La Lupita has become a Chicana heroine, representing, with Mexican artist Frida Kahlo, the female force paralleling male heroes like Emiliano Zapata and Diego Rivera.

Discovering one's own difference from the so-called norm—on TV, in schoolbooks, movies, and all the other social mirrors—can be a wrenching but illuminating experience. . . .

Adrian Piper is a black woman who often involuntarily passes for white. A daring performance artist and a Harvard-educated philosophy professor, Piper addresses her multiple identities directly, charging her art with a unique intensity. In fifth grade Piper's poise was such that a hostile teacher asked her mother, "Does she know she's colored?" In the '60s, when she was in art school, a professor asked a friend of Piper's, "Is she black? She's so aggressive." In recent years, because she not only acknowledges but flaunts and insists upon her racial heritage, Piper has been accused of masochism, of purveying bourgeois guilt by "passing for black" when she could pass for white. She considers unthinkable the alternative: to deny the sufferings of her family and of African Americans in general. Finding herself in the curious position of being able to "misrepresent herself," Piper writes:

> Blacks like me are unwilling observers of the forms racism takes when racists believe there are no blacks present. Sometimes what we observe hurts so much we want to disappear, disembody, disinherit ourselves from our blackness. Our experiences in this society manifest themselves in neuroses, demoralization, anger, and in art.[16]

As an artist, Piper has concocted a number of complex devices to let people know that she knows who she is. Her use of masks or disguises is as complex as her analysis of her situation. In her "Catalysis" pieces, performed in the streets and public places in the early '70s, Piper "mutilated" and "barbarized" her image as an attractive young woman (by wearing vile-smelling clothes and performing bizarre, nonviolent but antisocial acts) to mirror in repulsive exaggeration how the Other is perceived. By simultaneously emphasizing her difference and dissolving the usual means of communication between herself and a viewer of her art, she discovered a destabilizing strategy, a way of subverting social behavior to make it reflect upon itself.

For several years in the mid-'70s, Piper assumed an alter ego, the "Mythic Being," who also appeared in public and in poster pieces. A slight young man in shades, Afro, and a pencil mustache, he permitted Piper to experience a cross-sexual, androgynous identity, as well as to become the black or Latino street kid she could never fully transform into as a teenager. The Mythic Being was often hostile or threatening. He offered his creator a way of being both self and other, of escaping or exorcising her past and permitting her to re-form herself.

In the Mythic Being pieces Piper emerged in "blackface." In her concurrent performance pieces, however, she was made up in whiteface, as well as in a curious kind of drag, with long flowing hair and sensuously female dance movements unbalanced by a pencil mustache, a vestige of the Mythic Being's street persona. Piper's work since the early '70s may have provided the model for Cindy Sherman's shifting personae, which, detached from the anger about racism that fuels Piper's art, became a fashionable (and perceptive) individual exploration with full theoretical potential for both feminism and the mainstream.

In the autobiographical *Three Political Self-Portraits* of the late '70s, Piper made mass-produceable posters with long narrative overlays in which she detailed her experiences of conflicts in the categories of gender, race, and class. She recalls being called "paleface" by her neighbors in Harlem and "colored" at the private school she attended on scholarship. In the 1980 *Self-Portrait Exaggerating My Negroid Features*, Piper tried to embody "the racist's nightmare, the obscenity of miscegenation, the reminder that segregation has never been a fully functional concept, that sexual desire penetrates the social and racial barriers, and reproduces itself."[17] In all of her work, Piper enacts, as Homi Bhabha has said of Frantz Fanon's achievement in his classic *Black Skin, White Masks*: "the intricate irony of turning the European existentialist and psychoanalytic traditions to face the history of the Negro that they had never contemplated."[18]

As the internal search intensifies for names to counter anachronistic

impositions, names that will reflect and reinforce the difficult coalitions being forged among Asian, African, Latino, Native, and European Americans, it becomes clear that ethnicity itself, as Michael M.J. Fischer has pointed out, is

> something reinvented and reinterpreted in each generation by each individual and it's often something quite puzzling to the individual, something over which he or she lacks control. . . . It can be potent even when not consciously taught; it is something that emerges in full, often liberating flower, only through struggle.[19]

He goes on to say that today, as we reinvent ethnicity, it's also something new: "To be Chinese-American is not the same thing as being Chinese in America. . . . The search or struggle for a sense of ethnic identity is a (re)invention and discovery of a vision, both ethical and future-oriented."

Thus a "hyphenated" American is not "just an American" but a particular kind of American. All double identifications, awkward as they sound, make clear that the user acknowledges and is proud of her or his biculturalism. Nevertheless, the choices for artists of color in the United States, as well as for exiles and expatriates from the Third World living in North America, can seem irreconcilably polarized. There is a good deal of internal ambivalence and conflict about the degree to which they want to, or are able to, assimilate in their art. . . .

Although for artists of color looking back to suppressed traditions, self-portraiture and autobiography might be expected to be seen as anachronisms—the unwanted or unfamiliar products of a self-conscious Western experience—in fact, personal narratives continue to be revitalized and clearly play a significant role in the naming process. Robert Lee, director of the Asian American Arts Centre in New York, has suggested that "the Asian art of calligraphy is the nearest traditional equivalent to self portraiture."[20] Margo Machida has pointed out that for an Asian American, self-exposure and autobiography constitute "a crossing of a code of silence, transgression of the tradition of keeping problems within the family."[21] Her own use of "psychological self-portraiture" (from Polaroids of her own body) as a means of "self interrogation," is therefore "a radical step in affirming my experiences and presence in the society."[22]

Machida is a Japanese American artist raised in Hilo, Hawaii, who has lived for twenty years in New York, where she has been active in the Asian American political and cultural communities. Her self-images are introspective but also unexpectedly harsh and critical, incorporating a level of psychic violence repressed in most Asian American art. She studied psychology and art, and, deeply affected by the '60s vision of a counterculture based on humanist values, worked for ten years as a coun-

selor and art therapist in mental institutions, halfway houses, and schools for the emotionally disturbed and developmentally disabled. Her contact with the struggles of clients living on the edge of society led to a series of disturbing narrative paintings in 1984.

Machida's work . . . is based in her own "paralyzing feelings of culture shock, isolation, disorientation, and marginalization in New York," having come from "a small, conservative Asian community with close ties to traditional Oriental culture." As in all Pacific Island cultures, she recalls, there was a deep appreciation of natural forces, personified in a pantheon of goddesses, gods, and spirits manifested in volcanic eruptions, typhoons, and earthquakes. . . .

The waves, typhoons, and volcanoes of Hawaii are both metaphors and realities that continue to haunt the artist's nightmares. In *Tidal Wave* (1986) a child holds tightly to a red ball, in an attempt to ward off her fear of impending doom. This image has been read as representing the Asian awash in a dangerous sea of Occidental extroversion, employing introversion as a defense.[23] In many of her self-portraits since 1985, Machida calls upon animals as guardians and alter egos as well as images of personal power. In *Charmed* she is a snake handler, a metaphor for "confronting the dangers of self-discovery." In *First Bird* she represents herself as a ghostly geisha (the Asian female stereotype) and a skeletal Jurassic archaeopteryx (the transitional creature who straddled reptilian and avian worlds). She cites the influences of Francis Bacon, underground comics, and Frida Kahlo, "whose arrestingly frank, graphic and bizarre imagery of her body, sexuality, cultural and political identity showed how much more was possible to express." Like Kahlo, whose work and life have become models for women of all cultures, Machida uses skeletal references as images of illness, vulnerability, and mortality. . . .

The co-optation of images through reductive and restrictive stereotypes coexists with the loss of language, the loss of the original name, which inevitably includes the loss of culture and identity itself. In Hawaii, Machida's dilemmas about bicultural identity are reflected in the threat to the islands' lingua franca. Pidgin is a creole language that sounds strange to the English ear, "a spare, direct, and often delightfully irreverent patois" that is for many Hawaiians "a crucial link to a rich past that is quickly being bulldozed for tourist and commercial development."[24] It is a full language, "the mother song" for non-Anglo Hawaiians, the communicative link that blends Japanese, Chinese, Filipino, South Pacific, Portuguese, Puerto Rican, and other components into a unique culture that can stand up against the growing influx of mainlanders.

"Indian people still speak English as a second language, *even if we no longer speak our own languages,*" says Cherokee artist, Jimmie Durham. Native Americans and Mexican Americans are still punished for

using their own languages in schools, a practice that did not end in the early twentieth century; there are Chicano students in college today who recall being made to stand next to the blackboard on tiptoes for extended periods, placing their noses in a circle of chalk, for the crime of speaking their own language. The "English Only" movement—now law in several states—is attempting a total eradication of bilingual education and day-to-day commerce that might even be applied to Puerto Rico if it "achieves" statehood. "Official English" is a vestige of the discredited melting pot concept, lamented only by those who are threatened by diversity. . . .

The visual arts might be able to make a contribution to the inter-cultural process far greater than that of literature, due to language barriers and the gaps between written and oral traditions. Yet that has not been the case so far, in part because art is the prisoner of its status as object and commodity—its bulk and expense, and the perceived elitism that results. It is therefore necessary to broaden our definition of naming to include the processes and vehicles by which these names are transmitted and received.

North American critics and intellectuals have begun only recently to look with respect rather than rapacity at Third World cultures. The progressive postmodern sensibility (including the rejection of *all* "sensibility" as crippled by culture or ideology) has focused first on "decentering" and then on the relationship between center and margins. Yet it has been the discourse *about* rather than *by* Third World artists and writers that has risen to the surface via feminist and French theories about difference and the Other in the last decade. Most of the debate, like this book, has been within white control. In addition, it has been inaccessible to many working artists because scholars tend to prefer the illusory coherence of theory to the imperfections of practice. This bias against artists' attempts to expand or experiment with theoretical premises curtails the development and effectiveness of the art itself and permits theory to sail off into the ozone, unanchored by the difficulties of execution and direct communication with audiences.

African American literary critic Henry Louis Gates, Jr., says that rather than shying away from "white power—that is, literary theory" (and its hegemonic style), African Americans must translate it "into the black idiom, *renaming* principles of criticism where appropriate, but especially *naming* indigenous black principles of criticism and applying them to explicate our own texts." However, by questioning the ownership of the language itself, he seems to imply that renaming is not enough:

> In whose voices do we speak? Have we merely renamed terms received from the White Other? Just as we must urge that our writers meet this challenge, we as critics must turn to our peculiarly black structures of thought and

feeling to develop our own language of criticism. We must do so by turning
to the black vernacular, the language we use to speak to each other when
no white people are around. My central argument is this: black people
theorize about their art and their lives in the black vernacular.[25]

In his book *The Signifying Monkey*, which elaborates on this theory,
Gates uses the figure of the Yoruba trickster deity, Eshu-Elegbara, god
of the cross-roads, as a bridge—a precarious, teasing suspension bridge.
However, while recommending a new vernacular, Gates is also aware
that his medium is an analytical language incomprehensible to the black
community he writes about and for. He runs the risk of alienating not
only the white critical establishment, but also the black audience, which
is not monolithic in the first place and is often unwilling or unequipped
to deal with "the principles of criticism" in any case. Black visual artists
find themselves in a similar position. . . .

The young African American artist Lorna Simpson has fused current
theory with her practice, which consists of life-size color photographs of
female figures and cryptic texts that serve as both captions and speech.
Raised by parents politicized in the '60s, she is one of the generation that
includes filmmakers Spike Lee and Julie Dash, actress Alva Rogers, per-
formance artist Lisa Jones, artist Carrie Mae Weems, and writers Trey
Ellis, Michele Wallace, Greg Tate, and Kellie Jones. Originally a docu-
mentary street photographer, Simpson moved into more ambiguous ter-
ritory when she went to graduate school at the University of California
at San Diego, partly because she had become uncomfortable with inva-
sions of privacy endemic to documentary work. She remained interested
in both the gestural and the linguistic aspects of "body language," and
in the stereotypes they incorporate: "We need to shave off even the fictions
that we've created for ourselves in terms of who we think we are as
blacks."[26]

Appearance and disappearance, the invisibility of the "I witness"
who because of race or gender is disbelieved by society, is another one of
Simpson's themes. She prefers not to limit her subjects to specific issues
(such as South Africa) because she wants "an echo that I'm also talking
about America . . . so that the viewer realizes I'm also talking about your
life. . . . I leave the reconstruction to the viewer. . . . I'm not so interested
in morally defining what should be, [as in] exposing clichés that seem
quite harmless."[27] Simpson is questioning roles and how they are "played."
She looks back at the history of role-playing by using as sources game
books from the '50s, remarking at the same time how "fade-cream" (skin
lightener) ads have reappeared in the '80s. Given the apparent conserv-
atism of the upwardly mobile black community and some of the student
generation, Simpson is critical of a political ignorance abetted by national

historical amnesia. Her images are of day-to-day experience, the mundane as entrance to common ground, and she connects this to a trend (paralleling the early women's movement) "where everyone works from their personal experience or from incidents in their own lives." Kellie Jones sees in Simpson's allegories of "the archetypal Black woman" a "suave innuendo of the Blues and the duality of use and meaning in the Black community (e.g. bad = good)."[28] . . .

Self-naming is a project in which such relational factors—balancing one's own assumptions with an understanding of others—are all-important. When names and labels prove insubstantial or damaging, they can of course be exposed as falsely engendered and socially constructed by those who experience them; they can be discarded and discredited. But they can also be chosen anew, even if only temporarily, to play a part in the "polyphonous recuperation" that Gerardo Mosquera looks to from the Caribbean.[29] James Clifford seems to suggest the possibility of a changeable, relational identity when he says, "There can be no essence except as a political, cultural invention, a local tactic."[30] This seems a healthy compromise that allows historical and cultural commonality a role—and a political role at that—without freezing it into another instrument of control. As names and labels change, the questions change too. And as consciousness rises and dialogues take place, any single, unified resolution becomes more unlikely.

Notes

1. James Baldwin, "A Talk to Teachers," originally delivered in 1963; published in *Graywolf Annual Five: Multicultural Literacy*, ed. Simonson and Walker, p. 8.

2. See "Many Who Are Black Favor New Term for Who They Are," *New York Times* (Jan. 31, 1989). In Britain, "black" is applied to Africans, Asians, and all other people of color by racists as well as by people of color taking a political stance to emphasize a shared colonial history and experience of oppression.

3. In the nineteenth century, both here and in England and continental Europe, "Red Indian" was used as a semantic distinction from East Indian. "Squaw" is another insulting term, rumored to have originated because "we squawked when we were raped," according to Jaune Quick-To-See Smith.

4. The *New York Times* (Sept. 9, 1989) reported that today, as in Dr. Kenneth Clark's famous "black doll" experiment two generations ago, black children asked to select the "prettier, cleaner, smarter" image, chose the white over the black.

5. Elaine Kim, "Defining Asian American Realities Through Literature," *Cultural Critique* no. 6 (Spring 1987), p. 109.

6. Vine Deloria, Jr., quoted in Jamake Highwater, *The Primal Mind*, p. 173.

7. James Clifford, "Histories of the Tribal and the Modern," *Art in America* (April 1985), pp. 164–77. See also Lucy R. Lippard, "Give and Takeout," in *The Eloquent Object*, ed. Manhart and Manhart, pp. 202–27.

8. See John Berger, "Primitive Experience," *Seven Days* (March 13, 1977), pp. 50–51.

9. Jerome Rothenberg, "Pre-Face," *Technicians of the Sacred*, p. xix ff. Rothenberg sug-

gest the term "archaic" as "a cover-all term for 'primitive,' 'early high,' and 'remnant,'" which also encompasses "mixed" cultural situations and a vast variety of cultures.

10. Lowery Stokes Sims, "Race, Representation, and Appropriation," in *Race and Representation*, p. 17.

11. Gerardo Mosquera, *Contracandela* [collected essays] (Havana: Editorial José Martí, forthcoming).

12. Rasheed Araeen, "From Primitivism to Ethnic Arts," *Third Text* no. 1 (Autumn 1987), p. 10.

13. Gronk, in conversation with the author, Dec. 8, 1988.

14. Yolanda López, in conversation with the author, Oct. 1988. Her 28-minute videotape *When You Think of Mexico: Commercial Images of Mexicans* is distributed by Piñata Productions in Oakland, Cal.

15. Victor Turner, *Dramas, Fields, and Metaphors* (Ithaca: Cornell University Press, 1974), pp. 152–53.

16. See the exchange between Barbara Barr and Adrian Piper, *Woman Artists News* (June 1987), p. 6; the debate continued with letters from readers in subsequent issues.

17. Adrian Piper, "Flying," in *Adrian Piper* (New York: Alternative Museum, 1987), pp. 23–24.

18. Homi Bhabha, "Remembering Fanon," in *Remaking History*, ed. Kruger and Mariani, p. 146.

19. Michael M.J. Fischer, in *Writing Culture*, ed. Clifford and Marcus, pp. 195, 196.

20. Robert Lee, "Introduction: A Feather's Eye," in *The Mind's I: Part I*, p. 4.

21. Margo Machida, quoted on National Public Radio, Jan. 28, 1988, about the "Cut-Across" exhibition in Washington, D.C.

22. All quotations from Margo Machida here and below are drawn from a series of unpublished statements on her work, a published statement in *Cultural Currents* (San Diego: San Diego Museum of Art, 1988), and answers to a questionnaire from Arlene Raven (1989).

23. Dominique Nahas, in *Orientalism: Exhibition of Paintings by Margo Machida and Charles Yuen* (New York: Asian Arts Institute, 1986), n.p.

24. Robert Reinhold, *New York Times* (Dec. 13, 1987).

25. Henry Louis Gates, Jr., "Authority, (White) Power and the (Black) Critic; Or, It's All Greek to Me," from *Cultural Critique*, No. 7 (Fall 1987), pp. 33, 37.

26. Lorna Simpson, unpublished interview with Moira Roth, 1989.

27. Ibid.

28. Kellie Jones, in *Lorna Simpson* (New York: Josh Baer Gallery, Oct. 1989).

29. Mosquera, *Contracandela*.

30. James Clifford, *Predicament of Culture*, p. 12.

21

The Public Realm

Spiro Kostof

Boston Common is one of the earliest public places in America. For over three hundred years it has remained an open space—and that is no easy feat in the heart of a thriving city, where land is gold and progress virulent. The Bostonians' open-air living room has survived intact from the seventeenth century—when cows grazed there, and the local militia exercised, and "the Gallants a little before Sun-set walk with their Marmalet Madams," as an English visitor wrote in 1663, "till the nine a clock Bell rings them home to their respective habitations." And so it continued, free of encroachments, a common ground for pleasure and civic use, where all could come and go as they pleased and encounters were easy and unrehearsed.

In time, buildings surrounded the Common—churches with their graveyards, shops, elegant houses along Beacon Hill. The Massachusetts State House, one of the first capitols to go up after Independence, sat on an eminence on the Beacon Hill side, with an imposing set of stairs descending toward the Common. Monuments cropped up, to honor publicly what Boston thought worth honoring—a Civil War memorial, for example, to Colonel Robert Shaw and his regiment of black soldiers from Massachusetts, or on a central knoll, the Army and Navy monument topped by the "Genius of America." When department stores came of age in the 1880s, Filene's, one of the best, turned one side toward the Common,

only one block away from it, and the other toward the central business district.

At the far side of the Common, toward Arlington Street, on land reclaimed from the mud of the Back Bay in the mid-nineteenth century, a lovely Public Garden was installed. The great landscape artist Frederick Law Olmsted made this the starting point of a beautiful park system he called the Emerald Necklace. The Public Garden is all the things the common is not—small, fenced in, manicured. It has a choice variety of trees, properly labeled, formal flower beds that change with the seasons, a shallow lake shaded by willows, swan boats. It was meant for the more genteel Bostonian, and to this day it is preferred by people who disapprove of loud radios, winos, and running dogs.

Boston Common represents the public face of America. Every town, however small, designs into its fabric a stage of this sort. We seem to need more from life than just food, shelter, work, and entertainment. Beyond self, beyond family and neighborhood, there exists a public realm which holds our pride as a people. We need public places to enjoy the unplanned intimacy of civil society and to celebrate that sense of belonging to a broad community—a community with a shared record of accomplishment. We expect public buildings to express the dignity of our institutions. We choose to make monumental gestures that commemorate our heroes and mark the passage of our history.

Early Public Spaces

The public open space was there at the beginning, from the first European towns planted on this continent.

In the middle of their gridded pueblos, the Spanish invariably left a large plaza, one longer than it was wide and surrounded by porticoes where goods were sold. The administrative palace and other public buildings fronted the plaza, and so very often did the main church. But the center belonged to the people, for their fiestas and the customary evening stroll or *corso*, a time of socializing, flirting, showing off. The ghost of one such plaza survives in Santa Fe, New Mexico, where you can still see street merchants set up their stalls in the portico of the Governor's Palace. It was twice the present size originally, extending eastward to the present cathedral. The landscaping and paving are later refinements. A military chapel on the south side of the plaza related to one of its original uses—military exercises.

French towns were on rivers, and the town square, which doubled as a parade ground here too, overlooked the waterfront. The buildings

that defined the square usually included a barracks and a hospital. In New Orleans, the capital of the French province of Louisiana, a brick church stood on the inland side of the square, and the quay along the river had a gravel walk planted with orange trees. The square, miraculously, lives still—a charmed, evocative public place, full of shade and pungent odors. There is a later church on that axis now, and the framing buildings span the French, the Spanish, and the early American eras of the city. In the middle is Andrew Jackson poised on his horse. This statue and the landscaping, which turned the square into an urban garden in the 1850s, are American contributions.

Americans, that side of them that derives from the English at least, were never very comfortable with an empty public place. They liked it filled with something, preferably some sort of public building that would provide a good excuse for wanting to be there.

Take the New England common. At first, it was neither an open green nor the grazing ground for local livestock. Boston Common seems to have been an exception. Ordinarily, a common was much too small to sustain more than a few animals. Besides, there was no green on it at all. In the early morning, townsmen on their way to fields at the edge of town led their cattle to the "close" in this open, central area where a herdsman waited to lead them to graze in the common pastures. At dusk the returning men collected their animals and herded them home.

The real reason for the common was the meetinghouse—a religious center and town hall in one. When land was first allocated in a new town, a large plot was set aside for this most important building of community life. Once the meetinghouse was up, and the graveyard fenced in with a neat stone wall, other buildings gathered around. There was the nooning house, for example, where in winter months the parishioners could find shelter and heat during breaks in the long, cold services of the Sabbath. The tavern was just as good for this purpose, at least for the less scrupulous. It also served as temporary courthouse, and later, when regular stagecoach service was established, as a stage stop—often marked by a huge inn sign that dwarfed everything around it except the meetinghouse. A blacksmith shop did well on the common, and so did bootmakers and hatters. There might also be a magazine for the storage of powder, horse-sheds for the parishioners, or a schoolhouse.

Otherwise, the common was an unsightly, rutted piece of barren land, riddled with stumps and stones. The town's militia used it for its quarterly training, and its other public uses were reflected in its furnishings: the hay scale, the bulletin board, the well, the whipping post. To turn this stern Puritan civic center into the town green we now admire, the monopoly of the Congregational church on town life had first to be

broken. Then Baptists, Methodists, and others could stand their own churches on the common and civilizing improvements could begin.

In New Haven we have a classic example of this transformation. After the War of 1812, the city cleared its common, then called the Market Place, of its old buildings and roads, moved the graveyard, and in the middle, where the old meetinghouse had stood unchallenged, made provision for three churches—two of them for the Congregationalists and one for Episcopalians. Planned spaces were also allotted to the Methodists and Baptists at two corners of the common, now called the Green. The Methodists actually did put up a church, but the Proprietors of the Green, now full of civic pride, found the building too crude for such a public stage. They bought the Methodists out and moved them off the Green, across the street. The Baptists never took advantage of their allotted site, but chose instead to make their stand in the less formal Wooster Square nearby. North of the three new churches on the Green rose the new state house, in temple form, replacing an older building, which now seemed to spoil the symmetry. Yale's Brick Row faced the state house across College Street, and on the opposite, Church Street side, the town hall went up. As a finishing touch, the area was fenced in and edged with elms. When the elms matured this place became one of the most celebrated public squares in America.

By the middle of the nineteenth century, in the new railroad towns of the Midwest and the South, the New England green had found its counterpart in the courthouse square. It was the central feature of towns that served as county sets, and it represents as authentic a piece of American urbanism as Main Street. The courthouse stood in the middle of the one-block square, on a slight rise, surrounded by trees. In the treeless tallgrass prairie, this leafy oasis was a statement of survival and permanence. The townfolk spoke of it proudly as the "park" or the "grove." The jail and a clerk's fireproof office might be at the corners of the square. For the rest, it was small, local retail businesses, a hotel, and a restaurant or cafe where the businessmen ate their lunch. Board roofs projecting from the fronts of these establishments furnished shade, and plank seats between the roof supports made it easy to spend time there.

Farmers from the surrounding countryside stopped in regularly to take care of legal and tax matters. In the courthouse were kept land grants and commercial debt-bonds, and so the building would have to be solid, made of stone. To William Faulkner's eyes the courthouse at Jefferson, Mississippi, was "the center, the focus, the hub; sitting looming in the center of the county's circumference . . . protector of the weak, judiciate and curb of the passions and lusts, repository and guardian of the aspirations and hopes."

On the grounds there was room for the weekly market and some-times the county fair. Here statue-soldiers on pedestals memorialized past wars. In the South none was more sacred than the Confederate monument to the Civil War: Johnny Reb holding a rifle at parade rest, or else with arms folded, or carrying a flag or bugle, most often facing north whence the invasion came. And always an inscription, like this one at Lumberton, North Carolina.

> This marble minstrel's voiceless stone
> In deathless song shall tell
> When many a vanished age hath flown
> the story how they fell.
>
> On fame's eternal camping ground
> Their silent tents are spread.
> And glory guards with solemn round
> The bivouac of the dead.

So a public, urban place like the courthouse square, in these old days, was the setting where all sorts of people came together informally, where collective civic rituals like markets and parades took place, and where the prevalent values and beliefs of the community were made manifest. The institutional building—courthouse or public library or town hall—dominated. The space was well bounded and its scale intimate; it took its shape from the street pattern. It had many uses, some of them unplanned. But the urban square was above all political territory. Within its confines, people knew their place and found strength in their local tradition. The space held them, gave them identity. It is where they learned to live together.

Parks and Cemeteries

The urban park came later and was a different sort of public place. It was anti-city, to begin with, both in form and intent. What it offered visually was an invented romantic landscape, with no relation whatever to the city's street pattern. The sense was of a pleasure ground, a place of quiet and passive enjoyment. The park would set people free from the structured order of the town, free from its organized but also volatile behavior, its tensions. At the same time, the park would provide a neutral setting where the rich and poor could come together as equals. Alexis de Tocqueville, for one, believed that parks were a necessary instrument of democracy because they neutralized the strains of class consciousness built up within the cities.

So ran the rhetoric. But this outward look of innocent escapism and fraternal equality couched a more serious purpose. It had to do with the imposition of moral order where it was thought most wanting—among the urban poor. The creators and administrators of parks were gentlemen-idealists; in origin they were native-stock Americans, "Yankees." They viewed the park, from the very beginning, as an uplifting experience, a means to improve the social behavior of the citizenry—which really came down to making sure that the working classes, the immigrant labor of Yankee-owned businesses, behaved like their betters, the cultured upper crust. This is how Andrew Jackson Downing, for example, put it in 1848:

> You may take my word for it, [parks] will be better preachers of temperance than temperance societies, better refiners of national morals than dancing schools and better promoters of general good-feeling than any lectures on the philosophy of happiness.

Frederick Law Olmsted thought of the park in the same way. His name more than any other was to govern the philosophy and design of America's parks for the first fifty years of their history. Olmsted's attitude was moralizing from the start. Yes, the purpose of the park was to allow urban folk to enjoy an unadulterated rural experience. But what he really intended to do with his park designs was to wean the working classes away from their ethnic neighborhoods, away from the adventures of city streets, and to make proper Americans out of them.

By training, Olmsted was neither an engineer nor a landscape architect—the two preeminent skills called into use to transform and embellish large tracts of land into carefree "nature." In fact, landscape architecture did not as yet exist as a profession in this country. When he won the competition for the design of Central Park in New York in 1858, Olmsted had behind him the rudiments of surveying, which he learned from an engineer to whom he was apprenticed briefly at age fifteen, some experience at clerking and seafaring, and ten years or so of farming in Connecticut and Staten Island.

Parks were unknown in America at the time, and in Europe, where parks had always been the preserves of noblemen and royalty, publicly owned parks were just beginning to take shape. Birkenhead Park outside Liverpool was Olmsted's immediate model; the example of the informal style of the English landscape garden formed the background of his thinking. At home, besides the newly fashionable Gothic cottages of Downing and his peers sitting in their picturesquely landscaped suburban lots, the only precedent was the rural cemetery.

In Colonial days people were buried in the churchyard, or in graveyards in the center of town. Burial was the right of every church member;

you did not have to pay to get a plot. The graves had headstones with symbolic carvings and instructive inscriptions—reminders of the virtues of the deceased and the fearsomeness of death. These unlandscaped, fully visible churchyards in the center of town were a kind of collective monument that stressed the oneness of the living and the dead.

By 1800 most churchyards were crowded and neglected. Graves, and the stones of their occupants, were commonly reused. The need for larger and more sanitary burial grounds became evident, and one model cemetery was, in fact, planned as early as 1796—the New Burying Ground in New Haven, Connecticut, just north of the town, conceived by James Hillhouse. It was laid out as a regular grid and planted with Lombardy poplars and yews. This rational scheme did not catch on, however. Only after 1850 did the idea of a formal layout, with family plots delimited by iron railings and later on by curbstones, take over. By then the cemetery was a specialized, isolated place, removed from the urban scene. It gave one more proof of that nineteenth-century tendency for family, church, and community to drift apart—a tendency also evinced in the separation of workplace and dwelling and the eventual exit to the suburbs, where the family became a world unto itself.

These planned cemeteries were nondenominational, and you had to pay to be buried. Death here was nothing to be dreaded; it was the way to reunite with your loved ones and with God. The death's head of the Colonial headstone gave way to the neoclassical willow and urn, and the metaphor of the rose on a broken stem. Private, and not collective, commemoration was the ruling order, and cemeteries became showplaces for fancy family monuments. In time, these cities of the dead would reproduce the structure of real cities, with their fashionable and unfashionable neighborhoods, their main streets and alleys, their suburban sprawl and segregation of blacks.

But prior to this institutionalization of burial, in the 1830s death was given an alternate setting—a romantically conceived garden, more for the living than for the dead, with serpentine carriage avenues, graveled footpaths, and statues of patriotic figures. The original inspiration was probably French. The Père-Lachaise cemetery in Paris, designed in 1815, may have started the trend. The first rural cemetery in America was Mount Auburn in Cambridge, Massachusetts, which opened in 1835; in quick order followed Laurel Hill in Philadelphia in 1836, Brooklyn's Greenwood, which was called "The Garden City of the Dead," and others in Baltimore, Lowell, St. Louis. The new cemeteries were, in fact, the first instances in America of public or semi-public gardens associated with cities. They were part cemetery, part experimental garden. At Mount Auburn the carriage avenues carried names of trees and the footpaths, names of flowers. The arrangement insisted on being democratic and

nondenominational. Lot owners were allowed to design and decorate their own tombs, and the mood of these rural cemeteries was pastoral, a view of death culled from ancient Greek and Roman authors. City folk flocked to these peaceful, nostalgic gardens to spend the day among the flowers and the trees.

So from the rural cemeteries of America, and the eighteenth-century aristocratic tradition of English landscape design, our municipal parks drew their inspiration. But this is to put it too simply. What became Central Park was a huge piece of uninviting open land north of Fifty-ninth Street, between Fifth and Eighth avenues—some two and a half miles in one direction and half a mile in the other. Much of it was treeless swamp, large boulders pushed out of a thin hard soil. In other words, the park was a massive public works project, one which presented acute technical and political difficulties. The transformation was nothing short of magical, and the precedent of Central Park forever changed the look of American cities.

Olmsted and his gifted partner Calvert Vaux left the rocky, semi-wild northern section much as they found it, highlighting the terrain with cascades and plantings of evergreens. The southern half they laced with groves, small boating ponds, meadows, and they skirted these with open walks. They arranged the gently curving pedestrian walks, bridle paths, and carriage roads in such a manner that there were no intersections at grade with cross-town traffic, which was kept out of sight in four roads below park level. All these intersections were handled with graceful stone bridges at various heights that served as underpasses and overpasses.

Olmsted was uncompromising on the issue of built structures within his parks. There were to be no monuments, no decorations; the urban square was the proper place for such "townlike things," as his disciple the educational leader Charles Eliot put it.

It took a long time for all this to take shape. And it was a bitter struggle. The beautifully composed picture became the battlefield for two contending social factions: on one side, the cultured, cosmopolitan elite of Olmsted's peers who saw the park as a pristine work of art, a soothing middle landscape between raw nature and the unseemly entanglement of the city; on the other, ward politicians to whom parks were vacant land that could be filled with job-producing structures. And there was the related conflict of use. To the reformers, the park was where the classes could rub shoulders; it was the ideal place for cultural enlightenment. In time, rejecting Olmsted's purism on the subject, educational institutions like museums and conservatories, aquariums, observatories, and zoos were ensconced within the park's bounds, their purpose to combine instruction with pleasure. The working classes, on the other hand, were far more interested in a sturdy playground, a place to have a good time.

These conflicts were never resolved. It is in the nature of public places to act as fields of interaction and to change character in the process of mediating social behavior. The working classes insisted on, and got, their own playgrounds, distinct from the refined pleasure-garden of the middle class. After 1900 the urban park itself responded to their pressures. A new type of park that stressed organized activity gained currency. This was an accessible lot of ten to forty acres, ringed by shrubbery, with a straightforward layout and a dominant indoor plant called the field house, which had an assembly hall, club rooms, and gymnasiums. No meadows or undulating paths, no attempt to block the views of the city round about. Now there were shorter work weeks, longer vacations, early retirement. All this was creating what came to be known as "leisure time"; and it was best if it could be filled in an orderly way. So throughout the land came a sudden profusion of municipal beaches, stadiums, tennis courts, picnic areas, and public playgrounds.

But Olmsted's vision held its own. During his long career, he managed to give substance to twenty urban parks of his particular brand, and to go far beyond, toward a notion of the city as a landscape at large. He preached tirelessly that each city should be aired with a whole constellation of parks, linked together in an integrated system. Connectors would be green boulevards and parkways. Boulevards were broad and straight, with landscaped medians, and were meant to be bordered by elegant houses behind dense rows of trees. These were often run diagonally across the street grid. Later on cars would find these expansive connectors a godsend for fast, unencumbered travel and would change their intended character as tranquil, idyllic stretches, suitable for pedestrians and slow coaches, into dangerously paced fast-traffic lanes. But parkways, once out in the suburbs, moved in gentle curves along natural contours, looking out on broad expanses of landscape. Commercial traffic was allowed, but only at the far sides of the roadways.

Olmsted started it all with the magnificent Emerald Necklace in Boston, a loosely strung system of pleasure drives, ponds, and parks that followed the city's suburban edge along the grassy marshland of the Muddy River. He laid out six other park systems before his death, and his disciples added others—George Kessler in Kansas City and Cincinnati, and Horace W. S. Cleveland in Minneapolis where a chain of lakes was incorporated into a continuous greenbelt.

The American Renaissance

The boulevards and parkways used stately public buildings as focal points. In the time between the Civil War and the Chicago Fair the scale of our public buildings had steadily escalated. This was true for traditional

institutions, like government agencies, libraries, and museums, and for more modern structures, chief among them railway terminals and department stores. By the end of the century a spectacular monumentality had seized our cities, which made prewar courthouses, state capitols, and colleges look almost residential by comparison. Size was not all. There were sheathings of lavish materials, sculptural ornament and stained-glass windows, painted friezes and showy furnishings. Something had changed. America's vision of itself was not what it had been.

Nothing shows this escalation of public splendor more clearly than the nation's state houses. Like the later skyscraper, the state capitol was a uniquely American building type, and it struggled from the start to achieve a degree of monumental dignity and a suitable symbolic image. Jefferson's design for Virginia, interpreted in white stucco on an eminence in Richmond, resurrected an ancient Roman temple [Fig. 21-1]. Bulfinch's grandly domed State House for Massachusetts, overlooking Boston Common, took a contemporary English governmental building, Somerset House in London, for its model. But neither of these early capitols set a trend. What became the accepted formula was a building with balancing chambers on either side of a domed rotunda, and a portico up front. The obvious inspiration for this was the U.S. Capitol which was started in 1792, was burnt down by the British in 1814, and was revived along the same lines almost immediately.

Whatever their look, these early capitols were fairly modest struc-

Figure 21-1. Thomas Jefferson, *Virginia State Capitol*, Richmond. 1785. Photo courtesy of Virginia Division of Tourism.

tures. The walls and columns on the outside were usually of brick or wood, covered with a coat of stucco which was scored to imitate masonry blocks. The scale of the interior spaces was almost intimate; the furnishings, plain. The senate and house chambers were small rooms crowded with wooden desks. Flags and portraits of statesmen hung on the walls. A gallery for the public ran along one side just across from the speaker's dais. The airy, bright rotunda, or saloon, might hold a statue of George Washington, not much bigger than an ordinary human, elevated on a pedestal and accented by the dome above.

In the decade or two before the Civil War, we see a rise in the level of rich effects. On occasion, real stone is used outside—Kentucky marble or the granite of Maine and New Hampshire—and marbling and graining inside. Even so, the workings of government are still accessible, direct, in these relaxed surroundings. Filled by these well-worn offices in a historic building like the old Illinois state house [Fig. 21-2] today, with their spittoons and cast-iron stoves, we can hear the echo of eloquent orations and sense a raw ingenuousness in the rituals of caucusing and favor-trading.

Yet after the Civil War, and especially from about 1885 onward, architecture and bureaucracy combine to distance us from this homey feel of the democratic process. Government is encumbered with the mech-

Figure 21-2. John C. Cochrane and Alfred H. Piquenard, *Illinois State Capitol*, Springfield. 1868–88. Photo courtesy of Illinois Office of Tourism.

anisms of taxation, the pension system, land grants, and transportation. The capitol bulges outward and up; offices and corridors and stairs multiply infectiously. Along with its spreading size, pomp increases. A bright Classical mantle of stone drapes the imposing bulk, over which towers some version of the great dome by Thomas U. Walter that completed the U.S. Capitol in the closing years of the Civil War. Foreign materials—marbles from Italy, tiles from Liverpool—contribute to a dazzling surface opulence, and a whole new repertoire of monumental imagery is carved and painted in every prominent corner.

Until this time, public art was uncommon in America and limited in scale and subject. National imagery centered on George Washington and a handful of symbols like the eagle and the flag. Two of the earliest civic monuments to be designed, both of them by Robert Mills, were in honor of Washington. One was begun in 1815 in a landscaped setting in Baltimore—a shaft of white marble with a statue at the top. The other, of course, was the Washington Monument in the nation's capital. Mills described it as a "grand circular colonnaded building . . . from which springs an obelisk shaft." In the original design of 1833 a tomb for the president was to be at the base of the obelisk, surrounded by statues of the heroes of the Revolutionary War. But when the monument was finally completed twenty years after the Civil War, nothing remained of the original design save the Egyptian obelisk—a stark, stripped accent on the great axis of the Mall.

Monument means "to bring to mind." And the nation in the later nineteenth century was in a mood to remember. The Civil War had created a new mythology of heroism, a mythology of noble leaders and foot soldiers. There was pride in the resurgence of a united nation; and for the unvictorious side there was the gallant sacrifice of the Lost Cause. Meanwhile, the Philadelphia Centennial celebration of 1876 had broadcast our maturity and forced us to ask who we were and where we had been. So we started to look backward to our beginnings; and, at the same time, we started to commemorate the feats and actors of the Civil War, the bitter national conflict that reaffirmed the strength of our institutions and launched our ambition to cut a dashing figure in the world.

All this we could now do in the grand manner. Since the 1860s American artists had been studying painting and sculpture in European academies—in Dusseldorf and Munich, in the Hague and in the premier art school of all, the Ecole des Beaux-Arts in Paris. They came back armed with sophisticated techniques and a style that stressed historical pageantry and the rhetoric of allegory. These they applied to native themes. So in the capitols, along the walls and in the vaults, in fresco, mosaic, or low relief, you found epic friezes of local history: pioneer life in Illinois or *Minnesota, Granary of the World*; Classical figures representing ab-

stract principles of law or government—Justice, Peace, Equality; and appropriately draped personifications of continents and nations that connected us to universal history.

At the same time, our public places were peopled with monumental sculpture. In Springfield, Massachusetts, a full-bodied statue called *The Puritan*, by the best of our sculptors, Augustus Saint-Gaudens, was raised in 1881, and near Boston, Concord got Daniel Chester French's *Minute Man*, a fitting memorial to that town's past. Civil War monuments sprang up everywhere—equestrian statues of Lee and Sherman, reliefs of battles and marching regiments. All were mounted onto finely proportioned architectural frames, fixed with studied care in urban open spaces—at the entrance to parks, in public squares, as terminal markers of avenues and landscaped vistas. A triumphal arch in honor of our soldiers and sailors went up in Brooklyn's Grand Army Plaza. In Richmond, Virginia, the equestrian statue of Robert E. Lee rose on a tremendous pedestal in the middle of a square, at the head of Monument Avenue—a grand boulevard lined with statues of other Confederate heroes.

Most dramatic of all was the Statue of Liberty, a gift from France, dedicated on a foggy October afternoon in 1886 [Fig. 21-3]. It was the work of the Alsatian sculptor, Auguste Bartholdi, and stood poised on a

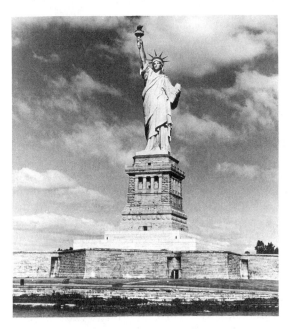

Figure 21-3. Frédéric-Auguste Bartholdi, *Statue of Liberty*. 1886. Copper plated, 151. Photo courtesy of New York Convention and Visitors Bureau.

massive base in the Doric mode designed by Paris-trained Richard Morris Hunt. The site could hardly have been more masterful. *Liberty Enlightening the World*, to use her formal name, towered over Bedloe's Island at the entrance to New York Harbor, greeting ships that steamed into The Narrows at the end of their long transatlantic voyage. At the time, nothing matched the grandeur of this colossal statue except perhaps the obelisk of the Washington Monument.

This new worldliness, which aimed to put us on a par with Europe, came at a price. The rich harvest of allusions in our public art left most viewers far behind. Unable to absorb the erudite references that kindled the artist's work, they settled for an overall look or some plain, straightforward message to attach to it. The Statue of Liberty they knew simply as the crowned lady who ushered oppressed people from abroad into the New World. Her learned pedigree—stretching back to the ancient goddess of Liberty, to her Christian reincarnations as Faith and Truth, and later to the heroine of the Romantic era who banished ignorance and beamed enlightenment—all this would be beyond most visitors to Bedloe's Island.

A similar distancing was taking place between our daily rituals and their aggrandizement through architecture. Reading, shopping, traveling were now being ensconced in luxurious settings, far grander than the functions themselves called for.

A visit to a public library, for example, had been a simple business until the Eighties. The building was small, without show even when dignified, and books were stored in alcoves, arranged around a central reading room. The idea of a free public library itself ranks as a great American institution. It originated in the 1830s (Peterboro, New Hampshire, is said to be the first), and it was meant to make knowledge broadly accessible and to encourage reading. But by the end of the century, the central libraries of many large cities were so monumental, so ornate, that they tended to intimidate the average user and discourage casual visits.

The Boston Public Library on Copley Square was the earliest of this resplendent breed. You climbed marble stairs and entered through fine iron gates—these enclosed within three spacious Roman arches and flanked by statues of seated women in classical garb, personifying Science and Art. Inside rose a grand staircase more appropriate, perhaps, to the great opera houses of Europe than to a library. At the top, the main reading room was a great vaulted hall that occupied the entire front of the building. Around an arcaded courtyard were rooms faced in rich marbles and decorated with sculpture and murals, where rare books and drawings were on display. This was indeed "a palace for the people," as the trustees had specified it would be. But it is also arguable that this cultural facility became so magnificent that it alienated the very people it sought to serve.

And besides, in the opinion of some librarians, it did not function well as a library at all.

The enjoyment of art, once a domestic pleasure of wealthy Americans and their friends, was also elevated to a public spectacle. Great private collections were opened to the people by bequest or grant, and most were housed in monumental buildings. Cities raised their own civic monuments to art, in the manner of the European palace-museums like the Louvre. Boston had its Museum of Fine Arts, Chicago its Art Institute. New York's Metropolitan Museum of Art gave its Fifth Avenue side a resplendent frontispiece of Roman imperial grandeur. Symphony halls and opera houses, and even small theaters like the Century in New York, smothered their frames with ornament.

The New Public Domain

The new tendency to design and build for show as much as for utility was not confined to institutions of government and culture. Metropolitan railroad stations now sat ponderously in the modestly scaled old townscapes. They were built of fine materials on a colossal scale and, in contrast to the older stations which tended to be picturesque, polychrome sheds with tall towers rendered in romantic styles, had uniformly white exteriors using a narrow range of Classical forms. Inside, the concourses were vast and vaulted like Roman bathing halls. The facades were opened up with deep Roman arches, or else screened by long, impressive colonnades. At the same time, the three- or four-story office buildings of earlier decades were growing into spectacular towers which, while still retaining the archaic floor plan partitioned into rows of small cubicles, were clothed in embroidered skins and topped with fanciful ornate crowns. And, finally, shopping areas in the old downtowns and along Main Street were being preempted by yet another palace for the people—this one a palace of consumption known as a department store.

Macy's, Marshall Field's, Wanamaker's, Jordan Marsh, Lord & Taylor—between 1880 and 1910 these stores became the true centers of our cities. Here was a creation that was genuinely popular, more so certainly than museums or public libraries, and openly expressive of the excitement and vigor of urban life. The scale, the variety, the luxury were mesmerizing. In one, block-size architectural envelope there might be as much as forty acres, or one million square feet, of floor space. The block would commonly have a rotunda with a leaded glass skylight on the ground floor and, above this, galleries opening onto a central courtyard. On display you could find everything being produced in the factories of America, from ready-made clothing to furniture and appliances, attrac-

tively designed and packaged. Much of it was novel, unfamiliar, astonishing. You were introduced to new cosmetics and medicines, to typewriters and fountain pens, to kitchen gadgets of all sorts, and you were made to feel that you could not do without them. And while you were entrapped in this wondrous showcase of the nation's horn of plenty, you could also make use of lavish lounges and rest rooms, restaurants, beauty salons and nurseries.

Department stores were large retail shops in the center of town and were revolutionary in a number of ways. First, they were accessible to everyone; they had none of the exclusivity of fine stores or the low-grade populism of markets, even though some department stores were considered smarter than others. They had a fixed-price policy, which dispensed with the customary rituals of bargaining. They advertised extensively in newspapers, and they offered services like charge accounts and free delivery. They combined the traditional features of public-minded architecture, the grand staircase for example, with modern materials and conveniences. It was for a department store, A. T. Stewart's in New York, that the largest iron building of its day was erected in 1862. Cast-iron made for a light structure, with slender supports that opened up the floors. In conjunction with the new large sheets of plate glass, it turned conventional windows into show windows and conventional floors into airy, spacious display areas. And it was in a department store, the Haughwout Department Store on Broadway, that the elevator found its first regular use.

Most of these consumers' palaces began modestly and expanded incrementally. The first Macy's was a fancy dry goods store on New York's Sixth Avenue, near Fourteenth Street. It opened in 1858 and sold ribbons, embroideries, feathers, hosiery, and gloves. R. H. Macy was a young unsuccessful merchant when he arrived in New York that year after a string of retail ventures that did not make it—two in Boston, one in California catering to the gold rush forty-niners, and the last in Haverhill, Massachusetts, which ended in bankruptcy. This time was different. The store on Sixth Avenue prospered. Macy bought another store at the back in 1866, and so he continued, annexing neighboring property until, at the time of his death in 1877, his business occupied the ground area of eleven stores with separate departments for drugs and toilet goods, glassware, silver and china, home furnishings, luggage, toys and musical instruments. In the 1880s a new facade unified the look of this collection of buildings, and in 1902 Macy's Herald Square opened on Broadway at Thirty-fourth Street—a nine-story building with thirty-three hydraulic elevators and four escalators that could move 40,000 customers every hour; there was even a pneumatic tube system that could shoot sales checks and cash from one part of the store to another.

The change brought about through this imperial monumentality of American cities was two-pronged. First, railroad stations, department stores, and office towers set up a colossal public domain that overwhelmed the once dominant scale of churches and government buildings. Over time, government and religion had ceased to be focuses of real power anyway. The church no longer anchored whole communities in the way a meetinghouse, say, ruled the New England town. Government turned progressively more impersonal as an institution and seemed perennially subject to corruption; by the end of the century, it spread out licentiously and impressed many as an imposition rather than a moral force.

Traditionally steeples and domes punctuated the skyline of American cities. The domes which rose over government buildings were a feature of the nineteenth century. But they were preempted in the 1890s by libraries and campus buildings. What happened is that the same monumental dress covered a whole range of buildings, banks as well as state capitols, clubs and apartment houses as well as town halls; the same puffed up scale might prevail in the business district and upper-class residential avenues beyond. It was hard in this grand unity of the monumental townscape to assign symbolic priorities among individual institutions.

22

The Malignant Object: Thoughts on Public Sculpture

Douglas Stalker and Clark Glymour

Millions of dollars are spent in this country on public sculpture—on sculpture that is created for the explicit purpose of public viewing, placed in public settings, and constructed generally by contemporary artists without any intention of commemorating or representing people or events associated with the site. The objects in question may be clothespins, boulders, or tortuous steel shapes. The money may sometimes come from private sources, but much of it comes from public treasuries.

One of the clearest and most general attempts to provide a justification for financing and placing these objects in public spaces is given by Janet Kardon, who is the Director of Philadelphia's Institute of Contemporary Art. "Public art," Ms. Kardon writes, "is not a style or a movement, but a compound social service based on the premise that public well-being is enhanced by the presence of large scale art works in public spaces." Large scale art works executed, to be sure, not to public taste but to the taste of the avant-garde art community. Elsewhere, she writes: "Public art is not a style, art movement or public service, but a compound event, based on the premise that our lives are enhanced by good art and that good art means work by advanced artists thrust into the public domain."[1] The justification here is moral rather than aesthetic, phrased in terms of well-being rather than those of beauty. Public art is good for us. Her thesis is put simply and with clarity; it is perhaps the same thesis as that put forward by many writers who claim that public art "enhances

This essay originally appeared in *The Public Interest*, No. 66 (Winter 1982), copyright © 1982 by National Affairs, Inc. Reprinted by permission of the authors and the publisher.

the quality of life" or "humanizes the urban environment," even "speaks to the spirit."

Our view is that much public sculpture, and public art generally as it is created nowadays in the United States, provides at best trivial benefits to the public, but does provide substantial and identifiable harm. This is so for a variety of reasons having to do with the character of contemporary artistic enterprises and with prevalent features of our society as well. We will discuss these issues in due course, but for now we want to make our view as clear as we can.

There is abundant evidence, albeit circumstantial, pointing directly to the conclusion that many pieces of contemporary public sculpture, perhaps the majority, are not much enjoyed by the public at large—even though the public firmly believes in a general way that art is a very good thing. In short, the outright aesthetic benefits are few and thin. Perhaps the public is wrong in its distaste or indifference, perhaps members of the public *ought* to take (in some moral sense, if you like) more pleasure in these objects thrust upon them, but these questions are wholly beside the point. Government, at whatever level, only has a legitimate interest in publicly displaying contemporary art in so far as that display provides *aesthetic* benefits to the citizenry. Many artists, critics and art administrators think otherwise, and claim for contemporary public sculpture, and for contemporary art more generally, various intellectual, pedagogical, or economic virtues which are appropriate for the state to foster. By and large the objects in question have no such virtues, so even if governments did wish to foster them, they could not properly or efficiently do so by placing contemporary sculpture in public environs. Further, there are identifiable harms caused by public contemporary art. . . . Thus, our argument runs, public contemporary sculpture does little or nothing to enhance the quality of life generally, and governments have no intrinsic interest in promoting it. Whatever legitimacy there is to government support of such displays derives from the tradition of serving the special interests of a very limited group of citizens—those served, for example, by museums of contemporary art. But this justification is overwhelmed by the fact that publicly displayed contemporary sculpture causes significant offense and harm, and does so in a way that intrudes repeatedly into people's normal living routines.

Doubtless some people will misread our argument and take it to be an attack on contemporary art *per se*. Our reasoning in no way depends on whether contemporary art is in general good or bad, or on whether particular pieces are or are not good art. It depends only on the facts (or what we claim to be facts) that much of the public derives minimal aesthetic pleasure from such contemporary art as is publicly displayed, that a significant segment of the public is offended and harmed by such dis-

plays, and that governments have, in these circumstances, no legitimate interest in furthering *public* art. Accordingly, this view is in no way a denigration of contemporary art; it is, however, a denigration of certain accounts of the value of that art, specifically those which find in the works of various artists, or schools of artists, vital lessons which the public desperately needs to learn.

Public Opinion of Public Sculpture

Contemporary public art is public *contemporary* art, and there is considerable evidence that the communities into which it is "thrust" do not revere it, like it, or (sometimes) even tolerate it. Examples abound, and we offer only a few that are representative.

In October 1980 a piece of public statuary was unveiled in Wilmington, Delaware. The piece was executed by Richard Stankiewicz, known for his "junk" art of the 1950's. The unveiling was received with cat-calls and denunciations from much of the public audience. In Pittsburgh, there has been popular, organized resistance to a proposal to build a piece of modern cement sculpture on a vacant lot on the North Side of the city. The people of the North Side, a middle-class working community, want a fountain, not a piece of modern sculpture. (It may or may not be relevant that the sculptor is not a resident of the community, but lives in the Squirrel Hill district of Pittsburgh, a predominantly affluent and academic neighborhood.)

Alexander Calder and Claes Oldenburg have each left a work in the city of Chicago. One rarely hears anything good said of them by Chicagoans who dwell outside of the Art Institute of Chicago. Away from the shadows and in the sunshine of the Letter-to-the-Editor columns, there is dismay at Calder's "Flamingo" and Oldenburg's "Bat-column." But the public dislike for these works hardly compares with the crescendo of distaste for a recent exercise in "Rag Art" at Chicago's Federal Building. A typical response to the exhibition bears quoting:

> Q. Please tell me how to complain about those unsightly canvas rags that have been wrapped around the pillars of the John C. Luzinski Federal Building. Those rags are a disgrace. While you're at it, what's all that scrap metal doing strewn around? Many blind people go in and out of the building, and it's a wonder no one trips over this garbage.
>
> F. G., Franklin Park[2]

The *Chicago Sun-Times* kindly informed the resident of Franklin Park that "the rags and scrap metal are objets d'art," which would have to be

tolerated through December of 1978. And so into the winter of that year pedestrians in the Second City had to suffer the assaults of both the elements and the artistes. . . .

The public distaste for today's public sculpture often goes well beyond mere words. The common responses include petitions, assemblies, litigation, and, occasionally, direct action. Enraged by what is thrust at them, the public often takes up a kind of vigilantism against contemporary public sculpture, and in community after community spontaneous bands of Aesthetic Avengers form, armed with hammers, chisels, and spray-paint cans. Jody Pinto's "Heart Chambers for Gertrude and Angelo," erected on the University of Pennsylvania campus for Ms. Kardon's own Institute of Contemporary Art, was turned into rubble overnight. Barnett Newman's "Broken Obelisk" was rapidly defaced when it was put on display in 1967. Removed to Houston, Texas, it is now placed in a pool away from errant paint. Claes Oldenburg's "Lipstick" was so thoroughly defaced at Yale that the sculptor retrieved it. Of course, for any object there is some thug or madman willing or eager to destroy what he can of it, but the defacement of some pieces of public sculpture seems to enjoy a measure of community support or at least tolerance.

The examples could be continued into tedium. On the whole, the public does not like today's public art. Of course, some people do actually take pleasure in "Bat-column" or in the twisted, painted tubes and rusted shards that can be found in almost every large American city. But the vast majority, convinced that art is a good thing, still takes no pleasure in the actual pieces of public art themselves. An expensive piece of contemporary sculpture has a life cycle of a predictable kind, a cycle frequently noted by others. Received with joy by a small coterie of aesthetes and with indignation by a sizable element of the community, the sculpture soon becomes an indifferent object, noticed chiefly by visitors. If it is very elaborate or very expensive, the local citizenry may try to take whatever minimal aesthetic pleasure they can from the thing; typically, after all, they paid a bundle for it. In time the aesthetes move on, no longer interested in a piece that is derrière-garde. But the public must remain.

Impressionistic evidence is rightfully mistrusted, and those who advocate public sculpture might well demand more precise evidence as to the extent and intensity of public dislike or indifference for contemporary public sculpture. But the plain fact is that there is little nonimpressionistic evidence to be had, one way or the other. Remarkably, although considerable sums are spent on public sculpture in this country by government and by corporations, virtually nothing is spent to find out whether or not the public likes particular objects or dislikes them, how intense such feelings are, or, most importantly, what proportion of the affected public would prefer that the space be put to some other use. . . .

Monuments to the Mundane

What basis can there be, then, for the claim that contemporary public sculpture enhances public well-being? The most obvious value of an aesthetic object—the aesthetic pleasure in seeing it and touching it and living with it—is apparently not present in today's public sculpture. By and large, the members of the public feel no pleasure, or very little, in seeing and touching and having such things. What else can be said in Ms. Kardon's defense? Perhaps that people become accustomed to public sculpture. After a piece has been in place for a while, the outrage, the shouts, the complaints cease. Children play on the thing if it can be played on. Old people may sit by it. This is a sorry defense, in which people's adaptability, and their impotence to control their environs, is used against them. People will, in fact, make what they can of *almost anything*, no matter how atrocious or harmful, if they have no choice. They will adapt to burned out tenements, to garbage in the streets, to death on the sidewalks. However horrible, tasteless, pointless, or insipid an object may be, if children can make a plaything of it they will. Bless them, not the artists.

Today's public sculpture, like the rest of contemporary art, is often defended for its intellectual value, for what the piece says or expresses, rather than for what it looks like. If this is to be any serious defense at all, it must be shown that typical pieces—or at least *some* pieces—of contemporary public sculpture are saying something serious and interesting, and doing so in a way that makes what is being expressed especially accessible to the public. None of these requirements is met—and moreover these requirements are *obviously* not met—by today's public sculpture.

Attempts to articulate the thought expressed by various pieces are, virtually without exception, trivial or fatuous or circular. Consider some remarks in *Newsweek* in defense and interpretation of a notable piece of public art: "Claes Oldenburg's work—his 'Batcolumn' in Chicago, for example—is formally strong as well as ironic. Oldenburg's silly subjects state a truth often overlooked: inside those self-important glass boxes, people are really thinking hard about such things as baseball bats or clothespins." We have no evidence that this is not the very thought that occurs to people when they see Oldenburg's column—but we doubt it. But even if it were, it is a patently trivial thought, and if the object is justified by the expression rather than the sensation, would not a small sign have been in better taste? The author continues, "Among other things, a work like Athena Tacha's 'Streams' in Oberlin, Ohio, reminds people, through its uneven steps, of what it means to walk."[3] Tacha's work is at least pleasing to our eyes, but we have not yet been reminded of what it "means" to walk. But if uneven steps will do the trick, the

meaning can be found in any city park, forest path, or homebuilt staircase. Why do we need monuments to get mundane? Why should the public pay for what it can get for free?

It is impossible, and in any case too painful, to examine the range of pretentious, vapid claims made by professional art critics for the intellectual content of contemporary sculpture. Much of it reads like the prose of ambitious students of a Schaumm's Outline on "Wittgenstein Made Simple" or "Beginning Phenomenology" or "Quantum Mechanics Made Simple." It is not serious. An example or two will have to suffice.

The late critic and sculptor Robert Smithson has written about the Park Place Group of sculptors, which includes Mark di Suvero, who has done a number of public sculptures (including "Moto Viget" in Grand Rapids, Michigan, and "Under Sky/One Family," Baltimore) in the leaning girder style. Smithson claims that the members of the Group "research a cosmos modeled after Einstein. . . . Through direct observation, rather than explanation, many of these artists have developed ways to treat the theory of sets, vectorial geometry, topology and crystal structure." Smithson also claims that these and other modern sculptors celebrate "entropy" or "energy-drain."[4] Taken literally, this is somewhere between unlikely and silly. What is a "cosmos modeled after Einstein"? A cosmos modeled after some solution to the field equations of general relativity? Which solution, of the infinity of them, and why that one? Do these sculptors really know *anything* about relativity? Perhaps. Perhaps di Suvero and company really do have some deep understanding of quantum theory, general relativity, and transfinite cardinals, but even that unlikely contingency will not justify the imposition of their art upon the public. There is no interesting lesson about these subjects which the citizen can be expected to draw from simple geometrical shapes cast together in a public place. That is simply the fact of the matter, and it guts any attempt to found the benefits of public art upon the thin and far fetched theories of certain art critics. For what is undeniable about nearly every critical account of the message of one or another school of contemporary art is that the message—whether it is about physics or philosophy—is *esoteric*, and cannot be garnered from any amount of gazing at, climbing on, or even vandalizing of the object.

More Failed Justifications

Inevitably, today's public sculpture is justified in a kind of circular way: The very fact that the public dislikes it, or even violently abhors it, is taken to warrant its presentation. Thus Jody Pinto, rather typically, remarked after her sculpture at the University of Pennsylvania was de-

stroyed that "Tons of letters were written to the *Daily Pennsylvanian*, both pro and con, which is wonderful. If art can stimulate that kind of discussion and really make people think, then it's accomplished probably more than most artists could even hope for."[5] Thus the justification for public art is that it causes people to think about why they do not like it, or about the propriety of having destroyed it. That is indeed a virtue, one supposes, but a virtue shared quite as much by every calamity.

There is also the common suggestion that, like travel, contemporary art in public places is broadening. It introduces the public to the fact that there are other and different tastes and sensitivities, alternative and unconventional standards of beauty. It makes people *tolerant*. In fact, there is no case at all that public sculpture makes people tolerant of anything that matters. Today's public sculpture may well make people tolerant of public sculpture, for the simple reason that if the object is too large, too strong, or too well fortified, they have no choice. Does it make people tolerant of, or sensitive to, the aesthetic expectations of other cultures or times? One doubts that it does, and surely not as well as an exhibition of Chinese calligraphy, or American ghetto art, or Tibetan dance, or the treasures of King Tut.

It is sometimes urged, rather opaquely, that there are significant economic benefits to be derived from public art. The case is seldom developed in any detailed fashion, and there is good reason to doubt that public support of permanent or quasi-permanent public art structures can lean very much on such considerations. These are some of the reasons.

First, the presence of public sculpture in booming areas is not evidence that the art itself makes significant contributions to the economies of Winston-Salem, or Charlotte, or Seattle. The effect is most likely in the other direction. (The same holds, of course, for the performing arts. As Dick Netzer remarks, "It is hard to believe that the presence of the Charlotte Symphony has much, if anything, to do with that area's booming economy."[6])

Second, while art may provide economic benefits for a few centers where the variety, or quality, or number of objects and events is markedly better than in surrounding areas, it cannot have much economic effect when more widely and, from the point of view of public patronage, more justly distributed. People may very well go to St. Louis to view its arch, but how many now go to Oberlin, Ohio, to see Tacha's "Streams" or to Chicago to see "Batcolumn"?

Third, those who point to the alleged economic benefits of public art almost always neglect to consider opportunity costs: Would the money spent on public art have produced greater economic benefits if it had been invested in capital equipment or in subsidies for business or for public transit or in amusement parks? And, finally, even in those circumstances

where the availability of cultural amenities provides or would provide significant economic benefits, there is no evidence that public sculpture of the sort bedecking our cities and towns contributes very significantly to that benefit. The forms of artistic culture which attract people and their money may very well be, as it seems to us, chiefly those of museums, music, and theatre.

Ms. Kardon's claims for the benefits of public art are unjustified and unjustifiable, and they can only result from a failure to be candid about the social conditions of contemporary art. Contemporary art has a small audience composed of some of the very rich who can afford to buy it and some of the not-so-very rich who go to galleries and museums to see it. The audience for this art takes pleasure in it for any of several not very complex reasons: because of the aesthetic appeal of a particular object, because of an interest in a segment of cultural history, because of the notoriety of its creator, because they find it an amusing joke (on other people), or perhaps, simply because they have been led to believe that they *ought* to enjoy it.

The aesthetic pleasures of contemporary art are not shared generally or widely, and the citizenry who must pay for and daily observe a public sculpture can take no pleasure in a joke played on others. . . . Some people, attending to the histories of past art that has proved to be great art, might be more tolerant about the untoward reactions. . . . Monet and Renoir caused quite a stir in their time, and the public did not take much pleasure in their works. Yet many of these same paintings have proved in time to be good, even great, art. Indeed, believing that this is a recurring and prevalent course of events with novel art in any form and time, it might seem prudent to take a different view of adverse reactions to our revolutionary and experimental works of public sculpture. This would be a mistake, for the appeal to art history wholly misses the point at issue: It is not for government to promote new conceptions or realizations of art. In short, the ultimate aesthetic quality of the works is not in question; their public display is.

Notes

1. See the introduction to the booklet *Urban Encounters: A Map of Public Art in Philadelphia, 1959–1979* (Philadelphia: Falcon Press, 1980); also the introduction to the brochure for the exhibition "Urban Encounters: Art Architecture Audience," Institute of Contemporary Art, University of Pennsylvania, March 19–April 30, 1980.

2. "Action Time" column, *The Chicago Sun-Times*, November 6, 1978. For a complaint about "Flamingo" and "Batcolumn," see the "Action/reaction" column, *The Chicago Sun-Times*, November 10, 1978.

3. "Sculpture Out in the Open," *Newsweek*, August 8, 1980, p. 71.

4. Nancy Holt, ed., *The Writings of Robert Smithson* (New York: New York University Press, 1979) pp. 9, 17, 18.

5. " 'I Don't Think of Myself As a Stevedore,' " an interview by Maralyn Polak in *Today Magazine*, February 1, 1981, p. 8.

6. Dick Netzer, *The Subsidized Muse* (Cambridge: Cambridge University Press, 1978) p. 161.

23

The Commissioning of a Work of Public Sculpture

Judith H. Balfe and Margaret J. Wyszomirski

The controversy over Richard Serra's *Tilted Arc* involves a number of issues concerning public art. While this case has prompted what is perhaps the most acrimonious and well-publicized debate over public art, controversies concerning other public artworks have arisen elsewhere with increasing frequency during the last decade. Since each artwork is unique, commentators have tended to regard each public art incident as essentially idiosyncratic, prompted by the impact of a particular artwork, governed by the tastes and degree of sophistication of a specific audience, and provoked by flawed administrative, educative or political considerations. Nevertheless, amid this apparent particularity, some common issues and interests can be discerned.

Before these can be identified and discussed, however, the entire subject of public art needs to be framed by the realization that the commissioning and fate of public art is a different and distinctly complex subject from that of the private commissioning and ownership of art. The interests directly involved in a private transaction are few, unitary and easily identified—namely, those of the artist and those of the private patron. In contrast, the interests involved in public art commissions are not only more numerous, but often arise from collectivities that are themselves variegated and diffuse.

The three major parties in public art commissions are:

1. **artists**, who desire artistic freedom, recognition, and security for their work;

2. **commissioning public agencies**, which are responsible for the promotion of the long-term aesthetic welfare of society, but which also must be concerned with meeting political and procedural expectations regarding their actions and with maintaining their bureaucratic resources and support bases; and

3. **the public**, which must assent to the funding and give community acceptance to the particular works installed in its midst.

Respectively, the major issue of concern for each party varies. For the artist, the primary issue is aesthetic. For the public agency, it is legal and political. For the public, a mixture of sociological and aesthetic issues are foremost. In the best of circumstances, the interests of these three parties converge to their mutual benefit. On other occasions, the interests may diverge, resulting in controversy. In such cases, the various rights and obligations of each party must be balanced and accommodated through predictable and rational procedures which all recognize to be fair and legitimate. The resolution of such controversies is particularly difficult because the basis for establishing a priority among interests or for setting the parameters for compromise is, as yet, still being evolved through case experience.

The Case of *Tilted Arc*

The Jacob Javits Federal Building Plaza, whose construction provided for the eventual commission of *Tilted Arc* [Fig. 23-1], was erected in 1968 in New York's Foley Square in the vicinity of other federal and state courthouses and office buildings. The second largest federal office building after the Pentagon, it houses a work force of over 10,000 and includes the regional offices of the General Services Administration (GSA). During the building's initial construction, the Art-in-Architecture Program was not functioning, as the program had been suspended between 1966 and 1972 following a controversy concerning one of its earlier commissions.[1] But in the mid-1970s, when an addition to the building was planned, the now-restored GSA Art-in-Architecture Program decided to commission a work of art for installation in the small plaza in front of the building's entrance. In 1979, the GSA administrator approved the recommendation of an NEA-appointed advisory panel (comprising three art-world professionals) that Richard Serra be awarded the commission to create a work for this site.

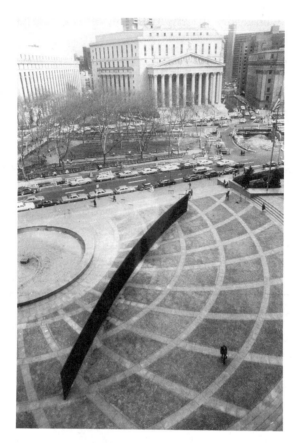

Figure 23-1. Richard Serra, *Tilted Arc*. 1981. Cor-Ten steel, 12 × 120′ × 2½″. Installed Federal Plaza, New York General Services Administration, Washington, D.C. Photo by Anne Chauvet.

Serra is an internationally acclaimed sculptor whose work follows a formalist, minimalist aesthetic, often using monumental slabs of corten steel (which acquires a rusty surface upon weathering). Such pieces commonly transect specific sites and establish new lines of spatial tension, visual excitement and an elegant—if brutally powerful—presence in and through the work itself.

Installed in 1981, *Tilted Arc* was greeted with hostility by many of the plaza office workers.[2] Indeed, their evident lack of understanding of *Tilted Arc* might have been predicted, since the Art-in-Architecture Program had not followed its own guidelines for the installation of public sculpture. These procedures mandate "introductory" programs for community groups to enhance their understanding of commissioned works,

and generally require that considerable local public relations work be done in advance of any installation. Here, as in previous instances of controversy of Art-in-Architecture commissions, GSA stood behind the artist and the work, and in time, overt hostility toward *Tilted Arc* seemed to subside.

Then, in the fall of 1984, the relatively new regional GSA administrator, William J. Diamond, circulated a petition demanding the removal of *Tilted Arc* and obtained nearly 4,000 signatures. In March 1985, Diamond convened a three-day hearing before a five-person panel (which included himself and two of his own GSA appointees) to consider the disposition of *Tilted Arc*. Over 180 people testified at the hearing, more than 120 of whom vehemently supported *Tilted Arc*'s retention.[3] Notably, few building workers testified or even attended the proceedings.

The controversy and hearings attracted considerable media attention, contributing to the hyperbolic polarization of the claims to "moral" correctness by each side. Those supporting the retention of *Tilted Arc* on the Javits Plaza site did not all claim to like the work, but all took stands on behalf of artistic freedom of expression and protection from censorship under First Amendment rights. They also emphasized the site-specificity of the work, which supported Serra's claim that its removal would be tantamount to its "destruction"; the responsibility of the GSA, rather than the artist, to assist the uninformed public in interpreting and understanding an admittedly "difficult" work; and the obligation to maintain the contractual agreement between the GSA and Serra. In sum, these were classic statements of the artist's interests.

Those (including Diamond) who insisted upon removal of *Tilted Arc* just as classically argued that official responsibility for the public's aesthetic and nonaesthetic welfare was being violated by the permanent presence of a disliked work. They claimed that the GSA's contractual ownership of all its commissioned sculptures gave the agency the right to remove them; that any guarantee of permanence was contingent upon circumstance, as the building itself and thus the site could not be expected to endure forever; that public art must not offend the public that pays for it; that to retain a work against the public's wishes would interfere with the public's "freedom of expression," which the agency was obliged to protect as much as that of any artist. In other words, these were classic statements of the interests of the commissioning agency and of its obligations to promote the public interest.

The hearing panel determined that *Tilted Arc* should indeed be relocated. Thereupon Serra announced his intention to sue the GSA for breach of contract and to petition for an injunction to prevent removal of the work pending settlement of his suit. Hundreds of letters flooded into GSA from members of the arts community, questioning the aesthetic and

political judgment and the legality, ethics, and procedures involved in the panel's decision. Despite the furor, Dwight Ink, the GSA's acting administrator, endorsed the panel's decision. But he also declared that the relocation of *Tilted Arc* would be determined by a new NEA-appointed panel that was to include not just art world figures (as before) but also community representatives from the present site location as well as from the site to which it might be relocated.

Although the decision to move *Tilted Arc* (should an acceptable alternative site be located) was announced on May 31, 1985, more than a year passed before a Site Review Advisory Panel was appointed. The seven standing members named to the committee were: Theodore W. Kheel, a lawyer and labor mediator who is knowledgeable in the visual arts; Jaquelin T. Robertson, New York architect; James Ingo Freed, New York architect; Robert Ryman, painter; Sam Hunter, Princeton University art historian and specialist in outdoor sculpture; Brenda Richardson of the Baltimore Museum of Art; and Joel Wachs, attorney and member of the Los Angeles City Council. In addition, two other panel members will be named at a later date as community representatives from proposed alternative sites.

This panel is presently awaiting proposals from GSA regional commissioner Diamond regarding suitable alternative sites. The panel will then consider these proposals and forward its recommendation concerning the relocation of *Tilted Arc* through the chairman of the National Endowment for the Arts to the head of the GSA in Washington, D.C. The GSA administrator will then make the final decision about whether to act upon this recommendation.[5] In other words, the site review process has been designed to parallel the original commissioning process while simultaneously extending the scope of community consultation. Thus, presumably, the interests of the various publics are to be addressed.

The controversy has placed the GSA Art-in-Architecture Program in a difficult position. Caught between its general public constituency and its specialized arts constituency, GSA has tried to mediate the controversy without losing legitimacy with either. Yet, until the recent decision to constitute the Site Review Advisory Panel, throughout the *Tilted Arc* dispute the public (as distinct from the arts community) has been cast in the role of "problem," rather than seen as a legitimate participant in the public art debate. In a classic example of interest-group politics, a government agency (GSA) has developed and sought to maintain a responsive, mutually advantageous relationship with a special-interest group (artists and the arts community) that has been readily mobilized to assert its interests and is most directly affected by agency action. A flaw of all such political alliances is the de facto exclusion of other (generally less well organized) involved groups both from the decision making

processes and from effective consideration of their particular interests. Specifically, in this case the general public interest has been presumed to be consistent with (and therefore protected by) the special interests of artists. Yet the case of *Tilted Arc* starkly demonstrates the flaw of such an assumption. Artistic interests are clearly not representative of the more diverse public interests. Furthermore, "the public interest" is likely to be composed of various, albeit overlapping, communities (whether neighborhood, local, state, national, occupational or ideological in character). Each of these communities has as legitimate a claim (perhaps a stronger claim) to represent the public as that which the artistic community has asserted for itself.

The Lessons of Public Art Commissions

The controversies surrounding *Tilted Arc* are not *sui generis*; therefore, they can be better understood through a comparison with other prior and current federal programs for commissioning art. None of these programs has been altogether without dispute, but all of the controversies have involved either or both of two kinds of issues: those concerning procedures and those concerning substance.

Historically, American governmental agencies have commissioned art to achieve commemorative or other functional purposes. Most public art commissions awarded before the mid-20th century made public artworks tools in the service of establishing a national identity or in fostering social cohesion. They were not commissioned "for art's sake" or for the aesthetic welfare of society, but rather artistic skill was sought as a means of broadening the appeal and the impact of public policies and institutions. Such commissions have been awarded infrequently and have involved only limited commitments of public funds.

An implicit public consensus has generally supported the purpose of these potential artworks. Thus, on those occasions when controversy has erupted over a particular artwork, it has tended to focus upon its form (that is, the style or quality of its execution)[6] rather than on either its conceptual content or the propriety of governmental sponsorship. In any case, both the relative infrequency of such commissions and the relatively small amount of public funds involved tended to mute those controversies that did arise. Thus, substantive issues were sometimes raised concerning the manner in which commissions were executed, but they were seldom raised about the object of the commission. In the few instances where procedural criticisms did arise, it pertained to the "quality" of the artwork received rather than to the breadth of consultation and consent involved in the award of the commission.

During the New Deal era, extensive art programs were initiated for the first time. But even here, the primary purpose was to provide work for unemployed artists and secondarily to channel artistic energies into fostering a more unified national identity and to helping to revive the Depression-troubled business community through the development of a consumer ethic.[7] Only incidentally did it matter that these programs also had the effect of preserving the creative resources that had flourished in the U.S. during the 1920s and which might otherwise have wilted and thereafter been lost during the economic crises of the 1930s.

The experience of the Works Progress Administration (WPA) arts projects and the Treasury Department's Fine Arts Section during the New Deal yielded three "lessons" for public arts policy. One was an appreciation of the importance of artistic quality as a significant factor in establishing the legitimacy of public patronage. Second, the federal government recognized both the importance of local input on artistic programs and the problems such involvement could produce. Finally, and particularly relevant to the case of *Tilted Arc*, it became evident that for artworks that did not enjoy a broad public consensus regarding their content or their aesthetic, the fact of direct governmental responsibility for these works could jeopardize the interests of all concerned (the public, the commissioning agency, and the artist) and give rise to insoluble battles of taste and interminable debates over procedures.

The issue of direct governmental responsibility was raised even more starkly in a somewhat later case in which the government not only sponsored but also retained the ownership of artworks, thereby becoming a trustee with responsibilities to both the artwork (and artist) and to the public. The controversy over the 1947 State Department exhibit on "Advancing American Art"[8] demonstrated that there could be a more hostile reaction to government ownership of artworks than to government sponsorship of the same or similar works. Sponsorship seemed to evoke expectations that works of all styles would be included, whereas ownership seemed to imply official recognition of a specific style of styles. In general, the cumulative impact of various experiences in government arts patronage in the 1930s and 1940s was so negative that it was not until the 1960s that two new programs were established to commission artworks for public spaces. These were the General Services Administration's Art-in-Architecture Program (1963) and the National Endowment for the Arts' Art in Public Places Program (1967). Although different in a number of ways, these two programs were similar in one important and historically innovative respect. The primary purpose of both programs was aesthetic, i.e., to enhance public places and to expand public awareness of contemporary art by the installation of artworks by contemporary American artists. Thus, contrary to prior federal arts commissioning programs,

the NEA and the GSA programs saw aesthetic concerns as the end instead of merely a means toward such other ends as employment, social cohesion or foreign relations. Additionally, both programs have implicitly rejected the assurance of a basic public consensus that underlay earlier public art commissions. By specifying both the aesthetic purpose and the use of contemporary artists, these public art programs virtually denied commemoration as their primary purpose since, by following the dominant aesthetic style of the time, it was virtually guaranteed that the commissioned works would be abstract rather than representational in style. Whereas representational art tries to universalize and facilitate the deeper understanding of common experiences and memories, current commissions of abstract art encourage personalized and particularized interpretation. Whereas previous public art was intended to be instructive and socially cohesive, modern public art has most often been experimental, individualistic and thus potentially divisive. In these ways, recent public art commissions have tended to be radically different in their artistic substance from preceding commissions. Concomitantly, the historic procedural lessons, perhaps thought to have been outlived, have evidently been ignored, in large measure.

Despite similarities in taste and in mission, the NEA and the GSA programs do vary procedurally. The NEA Art in Public Places Program was designed to enhance public places through the installation of artworks of living American artists and to assist "communities in their efforts to increase public awareness of contemporary art. . . ."[9] Rather than making direct commissions itself, the NEA accomplishes these goals by awarding matching funds for projects initiated by various communities. The community sponsor may be a public entity (such as a city government, a state arts agency, or a state university) or a private, nonprofit organization (such as a local art or civic foundation, an arts center, the Junior League, the chamber of commerce, a university or a hospital).

The NEA's program procedures have consistently emphasized local initiative, decision-making authority, and project responsibility. Extensive community planning efforts are required of applicants, including the establishment of *their own selection procedure for both the public site as well as the artist to be commissioned.* Applications must also include evidence of support from civic authorities and community groups, as well as a description of the public information and education campaign that is planned "to encourge an informed response to the project in the community."[10]

Once the grant project is completed—that is, the artwork is installed and the artist paid—the NEA's responsibility and formal involvement in the project is ended. Ownership, maintenance and disposition of the artwork rests with the sponsoring community organization. Although

initial public reaction to these artworks has often been one of skepticism, even antagonism, this attitude generally changes as community familiarity and acceptance of the work develops. In one such case, Alexander Calder's *La Grande Vitesse*, in Grand Rapids, Michigan, became the object of civic pride and was even adopted as the community logo, appearing on everything from the mayor's official stationary to the city's sanitation trucks. Hence, by working through community organizations, the extended commissioning and installation procedures required of the NEA's Art in Public Places Program have assured local involvement, enhanced prospects for community acceptance, and placed public responsibility for these artworks outside the federal government (and in most cases, outside government altogether).

In contrast, the Art-in-Architecture Program of the General Services Administration was established by administrative order in 1963. It was designed to "take advantage of the increasingly fruitful collaboration between architecture and the fine arts" by incorporating, where appropriate, fine art into the design of federal buildings. The emphasis was to be on the work of living American artists and commissions were to be underwritten by funds equal to no more than one-half of one percent of the construction budget allocated to new Federal building projects.[11]

Before long, the Art-in-Architecture Program encountered problems both in securing artworks of consistently high artistic quality and in managing public and political criticism. Thus, when public opposition to one of its commissions arose in 1966 and coincided with cost-cutting measures by the Johnson Administration, the program was suspended and remained dormant between August 1966 and February 1972.

Supposedly, having learned the pitfalls of "top-down" decision making about public art by government bureaucrats, the reactivated program revised its commissioning procedures after 1973 to involve a collaboration with the NEA. Under this new arrangement, the NEA convened peer review panels to recommend artists for specific GSA commissions. This provided the GSA program with a mechanism for attempting to assure artistic quality of the artists selected, thereby making the program's choices legitimate because they were now based upon artistically expert judgment. Furthermore, and going beyond the NEA in attempting to "democratize" its selections, the Art-in-Architecture Program viewed its projects cumulatively, as an effort to build a "national collection" of work by contemporary American artists that would be exhibited in a geographically dispersed manner. Thus, the GSA limited the award of major commissions to one per artist. This facilitated the diversification of its awards, thereby allowing it to recognize as many individual artists and art styles as possible, including those with regional significance although not national reputation.

Despite these attempts to build a legitimacy and rationale for the GSA's public art commissioning practices, the agency continued to encounter controversy and public criticism, as public tastes can vary from expert opinion. Indeed, after an incident concerning a George Sugarman piece that had been installed in Baltimore, the program's operations were temporarily halted once more, pending an internal review. This resulted in a 25-percent decrease of program funds (from one-half of one percent to three-eights of one percent of the construction budget) and a revision of its commissioning procedures to promote greater community involvement in the artist nominating panel.

During the remainder of the 1970s, the GSA and NEA repeatedly discussed the problem of community involvement with, and acceptance of, public art while tinkering with the commissioning and installation procedures. Despite this recurring attention, however, a 1980 report of a joint GSA-NEA task force still observed that:

> Obstacles to the continuing success of the program [Art-in-Architecture] have arisen as a result of initial adverse responses to works of art in the community. The roots of this response seem to lie in public perceptions that there is not a relationship between the community and the Art-in-Architecture Program's goals and procedures. . . .

It went on to point out that this was particularly problematic since art in public places "has much greater visual and psychological impact and touches a great many more people than does art in the traditional museum context."[12] Given this impact and a community's unfamiliarity with contemporary art, the task force said that the tenor of community response and the constructiveness of public debate regarding a public artwork could be significantly affected by public education and information programs preceding and accompanying a piece's installation. Unfortunately and unintentionally, this advice was not followed in the case of *Tilted Arc*, and the hard-learned lessons of past experience were again ignored.

In part, this failure may have stemmed from a mistaken and incomplete assessment of the probable community reception of *Tilted Arc*. It should have been obvious that Serra's work was likely to be controversial and difficult. Generally there has been a record of particular difficulties concerning local acceptance of corten steel works by any artist, especially if these were installed in congested urban settings and/or away from communities that were accustomed to dealing with abstraction (e.g., university campuses). Furthermore, Serra's work was not readily accessible even by those sophisticated about minimalist art. For example, on another project, Serra and the architect Robert Venturi had been unable to agree

upon an integrated concept for a piece that would have been part of the Pennsylvania Avenue Development Project in Washington, D.C. Additionally, Serra pieces have encountered objections even when locally sponsored under the procedures of the NEA program.[13] Clearly, the GSA should have known that this particular work was likely to require public education efforts to enhance community receptivity. This misassessment, in turn, indicates the ambiguity of the notion of "community," and the probable variation in response to any artwork, whether minimalist and of corten steel or not.

In this particular case, if "the community" meant the New York art cognoscenti, then community response to such a work could be assumed to be well-informed and positive. If "the community" referred to the residents adjacent to the Javits Plaza, then reaction was likely to be at least "accepting"; these diverse ethnic and socio-economic neighborhood groups were already familiar with abstract artworks in public places, since many had been installed in the vicinity as a result of corporate, private and governmental efforts. However, if "the community" comprised the federal workers employed in the buildings on the plaza, then its reaction might well be anticipated to be negative. Yet these would be the people who would come in contact with *Tilted Arc* most frequently, and involuntarily, as they came to and from work.

While the first of these communities (i.e., the arts cognoscenti) needed little if any introduction to *Tilted Arc*, both of the other two communities (neighborhood residents and federal workers) presumably could have benefited from informal and educational efforts. Indeed, the latter, who were easily reachable, might have been particularly responsive to such efforts. However, no outreach programs were conducted for either group. At the time of the installation, responsibilities for outreach efforts were in the process of being shifted from federal to regional authorities and apparently were not addressed at all in this case. As a result, the efforts made to inform people, especially building workers, of what to expect were quite inadequate.

For example, a small scale model displayed in a case in the GSA building lobby gave little real notion of the size and impact of the full piece. Nor did a pole-and-string stake-out of the piece on the plaza itself give an accurate impression of the mass and solidity of the artwork itself. Finally, upon installation, when opposition to the piece was voiced, no educational efforts were made. When opposition resurfaced in 1984, the GSA again made no effort from Washington to convene a hearing to air opinions and to engage in a productive discussion of the work (as it had nearly a decade earlier in the Baltimore case concerning Sugarman's work). Clearly, the processes used to commission and install *Tilted Arc* were distinctly flawed.

The legacy of mistakes and the controversy surrounding *Tilted Arc* will be two-fold: those specific to this artwork and those concerning public art in general. Resolving the tangle surrounding the possible relocation of *Tilted Arc* will be difficult and will confront many of the same ambiguities that characterized the original commission and installation. For example, will there be community representatives from all potential relocation sites on the review panel? And how are these "communities" to be conceived? Is the work inherently site-specific, and who is to decide that? Is the work a permanent installation, or can its integrity be maintained on another site?

From a different perspective, one might indeed ask: what is the nature of the problem here? Is it with the artwork itself, with public reaction to the piece, or with the inhospitality of the site? After 20 years of proliferating public art programs, many commentators assert that the public has become better educated, more sophisticated and therefore more accepting of abstract public art. If one can accept this premise at face value, then it is possible that public reaction to this piece is not the uninformed, philistine opinion it is caricatured to be, but rather an expression of informed public taste that views this piece as an instance of "the emperor's new clothes."

Alternatively, if the piece is so "difficult," then efforts to educate the public about how to "read" it are obviously necessary. While such informational activities are clearly the responsibility of GSA, one would think it would also be to the advantage of the artist to collaborate in such efforts. Finally, if the root of the problem is, as some have suggested, a dreary and inhospitable architectural setting that *Tilted Arc* has revealed as such with stark clarity, then perhaps one should make this controversy cause for efforts to improve the quality and character of public architecture.

In a more general sense, the *Tilted Arc* incident has raised important questions about the conservation, maintenance and deacquisition of public art. After 20 years of extensive efforts to create and acquire such networks, the time has now come to consider such issues. Toward this end, the National Endowment for the Arts began to convene a series of task force meetings in early 1987 to focus and further public discourse on such matters.[14]

Finally, it should be pointed out that controversy and debate need not be divisive. Instead, it can enhance understanding, accommodation and synthesis. Indeed, the successful history of the successive Vietnam Memorial commissions (one minimalist and one realistic) demonstrate that the process of accommodating different sides of a controversy can contribute to a broader consensus on aesthetic and political values as well as concerning particular artworks themselves. Debate and contro-

versy are natural characteristics of both art and politics. If such debate is to be productive, it seems clear that the interests and viewpoints of all parties—artists, commissioning agents, and publics—should be granted sympathetic and mutual attention; otherwise, the interests of none are likely to be truly served.

Notes

1. The controversy involved a mural by Robert Motherwell for the John F. Kennedy Memorial Building in Boston. The work—an abstract expressionist piece entitled *New England Elegy*—was interpreted to be representative of the moment of President Kennedy's assassination. The work, which some considered to be hideous and disrespectful, brought considerable criticism to bear on the relatively young GSA Art-in-Architecture Program at a time when the Johnson Administration was looking for ways to reduce government expenditures. This combination of factors contributed to the suspension of the Art-in-Architecture Program.

2. *The New York Times*, September 25, 1981, p. 24.

3. For newspaper coverage of the hearing, see *The New York Times*, March 7, 1985, p. B1 & B6; and *The Washington Post*, March 7, 1985, p. D1 & D16. Transcripts of the testimony were also made available to the authors by Donald Thalacker, director of the Art-in-Architecture Program.

4. On the decision, see *The New York Times*, June 1, 1985, p. 25 & 28.

5. On the notice of the panel's appointment, see *The New York Times*, July 28, 1986. Additional information on the panel membership and procedures was provided in a telephone interview with Richard Andrews, director of the Visual Arts Program of the National Endowment for the Arts in Washington, D.C., October 11, 1986.

6. For example, the "infamous" Horatio Greenough statue of George Washington that Congress commissioned in 1834. The work was strongly criticized because it portrayed Washington in the garb and style of an imperial Roman rather than as a leader of a democratic people. More recently, the initial reaction to the sparse, abstract style of the Vietnam War Memorial is another example of controversy over the form in which a public commission was executed.

7. On the variety of New Deal art programs, see Lawrence Mankin, "Government Patronage: An Historical Overview," in *Public Policy and the Arts*, Kevin V. Mulcahy and C. Richard Swaim, eds. (Boulder: Westview Press, 1982), pp. 111–140; and Helen Townsend, "The Social Origins of the Federal Arts Project," in *Art, Ideology and Politics*, Judith H. Balfe and Margaret Jane Wyszomirski, eds. (New York: Praeger, 1985), pp. 264–292.

8. On the controversial exhibit, see "Art and Politics in Cold War America" by Jane DeHart Mathews, *American Historical Review*, vol. 81 (October 1976), and also Montgomery Museum of Fine Arts, "Advancing American Art, Politics and Aesthetics in the State Department Exhibition, 1946–1948," with essays by Margaret Lynne Ausfeld and Virginia M. Mecklenburg (Montgomery, Alabama: 1984).

9. Andy Leon Harvey, ed., *Art in Public Places*, "Introduction" by John Beardsley (Washington, D.C.: Partners for Livable Places, 1981) p. 10.

10. Ibid, p. 13.

11. Donald W. Thalacker, *The Place of Art in the World of Architecture* (New York: Chelsea House Publishers, 1980), p. xii, on the early GSA Art-in-Architecture Program activities and problems; see also Jo Ann Lewis, "A Modern Medici for Public Art," *Art News* (April 1977), p. 39.

12. *Report of the Joint GSA-NEA Task Force on the Art-in-Architecture Program* (Washington, D.C.: document copy, January 22, 1980) p. 1.

13. See the *New York Times*, March 16, 1981 & August 21, 1985.

14. Telephone interview with Richard Andrews, director of the Visual Arts Program of the National Endowment for the Arts in Washington, D.C., October 11, 1986.

24

Vietnam Veterans Memorial Washington, D.C.
Designer: Maya Ying Lin
Architects of record:
The Cooper-Lecky Partnership

Nicholas Capasso

The national Vietnam Veterans Memorial may well have generated more controversy than any work of [public art] in recent memory [Fig. 24-1]. The issues surrounding the Memorial have ranged from aesthetics to patronage to politics, engaging veterans, veterans' organizations, architects, critics, the media, the legislative and executive branches of the federal government, and concerned private citizens in fiery emotional debates. The story of the memorial's development is a fascinating record of architectural design and imputed meanings, of pure form and political associations, of political meddling and compromise, and of accusation and recrimination on the part of involved interest groups. The unlikely result is a public monument that has become the most heavily visited site in Washington, D.C. since its unveiling in 1982 [Fig. 24-2]. By all measurable accounts, it has also become a triumphant . . . success.

On April 27, 1979, Jan Scruggs, a Vietnam combat veteran and veterans' advocate, formed the Vietnam Veterans Memorial Fund (VVMF), a non-profit, volunteer organization devoted solely to the creation of a

From *The Critical Edge: Controversy in Recent American Architecture* by Tod A. Marder, copyright © 1985 Massachusetts Institute of Technology Press. Reprinted by permission of the publisher.

national memorial to the veterans of the Vietnam War. The VVMF began its planning, after nearly a year of fund-raising, by asking Congress for permission to erect a memorial on a two-acre section of Constitution Gardens in the northwest corner of the Mall in Washington, D.C.[1] . . .

The United States Senate, led by Sen. Charles Mathias (R-Md), approved this site on May 22, 1980, with unanimous passage of Senate Joint Resolution 119. Then, after this auspicious beginning, came the first of many delays and political skirmishes: the House of Representatives blocked the Resolution by passing a bill, sponsored by Rep. Philip Burton (D-Cal), which would allow the Secretary of the Interior, then James Watt, to select the site.[2] The Senate and House finally reached an accord on June 24, 1980, when both houses unanimously passed Senate Joint Resolution 119 to allow construction on the Constitution Gardens

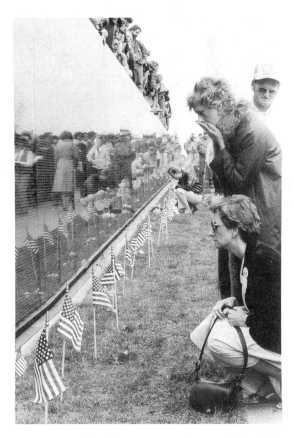

Figure 24-1. Maya Ying Lin, *Vietnam Veterans Memorial*, Washington, D.C. 1982. Photo by UPI/Bettmann Newsphotos.

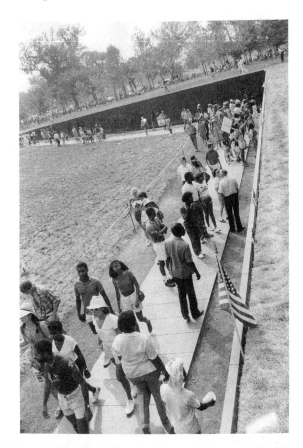

Figure 24-2. Visitors at the Vietnam Veterans Memorial, Washington, D.C. Photo by Marc Anderson.

site. The bill stipulated that any design selected by the VVMF was to be subject to the approval of the Secretary of the Interior, the Commission of Fine Arts (CFA), and the National Capital Planning Commission (NCPC).[3] When President Carter signed the bill into law on July 1, 1980, few could have predicted the complicated scenario that was to follow.

After further fund-raising efforts, the VVMF announced a national design competition on November 10, 1980, and two weeks later the VVMF released a fourteen-page design competition package which outlined the purpose of the Memorial and the nature of the competition.[4] The VVMF wanted the Memorial to honor the members of the United States Armed Forces who had served in Vietnam: those who were killed, those who remained missing in action, and those who returned home. The Memorial was intended to express "a nation's respect and gratitude" and to serve

as a symbol of national unity. The competition was open to all Americans over the age of eighteen, as individuals or in groups, and submissions would be anonymous. Submissions could include any design elements—landscape, sculpture, or architecture, or any combination thereof. The only stipulations to submissions were as follows: the Memorial must be "reflective and contemplative in character," harmonious with its site and with the nearby Lincoln Memorial and Washington Monument, must provide for a listing of the names of all 57,661 Americans killed in Vietnam as well as an approximate 2,500 who remain unaccounted for, and must make no political statement regarding the war or how it was conducted. The eight-person jury included architects Pietro Belluschi and Harry M. Weese; landscape architects Garrett Eckbo and Hideo Sasaki; sculptors Richard Hunt, Constantino Nivola, and James Rosati; and Grady Clay, editor of *Landscape Architecture.* . . .

. . . On May 6, 1981, the VVMF announced that the jury had unanimously selected [the entry] submitted by Maya Ying Lin, a twenty-one year old senior undergraduate architecture student at Yale.

Lin's design called for a V-shaped wall on which the names of the dead and missing would be carved. Each arm of this "V" would be 200 feet long, of black granite panels that would rise from ground level to converge at a vertex where the wall would be ten feet high. Behind the wall the ground would rise with its elevation, consistently flush with its top. In front of the wall a grassy sward would slope gently upward to a screen of trees. The eastern arm of this wall would point directly to the Washington Monument, a mile away, and the western arm would point to the Lincoln Memorial, approximately 600 yards away. The names on the wall were to be ordered neither alphabetically nor by military division, as is customary with war memorials, but chronologically, in the order of each soldier's death. As the walls extended, the number of lines of names would decrease with the height of the black granite until only one line of names appeared.[5]

In its official report to the VVMF, the jury was clearly enthusiastic about its choice:

> . . . Of all the proposals submitted, this most clearly meets the spirit and formal requirements of the program. It is contemplative and reflective. It is superbly harmonious with its site, and yet frees visitors from the noise and traffic of the surrounding city. Its open nature will encourge access, on all occasions, at all hours, without barriers. Its siting and materials are simple and forthright.

> This memorial with its wall of names becomes a place of quiet reflection and a tribute to all those who served their nation in difficult times. All who come here can find it a place of healing.

This is very much a memorial of our own times, one that could not have been achieved in another time and place. The designer has created an eloquent place where the simple meeting of earth, sky, and remembered names contains messages for all who will know this place.[6] . . .

Most of the immediate [public and media] reaction to [Lin's] design was favorable, echoing the selection jury's statement.[7] . . . [T]he National Parks Service and the [Commission of Fine Arts also supported the winning entry and formally approved it in hearings] during the summer of 1981. [During these hearings no] testimony was presented opposing the design. . . . [But, by summer's end], public controversy [had begun] in earnest.

On September 18, 1981, the politically conservative *National Review* published an editorial attacking the Memorial, calling it "a disgrace to the country and an insult to the courage and the memory of the men who died in Vietnam."[8] It was argued that the Memorial implied an anti-war stance because of its black color, its V-shaped plan ("the anti-war signal, the V protest made with the fingers"), and the lack of other identifying inscriptions beyond the names of the dead. The *National Review* editorial also criticized the names, for it seemed to imply individual deaths rather than deaths in a collective, unspecified cause.

These charges were answered by both [VVMF Project Director] Robert Doubek and the columnist James J. Kilpatrick in letters to the *National Review*.[9] Doubek wrote that the black color of the wall was as apolitical as the black color of the Iwo Jima or Seabee Memorials in Washington, and that the chronological ordering of the names served to integrate them into the entire experience of the war. He dismissed the reading of the V-shaped plan as a symbol of the anti-war movement: "More astute observers see the chevron of the PFC who bore the brunt in the fighting of the war." Kilpatrick claimed the monument "approaches a level of architectural genius," and he upbraided his conservative colleagues for the "untruth" regarding the lack of reference to Vietnam on the memorial when in fact there was such a reference in the inscription.

At a CFA meeting on October 13, 1981, originally convened to discuss granite samples for Lin's walls, the Commission was asked to reconsider its approval of the design. This appeal came from Tom Carhart, a twice-wounded Vietnam veteran and civilian lawyer for the Pentagon who had joined the VVMF as a volunteer in March 1980, and subsequently resigned in order to enter the design competition. Carhart echoed the analysis offered by the *National Review* that Lin's design was an anti-war statement. He felt that such a political stance was inevitable, as there had been no Vietnam veterans on the competition jury. As he explained it:

The net result is that the design the jury chose as the winner was necessarily a function of their perception of the war they lived through in America. It may be that black walls sunk into a trench would be an appropriate statement of the political war in this country.[10]

Carhart particularly objected to the black walls, calling the memorial a "shameful, degrading ditch, a black gash of sorrow,"[11] and claiming that "black is the universal color of shame, sorrow, and degradation in all races, all societies worldwide." He then demanded a white memorial.[12] Carhart's final objection was to the chronological ordering of the names. He found it to be a "random scattering . . . such that neither brother nor father nor lover nor friend could ever be found."[13] The CFA listened to Carhart's statement but would not accept his recommendation that Lin's design be scrapped.

Carhart followed up his CFA testimony with a statement printed in the *Washington Post* on October 24.[14] While reiterating much of what he had said earlier, he lodged two new objections. First, he took up the criticism voiced by the veterans who wrote to the *Post* in May, that Lin's design did not honor the surviving veterans. Second, he claimed that even if the design was not a statement of shame or dishonor, it did denote sorrow. Sorrow, he felt, was not an appropriate comment on the war and should be replaced with a statement of pride. At this point, realizing that the CFA would retain Lin's design despite his protests, he suggested formal modifications to honor the living and to emphasize pride rather than sadness. He advocated changing the wall's color to white, "the symbol of faithful national service and honor," raising the wall above ground, and installing an American flag at the wall's vertex.

This statement in the *Post* and the publicity attendant upon Carhart's appearance at the CFA meeting served to generate interest among disaffected veterans in modifying the memorial. It was reported, furthermore, that H. Ross Perot, a wealthy Texas financier, played a large role in organizing opposition to Lin's design. Perot, who had earlier supported the VVMF with $160,000 to set up the design competition, was not pleased with the jury's choice. In *Art in America*, Elizabeth Hess claimed that Perot tried to do away with Lin's design by creating the impression that the veterans themselves were dissatisfied with it. Hess also interviewed Jan Scruggs and Maya Lin, who both voiced suspicions that Perot had flown veterans into Washington to oppose the design. Lin also believed that Perot spread rumors around the capital that she and certain jury members were Communists. Perot denied this and maintained that he only tried to "get the Fund [VVMF] off their ego trip long enough to remember their constituency of two million vets."[15]

Whatever their source, the rumors of communist affiliation did spread until the VVMF was forced to [refute] them by circulating a fact sheet entitled "The Truth About the Vietnam Veterans Memorial." . . .

The fact sheet was also used to counter some of the objections raised by Carhart. While admitting that there were no Vietnam veterans on the competition jury, the VVMF explained that such veterans were integrally involved in other important stages of the selection process. Vietnam veterans set the design criteria, interviewed and selected each jury member, and approved the winning design. Also, it was noted that four of the jurors were veterans of other wars. The monument's black color was defended as being dignified and serene, as well as providing a necessary contrast to make the inscribed names legible. The names, when cut into the shiny black surface, would appear in the light grey color of the unpolished stone. White marble, it was noted, presents no such opportunity for color contrast. The chronological ordering of the names, too, was supported as displaying individual sacrifice as well as the nation's total sacrifice over time. An alphabetical sequence was deemed cold and bureaucratic and would not allow differentiation between veterans with identical names. . . .

Other defenders of the scheme were not lacking. Maya Lin, in a statement to the *Washington Post*, explained that the surviving veterans were indeed served by her design. The actual park setting was intended as a "living gift," and the chronological ordering of the names served to involve the living in their own experience of the war.[16] The press also defended Lin's design. The *Washington Post*, the *New York Times*, *Time* magazine, and syndicated columnist James J. Kilpatrick all ran pieces praising the memorial, stressing its neutral, apolitical aspect.[17] A more heroic monument, as called for by Carhart, was deemed unnecessary and even fraudulent: William Grieder, in the *Post*, explained that "our shared images of the war do not include any suitably heroic images which a sculptor could convert into stone or bronze,"[18] and an editorial in the *New York Times* claimed that a heroic monument would be a "shallow monument to politics."[19] Even the *National Review* recanted its earlier anti-memorial stance, calling it a "premature evaluation."[20] . . .

On December 4, 1981, the memorial moved one step closer to realization as the NCPC unanimously approved the original design. Construction on the site could now proceed, and the VVMF planned a groundbreaking ceremony for February 1982.

Despite the VVMF's explanations, the support of the press . . . , and the approval of the required government agencies, . . . the opponents of Lin's design did not give up their fight. Four days after the NCPC decision, Carhart and other veterans called a press conference. The veterans announced that Lin's design was an insult and demanded that its color be

changed to white, that the wall be raised above the ground, and that the scheme include an American flag.[21] Shortly thereafter, James Webb, Patrick Buchanan, and Phyllis Schlafly published articles in support of this group of veterans.[22] All stressed that Lin's design seemed to contain a left-wing, anti-war political message. Webb, a Vietnam veteran and novelist, and former counsel to the House Veterans Affairs Committee, also organized opposition to Lin's design on Capitol Hill.[23] Thus, in early January, 1982, a letter condemning Lin's design was circulated by Rep. Henry J. Hyde (R-Ill) and co-signed by another thirty Republican congressmen and then sent to President Reagan and Interior Secretary James Watt. . . .

Upon receiving this letter, Watt, who had approved Lin's design some six months earlier, wrote to the VVMF, saying: "As a result of continuing modifications in the original concept, I hereby request that you advise me once the design has been finalized in order that I might proceed to a full consideration of that proposal to fulfill my statutory responsibilities."[24] But, according to Robert Doubek, when Watt met with the VVMF on January 14, 1982, the design modifications were not discussed.[25] An article in the *Washington Post* claimed that Watt personally disliked Lin's design, calling it "an act of treason."[26] Sculptor Frederick Hart believed that Watt was only responding to the opposition of his constituency, which took the form of letters written to the White House and forwarded to the Department of the Interior.[27] Grady Clay, a competition juror, thought that Watt feared a lawsuit from Carhart and that the opposition veterans intended to halt the construction of the memorial.[28]

Whatever the reasons, it became apparent that Watt had changed his mind and would withhold approval of Lin's design unless it were modified in some fashion. Anxious to speed the construction of the memorial, Sen. John Warner (R-Va), a long-time supporter of the VVMF, convened a special hearing on January 28 to allow proponents and opponents of the design to air their views. After five hours of heated emotional debate, a compromise was reached. This plan, suggested by General Mike Davison, who led the 1970 Cambodian incursion, allowed Lin's design to be constructed as planned, with the addition of two elements: an American flag and a figural sculpture of a soldier or soldiers. In early March, Watt, the CFA, and the NCPC quickly approved these additions to allow construction to begin but withheld final approval until the actual positioning of the flag and sculpture could be worked out.[29]

On March 11, Sen. Warner and the VVMF held another meeting of the dissident factions to reach an agreement on placement. After another round of testimony, the VVMF agreed to allow the flagpole to be erected forty feet behind the wall's vertex, and the sculpture to be situated 170 feet in front of the wall's vertex amongst a stand of trees. With this

solution Carhart, though not competely satisfied, vowed to give up his fight and let the matter rest. Thus, with the approval of Watt on March 26, 1982, ground was broken for the memorial in Constitution Gardens, and on July 1, the VVMF commissioned sculptor Frederick Hart to design the figural sculpture.[30] Despite the apparent unanimity at this juncture, however, the battle over the added features of the flagpole and the sculpture had just begun.

For Maya Lin . . . the addition of the flagpole and statue ruined the integrity of her design. In a *Washington Post* article of July 7, 1982, Lin attacked the VVMF, Hart, and the additions. The VVMF, she claimed, never informed her of the changes, which she learned of from a televised report of the compromise. She also accused the VVMF of subverting the competition process and not defending her design. Of Hart, she said: "It's unprecedented—artists don't go around scabbing on other artists' work. I can't see how anyone of integrity can go around drawing mustaches on other people's portraits." She also felt that the addition of a single flagpole to her design would make the memorial look like a golf green.[31]

Members of the original competition jury were also disappointed. Harry Weese, objecting to the political manipulations which forced the changes, said that "it's as if Michelangelo had the Secretary of the Interior climb onto the scaffold and muck around with his work."[32] Robert M. Lawrence, then President of the American Institute of Architects, opposed any modifications to the award-winning memorial, saying that any intrusions would "cut the soul out of" Lin's design.[33] . . .

On September 20, 1982, Frederick Hart unveiled a maquette of his sculpture. His proposed work included figures of three young American servicemen, [one white, one black, and one of intentionally vague race or ethnicity,] carrying weapons and dressed in Vietnam-era military attire. The completed statue would stand over eight feet high and be cast in bronze. Hart envisioned his work in relation to Lin's design as

> an interplay between image and metaphor. . . . I see the wall as a kind of ocean, a sea of sacrifice that is overwhelming and nearly incomprehensible in its sweep of names. I place these figures upon the shore of that sea, gazing upon it, standing vigil before it, reflecting the human face of it, the human heart.[34]

[The inclusion of Hart's sculpture drew immediate fire from the press.] Paul Goldberger, architecture critic for the *New York Times*, summed up the arguments against the addition. He felt that the figural group would destroy the aesthetic integrity of Lin's design, would destroy the integrity of the competition process, and would be a political statement spoiling the intentional ambiguity of the wall.[35]

A meeting of the CFA scheduled for October 13 to review the VVMF's

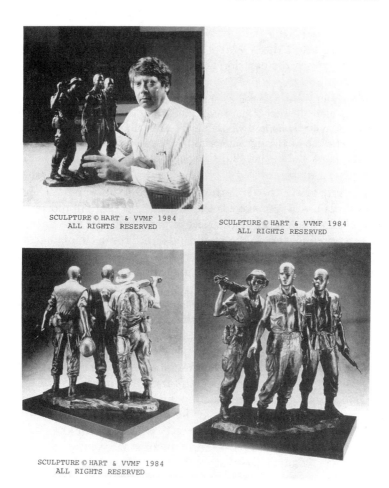

Figure 24-3. Frederick Hart, Maquette of *Three Fighting Men*. Photo by The Friends of the Vietnam Veterans Memorial, Inc. Sculpture © Hart & VVMF, 1984. All rights reserved.

recommendation for the placement of the flag and the sculpture caused a flurry of lobbying both for and against the additions. Maya Lin wrote to the VVMF to ask that they withdraw their recommendation, and AIA president Robert Lawrence wrote to J. Carter Brown, chairman of the CFA, claiming that any changes would corrupt the original competition.[36] Two days before the CFA hearing, Tom Carhart released the results of a poll taken of Vietnam POW's in January in which 67 percent of the respondents disliked Lin's original design.[37] Scruggs had this poll checked by experts and claimed that it was worthless. H. Ross Perot, who had paid for the poll, responded: "Losers always discredit the winners."[38]

The CFA's decision at the October 13th meeting surprised everyone.

While approving Hart's maquette and the addition of the flagpole, the Commission rejected the VVMF's proposed placement of the additions. J. Carter Brown, in his decision statement, explained:

> If the sculpture is allowed to shiver naked out there in the field, to be an episodic element that is not integrated, that somehow relates to a flagpole which is so far away and whose height and silhouette will be cut off as one approaches the existing memorial ... they will not combine to have the critical mass and impact that those elements deserve.[39]

On its own initiative, the CFA then suggested a placement scheme that, if proposed, would be approved: the statue and flag should be grouped together at the near end of the access path from Henry Bacon Drive, creating an entranceway to the memorial site. This decision placated both Lin and Lawrence, but enraged the original proponents of the additions, who threatened to build another memorial if those additions were not placed close enough to the wall.[40]

With the issue of placement still undecided the memorial—complete as Lin designed it—was opened to the public on November 10 and formally dedicated on November 13, 1982, during the one-week National Salute to Vietnam Veterans. Most major U.S. newspapers and magazines ran articles on the dedication and commentaries on the memorial's impact upon visitors.[41] The wall, and especially its litany of names, was reported to have had a deep emotional effect upon viewers, leaving many in tears and others standing and staring for long periods of time. Relatives and friends of the deceased interacted directly with individual names. Flowers, written messages, and personal mementos were taped to the wall or left by its base. Many took photographs or rubbings of the names, and almost all were moved to touch the wall, some even to kiss it. The press noted that the wall had a healing, cathartic effect, especially on visiting veterans. So pronounced is this phenomenon that psychologists who specialize in Vietnam-stress-syndrome cases regularly bring groups of patients to the memorial to help them come to terms with their grief, anger, and suppressed feelings.

Praise for Lin's completed memorial in the press was almost universal. Many stressed the neutral, apolitical aspect of the wall, claiming that one could bring one's own ideas and feelings to it and come away satisfied. Some felt that the experience of the monument's vast catalytic power upon the emotions nullified all objections levied against it.[42] ...

The opponents of the original design nevertheless remained dissatisfied[, and in] ... early 1983, Interior Secretary Watt re-entered the picture. On January 11, he announced plans to re-submit the placement plan which the CFA had already rejected, and he vowed to fight for its

approval.[43] Three placement plans were on his desk awaiting submission to the CFA: the original plan calling for a linear alignment of the flagpole, the wall's vertex, and the statue; the entrance grouping plan favored by the CFA; and another plan proposed by the AIA calling for placement of the flag at the entrance and the sculpture in a grove of trees separating the Vietnam Veterans and Lincoln Memorials. In this context on January 28, Watt changed his mind and decided not to submit any of the plans in order to allow time for a political consensus to emerge. He expected the matter to be resolved within twelve to fifteen months.[44]

The VVMF, weary of political meddling and anxious to complete the memorial, strongly objected to Watt's decision. Scruggs and important veterans' organizations urged Watt to submit all three plans to the CFA, saying that at this point they would agree to any of them.[45] As a result, on February 1, 1983, Watt again reversed his position and submitted the three placement alternatives to the CFA. So doing, Watt incurred the displeasure of those opposed to the entrance grouping, who felt that the CFA was sympathetic to only a small segment of the arts community and had placed trifling aesthetic concerns before the wishes of the veterans.[46]

The CFA held a hearing on the placement issue on February 8, 1983. In an emotional three-hour session, the relative virtues of the original, linear placement plan and the entrance grouping plan were hotly debated. The AIA proposal was largely ignored. Arguing for the entrance plan were the VVMF, Frederick Hart, the Veterans of Foreign Wars, AMVETs, the Vietnam Veterans of America, J. Carter Brown, and Harry G. Robinson III, Dean of the Howard University School of Architecture and Planning. They argued that if the sculpture were to be placed before the wall it would weaken the wall's impact and relegate the figural group to a spatially awkward position. A flagpole placed behind the wall "would be an intrusion into the tranquil horizontal space of the meadow and the awe-inspiring quality of the wall." If both flag and statuary were located at the entrance, however, the flag would have maximum prominence and the sculpture would benefit from the "scale giving" context of a copse of trees. Situated closer to the memorial, the sculpture would only compete with it for attention while being dwarfed by the wall.

The proponents of the original plan claimed to speak for a majority of Vietnam veterans. In support of this claim, they cited a poll taken by Milton Copulos in November 1982, which revealed that 74 percent of veterans surveyed preferred what the opposition called the more "prominent" placement of the statue and flagpole, i.e., with the sculpture, the vertex of the wall, and the flag in a line. The prominence of this arrangement derived from its symbolic content: the soldiers in the figural group were to gaze across the wall, a symbol of the tragedy of the war, to the flag which signified their patriotism. Such content would help memo-

rialize living veterans, as well as the dead, and make a statement of pride to counteract the wall's emphasis on sorrow. These veterans felt that this symbolic intergration was more important than the visual integration of the entrance placement plan.

After considering this testimony, the CFA voted unanimously to uphold its own suggestion: the statue and flagpole would be placed together 120 feet to the side of the standing memorial to form an entranceway to the memorial site.[47] With this decision, the veterans in favor of the original placement plan gave up their fight. At the NCPC hearing on March 3, 1983, no one testified against the entrance placement plan, though veterans were there in force to support it. On the same day, Interior Secretary Watt also gave what would be his final approval.[48]

[These approvals in effect ended the first round of controversies over the national Vietnam Veterans Memorial, and Hart's statue was dedicated on Veterans Day, 1984. A new round of debates began, however, in April of 1984 with the formation of the Vietnam Women's Memorial Project. This organization feels the Hart's *Three Fightingmen* excludes the commemoration of the thousands of women who served in Indochina and continues to lobby for some sort of sculptural parity on the memorial site.[49]

The controversies surrounding the national Vietnam Veterans Memorial are paradigmatic, though exacerbated, examples of the kinds of debates that almost always accompany the selection of contemporary works of commemorative public art. In this process, concerned segments of the press and public call into question the appropriateness of memorial designs, the mechanisms by which they are chosen, the designers and their intentions, and even the events or persons commemorated. Disagreements are often bitter and protracted, and sometimes lead to unhappy compromise or the wholesale abandonment of commemorative projects. But this does not mean that controversy is something to be shunned or smoothed over. In our pluralistic society, the public arising of dissent is essential. This is especially so in the realm of commemoration, for memorials are a public expression of our history literally carved in stone or cast in bronze.]

Notes

1. W. von Eckardt, "The Making of a Monument," *Washington Post*, 26 April 1980, p. C7.
2. "Needless Obstacle," *The New Republic*, 31 May 1980, p. 7.
3. C. Romano, "Moving the Memorial," *Washington Post*, 25 June 1980, p. B8. The Commission of Fine Arts was created by Congress in 1910 to give expert advice on works of art or architecture acquired or commissioned by the federal government. The Na-

tional Capital Planning Commission approves structures to be built on federal land in the District of Columbia and generally follows the recommendations of the CFA. See E. Hess, "A Tale of Two Memorials," *Art in America* 71 (April 1983): 122.

4. "Design Competition for Vietnam Memorial," *Washington Post*, 11 November 1980, p. B7; and VVMF, "The Vietnam Veterans Memorial Design Competition" (rules package sent to prospective competitors), Washington, D.C., 24 November 1980.

5. H. Allen, "Epitaph for Vietnam: Memorial Design Is Selected," *Washington Post*, 7 May 1981, p. F1.

6. "Program Souvenir: National Salute to Vietnam Veterans," MacLean, Va., 1982, pp. 9, 34.

7. Favorable reviews include W. von Eckardt, "Of Heart and Mind: The Serene Grace of the Vietnam Memorial," *Washington Post*, 16 May 1981, p. B4; "Vietnam Veterans Memorial Design Competition," *Architectural Record* 169 (June 1981): 47; "Unmonumental Vietnam Memorial," *AIA Journal* 70 (June 1981): 17; and A. Freeman, "An Extraordinary Competition," *AIA Journal* 70 (August 1981): p. 47–53.

8. "Stop that Monument," *National Review*, 18 September 1981, p. 1064.

9. R. Doubek and J. Kilpatrick, letters to *National Review*, 16 October 1981, pp. 1170–72.

10. T. Carhart, "Insulting Vietnam Vets," *New York Times*, 24 October 1981, p. 23. His entry for the competition consisted of a sculpture of an officer raising a dead soldier heavenward. It was the first work of art he had ever attempted.

11. Quoted in J. Eisen, "Commission Rejects Veteran's Protest, Reapproves Vietnam Memorial Design," *Washington Post*, 14 October 1981, p. C3. This phrase, or parts of it, was often repeated by those who objected to Lin's design.

12. Quoted in Hess, "Tale of Two Memorials," p. 122.

13. Ibid., p. 124.

14. T. Carhart, "A Better Way to Honor Viet Vets," *Washington Post*, 15 November 1981, p. C5.

15. Hess, "Tale of Two Memorials," pp. 121–23.

16. P. McCombs, "Maya Lin and the Great Call of China," *Washington Post*, 3 January 1982, p. F10.

17. B. Forgey, "Model of Simplicity: Another Look at the Vietnam Memorial," *Washington Post*, 14 November 1981, p. C1; "How to Remember Vietnam," *New York Times*, 11 November 1981, p. A30; W. von Eckardt, "Storm over a Vietnam Memorial," *Time*, 9 November 1981, p. 103; J. Kilpatrick, "Finally We Honor the Vietnam Dead," *Washington Post*, 11 November 1981, p. A27.

18. W. Greider, "Memories that Shape Our Future," *Washington Post*, 8 November 1981, p. C2.

19. *New York Times*, 11 November 1981, p. A30.

20. N. Hannah, "Open Book Memorial," *National Review*, 11 December 1981, p. 1476.

21. "Veterans Fault Vietnam War Memorial Plans," *Washington Post*, 8 December 1981, p. A11.

22. J. Webb, "Reassessing the Vietnam Veterans Memorial," *Wall Street Journal*, 18 December 1981, p. 22; P. Buchanan, "Memorial Does Not Honor Vietnam Vets," *Chicago Tribune*, 26 December 1981; P. Schlafly, "Viet Memorial Opens Old Wounds," *Buffalo Evening News*, 15 January 1982, p. 21.

23. P. McCombs, "Reconciliation: Ground Broken for Shrine to Vietnam War Veterans," *Washington Post*, 27 March 1982, p. A14. McCombs identifies Webb as the party responsible for organizing opposition to Lin's design in Congress. Webb's novels include *Fields of Fire* and *A Scene of Honor*, both based on the Vietnam War.

24. Quoted in "Politics Threaten to Engulf Vietnam Memorial Design," *AIA Journal* 71 (February 1982): 13.

25. Ibid.

26. P. Geyelin, "The Vietnam Memorial," *Washington Post*, 11 January 1983, p. A15.

27. From an interview with Frederick Hart in Hess, "Tale of Two Memorials," p. 124.

28. "Politics Threatens to Engulf Vietnam," p. 13.

29. For the Warner hearing, see B. Forgey, "Vietnam Memorial Clears Last Hurdle," *Washington Post*, 14 October 1982; "Watt Approves a Vietnam Memorial," *Newsweek*, 22 March 1982, p. 38; H. Sidey, "Tribute to Sacrifice," *Time*, 22 February 1982, p. 19.

30. For the placement compromise see J. White, "Watt Okays a Memorial Plan," *Washington Post*, 12 March 1982, p. C1; and "Compromise on Vietnam Memorial," *Washington Post*, 25 March 1982, p. B3. For the groundbreaking, see McCombs, "Reconciliation," p. A14. Hart, who was a member of the third-prize winning design team in the original competition, was chosen by a panel of four Vietnam veterans, two who had originally supported Lin's design (Arthur Mosely and William Jayne), and two who had opposed it (James Webb and Milton Copulos).

31. R. Horowitz, "Maya Lin's Angry Objections," *Washington Post*, 7 July 1982, pp. B1–6.

32. Quoted in I. Wilkerson, "Art War Erupts over Vietnam Veterans Memorial," *Washington Post*, 8 July 1982, p. D3.

33. B. Forgey, "Hart's Vietnam Statue Unveiled," *Washington Post*, 21 September 1982, p. B4.

34. Quoted in ibid., pp. B1, 4.

35. P. Goldberger, "Vietnam Memorial: Questions of Architecture," *New York Times*, 7 October 1982, p. C25.

36. Ibid., p. C25.

37. "Most Ex-POW's Polled Dislike Vietnam War Memorial Design," *Washington Post*, 12 October 1982, p. C2.

38. Hess, "Tale of Two Memorials," p. 123.

39. J. Carter Brown, "The Vietnam Memorial Decision: 'Part of the Healing'," *Washington Post*, 16 October 1982, p. A15.

40. Forgey, "Vietnam Memorial Changes," p. A1.

41. E.g., "The Vietnam Memorial," *Washington Post*, 13 November 1982, p. A18; B. Forgey, "A Mood Is Built—Stillness and Force in the Vietnam Memorial," *Washington Post*, 13 November 1982, p. C1; R. Cohen, "Roll Call," *Washington Post*, 14 November 1982, p. B1; W. Broyles, "Remembering a War We Want to Forget," *Newsweek*, 22 November 1982, pp. 82–83; K. Anderson, "A Homecoming at Last," *Time*, 22 November 1982, pp. 44–46; "What's in a Name?," *The New Republic*, 6 December 1982, pp. 6ff; M. Scrogin, "Symbol of the Valley of Shadow," *Christian Century*, 5–12 January 1983, pp. 7–8; H. Maurer, "The Invisible Veterans," *New York Review of Books*, 3 February 1983, pp. 38–39; "Notes and Comments," *New Yorker*, 20 June 1983, pp. 25–26; D. Hoekema, "A Wall for Remembering," *Commonweal*, 15 July 1983, pp. 397–98; P. Gailey, "Vietnam Memorial: Touching, Tears, Roses, Rain," *New York Times*, 30 August 1983, p. B6.

42. I have found only two negative reports published: C. Krauthammer, "Washington Diarist," *The New Republic*, 29 November 1982, p. 42; and W. Hubbard, "A Meaning for Monuments," *The Public Interest* (Winter 1984): p. 17–30. Krauthammer called the memorial a tomb and a "monument to death." Hubbard believes that the memorial is inadequate because it acts only as a catalyst for personal emotions rather than as a stimulus for public thought about the historical event it represents.

43. Geyelin, "The Vietnam Veterans Memorial (Cont'd)," p. A15.

44. P. McCombs, "Watt Stalls Addition to Vietnam Memorial," *Washington Post*, 29 January 1983, p. C1.

45. Ibid.

46. P. McCombs, "Watt's Memorial Turnabout," *Washington Post*, 2 February 1983, p. D3.

47. For the CFA hearing and testimonies, see B. Forgey, "A Solution with Pride, Harmony, and Vision," *Washington Post*, 9 February 1983, p. F4. The VVMF had Copulos's poll evaluated by polling consultants who found it to be seriously flawed.

48. B. Forgey, "Vietnam Memorial Approved," *Washington Post*, 4 March 1983, p. D1.

49. For the Vietnam Women's Memorial Project, see K. Marling and J. Wetenhall, "The Sexual Politics of Memory: The Vietnam Women's Memorial Project and "the Wall," *Prospects* 14 (1990): 341–72.

25

The Senses and Censorship

David Freedberg

On 31 March 1864, Swinburne wrote frankly to his friend Milnes—who had just been created Lord Houghton—about the *Venus of Urbino*. He was writing from Florence, and after commenting on various works of art described Titian's painting:

> As for Titian's Venus—Sappho and Anactoria in one—four lazy fingers buried dans les fluers de son jardin—how any creature can be decently virtuous within thirty square miles of it passes of my comprehension. I think with her Tannhauser need not have been bored—even until the end of the world: but who knows?[1]

Now the passage may be more an index of Swinburne's rather febrile sexual sensibility than of any particular candor, more frivolous than frank perhaps; but it is not as overtly hostile as the remarks of Mark Twain about exactly this picture less than twenty years later:

> You enter the [Uffizi] and proceed to that most-visited little gallery that exists in the world—the Tribune—and there, against the wall, without obstructing rag or leaf, you may look your fill upon the foulest, the vilest, the obscenest picture the world possesses—Titian's Venus. It isn't that she is naked and stretched out on a bed—no, it is the attitude of one of her arms and hand. If I ventured to describe that attitude there would be a fine howl—but there the Venus lies for anybody to gloat over that wants to—

From *The Power of Images: Studies in the History and Theory of Response* by David Freedberg, copyright © 1989 University of Chicago Press. Reprinted by permission of the publisher.

and there she has a right to lie, for she is a work of art, and art has its privileges. I saw a young girl stealing furtive glances at her; I saw young men gazing long and absorbedly at her; I saw aged infirm men hang upon her charms with a pathetic interest. How I should like to describe her— just to see what a holy indignation I could stir up in the world . . . yet the world is willing to let its sons and its daughters and itself look at Titian's beast, but won't stand a description of it in words. . . . There are pictures of nude women which suggest no impure thought—I am well aware of that. I am not railing at such. What I am trying to emphasize is the fact that Titian's Venus is very far from being one of that sort. Without any question it was painted for a bagnio and it was probably refused because it was a trifle too strong. In truth, it is a trifle too strong for any place but a public art gallery.[2]

"Look your fill" is exactly the kind of looking that fetishizes the object, that makes it seem to be alive and makes one respond to it as if it were. That it becomes an object of great sexual interest is evident from the fetishistic symptoms of this looking; this happens as soon as looking at *it* becomes looking at *her*. And not only that: "anybody" gloats; girls steal furtive glances at her; young men gaze long and absorbedly at her; aged men hang upon her charms with pathetic interest. We have already noted the keen relationship between looking and enlivening; but the passage now introduces a crucial issue: censorship. It also reminds us, once again, of the relations between repression and art. The picture is too strong, even for a "bagnio." Indeed the only place it could hang—as Twain's final, sarcastic lapse into philistinism makes clear—is in a public art gallery. Equally telling is the repeated insistence that such a representation would not be tolerated in words.

A brief passage in Vasari reveals another facet of the relations between sexual arousal and what is regarded as art. It also happens to be one of the few places in the classic historiography of Western art to refer to a specifically female response of this general order. He tells of how Fra Bartolomeo responded to the frequent taunt (which upset him) that he was unable to paint nudes: he did a Saint Sebastian (as the pendant to a lifesize Saint Mark) "with very good flesh colouring, of sweet aspect and great personal beauty." . . . But while the picture was on display in the church (San Marco in Florence), "the friars found out by the confessional that women had sinned in looking at it, because of the comely and lascivious realism with which Fra Bartolomeo had endowed it." So they decided to remove it to the chapter house (where it would only be seen by men) before finally selling it to the king of France.[3]

It was not only that the chapter house was an all-male preserve and that the provocative nude would thus be sequestered from the sight of women. By taking it into the chapter house, the picture was removed one

stage further from a religious context. Keeping it anywhere in the church implied acknowledgment of its functional affectiveness; taking it out-side—even to the chapter house—not only distanced it, at least some-what, from the arena of arousal and sexuality. It made it more a work of art, something to be displayed and admired (as in a museum) for precisely the qualities that Vasari extols—certainly less liable to cause sin, more to be praised, interpreted, and understood than to be felt. In being sold off to the king of France its status as a work of art could finally be confirmed. It entered his collections precisely because it was a work of art, and not because of its erotic power (though we know perfectly well how François Ier could respond to the objects in his collection).

When Vasari reflects on the "colour very similar to flesh, sweet air and great beauty" of Fra Bartolomeo's *Saint Sebastian*, he adds that, as a result, the painter-friar "won great praise among artists."[4] Women might sin in regarding it; but what Vasari had to ensure was that neither his responses nor those of his readers should seem to be predicated on anything other than purely artistic criteria. Repressive talk about art has its beginnings in the earliest forms of criticism of art. When Vasari alerts us to the qualities of the picture, he does so in a way that does not draw attention to the dangerous power of its effects. But at least he does report on them, even a little pointedly.

When we turn to modern art historical writing—as with that on the *Venus of Urbino*—the effects of the picture are turned into something as unthreatening and undangerous as possible. Thus the standard mono-graphic treatment of Fra Bartolomeo's *Saint Sebastian* and its pendant mentions nothing of the women of San Marco.[5] Indeed, it even takes issue with Vasari's explanation of the genesis of the picture in terms of the taunt that Fra Bartolomeo was unable to do nudes. In calling this ex-planation a rationalization, the writer insists instead that the novelty of both pictures "is explicable by their dependence on contemporary mon-umental sculpture."[6] And there follows a long art historical account of the influence of contemporary sculpture on the pictures, and of Fra Bar-tolomeo's involvement with it. Not a word of the effects of the picture recorded by Vasari. These, so one might assume such writers to imply, have nothing to do with art history; or they are not thought to be suitable for academic discussion.[7] Thus art history deprives objects of their most violent effects, and of the strongest responses to them. Thus it makes them anodyne. In doing so it ensures that the objects remain as art. But when we suspect that there might be a better word for this deprivation of the powers of an object—when, in short, we say that art history *emas-culates* objects like these—we become immediately aware of the profound gender issues.

There is at least one further aspect of Vasari's life of Fra Bartolomeo

that is germane here. This is where he describes the terrible and famous *bruciamenti* instigated by Savonarola on Shrove Tuesday 1496. "Stirred up by the preacher, the people brought numbers of profane paintings and sculptures, many of them the work of great masters, with books, lutes and collections of love songs. This was most unfortunate, especially in the case of paintings."[8] But who was it who brought his own studies of the nude to be burned? None other, of course, than Fra Bartolomeo (then still called Baccio). Less than thirty years later, the zealot who had encouraged other painters, including Lorenzo di Credi, to follow his example, and who shortly thereafter become a Dominican monk, painted the abundantly sweet and handsome nude that inspired women to sin.

Of all people, then, Fra Bartolomeo must have been aware of the powers of art (and from an early age); thirty years earlier the way of rendering art ineffectual could only be to destroy it altogether. Religious pictures were allowed to be powerful, but only in certain ways. If their powers implicated the overtly or explicitly sexual, they could be shifted into the realm of the more purely artistic, into the realm of the profane. But if they still had effects of the strength that we might just tolerate with religious imagery, then—according to the thought of Savonarola and his followers, as with Calvin and the sixteenth-century iconoclasts— they had to be destroyed.

But there were other ways of dealing with the problem of the arousal of the senses. They have to do with censorship, rather than with the ultimate act of destruction. The paradox of censorship is that while it may destroy part of an image, indeed damage its artistic qualities, it allows the image to remain within the category of art. It does so with the aim of depriving the work of qualities that engage the senses too deeply and too intimately. But this is also characteristic of the censorship of all images, not just artistic ones.

Let us ponder more closely the analytic relationship between the assignment of the label which says "art" and the arousal that springs from looking and gazing at any image, whether we call it art or not. The issue comes acutely to the fore in the case of photography. Indeed, it might be argued that the history of photography begins with and is a result of the gaze that fetishizes; and that the tension between the need to classify as art and the need to arouse and be aroused is what inspires its origins.

Let us also use the term pornographic. It is not part of my intention in this book to define what is or is not pornographic; or to attempt to establish the boundaries between the sensual, the erotic, and the pornographic. These may indeed shift according to context; if anything such definitions and such boundaries are among the most liable to change. I use the term as an expedient one for the purposes of argument.

We are all as familiar with the variety of ways in which images are somehow made "respectable" by allowing them to fall into the canonical category of art as we are with the ways in which we explain away discomfort or embarrassment by thus elevating their status. If an image is pornographic, it either cannot be allowed as art; or (we assert) it is not art. If it is pornographic, then it must be low-level and crude—"crude" in both senses of the word. It is vulgar (again in both senses) and not high. These are the commonplace positions of repression, and it is true that they are changing. Notions of canonicity, now, seem to expand; but however much we (as sophisticated critics and consumers of art) may be pleased with the processes of liberalization and liberation, it is clear that the dismissal of artists who represent subjects commonly subsumed under the category of pornography is predicted on just the position that the images are not art but pornography. On the other hand, we sophisticates deal with our greater or lesser discomfort in perceiving the images as straightforwardly erotic by putting them into a loftier category, by granting them the higher status of art. Hang them in galleries and exhibit them in the art museum.

The relations between what we define as art and what we call arousing or erotic or pornographic appear—to say it again but more bluntly—in the earliest history of photography.[9] [It is not necessary to] examine here the abundant and well-documented ways in which the photograph was used as a vehicle for pornography, not the way in which its subjects were often seen as pornographic.[10] There are plenty of contemporary parallels to the many late-nineteenth century raids on photographic dealers, and to the petty bourgeois moral positioning represented by the letter to the London *Photographic News* in 1860 expressing the view "that a man who takes a walk with his wife and daughters dare not venture to look at the windows of many of our photographic publishers."[11] On the other hand, when we reflect on the confiscation of photographic reproductions of the *Venus of Urbino* and other famous paintings . . . , such as that documented in Hamburg in 1880, we come closer to the issue at hand.[12] And when we recall the huge public success of the move that Julien Vallou de Villeneuve made from erotic lithography to erotic photographs in the early 1840s—to say nothing of their use in the work of Courbet—then it is clear that the matter merits further exploration.

The use of early photographs by both Delacroix and Courbet is well known. It is not surprising that they should have taken realistic photographs of female nudes and added to them. They did so in a variety of ways, and they turned them into easel pictures. Delacroix, broadly, idealized the photographic images he had made or collected in his album. He made them less ugly and generally more suitable for the more beautiful and decorous medium of painting. . . .[13] Taking nudes such as those pro-

duced by Villeneuve, Courbet made them still fleshier, still more replete with the accidents, dimples, and bumps of nature [Fig. 25-1].[14] We know that the photograph was realistic because it was called that. It was called realistic because it was regarded as being too close to nature. That is precisely why it was not art. Art improved on nature; it was not so bluntly realistic; it made it more beautiful.[15] As Aaron Scharf put it in his excellent summary of these issues: "Realism was the new enemy of art and it was believed that it had been nurtured and sustained by photography."[16] It is hard not to reflect on how the prosecution condemned *Madame*

Figure 25-1. Gustave Courbet, *Les Baigneuses*, detail. 1853. Photo by Giraudon/Art Resource.

Bovary at the trial of 1857 on the grounds that it belonged to "the realistic school of painting."

The implications of the constant insistence on the categorial distinction between art and photography, and on the need to keep the boundary between them absolutely firm are now clear. Arousal by image (whether pornographic or not) only occurs in context: in the context of the individual beholder's conditioning, and, as it were, of his [or her] preparation for seeing the arousing, erotic, or pornographic image. It is dependent on the prior availability of images and prevailing boundaries of shame. If one has not seen too many images of a particular kind before, and if the particular image infringes some preconception of what should not be or is not usually exposed (to the gaze), then the image may well turn out to be arousing.[17]

All this may be irrefragably true, and one may well want to argue thus. But it is only part of the story, and it does not take care of the particular and peculiar case of the photograph. It is only half an account. The fact is that the early photographs were seen as realistic and arousing, and they were both used and censored for that reason. Moreover, they were seen and used as arousing *because* they were realistic. This conjunction was always made by the censors; and it could be quite plainly expressed, as in the English court case of 1861, initiated because "provocative and too real photographs" were displayed in public places.[18] But the concern was not only that they were realistic; it was that they were available to the crowd. Of course the censors might have been equally concerned with private misuse; but once again the connection between realism and the vulgar (in the sense of popular and low-level) could not be plainer.

But perhaps it is possible to be less elliptical about these connections and about the relations between realism and arousal. The gaze, as we have seen, fetishizes. We fall in love with the represented object; or feel — possibly — some species of physical sympathy with swirling lines, or with large sculptures that make us want to move to see or feel their end. We look and gaze, like Tamino. Like him, and even more like Pygmalion, we want the image to be alive — to be real. It has to be real because we do not wish it any longer to remain as lifeless material, or as two-dimensional. It has to be real so that we can properly possess it. The perceived realism of photography springs from this kind of fetishization; and it is always pregnant with the possibility of arousal. The basic fact about art, at least in those days, was that it was not as real as the photograph and could not be so — because otherwise it would arouse.

Art, of course, was also more beautiful than anything that realistically reproduced nature. Courbet had more trouble with this attitude than [almost] anyone else. His *Burial at Ornans* was regarded as ugly because it was too realistic, and it was belittled by comparing it with a

photographic image. "In that scene," wrote Delécluze, "which one might mistake for a faulty daguerrotype, there is the natural coarseness which one always gets in taking nature as it is, and in reproducing it just as it is seen."[19] And it had a commonplace subject too. But Courbet also exploited this attitude, and in doing so he knew exactly what he was about (as when he used Villeneuve's photographs as the basis for his own, often more abundant, female nudes). The whole issue may seem to be entirely of the nineteenth century; but it is not. In recounting the fate of Fra Bartolomeo's *Saint Sebastian*, Vasari observed that the women of the congregation sinned in looking at it because of the realistic skill of Fra Bartolomeo. Thus he established the direct connection between arousal and realism that—consciously or unconsciously—continued to alarm the demarcators between art and photography.

But there is still another lesson in all this. If the makers and purveyors of pornography (and realism) want to make their pornography acceptable; if they are aware of the need for its consumption and its uses for purposes of arousal, then they can and do make their pornography seem like art. Especially if the society which consumes it is sunk in its bourgeois repression. It is no surprise, nor any consequence of the old idea that nature follows art, that even Villeneuve's nude females—even the ones used by Courbet—look so artistic. They are posed in artistic ways, with artistic trappings, in ways that Villeneuve learned from that high and canonical category. There are the archer, or more abandoned, or coyer adaptations—by Villeneuve himself and many others—of Titian's *Venus of Urbino* (swiftly destined to be turned into Manet's *Olympia* . . . , a picture that carries with it the full consciousness of every issue discussed in this chapter); there are the robust/delicious/plain/peasant-like studies related to Ingres's *Odalisques* (pictures which to many must have seemed erotic enough, but which could not be carried around with one for private consumption); and finally there were the multitudinous derivations from Velazquez's *Rokeby Venus*, each one emphasizing or changing those parts of the picture assumed to be of sexual interest by their makers. . . . But now, because they were photographs, the pictures were realistic, and therefore both uglier and more arousing. In most of these adaptations the increasing fetishization of breasts and buttocks is easily identified.[20] In any event, once photographs like all these make their kinship with art apparent, they seem to be safer; they may be bought by the widest of markets; and fetishization of the body becomes large-scale commodity fetishism at every level of image consumption.

But there is a brute fact that subverts the categories and the pigeonholes of a bourgeoisie that so blatantly makes capital of repression (or allows the exploiters of these categories to do so). It is this: As soon as the photographic image is seen as too threatening it does not qualify

as art; nor is it perceived as such. Its threat is too plain. Then, of course, it can be censored—or kept under covers, or appropriately, in the bedroom, and certainly away from children and old maids)—it *must* be censored. We begin to come closer to the relationship between realism and censorship. What is realistic is ugly and vulgar. Art is beautiful and high. The photograph is realistic; it is vulgar; it elicits natural and realistic responses. In art, nudity is beautiful and ideal; in the photograph (unless it has acquired the status of art), it is ugly and (therefore?) provocative. In 1862 the photographer André Disderi complained about the abundance of obscene photographs in his time by referring to "those sad nudities which display with a desperate truth all the physical and moral ugliness of the models paid by the session."[21] Once again Scharf provides the most appropriate of glosses to this attitude: "The crudities of actuality in photographs of nudes especially did not blend very elegantly with the antique, and photographs of this kind were an effrontery to men and women of good taste."[22]

In the phenomenon of censorship we see most clearly the convergence of good taste and the fear of realism. The covering of genitals (probably the commonest form of censorship) is the ultimate acknowledgment of the relations between realism and offence. When we cover or remove them (or when we cover the breast that nourishes or the parts of the body that excrete, or even when we cover feet or other physical features regarded as sexual), we take away the profoundest marks and criteria of realism. The provision of fig leaves—as now seems obvious—registers a fear of the consequences that the artistic and ideal work may somehow not be so ideal after all; it reveals to the gaze that which, were it real, would be the most realistic proof of its sexuality. Herein lies the true subversiveness of the beautiful: it traps the enlivening and therefore dangerous gaze. That is why art may be censored as much as non-art, and sometimes even more so.

I have omitted one reason for the opposition of photography to art (or, at the very least, the worry about whether it qualifies as such). Photography is reproductive; art is unique. Almost everyone can own or have access to a photograph; but art, being high, is reserved for the few. The crowd responds in basic and crude ways to reproductive imagery; but art only yields its secrets, as if hermetically, to the select people who are trained to understand it or are born into the culture that financially enables it.[23]

One final aspect of the kinds of photographs that I have been considering maybe too obvious to merit special comment, but it is so telling an aspect of the nature of Western looking and arousal that it cannot be emphasized enough. It is also directly implicit in every issue in this section: from art and non-art, to looking, gazing, fetishization, enlivening,

arousal, and possession, through to the vulgarity of reproduction and the commonplace promiscuity it implies. I refer to the fact that the majority of the photographs called obscene or erotic are of the female nude. Of course there are some that are male, and when they exist they are probably censored in equal proportion; but erotic and arousing and pornographic photographs of the female nude crucially and vastly outweigh those of the male. One could not say that the situation now is substantially different—even with the elevation into art of photographs such as those by Robert Mapplethorpe. . . .

Notes

1. *The Swinburne Letters*, ed. C.Y. Lang (London, 1959), I:99, no. 55.

2. Mark Twain, *A Tramp Abroad* (1880); cited and discussed in Leo Steinberg, "Art and Science: Do They Need to be Yoked?" *Daedalus* (Summer 1986), p. 11.

3. Vasari-Milanesi 4:188.

4. Ibid.

5. Janet Cox-Rearick, "Fra Bartolomeo's St. Mark Evangelist and St. Sebastian with an Angel," *Mitteilungen des Kunsthistorischen Institutes in Florenz* 18 (1974):329–54.

6. Ibid., p. 345.

7. That the large-scale sculpture iscussed might also have some of the effects ascribed to Fra Bartolomeo's picture is, of course, omitted altogether.

8. Vasari-Milanesi 4:178–79.

9. The fact that I say "what we define as" and "what we call" should make it clear that I hold to no absolute sense of either art or arousal.

10. For a good range of bibliographic references, as well as a useful brief discussion, see Scharf 1974, pp. 345–46.

11. Ibid., p. 345.

12. Ibid.

13. Though by no means always. It would have been hard to "improve" on—or make still more "artistic"—a photograph such as the well-known one (ca. 1854) given to Durieu and Delacroix, showing a seated model seen from behind with her torso bare, but with a cloth falling downward from the back of the chair and across her lap.

14. It is difficult not to reflect here, as Courbet endows the photographic model with extra fleshiness, on the way in which Rubens invested the taut model of his antique prototypes with exuberant carnality and luxuriant palpability, perfectly in keeping with the desire expressed in his lost treatise *De imitatione statuarum* that the painter should above all avoid the effect of stone: *omnino citra saxum*.

15. This, of course, also happened to be the position with which Courbet, both explicitly and implicitly, was himself consistently to take issue.

16. Scharf 1974, p. 96.

17. Of course the converse may also be the case, namely, that arousal may proceed from the habitual connection with a particular kind of image.

18. Scharf 1974, p. 130, citing *Le Moniteur de la Photographie* (October 1863), p. III.

19. *Journal des Débats*, 21 March 1851, cited in Scharf 1974, p. 128.

20. Some instances of this kind of transmutation verge on the absurd, as in Richard Polak's

ridiculous photographic realization of Vermeer's *Painter in His Studio*, illustrated in Scharf 1974, p. 240 (fig. 175). It dates from 1915, but it is an extreme example of a tendency already seen much earlier. The absurdity is highlighted, perhaps, by the use of a genre picture to make the potentially arousing image more domestic and comfortable.

21. Scharf 1974, p. 130 (his translation from *L'Art de la photographie* [Paris, 1862], p. 302).

22. Ibid., p. 134.

23. The same set of oppositions arises in the case of the other great development in reproductive imagemaking, the woodcuts, etchings and above all engravings of the fifteenth and sixteenth century.

26

The Obscenity Trial
How They Voted to Acquit

Robin Cembalest

"If I had put my moral values in, I would have said guilty," says Jennifer Loesing, an X-ray technician from Anderson Township, a Cincinnati suburb. She was one of the jurors charged with deciding whether Dennis Barrie, director of Cincinnati's Contemporary Arts Center (CAC), had broken the law by including sexually explicit photographs by Robert Mapplethorpe in the exhibition "The Perfect Moment" at the museum last spring. For the charges of pandering obscenity and illegal use of minors, Barrie faced a $2,000 fine and a one-year jail term if convicted. The CAC, which was also a defendant in the suit, faced a $10,000 fine.

None of the eight jurors sitting on the highly publicized case had visited an art museum in recent years, none had seen the Mapplethorpe exhibition, and none liked the reproductions of the seven photographs they saw in court; one shows a man urinating in another man's mouth; three show penetration of a man's anus with various objects; one shows a finger inserted in a penis; two show children with their genitals exposed. "We had no idea that something like this existed," says juror James Jones, a warehouse manager. "As far as we were concerned," says juror Anthony Eckstein, an engineer, "they were gross and lewd."

But were they art? If they were, they could not legally be obscene, according to the Supreme Court. In the 1973 case *Miller v. California*, the court said that a work is obscene if it depicts sexual conduct "in a patently offensive way"; if the "average person, applying contemporary

This essay originally appeared in *ARTnews*, December 1990. Reprinted by permission of the publisher.

community standards" finds that it appeals to prurient interest; and if it "lacks serious literary, artistic, political, or scientific value." Accordingly, H. Louis Sirkin, the local lawyer who represented the defendants with Marc D. Mezibov, tried to show that "each image was put in that exhibition for one reason—serious artistic value. We thought that if we could convey that to a jury, we could win. No one else thought we could."

On October 5, after a ten-day trial, the jurors emerged after only two hours of deliberations and announced that they had decided to acquit Barrie and the CAC on every charge. "We felt we had no choice," says Eckstein, "even though we may not have liked the pictures. We learned that art doesn't have to be pretty."

During the brief deliberations, says Eckstein, "the first thing we did was to make sure that each of us understood the obscenity law. It was not too difficult. Then we had to decide whether the photographs were art or not. The prosecution didn't have witnesses that testified to the contrary." But the defense did have witnesses the jurors found credible— museum experts and local art critics chosen specifically to appeal to a midwestern sensibility. "The law is what we made the judgment on," says juror Martin J. Hall a data processor. "The experts helped me form an opinion on the law."

Barrie's trial will undoubtedly be studied carefully by attorneys undertaking similar cases in the future, especially after the recent disparate verdicts in two lawsuits concerning the lyrics of the rap group 2 Live Crew—though the group was acquitted of obscenity charges, a Florida store owner was found guilty for selling their records. That there will be further trials regarding artworks, observers on both sides of the issue believe, is inevitable. "This was not a landmark, Pearl Harbor decision," announced Donald Wildmon, who heads the Mississippi-based American Family Association (AFA), a conservative religious group that has opposed government sponsorship of art it deems obscene. "I agree with Wildmon. This was just a skirmish," says Robert Sobieszek, a curator who testified for the defense. "It's going to be tried again and again and again. But the precedent here means that the case against will be a little better thought out. For the AFA, this was an important case. They thought they could win. It wasn't the art experts who said no, it was their own folk— people from the suburbs."

"We did turn Cincinnati upside down," says Stacey Burton, a secretary who served as the jury's forewoman. Indeed, if there was one place where "community standards," as the Supreme Court put it, could be violated by the Mapplethorpe exhibition (which had been shown in six other institutions across the country), Cincinnati seemed to be it. The city has the most restrictive antipornography laws in the nation—it outlaws *Penthouse* and *Playboy*, X-rated videos, and topless bars, and has

banned such plays as *Oh! Calcutta!* and *Hair*. It is the home of the National Coalition Against Pornography and of Concerned Citizens for Community Values (CCV), which sent a mass mailing calling for "action to prevent this pornographic art from being shown in our city" when the Mapplethorpe show opened at the CAC in April. "I was fairly sure Barrie would be convicted," says *Cincinnati Enquirer* art critic Owen Findsen, who testified for the defense. "Everything was so carefully orchestrated between the people opposed to the exhibition."

Among the staunchest antipornography crusaders is Simon Leis, the Hamilton County sheriff who urged the CAC to cancel the show before it opened and pushed for its prosecution. Consequently, supporters of the museum were discouraged when it was revealed that David J. Albanese, a schoolmate and political ally of Leis, was the Hamilton County Municipal Court judge selected to try the case. "We've been inundated with aliens," said Albanese, who is known as a law-and-order Republican, of the deluge of media from out of town. He refused to switch to a larger room to handle the overflow, and reporters who came to see the first criminal case brought against an American art museum for the contents of an exhibition found themselves watching on monitors in the hall.

At the pretrial hearings, most of the discussion revolved around the issue of whether the five photographs showing homosexual activity that the prosecution deemed obscene and the two that showed child nudity should be considered in the context of the rest of the 175 works in the Mapplethorpe retrospective. To the defense this was a crucial point and one that they did not expect to lose—in previous obscenity trials, courts have ruled that questionable passages of a book or a film must be considered in the context of the work as a whole.

Frank H. Prouty, the senior assistant city prosecutor, called one witness: Judith Reisman, who has a doctorate in communications from Case Western Reserve University, worked for several years producing music videos for the TV show *Captain Kangaroo*, and had studied sexually explicit photographs for the AFA. The defense sought to exclude Reisman on the basis that she was not an art expert and that she had "a particular political agenda." When Mezibov asked her if she was "an expert in appraising the works of Robert Mapplethorpe as to artistic value," the prosecution objected, but Reisman had already responded, "No." Albanese decided to admit her as a witness anyway, although she acknowledged that she had seen the Mapplethorpe exhibition in Cincinnati only in videotape form. She testified that the seven photographs could indeed stand on their own: each one, she said, is "an individual work with a capital 'W.' . . . It is true of when you bring the photograph home. It is true of whether you put the photograph in the living room or the bathroom or the dining room."

Evan Turner, director of the Cleveland Museum of Art, testified for the defense, describing the seven photographs as "images of rejection, aggression, anxiety" that are "indispensable" to an understanding of Mapplethorpe's overall approach. Martin Friedman, at that time director of Minneapolis' Walker Art Center, testified that the works under discussion "represent a very small proportion of the output of this artist, but they . . . are essential to the understanding of the spirit that moved him, as it were. I mean, I recognize that they are difficult. I recognize that they are confrontational. I recognize that they tell us things maybe we would rather not hear. But they do shine lights in some rather dark corners of the human psyche. And they symbolize, in disturbing, eloquent fashion, an attitude. And they do reflect an attitude that is not necessarily limited to the artist."

Judge Albanese was still undecided about whether to isolate the seven photographs. He asked the defense to call Janet Kardon, who organized the Mapplethorpe exhibition at Philadelphia's Institute of Contemporary Art in 1988, a year before the artist's death from AIDS. Kardon, who is now the director of the American Craft Museum in New York, testified that the photographs were "important for the exhibition as a retrospective" because they were the only ones "that showed Mapplethorpe's ability to handle sequence." To have omitted them, she said, "would be to leave out a chapter in a novel or a segment of history." She also discussed her working relationship with Mapplethorpe and his skills as an artist. "No matter what his subject matter, he brought a sense of perfection to it," she explained. "And all of the attributes one characterizes a good formal portrait by, that is composition and light and the way the frame is placed around the image, all of those things are brought to bear in every image." After Kardon testified, Albanese informed the jurors of his decision. The photographs would stand by themselves.

"I don't know anything about art," Albanese commented to Turner during the pretrial hearings. "You must have an interesting time learning," Turner replied. In the trial itself Sirkin knew he would be dealing not only with a judge unfamiliar with art but also with a jury that was churchgoing, high school educated, and clearly uncomfortable with the subject matter of the photographs. During the four-day-long jury selection, he had explained points of law with homey metaphors. When he explained that a person doesn't have to like a work to consider it art, he mentioned San Francisco 49ers quarterback Joe Montana. "You don't have to like that pass he threw in the Super Bowl against us to see that he's one heck of a quarterback," he said. Then he compared the three-pronged legal test for obscenity to a recipe for apple pie. "One or two ingredients may be present," he stressed. "But that does not make an apple pie."

When it came to choosing expert witnesses, Sirkin looked for people who were unintimidating. That excluded New Yorkers. "We are a midwestern belt city," he explains. "There always seems to be a negative feeling about New York, and even about the West Coast." He also avoided Dayton and Cleveland because people in Cincinnati consider them too progressive. *Enquirer* critic Findsen, who, like Sirkin, was born and raised in Cincinnati, thinks the strategy was correct. "Cincinnati doesn't even think of itself as part of Ohio," he says. "To Cincinnatians, people from Dayton and Cleveland are wild-eyed radicals. The assumption is that the art world is an elitist group that they can tell other people what to think."

The closest he got to New York, Sirkin says, was Rochester, represented by Sobieszek, at the time of the trial a curator of photography at the George Eastman House (he has since become the head of the photography department at the Los Angeles County Museum of Art). Sirkin also called Kardon; John Walsh, director of the J. Paul Getty Museum in Malibu (because he is a "class act, a soft-spoken person"); Jacquelynn Baas, director of the University Art Museum at the University of California in Berkeley ("she's from Michigan"); Stuart Schloss, a member of the CAC board; and two local art critics—Findsen and Jerry Stein of the *Cincinnati Post*. They all, Sirkin says, "portrayed a real warm feeling. They were charming, educated, and their credentials were impeccable. They put in everyday language to people what has serious artistic value and why."

"Everyone was there with a sense of conviction," Barrie says of the witnesses. In his view, there were several moments that strongly influenced the jurors: "Kardon talking about how she worked with Mapplethorpe to assemble the show. Walsh talking about how the purposes of a contemporary museum are to challenge, present work that is controversial. And quite honestly myself, responding to the pictures, explaining why we took the exhibition."

"I grew up in the Midwest. I understand that community. You don't come in with a lot of jargon," Sobieszek says. "I do that when I talk to groups in the museum—trying to communicate to ordinary citizens who may not have a special love for the medium but who are open to considering things rationally. It was all I could do." He described Mapplethorpe's sensibility as "a search for understanding, not unlike Vincent van Gogh painting himself with his ear torn off."

Findsen says that his strategy was similar. "I didn't ever say that the five homosexual pictures were attractive," he explains. "Dennis was defending asymmetry, formal balance. I said I felt they were repulsive—but I didn't feel I had any right to dismiss them. Because of the nature of Mapplethorpe's life and the impact of AIDS on the art world, they were integral to the show. Taking them out would be like taking out a chapter

of a biography. I never said, "You're wrong because you think they're dirty.'" When the prosecution asked him if he considered the sexually explicit photographs to be works of art, "I said that if you go to a restaurant and have a bad meal, you can't say that's not food—you can say it's bad food. I don't put limitations on art. You might say it's disgusting, but it's still art. I think this was effective on the jury. People outside the art world think art means beautiful things."

When Findsen discussed the photographs of the children, he recounts, "I said evil existed in the eye of the beholder. Prouty said that some people could see them as evil. I said pictures tell stories in new ways. I saw these as Adam and Even in the garden of Eden. If the viewer was after the fall, there was nothing I could do. I could hear applause in the hall, where the reporters were." And the charges of illegal use of minors, jurors say, were the first ones they decided to drop. First of all, Loesing explains, Mapplethorpe had permission from the parents. And though as a mother she found the images upsetting, "I decided that the children look morally innocent. I don't think harm was meant."

The expertise of the defense witnesses was persuasive, the jurors say. "They were all excellent," says Loesing. "They were very well prepared." Eckstein felt the same way. "They were all good—that's what impressed us." The testimony, says Burton, helped her to gain a new perspective on unfamiliar and disturbing images. "When the experts said this is why it's art, they were very convincing. One said that Mapplethorpe was depicting a lifestyle of the '70s that I never knew existed." She adds that Kardon particularly impressed her, "with everything she said about Mapplethorpe personally, about putting together this exhibition. I didn't realize so much was involved—she said that they went through thousands and thousands of pictures."

However, the jurors say, they were less than overwhelmed with the witnesses the prosecution called. Prouty seemed to want the photographs to speak for themselves. "Are these van Goghs, these pictures?" he asked the jurors. "*You* tell what is and what is not art."

"We were shocked the state didn't have more witnesses," Loesing says. "All we had was a few policemen"—members of the vice squad who videotaped the Mapplethorpe show as evidence. She adds that the prosecution often mentioned the CCV and the AFA. "We didn't understand why they didn't show up. Their opinion could have mattered." Reisman, the prosecution's sole expert witness—who testified that the photographs lack the "human emotion or feeling" necessary in an artwork—"did not make a big impression," Loesing adds. "She was reading off her résumé." Eckstein concurs. "She wasn't being straightforward—at first she didn't even bring up that she was paid for these works," he says of her research for the AFA. Prouty, however, says that if he had to try the case again,

he still would not bring more witnesses. "I'd do it the same way," he claims. "The pictures are what is on trial."

Barrie, who is more confident about the matter than many in the art world, believes that the trial "has probably shut the door on actions against museums. If there was a conviction, people would have attempted this all over." However, in financial terms the trial was a great drain on the museum: it spent $200,000 on legal fees and $100,000 on additional expenses (some of which have been paid by organizations including the Mapplethorpe Foundation and the Art Dealers Association of America). "The corporate community will not support us for the next few years," Barrie says. "But we'll continue to do challenging and provocative work. We're not going to shy away from controversy." However, Barrie does worry that many arts institutions will be intimidated by the high costs a trial could incur. "There's not so much fear of prosecution as of economic reprisal," he comments.

Bruce Cohen, spokesman for the American Council for the Arts in New York, agrees that the financial threat to museums is a powerful factor. "People will be looking over their shoulder," he says. "Not because they believe they'll be convicted of obscenity. Everyone's afraid of their funding. It's like McCarthyism—it's not a creative atmosphere. You don't know if what you do next season will turn into a Jesse Helms speech on the floor of the Senate. If museums or theaters are planning to do new works, corporations and foundations are probably asking—off the record—'You're not going to do anything controversial, are you?' A corporation doesn't want to get 50,000 letters."

Sobieszek also feels that the acquittal is not enough to quell curators' worries. They may continue to present provocative exhibitions, he says, "But we're saying, 'Is this going to be a half a year trauma, the way Barrie suffered? Will my trustees support me the way Barrie's supported him?' I can see some institutions' trustees not doing that. Barrie's trustees went full tilt."

In Cincinnati itself there are signs that the battle is far from over. Monty Lobb, Jr., president of Citizens for Community Values, told the *Cincinnati Post* that the trial sends a message to other museums that might consider presenting similar exhibitions. "The community standards here are so high that we may not win every trial, but you are going to be prosecuted." Prouty also thinks that this case does not discount the possibility of more battles in the future. "The way Dennis Barrie talks it's a victory for them—he's intending to proceed as usual," he comments. "But the thing to remember is that obscenity is not protected by the First Amendment."

"Many of the opponents in Cincinnati think they won through what would be called a chilling effect," *Post* critic Stein says. "How many small

arts organizations would have $100,000 to defend themselves? We have to guard against an almost subliminal self-censorship out of fear the prosecution will come again on the same subjects."

However, there are also signs that many Cincinnatians have had enough. In a poll commissioned by the museum before the trial, more than half of the respondents—59 percent—believed that Barrie was not guilty, while 26 percent said that he was. Only 26 percent were in favor of the state prosecuting the museum. And one of the respondents' biggest complaints was that the trial was paid for with their taxes—71 percent said they thought it was a waste of money. After the trial, the *Cincinnati Enquirer* reported that Councilman David Mann had urged County Prosecutor Arthur M. Ney, who originally brought the case to a grand jury before it was passed on to the city solicitor's office, to reimburse the city for the costs of prosecution.

When it was all over, there was a public expression of relief. "The jury's decision," said a *Cincinnati Post* editorial, "saved Cincinnati from becoming the first city to convict an art museum of pandering obscenity. That would have been a difficult distinction to live down." When the verdict was reached, Barrie recalls, the news was immediately announced by a local radio station broadcasting a Cincinnati Reds baseball game. "People in the stadium stood up and cheered," he says. "Eight people with their decision redeemed the whole city."

As difficult as the decision was for the jurors to make, they now express pride in it. "I think this proved it's not as conservative here as people think," Eckstein says. And Loesing adds that many of her neighbors, to her surprise, think they made a good decision. "I talked to more people who think the right thing was done than people with negative opinions."

The jurors are also proud of something else—the new knowledge they took away with them. "I think we all learned from this," Eckstein says. "I know art has some meanings I don't see." He says he would like to see more shows, though "not this kind of thing." Burton also says that her experience as a juror has expanded her horizons. "Art was never something that I was interested in," she explains. "I'm definitely interested now. I would like to maybe go to the CAC some time and see what they're all about. If the Mapplethorpe exhibit ever came back through Cincinnati, I think I might want to see what the whole exhibit was like."

"Going in, I would never have said the pictures have artistic value," Loesing says. "Learning as we did about art, I and everyone else thought they did have some value. We were learning about something ugly and harsh in society that went on."

In the end, she adds, "it seemed like Robert Mapplethorpe had talent and had a story to tell behind each one of the pictures. I would have liked to see the ones he did of flowers."

27

Is Art above the Laws of Decency?

Hilton Kramer

The fierce controversy now raging over the decision of the Corcoran Gallery of Art in Washington to cancel an exhibition of photographs by the late Robert Mapplethorpe was an event waiting to happen, if it hadn't happened at this time and at this institution, sooner or later it would surely have erupted elsewhere. The wonder is that it didn't occur earlier, for it involves an issue that has haunted our arts institutions, their supporters and their public for as long as Government money—taxpayers' money—has come to play the major role it now does in financing the arts.

The issue may be briefly and in the most general terms stated as follows: Should public standards of decency and civility be observed in determining which works of art or art events are to be selected for the Government's support? Or, to state the issue another way, is everything and anything to be permitted in the name of art? Or, to state the issue in still another way, is art now to be considered such an absolute value that no other standard—no standard of taste, no social or moral standard—is to be allowed to play any role in determining what sort of art it is appropriate for the Government to support?

The Corcoran Gallery's decision was prompted by the special character of Mapplethorpe's sexual imagery and a quite reasonable fear on the part of the museum's leadership that a showing of such pictures in Washington right now—especially in an exhibition partly financed by

This essay originally appeared in *The New York Times*, 2 July, 1989. Copyright © 1984/ 89 by The New York Times Company. Reprinted by permission.

the National Endowment for the Arts—would result in grave damage both to the Corcoran itself and to the whole program of Government support for the arts. . . .

Getting the Issue Exactly Wrong

In the case of the Mapplethorpe exhibition, which the Corcoran Gallery found it prudent on June 13 to cancel prior to its opening, even in the face of what everyone knew would be the inevitable uproar, we are once again being asked to accept the judgment of the art-world establishment as absolute and incontestable. (The fact that the Washington Project for the Arts immediately appropriated the right to show the exhibition in Washington only serves to underscore this point.) We are being told, in other words, that no one outside the professional art establishment has a right to question or oppose the exhibition of Mapplethorpe's work even when it is being shown at the Government's expense. In this instance, to be sure, the Government did not cause the photographs in question to be created. Mercifully, they were not commissioned by a Government agency. But such an agency did contribute funds to support their public exhibition, and by so doing it gave the public and its elected representatives the right to have a voice in assessing the probable consequence of such an exhibition—a task that the art establishment has lately shown itself to be utterly incapable of performing in any disinterested way.

Here again, to suggest that the public's legitimate interest in this matter amounts to political repression is to get the whole issue exactly wrong. The public's right to have an interest in the fate of this exhibition began on the day tax dollars were allocated for [such] display. There was no public outcry, after all, though there was a certain amount of private outrage, when Mapplethorpe's pictures were exhibited in commercial galleries. Some of the people who went to the galleries to see the photographs, unaware of what it was they would be seeing, had plenty of reason to be shocked at what they saw depicted in the work. This was especially the case, as I myself witnessed on one occasion, with parents who are in the habit of making the rounds of the art galleries in the company of their young children.

Public Money for Pornography?

What is it, then, about some of these photographs—the ones that are the cause of the trouble—that makes them so offensive? It isn't simply that they depict male nudity. There are male nudes in the Minor White retrospective now on view at the Museum of Modern Art that no one, as far

as I know, has made any fuss about. In today's cultural climate, in which it has become commonplace for schoolchildren to be instructed in the use of condoms, it takes a lot more than a museum exhibition of pictures showing the male genitals to cause an uproar.

What one finds in many Mapplethorpe photographs is something else—so absolute and extreme a concentration on male sexual endowments that every other attribute of the human subject is reduced to insignificance. In these photographs, men are rendered as nothing but sexual—which is to say, homosexual—objects. Or, as the poet Richard Howard wrote in a tribute to Mapplethorpe, "The male genitals are often presented . . . as surrogates for the face."

Even so, these homoerotic idealizations of male sexuality are not the most extreme of Mapplethorpe's pictures. That dubious honor belongs to the pictures that celebrate in graphic and grisly detail what Richard Marshall, the curator who organized a Mapplethorpe retrospective at the Whitney Museum last summer—not the same exhibition as the one in dispute at the Corcoran, by the way—identified as the "sadomasochistic theme." In this case, it is a theme enacted by male homosexual partners whom we may presume to be consenting adults—consenting not only to the sexual practices depicted but to Mapplethorpe's role in photographing them.

The Issue Is Not Esthetics

I cannot bring myself to describe these pictures in all their gruesome particularities, and it is doubtful that this newspaper would agree to publish such a description even if I could bring myself to write one. (There can be no question either, of course, of illustrating such pictures on this page, which raises an interesting and not irrelevant question: Should public funds be used to exhibit pictures which the press even in our liberated era still finds too explicit or repulsive to publish?) Suffice it to say that Mr. Marshall, who presumably knows what he is talking about in this matter, assured us in the Whitney catalogue that Mapplethorpe made these pictures "not as a voyeur but as an advocate" and "sympathetic participant."

Even in a social environment as emancipated from conventional sexual attitudes as ours is today, to exhibit photographic images of this sort, which are designed to aggrandize and abet erotic rituals involving coercion, degradation, bloodshed and the infliction of pain, cannot be regarded as anything but a violation of public decency. Such pictures have long circulated in private, of course. They belonged, and were seen to belong, to the realm of specialized erotica. In that realm, it was clearly

understood that the primary function of such images was to promote sexual practices commonly regarded as unruly and perverse, or to aid in fantasizing about such practices. The appeal of such images for those who were drawn to them lay precisely in the fact that they were forbidden. They belonged, in other words, to the world of pornography.

It may be asked whether the disputed Mapplethorpe pictures really differ from earlier works of art that, owing to their violation of conventional taste, caused the public to denounce them, only to embrace them later as treasured classics. The example that comes to mind is Manet, whose two most famous paintings, "Déjeuner sur l'Herbe" and "Olympia" (both 1863), were attacked as indecent when they were first exhibited in Paris.

For a true counterpart to Mapplethorpe in 19th-century art, however, it isn't in a master like Manet but in graphic artists who specialized in pornographic images that we will find an appropriate parallel, and we still don't see much of that art on public exhibition in our museums even today.

What has turned these Mapplethorpe photographs into a public controversy is not that they exist. We may not approve of their existence, and we may certainly regard both the creation and the consumption of them as a form of social pathology. But so long as they remained a private taste, they could not, I believe, be seen to be a threat to public decency. What has made them a public issue is the demand that is now being made to accord these hitherto forbidden images the status of perfectly respectable works of art, to exhibit them without restriction in public institutions, and to require our Government to provide funds for their public exhibition.

Ostensibly, these are demands that are being made in the name of art. That isn't the whole story, of course—it never is where art is made to serve extra-artistic purposes—but before looking into the extra-artistic aspects of this matter, a prior question must be addressed. Are these disputed pictures works of art? My own answer to this question, as far as the Mapplethorpe pictures are concerned, is: Alas, I suppose they are. But so, I believe, was Richard Serra's "Tilted Arc" a work of art. This is not to say that either "Tilted Arc" or the Mapplethorpe pictures belong to the highest levels of art—in my opinion, they do not—but I know of no way to exclude them from the realm of art itself. Failed art, even pernicious art, still remains art in some sense. . . . I believe we must accord Mapplethorpe a place—though not the exalted place being claimed for him—in the annals of art photography. It doesn't solve any of the problems raised by the Mapplethorpe pictures to say they aren't art. It is only a way of running away from the difficult issue, which doesn't lie in the realm of esthetics.

What has to be acknowledged in this debate is a fact of cultural life

that the art-world establishment has never been willing to deal with—
namely, that not all forms of art are socially benign in either their in-
tentions or their effects. Everybody knows—certainly every intelligent
parent knows—that certain forms of popular culture have a devastating
effect on the moral sensibilities of the young. Well, it is not less true that
certain forms of high culture are capable of having something other than
a socially desirable impact on the sensibilities of young and old alike.
How we, as adult citizens, wish to deal in our own lives with this antisocial
element in the arts should not, I think, be a matter for the Government
to determine, for systematic programs of censorship are likely to have
consequences that are detrimental to our liberties. (The question of pro-
tecting children is another matter entirely.) It is when our Government
intervenes in this process by supporting the kind of art that is seen to be
antisocial that we as citizens have a right to be heard—not, I hasten to
add, in order to deny the artist his freedom of expression, but to have a
voice in determining what our representatives in the Government are
going to support and thus validate in our name.

A Dedication to Pernicious Ideas

Unfortunately, professional opinion in the art world can no longer be
depended upon to make wise decisions in these matters. (If it could, there
never would have been a "Tilted Arc" controversy or the current uproar
over the Mapplethorpe pictures.) There is in the professional art world a
sentimental attachment to the idea that art is at its best when it is most
extreme and disruptive. This is the point of view that prompted an art
student in Chicago to think he was creating a valid work of art by spread-
ing out an American flag on the floor and inviting the public to walk on
it, and then recording their responses to what was at the time a proscribed
practice (now that the Supreme Court has ruled in its favor, I suspect
that this particular idea will lose some of its appeal to "advanced" taste).
It was this notion of equating artistic originality with sheer provocation
that also led the Southeastern Center for Contemporary Art to give a
grant of the Government's money to Andres Serrano, now famous for the
work that consists of a photograph of Christ on the Cross submerged in
the artist's urine. This is the kind of thing some people mean when they
talk about the so-called "cutting edge." Basically, it is a sentimentali-
zation as well as a commercialization of the old idea of the avant-garde,
which everyone knows no longer exists—except, possibly, in the realm
of fashion design and advertising. The phenomenon of the avant-garde
in art died a long time ago, and now lies buried under the millions of
dollars that have been spent on the art that bears its name.

In lieu of an authentic avant-garde in art, we now have something

else—that famous "cutting edge" that looks more and more to an extra-artistic content for its fundamental raison-d'être. In the case of "Tilted Arc," the "cutting edge" element consisted of the sculptor's wish to de-construct and otherwise render uninhabitable the public site the sculpture was designed to occupy. In the case of the disputed Mapplethorpe pictures, it consists of the attempt to force upon the public the acceptance of the values of a sexual sub-culture that the public at large finds loathsome—and here I do not mean homosexuality as such but the particular practices depicted in the most extreme of these pictures. In both cases, we are being asked to accept the unacceptable in the name of art, but this is sheer hypocrisy, and all the parties concerned know it is hypocrisy. What we are being asked to support and embrace in the name of art is an attitude toward life, which nowadays is where the real cutting edge (no quotation marks required) is to be found.

If our agencies of Government are incapable of making this distinction between art and life, the public will have more and more reason to be concerned with the way tax dollars are being spent in the name of art. The problem won't go away, and it can't be argued away by cries of repression or censorship. Much of what the Government spends on the arts still goes—and ought to go—to supporting the highest achievements of our civilization, and it would be a tragedy for our country and our culture if that support were to be lost because of a few obtuse decisions and a dedication in some quarters to outmoded and even pernicious ideas. But if the arts community is not prepared to correct the outrages committed in its name, there will be no shortage of other elements in our society ready and eager to impose drastic remedies. This is a problem that the art world has brought upon itself.

28

The National Endowment for the Arts: A Misunderstood Patron

Elaine A. King

The primary goal of the National Endowment for the Arts (NEA) has been to promote the growth and development of the arts in the United States, to enrich and preserve the cultural resources of the nation, and to allow individuals from all socioeconomic backgrounds to experience and participate in the arts. Today the NEA continues to play a key role in the educational process of bridging the elite and masses despite the blazing battle of censorship begun in the summer of 1989 around the Robert Mapplethorpe exhibition and its unfortunate cancellation at the Corcoran Gallery of Art. In light of the nationwide support and attention the arts had gained during the NEA's first twenty-five years and the current political climate, the NEA controversy seems at one and the same time to be both surprising and almost predictable.

When we consider that the NEA has made more than eighty-five thousand grants in twenty-five years with little or no public objection until now, it does seem surprising that public officials specifically and the public generally would ignore the fact that the general impact of the agency over twenty-five years had been positive. However, the country's weakening economy, combined with other national shifting ideological trends could easily give rise to more debate over the fundamental question of whether the government should be funding art at all, and even worse, work that may be deemed offensive to "traditional American values." History has taught us that these are always relative and evolve over time.

This essay is adapted from a lecture given at the College Art Association Meeting, Washington, D.C., February, 1991. Printed by permission of the author.

This essay aspires to show the social-historical context in which the NEA emerged. When substantial federal funding was appropriated for the arts between 1969 through 1978, the NEA played a vital role in liberating the arts and artists beyond limited formal definitions and a few urban cultural centers. Between 1970 to 1976 a surge of activity occurred in the Visual Art Programs of the NEA: During this short period approximately fourteen new visual arts categories were created. These paralleled the rapid changes taking place in the 1970s when collectively artists overturned a whole system of traditional categories. The experimentation of artists at this time was necessary to liberate art from the rigidity of formalism and the autocratic dogma of Clement Greenberg imposed on the art of the 1960s. What resulted was a relaxation of categories and boundaries: the art of the 1970s became known as an era of pluralism. Often several genres would be assimilated in a single work of art: postminimalists such as Keith Sonnier, Mel Bochner, Eva Hesse, and Barry Le Va led the way in mixing materials and challenging definitions of art at the onset of this decade. The NEA's encouragement of a pluralist attitude in the visual arts challenged the long-held assumption that only a handful of aesthetic approaches were significant or worthwhile. Such assumptions meant that artists who did not choose to express themselves through abstract expressionism or minimalism, or whatever the current aesthetic mode might be, condemned themselves to a lifetime of obscurity and lack of financial support. The NEA's endorsement of a great variety of artistic agendas allowed the visual arts to bring to the public works that expressed many viewpoints and diverse social, ethnic, and political backgrounds. Gender and race issues, the student rebellions of the late 1960s and early 1970s, the civil rights movements, and antiwar protests, and the intensification of the feminist and ecological concerns all contributed to the development of a pluralist aesthetic. The blurring of forms and content boundaries opened up vast possibilities within each genre of art and contributed to a major shift in attitude among patrons, collectors, critics, and the general public—a major shift in thinking had occurred, and its wider significance has yet to be fully appreciated by both art historians and social scientists.

When considering arts patronage via the federal government, and freedom of expression, we must recall that the framers of our Constitution did not think of themselves as democrats. As quoted by Stanley Katz:

> They called themselves republicans. They had explicitly rejected democracy as a form of government and adopted republicanism instead. There was in a republican society a sufficient quantum of virtue in every individual, and it was assumed that those individuals would prefer the good of the common weal to their own welfare. In a social-democratic society, where every in-

dividual would tend to favor his or her own welfare, the social fabric would be disrupted. Our national history is a tension between these two ideals and realities."[1]

In 1776 the United States became the first revolutionary country.

We revolted from a monarchy and established ourselves as a republic. In doing that, we divorced ourselves from what Michael O'Hare has referred to as the ideal of the mad-king Ludwig. That is to say, we divorced ourselves from the idea of patronage.[2]

Patronage in European history is linked to the crown and to wealth, and, for many American citizens the arts have very little to do with the social welfare of the people. Before the funding of the NEA in 1965, support for the arts in the United States was marginally private. Although the American government was involved with the arts during the Great Depression, the governmental arts projects of the 1930s were conceived as a means of economic relief to artists and as mainly a symbol of encouragement for creating a sense of national identification and not an endorsement of the arts and culture as an essential national resource.

Since the inception of the NEA in 1965, a debate centering around "Elitism versus Populism" has been an inflammatory issue. At the onset of the Carter administration, the following statement appeared in the *Washington Star*: "The past decade has seen an unprecedented growth of the arts in America. But the 'high arts' patrons are still largely upper-class."[3] Many congressmen and citizens abhorred the Mandarin tastes of the NEA program directors and panelists. President Jimmy Carter who was a populist-oriented president aspiring to make the arts available to a wider public, shortly after entering the White House made an investigation of the NEA. He commissioned a Cambridge group of researchers at the Center for the Study of Public Policy to analyze the composition of the American arts audience. "The study found that arts audiences, by far, have more education, higher status jobs and earnings than the population at large."[4] Even though Ronald Reagan was not a pro-NEA president, throughout most of the 1980s the elitist debate somewhat subsided because the arts did not hold a high priority in the Reagan administration. However, this debate heated up again in 1989 when the incident at the Corcoran Gallery of Art surrounding the Robert Mapplethorpe photography exhibition raised numerous issues about art and about who should judge its appropriateness. The issue of censorship once again rekindled the elitist fires, and it continues today, only more polarized and complicated by the hidden homophobic agendas of the right wing political factions headed by Senator Jesse Helms. Perhaps the most positive result from the entire NEA/censorship debate is the painful lesson learned about

our society's fear of the unknown and the power of ignorance. It is apparent that the American public needs to become educated about art and the role artists have played throughout history. Making art more accessible through clearer programs and exhibitions, and having art become a regular subject within the school curriculum can assist in the process of clarification. The emphasis on educating citizens about art has become a focus of priority not only at the NEA but also at state arts councils across the United States.

The history of European patronage is rooted in the monarchy, aristocracy, and the church. Europe expanded culturally and artistically throughout the eighteenth and nineteenth century because of private patronage. However, in the United States there virtually was no support for the·arts, let alone government patronage. In this century, Europe's tradition of private arts patronage has been replaced largely by generous state subsidies. In countries such as France and Germany, bureaus of art and culture promote arts both at home and abroad. Because the arts are viewed as an important national resource large sums of money are appropriated for a range of cultural programs. In New York or Washington, D.C., an American museum could apply for financial aid for an exhibition or catalogue that would promote a French artist. In France the government funding for the arts is approximately four times that of the United States. When one compares the size and population of that nation to that of the United States, our federal government arts subsidy is shameful. However, the European precedent for making culture a priority has been established over centuries—art is viewed as a vital element in the quality of life equation. This is a key factor—one that crucially separates attitudes of Europeans and Americans, vis-à-vis art and cultural subsidy.

In the United States, most government support for the arts had been primarily rhetorical rather then financial, with the exception of government buildings and public commemorative monuments. And here, too, our Puritan ethics and suspicions about art and artists underlie this nation's psychological core. As early as 1843, the American public resisted innovation and support for the arts. A case study for the monumental statue of George Washington, produced by the sculptor, Horatio Greenough serves as a fine example.

> The statue was the perfect image of the President's face and features blended with the Roman past, from toga, sandals. . . . But in 1843 neither the American public nor Congress was ready to accept the "father of our country" as a half-naked Roman.[5]

In the 1930s, government subsidy for the arts occurred. However,

the Works Progress Administration (WPA), founded in 1935, unlike the NEA, which encourages art for its own sake, was not created to promote the expression of individual artists. The project was strained because administrators wanted to control the expression of the artists employed; however, this went against the very nature of an artist's temperament. It was ultimately an economic relief program for creating jobs for artists and to promote American nationalism. By the middle of 1940, the arts projects were being filtered into the defense program. The WPA community art centers held classes on camouflage for officers and gave craft courses to enlisted men. Increasingly the creative arts were supplanted by the practical arts. By mid-1943, all WPA projects were phased out and the concept of federal patronage was history. Politicians in the late 1940s viewed the arts with suspicion. In general congressmen and politicians were confused either about what art was or about its role in American society. Rampant paranoia characterized the political climate in the United States, causing a cautious atmosphere: By 1950 the door slammed shut on the arts because of the mounting fears of communism. Curiously at this time, American artists gathered strength and created the first genuinely American movement—abstract expressionism. The efforts of the National Arts Foundation (founded in 1947) was a nonprofit agency dedicated to stimulating interest in the arts and to obtaining support of the arts; the dedication of this group was critical in improving America's art image abroad and as well as keeping Congress enlightened.

In 1951, President Truman requested a report on the arts in the United States. "It was through the efforts of Lloyd Goodrich and the Committee on Government and the Art, which mobilized arts organizations across the country, that Truman was encouraged to commission this study."[6] The document titled *Art and Government* was completed in 1953 and its contents were influential in getting the Eisenhower administration to increase support for the Smithsonian Institution. The year 1955 was critical: in his annual State of the Union address, President Eisenhower made a surprising declaration about the arts in relationship to government. This was of major significance, marking a positive thrust toward the arts since the New Deal.

> The federal government should do more to give official recognition to the importance of the arts and other cultural activities. I shall recommend the establishment of a Federal Advisory Commission on the arts within the Department of Health, Education and Welfare, to advise the federal government on ways to encourage artistic endeavor and appreciation.[7]

The debates, the reports, and delays centering around the NEA's formation took almost twenty-five years of vigilant and rigorous activity.

Executive Order 11112, 1963, calling for the establishment of an Advisory Council on the Arts was a watershed act. John Kennedy's arrival in the White House in 1960 paved the road to the creation of the NEA and the National Endowment for the Humanities (NEH). Kennedy's assassination in 1963 postponed further action. Fortunately, Senator Claiborne Pell urged Congress to keep the National Arts and Cultural Development Act of 1963 alive, with Sidney Yates, Livingston Biddle, and Jacob Javits fueling the fires. President Lyndon Johnson's signing of the Supplemental Appropriations Act of 1966, Public Law 309, on October 31, 1965, providing the NEA with authorized funds, marked this government's formal entry into the business of providing support of the cultural life of America.

Under Richard M. Nixon, the NEA experienced amazing growth. Nixon's verbal endorsement was backed up with increased appropriations for the NEA and the selection of Nancy Hanks as its chairperson in 1969. Nixon was a conservative, and by some considered a Philistine. However, he too was an astute politician, well aware that many leading Republicans were trustees and board members of key American museums, symphony orchestras, theaters, and other cultural agencies. He understood, that whereas a Democrat could take the world of artists and art lovers for granted, a Republican would have to exert himself in demonstrating that he was an advocate of art and culture beyond elite institutions. Nixon was also aware that the ideals of the Great Society were a major factor underlying the principles of the NEA. Promoting the NEA and NEH programs provided Nixon with a vehicle for enriching and expanding the parameters of American society beyond key urban centers.

Nancy Hanks, who lead the NEA through its golden years, 1969 to 1976, fully understood the power of the Senate and House, and the role each member played in reaching and representing the American public. Sidney Yates stated: "She made it a point to visit members of Congress." Members of the Congress and Senate knew Nixon's feelings: Richard Contee, former assistant chairman for management, remarked, "Congress is very disposed to this agency," and "Enemies do not exist."[8] Andrew Glass commented: "The Endowment is wired into the lobbying process in a way that, say, the State Department is not—and Hanks is not shy about reminding Congress how support of the arts pays off politically." He also stated, "Hanks has won a reputation for submitting budgets that zip through Congress unscratched."[9] Hanks aspired to reach a wider American audience through the NEA funding, and she wanted the arts to benefit the majority of Americans. In 1969 funding for the NEA was $7,756,875. Funds for fiscal 1971 jumped to $15,000,000; by 1977 it had jumped to $94,000,000.

Before 1965, when the National Foundation on the Arts and the Humanities Act was passed, only five states had functioning arts agen-

cies. The response from states across the United States for the available government monies for the arts was immediate. Within a year, state agencies were operating with appropriated funds in twenty-two states and in Puerto Rico. In 1974 there were fifty-five, and since 1978 there have been fifty-six, representing all fifty states, the District of Columbia, and five special jurisdictions. Between 1970 and 1978, funding for the Visual Arts Program went from $970,244 to $4,902,931. An examination of the expansion of the Visual Arts Programs between 1970 through 1976 indicates the NEA was sensitive to the changing attitudes about art at this time. Hanks's appointment of Brian O'Doherty, director of the Visual Art Program was an excellent choice: He was aware of the undercurrents of the art world, shifting away from the linear, modernist lines. He was sympathetic to experiment, and supportive of pluralist thought. Replacing the concept of definitive styles and movements in the 1970s was the notion of vast genres that became known as site specific, installation, language art, video, photography, political, conceptual, feminist, and so on. The fact that most of the new categories of funding were created during the first few years of the 1970s is relevant to understanding the evolution of pluralism. The diversity of programs, and the range of artists and arts organizations receiving monies added to the development and expansion of the visual arts across this nation throughout the 1970s. In the beginning of this decade the galleries and museums were reluctant to accept the ephemeral post–modern art created by a new generation of younger artists who re-refuted the dictates of 1960s formalism. Important programs created in the first half of the decade included the Intermediate Program (1971), which eventually split into three distinctive programs that became Artists' Services (1972), Artists-in-Residence (1971) and Workshop Program (1972), which became both the important funding source for alternative spaces and a vital cause for the growth of alternative spaces throughout the country. Within a few years vital programs included Public Media (1971), Museum Program (SLIDE) (1971), which included Purchase Plan and Wider Audience Availability, Photography Fellowships (1971), Photography Exhibitions and Publications (1973), Art Critics Fellowships (1972), Video (1974), Performance Art (1974), Printmaking and Drawing Fellowships (1974), and Craft Fellowships (1975). This list is impressive, not only because it reveals the diversity of programming being supported but also indicates the range of art activity involved. The Workshop Program, begun as only a pilot in 1971, was perhaps the one single program that made a major impact on the expansion of pluralist art. The funding available through this program was catalytic in giving rise to alternatives spaces throughout the United States. Grants averaged between, $5,000 to $15,000, depending on size and actual budget. To an alternative space, these figures represented substantial

amounts of money. Furthermore, NEA dollars represented a "golden stamp of approval," which led to state, local, and private grants for many small alternative spaces. Although the concept of the alternative spaces began in New York City in 1971 at P.S.I., Artists Space, and the Kitchen, by 1975 alternative spaces existed in cities as far reaching as Seattle, Chicago, and Minneapolis. Throughout the 1970s new work was often first presented in artists' spaces, now a national filtration system for emerging talent. Many of the alternative spaces begun in the 1970s continue today as launching pads for emerging artists across this nation. Most often NEA support was vital to these organizations' survival, at least in the formative years of their existence.

In the early 1970s the women's movement gathered momentum. NEA monies afforded places such as A.I.R. (New York City), ARC, and Artemesia (Chicago), and WARM (Minneapolis) to not only showcase a variety of art, but also provide women with a much-needed serious forum for provocative exchange through panels, visiting speakers, and programs. Women such as Nancy Spero, Sylvia Sleigh, Dottie Attie, Miriam Shapiro, and Mary Beth Edelson became role models and driving forces of the feminist movement. They gained their recognition through the alternative space networks. Much feminist imagery freed artists from the confines of formalism and contributed to a new art vocabulary based on personal experience and feelings. Women's art from this era was issue oriented, and it gave rise to the new emotive figuration that came to characterize much of 1980s art. In addition, feminist concerns played a major role in bringing content back into art.

Through assistance from the *Service to the Field* grants, alternative magazines, books, and directories were published. *Afterimage, Heresies, New Art Examiner, Artweek, Feminist Art Journal*, and *Midwest Art* were some among the many publications. *Printed Matter* became a vital place for the distribution of artists' books (which often became the lasting art form for much of the performance and conceptual art).

In her statement for the 1976 Annual Report of the NEA, Nancy Hanks wrote: "Museums grew in number from 1,700 to 1,880. The number of literary magazines advanced from 450 to 700 and independent presses from 200 to 350."[10] Ten museums across the country experienced a financial boost from NEA grants targeted for exhibitions and purchases.

In 1977 the NEA appropriation was $94 million. In 1981, its appropriation was $158,795,000. During the past ten years the NEA has only had an increase of approximately $17 million or less then 8 percent. Lawmakers such as Senator Jesse Helms has used the Serrano and Mapplethorpe controversy to stir up Americans against federal arts patronage. Because of the theatrics of the past two years, the NEA was the only federal agency whose budget remained unchanged in 1991, at $174 mil-

lion. Of the total proposed national budget of $1.45 trillion for 1992, the NEA will receive .012 percent of the pie. According to the 1989 Annual Report

> Over the past 25 years millions of Americans have benefitted from NEA monies as it filters down to regions and communities through state arts councils. According to the most recent NEA Annual Report providing financial data through 1989, state arts agencies and six special jurisdictions awarded almost 40,000 grants totaling $225 million in more than 4,200 communities.[11]

These include basic state grants, dance tour, regional art planning, special projects, and state support services. In many arts agencies NEA money comprises more then 65 percent of their total arts council budget. In the area of arts education alone 9,700 artists-in-residence grants were awarded in nearly 11,600 sites and reached more than 4,250,000 students. These grants were then matched by local public and private funds to support artists' fellowships, school residences, arts festivals, exhibitions, and thousands of other kinds of projects. It is hoped that this type of financial endorsement of cultural activities will further raise the artistic consciousness of the citizens of the United States.

The amount of monies allocated by our government for the NEA, $176 million, is a drop in the bucket when compared with the total national budget. The NEA is considered a very small agency, by Washington staff and budget standards, but has played a pivotal role in the development of a pluralist approach to art and in reducing, but not eliminating, the many barriers that separate the classes. However, if the NEA is to thrive and regain some of the power and strength it once possessed in the 1970s, it will need leadership from within it as an agency, support from leaders and lawmakers of this country, and an educated public that is not overwhelmed by fear of the arts and issues they do not readily understand.

Many solutions to the NEA have been proposed. In the future, policy and issues about the NEA will increasingly become more heated and difficult. The forced resignation of John Frohnmayer indicates that a gloomy future could await the NEA because of its precarious position on the political tennis court.

The threat of abolishing the NEA is frightening—what has ensued is chilling and painful, and the air has not cleared but only has temporarily been stilled because of the pending presidential and congressional elections. However, the public policy debate ensuing during the past 30 months has brought to light important and ongoing issues for the public, politicians, the NEA itself, and the larger arts community to consider. A

critical issue in the next several years' debate of public support is the issue of public accountability. How do we equitably distribute and accurately account for the taxpayer's investment in the arts? As long as the government is an arts patron, it must apply constitutional mandates of quality and equity of funding, and access to the arts and balance these standards of excellence; however, the problem arises when considering: whose standards?

T.S. Eliot believed that equality and culture were deadly enemies and equated the "well educated" and the "elite." He subscribed to Karl Mannheim's theory that whatever labels may be attached to the warring dogmas of the twentieth century, contemporary society in its complexity can be governed by elites.[12] In American society references to elitism stir negative connotations; the views of Eliot, vis-à-vis art and culture, have fallen out of favor in our politically correct society that pretends to be democratic and equal. Any astute individual knows that there continues to exist a hierarchical cultural structure in all nations. However, only through the education of a greater population can class barriers be broken down. The European model of making art and culture a regular part of daily life needs to be reexamined and emulated in the United States if we hope to prepare our citizens to communicate and function within a rapidly ever-shifting international society. Monies allocated to the NEA for the arts is only one step in a difficult but important process. It is curious that most Pulitzer Prize–winning plays had their premier productions at nonprofit theaters funded by the NEA.

Notes

1. Stanley Katz, "The Arts and Humanities under Fire: New Arguments for Government Support" (New York: American Council for the Arts 1990), p. 9. (Proceedings from a panel discussion on censorship and NEA funding).

2. Ibid., p. 9.

3. Phillip M. Kadis, "News Flash: Arts Audiences Are Better Educated than No-Shows," *Washington Star*, 27 December 1977, p. D1.

4. Ibid., p. D1.

5. Robert Myron and Abner Sundell, *Art in America* (New York: Crowell-Collier Press, 1968), pp. 67–68.

6. Original members of the CGA included representatives from the American Federation of Arts, American Association of Museums, College Art Association, Association of Art Museum Directors, Artist Equity, and the National Academy of Design. Other organizations that joined included the National Society of Mural Painters, Sculptors Guild, National Association of Women Artists, American Institute of Decorators, and the American Institute of Architects.

7. *New York Times*, 18 January 1955, p. 17. Reprint of President Dwight D. Eisenhower's "Annual Message to Congress on the State of the Union," 6 January 1955. Also see Public Papers on the President of the United States, Dwight D. Eisenhower. This was

a significant declaration, marking the first public support of the arts by a government official since the New Deal.

8. C. Richard Swaim, "The Fine Politics of Art: Organizational Behavior, Budget Strategies and Some Implications for Art Policy," Ph.D. dissertation, University of Colorado, 1977, p. 117. Richard Contee, assistant chairman for management, NEA, Remarks to an Intern seminar, 12 April 1976.

9. Andrew Glass, "She's an Artist at Getting Money in the Arts," *New York Times*, 14 December 1975, D1, p. 32.

10. *1976 Annual Report*, National Endowment for the Arts and National Council on the Arts (Washington, D.C.: United States Government Printing Ofice, 1977), p. 405.

11. *1989 Annual Report*, National Endowment for the Arts and National Council on the Arts (Washington, D.C.: United States Government Printing Office, 1990), p. 216.

12. Michael Straight, *Twigs for an Eagle's Nest: Government and the Arts: 1965–1978* (New York: Devon Press, 1979), p. 60.

13. The essence of this essay comes from a paper delivered at the College Art Association meeting in Washington, D.C., on 23 February 1991 as part of a panel titled "Art Patronage in the Modern Period: Structures, Strategies and Supporters." Much of the statistical data has been taken from the research material compiled in her Ph.D. dissertation for Northwestern University, 1986, titled "Pluralism in the Visual Arts in the United States, 1965–1978: The National Endowment for the Arts, an Influential Force."